# INSIDE THE ARTIST'S STUDIO

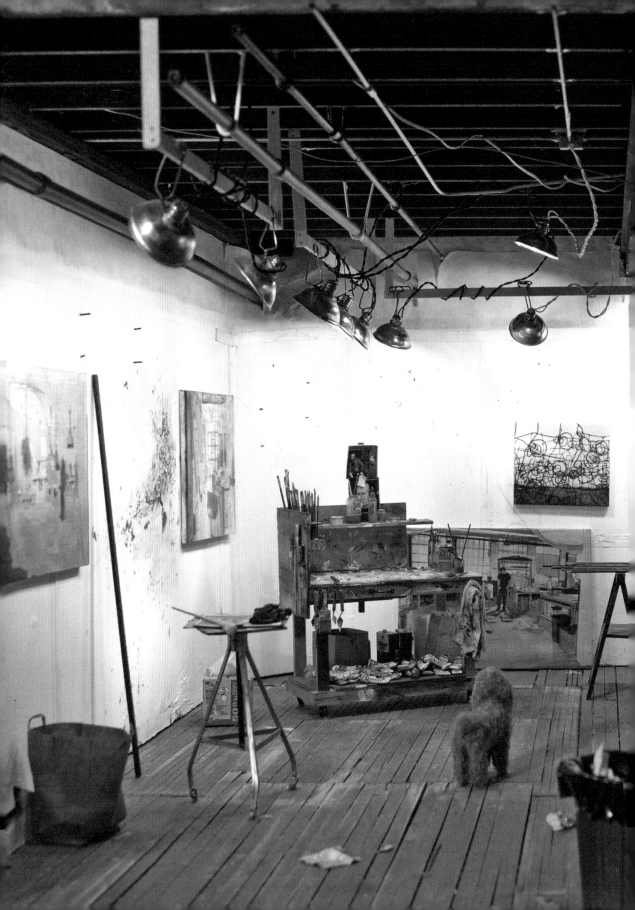

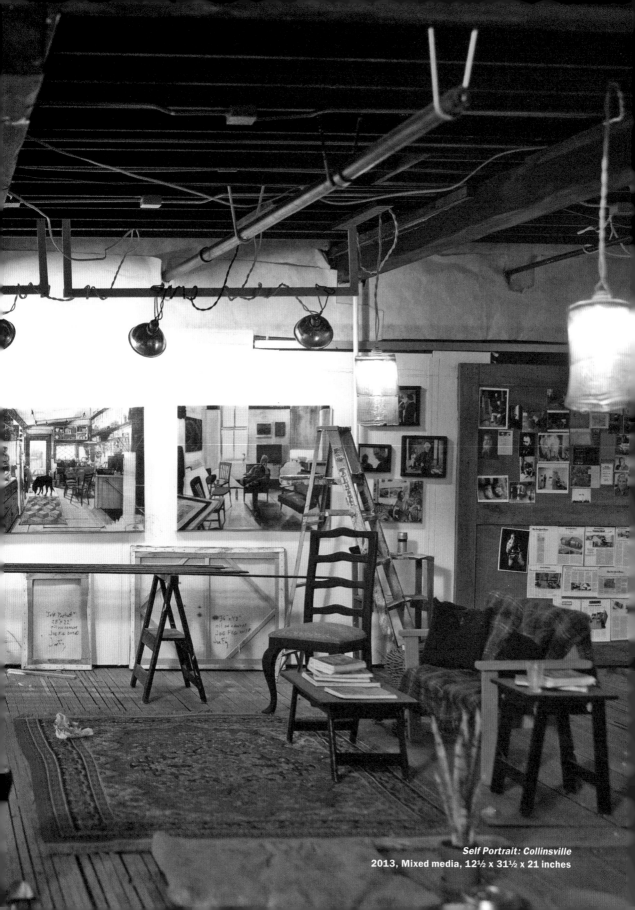

*Self Portrait: Collinsville*
2013, Mixed media, 12½ x 31½ x 21 inches

# INSIDE THE ARTIST'S STUDIO

**Joe Fig**

**Princeton Architectural Press** | New York

Published by
Princeton Architectural Press
37 East Seventh Street
New York, New York 10003

Visit our website at www.papress.com

Editor: Sara E. Stemen
Designer: Paul Wagner
Design assistance: Mia Johnson

Special thanks to: Nicola Bednarek Brower, Janet Behning,
Erin Cain, Megan Carey, Carina Cha, Andrea Chlad,
Tom Cho, Barbara Darko, Benjamin English,
Jan Cigliano Hartman, Jan Haux, Stephanie Leke,
Diane Levinson, Jennifer Lippert, Jaime Nelson, Rob Shaeffer,
Marielle Suba, Kaymar Thomas, Joseph Weston, and
Janet Wong of Princeton Architectural Press
—Kevin C. Lippert, publisher

Library of Congress Cataloging-in-Publication Data
Fig, Joe, 1968–
Inside the artist's studio / Joe Fig.
      pages      cm
ISBN 978-1-61689-304-0
1. Art, American—21st century. 2. Artists—United States—
Interviews. 3. Fig, Joe, 1968– 4. Artists' studios in art. I. Title.
N6512.7.F54 2015
709.2'273—dc23
                2015000441

# Contents

8    **Preface**

10    **Introduction:** *Atelierdasein*
       Jonathan T. D. Neil

16    **Ellen Altfest**

24    **Peter Campus**

34    **Ellen Carey**

42    **Petah Coyne**

50    **Adam Cvijanovic**

60    **Tara Donovan**

70    **Leonardo Drew**

82    **Carroll Dunham**

90    **Tom Friedman**

100    **Kate Gilmore**

108    **Red Grooms**

118    **Hilary Harkness**

126    **Byron Kim**

136    **Alois Kronschlaeger**

146    **Tom Otterness**

158    **Tony Oursler**

170    **Roxy Paine**

180    **Judy Pfaff**

190    **Will Ryman**

198    **Laurie Simmons**

210    **Eve Sussman**

220    **Philip Taaffe**

232    **Janaina Tschäpe**

242    **Ursula von Rydingsvard**

252    **About the Artists**

# Preface

What was your path to becoming an artist? Was there a moment in
your childhood of artistic recognition? How did you get your first
gallery show? Is there a correlation between your studio setup and the
work you make in that space? These are some of the questions I ask
when I go inside an artist's studio. This book is in part a follow-up
to the success of my 2009 publication *Inside the Painter's Studio* as well
as a continuation of a project begun in 2002. Since that time I've
interviewed over one hundred and twenty artists. *Inside the Artist's
Studio* focuses on twenty-four artists working in a variety of media:
sculpture, video, photography, performance, painting, and/or
a combination of all.

My artwork is an investigation into the creative process of the
artist and the space where art is made. The resulting paintings and
sculptures, which are included in this book, are a type of portraiture,
a celebration of the wonders of this process and a revealing look at the
real, intimate, and sometimes mundane tasks involved in making art.

The interview is essential to my process, and that's where my
work begins. It is the determining factor for whether I'm to make
a painting or a sculpture of each artist's space. Through the questioning
I slowly enter the artists' world, beginning with their younger selves,
following their development up to today. I gain insight into how
they go about their day, the content of their current work, and their
choreography within the studio space. Ultimately, a portrait evolves.

I am very grateful and indebted to the artists who allow me to
visit them, to sit in their studios, and to discuss their personal and
professional lives. Their hospitality, generosity, and kindness is
always far greater than expected. To share in the experience of a studio
visit is a privilege most do not get. My aim, through this book, is to
bring you along for the studio visit in the hope that you will find the
same inspiration and feel the same sense of awe that I do. *Inside the
Artist's Studio* was over three years in the making. It is a historical
document, a portrait of the contemporary art world. It is an artwork
in itself.

The door of Joe Fig's studio

There are many people who have helped bring this project together. I am extremely grateful to Cristin Tierney, whose friendship, humor, guidance, and support have meant more to me than can be expressed. I am honored to include Jonathan T. D. Neil's insightful essay as a part of this publication; I'm a huge fan. Special thanks to Princeton Architectural Press: Kevin Lippert, Jennifer Lippert, Paul Wagner, and especially Sara Stemen. Thanks to all those at Cristin Tierney Gallery, including Jasper Goodrich, Candace Moeller, Julie Kreinik, William Petroni, and Derrick Foust. My appreciation for the helpful assistance of Donna Fleischer, Raymond Foye, Lauren Haskell, Maria Kucinski, Teresa LoJacono, Ashley Ludwig, Jessica Maliszewski, Andria Morales, and Meaghan Steele. Thanks to Rusty Tilney and my support group in Collinsville, especially the camaraderie of Cary Smith. Thanks to my friends at the Hartford Art School for welcoming me into the community. Special thanks to Joseph Carroll and John and Ronnie Shore. This project was made with the support of Connecticut's Department of Economic and Community Development.

Lastly, this book is dedicated to my wife, Rosie; our children, Charlie and Henry; and our dog, Casey, for their unconditional love, support, encouragement, and companionship.

# Introduction: *Atelierdasein*

Jonathan T. D. Neil

Studio. Post-studio. Post-post-studio. Since the early 1990s we have seen a growth in the amount of attention—artistic, critical, academic, curatorial—paid to the idea of "the studio" and the role it plays in work that visual artists do and make. One need look little further than Joe Fig's mature work, which began in 2000 (the same year he began the MFA program at the School of Visual Arts in New York City) and is exemplary of the "return" to the studio that the rather inelegant adjective *post-post-studio* has sought to indicate. Primarily through an intricate dialogue between sculpture, photography, and painting, Fig has offered one of the most sustained and intensive engagements with the artist's studio and the creative process that happens in it. Fig deals with the artist and the studio, and the artist in the studio (from Matisse to Pollock to Matthew Ritchie to himself) as a problem of—and for—representation and mediation.

In 2009 Fig published *Inside the Painter's Studio* with Princeton Architectural Press, an anthology-cum-catalog that gathered images of Fig's work alongside responses to a questionnaire that he followed when visiting the contemporary artists who would become his subjects. *Inside the Painter's Studio* begins with an account of Fig's first studio visit, itself the genesis of the book. When he began requesting to visit significant contemporary artists, his "intention was to get a clearer understanding of the real, day-to-day practicalities of being an artist." Michael Goldberg was the first to accept, as Fig describes: "The studio visit was unique in that the artwork was not the main focus of discussion.

I was interested in everything else: the making of the artwork, his creative process, the studio setup, his daily routine, and in particular his painting table. I photographed everything." Goldberg's studio on the Bowery had once been Mark Rothko's, and Fig was, understandably, enamored—not just of the space but of Goldberg's many stories of his days as a second-generation abstract expressionist. "It was an amazing experience for a young artist just starting out," writes Fig. "When I left I wanted to get to my own studio and work…except I had one great, nagging regret: if only I had recorded our conversation!" Hence the questionnaire and a voice recorder on every subsequent visit.

For all that it is—intimate and voyeuristic, documentary and inventive—*Inside the Painter's Studio* is not just a record of Fig's work and of the many artists' thoughts on their studios and quotidian working processes, which Fig has solicited, taped, and transcribed. Nor is it a book about the studio visits that have served Fig as so much source material. Rather, it's a testament, in some sense, to a lost conversation, which no battery of photographs nor hours of recorded speech can retrieve. Though it was no doubt rich with incident, with pregnant moments and perhaps profane illuminations, the sound and content of that conversation with Goldberg now exists in Fig's memory alone (Goldberg passed away in 2007). Between photographs of the artist's studio and of the artist within it, between the recorded voice and conversations that can't be fully recalled, there is this thing called the studio visit.

◆ ◆ ◆

I don't have a formula or a program when I visit an artist's studio. I give myself a rule based on my first studio visit back in '44–45 with the Pollocks, Lee and Jackson. We visited a painter who was living on, I think, 8th Street in Greenwich Village.…I've forgotten his name; I didn't keep a diary in those days. He took his pictures out one by one and showed them to us, and I wouldn't take the lead expressing my opinion. I waited for the Pollocks. And they greeted each picture with dead silence and that was that; I didn't speak up. When we left I didn't take the trouble to notice the expression on the artist's face, but when we got downstairs my imagination began to run and I said God, he must feel awful. I resolved, later, that when you go to an artist's studio you can't greet the art with silence. If you don't like anything you must find something— you can always find something—that you like more than anything else in the studio. You point to that and say you like it best and then you talk.[1]

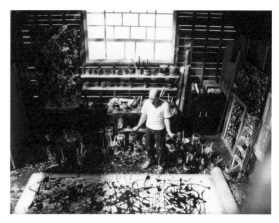

Joe Fig, *Jackson Pollock 1950 # 1*, 2002.
C-print, 30 x 40 inches.

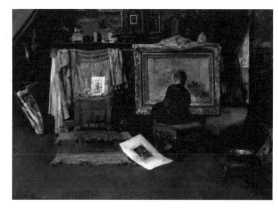

William Merritt Chase, *The Inner Studio, Tenth Street*, 1882.
Oil on canvas, 32⅜ x 44¼ inches (framed 42 x 54½ x 3 inches).

Clement Greenberg's recollection of that first studio visit with the Pollocks raises some fraught yet important questions: What if, when visiting an artist's studio, one really finds nothing to say? Does decorum dictate an exchange of pleasantries? Small talk as the only talk there will be? This raises the following question in turn: Why can't one greet the art with silence? Why isn't such reticence justified?

Perhaps Greenberg's anxiety over his own and the Pollocks' silence in the studio was an early indication of the superfluity with which critical discourse would come to be identified in our contemporary moment.[2] The work that Jackson Pollock would make in his Springs studio in the first years of the fifties has come to stand as the last great gasp of a romantic tradition that could legitimately reject any and all temptation to talk.

If we compare Hans Namuth's famous portrait photographs of Pollock working in the studio with the short film he shot in the fall of 1950, we have a figure for how the silent studio was in fact central to the romantic persona of the artist and how sound of one sort or another—be it the artist's or the critic's

voice or some recorded noise or the outside world itself—killed it. The romantic tradition depended upon the studio as the wellspring of the artist's creative genius. One can draw a direct line from Namuth's pictures to those taken of artists such as William-Adolphe Bouguereau, Jean-Léon Gérôme, John Singer Sargent, and Pierre Puvis de Chavannes in their Paris studios in the 1880s, a time when the impressionists' practice of plein air painting offered an early instance of post-studio art and so an intimation of the obsolescence of the studio—or of a certain kind of studio, namely, the one modeled on the decadent bourgeois interior, which the space pictured in William Merritt Chase's *The Inner Studio, Tenth Street* (1882) exemplifies.[3]

When Namuth moves to film Pollock painting outdoors, he begins with an exterior shot of the studio—the only time we will see it. He then pans away, leaving the studio behind. As if embarrassed by the unbearable silence of the moving image—a silence so necessary to the photographs—Namuth includes atonal music composed by Morton Feldman and voiceover by Pollock: it's a subtle declaration of the end of the studio and the quiet triumphs that went with it.

Fig's work revolves around, or circles, this silence, as if to recuperate it, but without the triumphalism embodied in the romantic notion of the artist at work. Instead, the studio alone stands in for the latter. Nowhere do we see artists putting brush to canvas, or tool to material. Carroll Dunham just stands there (*Carroll Dunham: July 18, 2013* [2014]). Tony Oursler plays Auguste Rodin's *Thinker* (*Contemplation: Oursler* [2013]). Many works don't feature the artist at all, only the empty studio as artist's proxy and portrait. Some are quite linear in their substitutions, as with *Tara Donovan: November 21, 2013* (2014) or *Ursula von Rydingsvard: February 6, 2013* (2014), which offer up sculptures in progress. But others are elliptical. *Roxy Paine: April 10, 2014* (2014), for example, doesn't bother with the studio's interior at all but settles instead for its front door. Shut out, we are also shut up, like the Pollocks on Eighth Street.

◆  ◆  ◆

What happened to our image of the artist when, to use Allan Kaprow's way of putting it, "paintings ceased to become paintings and became environments"? A photograph of Kaprow amid his *Yard* (1961), with its allover spread of tires and its horizontal expanse, showing the artist and his son immersed in the work, offers its own best answer. For Kaprow, the "legacy" of Pollock's work was that subsequent artists "must become preoccupied and even dazzled by the space and objects of our everyday life."[4]

For many artists today, that space has become the studio itself. Think of Corin Hewitt's *Seed Stage* (2008–9), for which the artist mounted a

Allan Kaprow, *Yard*, 1961. Environment presented for *Environments, Situations, Spaces*, sculpture garden at Martha Jackson Gallery, New York.

temporary installation of his studio space in the galleries on the Whitney Museum of American Art's first floor. Primarily concerned with "anxieties of reproduction" rather than action (as Hewitt noted), the studio was cut open at the corners, which offered only an "image-based relationship" to the room's "physical space."[5] As the art historian and media critic Judith Rodenbeck writes: "This understanding of the studio-laboratory through photography renders the chamber itself as a camera, that is, a small room with a limited view."[6] For Hewitt, this "language of photography" suffuses the project, right down to the image-based arrangement, which keeps talk, or dialogue, between the artist and his audience to a minimum, if it doesn't eliminate it altogether.

Joe Fig's painting *A Visit to the Studio* (2013) has its place here. What Fig ostensibly presents to the collector couple in that picture is a work of his, which he appears to be revealing with a flourish of his right hand. What Fig is showing his visitors, though, isn't a picture but rather us, the audience, who occupy the space and position of that work. But then again, Fig's gesture, his revelatory flourish, combined with his visitors' frozen poses, suggests nothing so much as a photographic setup, as if what Fig is showing them is a stationary camera that

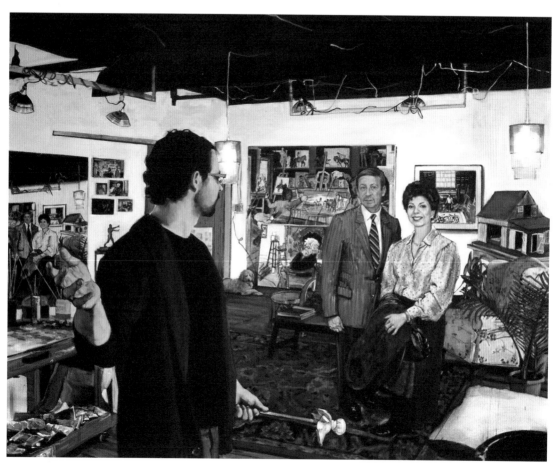

Joe Fig, *A Visit to the Studio*, 2013. Oil on canvas, 48 x 60 inches.

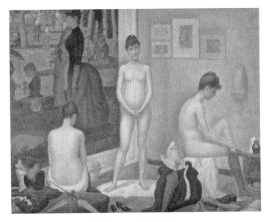

Georges Seurat, *Models (Poseuses)*, 1886–88.
Oil on canvas, 78¾ x 98⅜ inches.

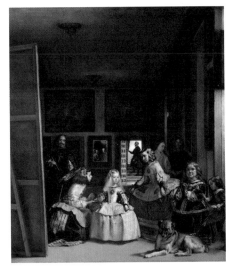

Diego Rodriguez Velázquez, *Las Meninas*, or *The Family of Felipe IV*, ca. 1656. Oil on canvas, 125¼ x 108⅔ inches.

captures the scene. This apparent photographic moment and its image-based relationship—of visitors to artist to audience to art—sets in motion a mise en abyme of relative positions, figured most prominently by the paradox that the same picture we as an audience are looking at also sits inside the picture we are looking at.

Such anxieties of reproduction are not foreign to the history of art, nor of photography. One thinks of Jeff Wall's *Picture for Women* (1979) and its echo of Édouard Manet's *A Bar at the Folies-Bergère* (1882; and not without its own deviant perspectives). Wall's piece updated and played on the photographic (and feminist) implications of modern painting's coming to self-consciousness. (That *Picture for Women* is also a self-portrait in the studio should not go unmentioned, either.) One could also point to Georges Seurat's *Models (Poseuses)* (1886–88), whose three models in different states of undress point to the chronophotographic conditions of temporality that Seurat sought to exploit in his major works, such as *A Sunday Afternoon on the Island of La Grande Jatte* (1884), which appears truncated on the left wall of the studio pictured in *Les Poseuses*, just as Fig's *A Visit to the Studio* appears truncated on the left wall of the studio pictured in *A Visit to the Studio*.

But it is Diego Rodriguez Velázquez's *Las Meninas* (ca. 1656) that epitomizes this "anxiety of reproduction" via its "epistemological riddle," its "mirror of consciousness."[7] *Las Meninas* is not a picture of a studio, as Seurat's and Wall's images are, but looking at it one may pose the question of what exactly makes an artist's studio? If it is enough to have the artist in a room, at work, then the painting gallery of the Alcázar palace in which Velázquez paints the royal couple's portrait is, at that moment, the artist's studio. And if *Las Meninas* shows us the artist's studio, then what else does the presence of the Infanta Margarita and her attendants, in addition to the royal couple whose portrait is being painted, offer us but a picture of a visit to this artist's—albeit provisional—studio?

Two things: First, *Las Meninas*'s realism, the subtle yet unshakable logic of what is happening in the picture, has led more than one commentator to point to its "snapshot" or photographic character. We are being shown a moment in the creation of a work, which is also a moment in the lives of the artist, his subjects, and their circle—a moment when no figure is posed so much as simply seen, caught in a network of looks, of which our own, the audience's, is one, and not necessarily a privileged one at that. It is also, at bottom, a quiet moment.

Second, *Las Meninas*, anticipating works such as *Les Poseuses* or Manet's *Portrait of Émile Zola* (1868) or even Henri Matisse's *The Red Studio* (1911), not to mention Fig's *A Visit to the Studio*—studio pictures, every one—is a work of calculated self-reference. As we have come to learn, the mirror on the back wall of the palace hall does not reflect the king and queen standing outside the picture (where we also stand) but rather their portrait, which Velázquez is painting. Velázquez's sly centering of representation over reality, his edging of it into the picture, so to speak, initiates a reflexivity of looking and picturing, of seeing and being seen, which continues to inflect and influence Western pictorial practice and discourse to the present day. And what is more, every studio visit takes place within the triangulated theater of this reflexivity, where the looks of the work, audience, and artist ricochet around a shallow space—call it a studio—at once sealed off from the world and yet radically open to it.

•  •  •

I have never visited Fig in his studio, but I have visited some of the same studios he has: Eve Sussman's, Tara Donovan's, and Roxy Paine's, to name a few. Curiously, I recall little of my conversations with the artists (I have no memory for conversations), but I have distinct memories of the places and the things I saw, for example, watching clips of Sussman's *89 Seconds at Alcázar* (2004) (her own speculative take on the whisper-quiet scurryings and scenes surrounding the moment of repose we see in *Las Meninas*), as well as the raised, open living room of her studio/home, with its expansive view of New York Harbor; I recall whitewashed walls and natural wood floors in Paine's Williamsburg townhouse, as well as small sculptures of plants that rivaled the Blaschka Glass Flowers in their verisimilitude; I recall pins, pins, and more steel pins, in boxes and cups, on the floor and in the wall-scaled works that lined the former studio of Donovan's house.

Mere stories or recollections of studio visits, mine or anyone else's, however, are inevitably uninteresting. To even gesture at them here, as

I have, puts me in mind of something Ludwig Wittgenstein once wrote about photographs: "I am always reminded of one of those insipid photographs of a piece of scenery which is interesting to the person who took it because he was there himself, experienced something, but which a third party looks at with justifiable coldness."[8] Typologies of the studio visit, theories of it, are no better.[9] Representations of the studio visit are precarious things because the visit itself is so quotidian—it is just part of life as it is lived by people who share an enthusiasm for art in general, even if not, on any given occasion, an enthusiasm for the art in the studio or the parties to the visit. It is only through art, and Fig's art more than any other's, that we may be given access to the singularity of that tricky ontology—photographic and not, silent and not, realist and not—of being-in-the-studio.

**1.** Clement Greenberg, "Interview," in *The Edmonton Contemporary Artists' Society Newsletter* 3, no. 2, and 4, no. 1 (1991), http://www.sharecom.ca/greenberg/interview.html.
**2.** Boris Groys, "Critical Reflections," in *Art Power* (Cambridge, MA: MIT Press, 2008).
**3.** Multiple examples of artists in their Paris studios can be found in the Smithsonian Archives of American Art: http://www.aaa.si.edu/collections/images/collection/photographs-artists-their-paris-studios-10228/1. We should not forget, either, that one of the first photographs, a daguerreotype from 1837, is of a "still life" in an artist's studio. See usc.edu/schools/annenberg/asc/projects/comm544/library/images/164.html.
**4.** Allan Kaprow, "The Legacy of Jackson Pollock" (1958), in *Essays on the Blurring of Art and Life*, ed. Jeff Kelley (Berkeley and Los Angeles: University of California Press, 2003), 7.
**5.** Quoted in Judith Rodenbeck, "Studio Visit," *Modern Painters* 21, no. 2 (March 2009), reprinted in *The Studio Reader: On the Space of Artists*, eds. Mary Jane Jacobs and Michelle Grabner (Chicago: University of Chicago Press, 2010), 337.
**6.** Ibid.
**7.** See Leo Steinberg, "Las Meninas," *October* 19 (Winter 1981): 45–54.
**8.** Ludwig Wittgenstein, *Culture and Value: A Selection from the Posthumous Remains*, trans. Peter Winch, ed. Georg Henrik von Wright, Heikki Nyman, and Alois Pichler (Oxford, UK: Blackwell, 1998), 6e–7e; also quoted in Michael Fried, "Jeff Wall, Wittgenstein, and the Everyday," *Critical Inquiry* 33 (Spring 2007), 518.
**9.** As evidence, one need look little further than Marjorie Welish's essays on "The Studio Visit" and "The Studio Revisited," both reproduced in *The Studio Reader: On the Space of Artists*.

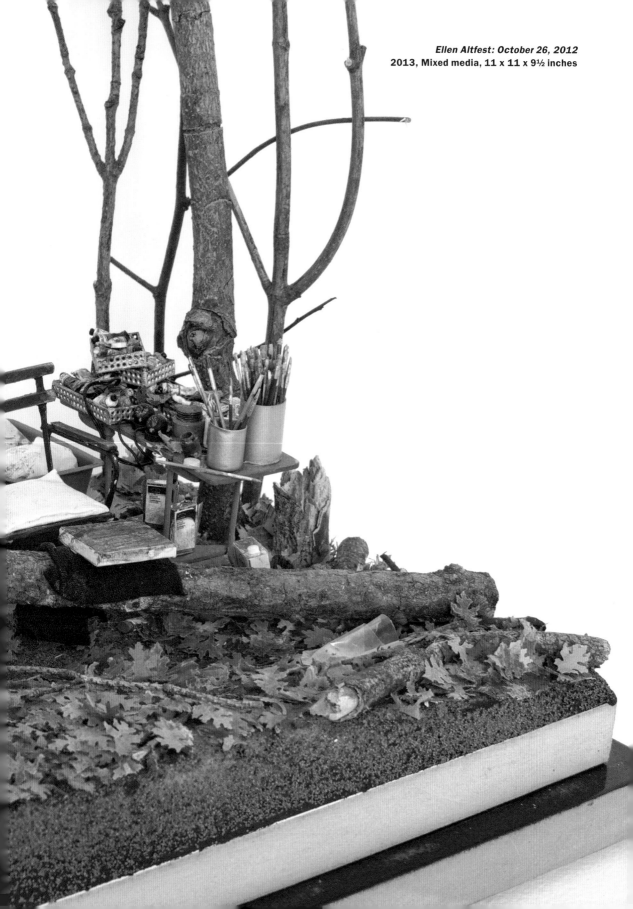

*Ellen Altfest: October 26, 2012*
2013, Mixed media, 11 x 11 x 9½ inches

# Ellen Altfest

Kent, Connecticut / October 26, 2012

Photo: Vinnie Dillio

**Can you please tell me a bit about your background?**

I grew up in New York City and I went to Cornell for undergraduate. There was a two-year break before I went to Yale for graduate school. I spent five years as an undergraduate because I received two degrees, one in English and one in painting.

My high school in New York City had an amazing art program. The teacher who taught the freshman art class was Robert LaHotan. We spent the entire year drawing from two plaster-cast heads. It sounds torturous but it was great! It's all about the teacher, really; a teacher can make it exciting. The excitement with that class was that we were working up to something big…and the big part was when he [LaHotan] tilted the plaster head back, and that then became foreshortened. That was a WOW moment. [*laughs*] We started drawing live models sophomore year. It was serious. So I was on that [figurative] path, but I didn't intend to get this crazy with it. But you have to do what makes the work the best, and for me it was having this intense level of detail.

**What was your first gallery show, and how did that come about?**

My first show was in New York at Bellwether Gallery. Becky Smith [the owner] and I had gone to graduate school together. She opened the gallery to show work by her peers. I was lucky because at that time there wasn't a lot of interest in showing younger artists' work. First I was in a group show, then I curated a show, and finally I had my first solo in 2006. That set things in motion. From there I got

a show at White Cube in London and have been able to support myself since.

**When did you do your first plein air painting?**

It was after graduate school. I was awarded a residency at the Vermont Studio Center,[1] and I really wanted to paint nature. I was sick of painting inside—I felt very confined.

**So, I'm going to consider where we are now as your studio. We are out in the woods alongside a stream. It is midautumn in northwestern Connecticut. It's about forty-five degrees.**

**How long have you been working in this studio?**

Since March.

**Did you have a plan for the layout of your studio or did it develop organically? [*laughs*]**

This is my second studio outdoors in recent years. Marfa, Texas,[2] is where I learned how to set up an outdoor studio. You need plastic waterproof tubs to hold all your supplies, and those can stay outside. For this current situation I had to figure out how I was going to make a painting of this fallen tree. At first I was going to work on an easel, but that wasn't comfortable. I needed to sit, so I take some black cloth—because black doesn't reflect light—and put that on my lap, and then I rest the canvas on top of that and paint that way. It's not my preferred way

---

1. Located in Johnson, Vermont, the Vermont Studio Center was founded by artists in 1984. It is the largest international artists' and writers' residency program in the United States.
2. The Chinati Foundation in Marfa, Texas, is a contemporary art museum founded by Donald Judd. Its artists-in-residence program provides artists an opportunity to develop work.

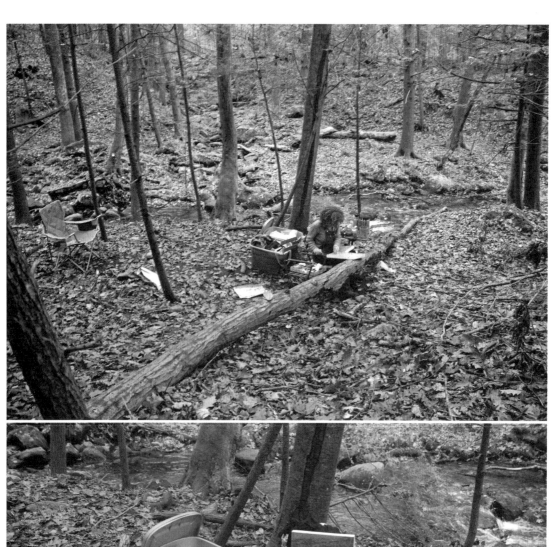

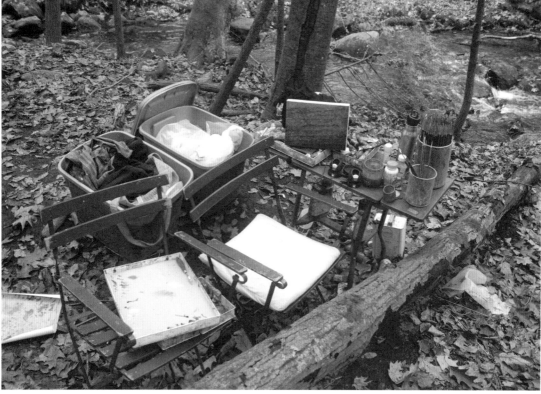

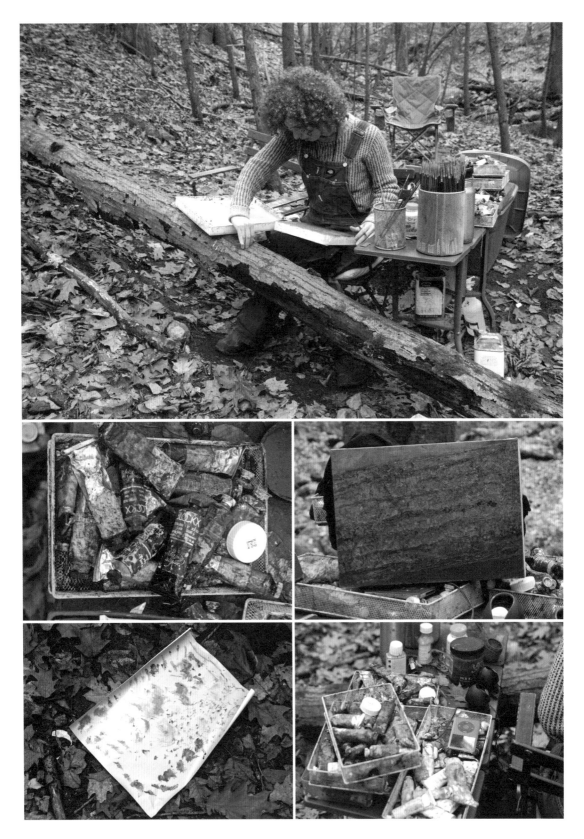

of working, but this is how I had to do it for this painting. The studio out here has been growing. I just leave the individual paint tubes and containers of different colors on this table next to me. I've recently gotten an umbrella that pivots, and that's great because it can cast a shadow onto the tree or onto me or my palette any time of day, and it makes the light more consistent.

I have this outdoor studio, and I just love it. And I definitely enjoy having it by the stream. Even though it's not part of the painting, it's a nice background and a nice ambiance. I chose this place mostly because it's a wetter area that has more moss. I like moss in the paintings.

**Has the studio location influenced your work in any way?**

Yes—it goes hand in hand. [*laughs*]

**Can you describe your typical day, being as specific as possible?**

I usually get to work early, but lately I've been starting at 9:00 a.m., which I consider slacking off. So, I get up, and I've been trying to meditate. Sometimes I will go to an early yoga class. Now that it's colder it takes me longer to get ready, as there's more to take with me. I have a hot beverage in an insulated travel cup. Then there are all these layers of clothing: there is long underwear, my heated vest that I just got that has a rechargeable battery. I have to take my bear-repellent spray that I wear around my neck in case I see a bear. I have these fur-lined boots that have little heating pads under my toes to keep my feet warm. I usually wear a hat, which makes me look like a farmer. These overalls I'm wearing are good because they keep the ticks out. I bring my rechargeable speakers for my iPod. And then I come out here, and I just basically sit. I have to remember to take breaks. Now it's getting colder. The other day it wasn't even forty [degrees] in the morning. And as it gets colder I'm just going to put on more layers. My artist friend Chie Fueki[3] recommended this heat patch that old Japanese ladies wear to keep warm; it goes on your lower back. Apparently if your kidneys are warm, you feel warmer.

**Do you have music that you like to listen to?**

I do. I have different music for different moods.

Sometimes when I'm dragging I need upbeat music, but then if I'm really in the zone, I like music that has a little bit of a drone to it—Yo La Tengo or something like that—that I can get mesmerized by. I just got the new Cat Power album *Sun*. Then I'll listen to podcasts. I like *Fresh Air*; I've been listening to *Dharma Seed*, which is a Buddhist podcast that helps keep my head in a good place, but sometimes I like something a little more fun. I love this sex podcast called *Savage Love* that's very entertaining. It's nice to have a mix—some that are fun and some that are more about getting myself centered. I have a whole range.

**What kind of paints do you use?**

I use Old Holland, Blockx, and Williamsburg brands primarily.

**Do you have a favorite color?**

I like the variations on white like Unbleached Titanium. I like Zinc Buff. Those are probably my favorites. Blockx makes a Cassel Earth: it's like a dark brown, almost a black, but it's not. A little while ago I was really into this Williamsburg color called Quinacridone Brown. It feels like the Alizarin Crimson of brown. That's a really awesome color.

**How long have you had that painting table, and how did you decide to set up?**

It's an old typing table I got at a thrift store in town for $5. I was really happy. It's metal, so it's not going to warp, and it can stay outside. I definitely need a table next to me when I'm painting, for my brushes, mediums, and paints and stuff. It's in the perfect spot and is just about how close it needs to be to where I'm sitting.

**You use gray disposable palettes in a plastic bin?**

It's one of those portable palette containers; you're supposed to preserve your paint by putting your palette in there. It has a lid, but I don't know what I did with it. Leaving it open overnight makes the paint stiff. I have to find that lid! [*laughs*] I've just begun using gray, disposable palette paper that is

---

3. Chie Fueki (b. 1973), Brazilian/Japanese. Painter who interweaves images, patterns, and spatial constructions to make complex, richly colored works.

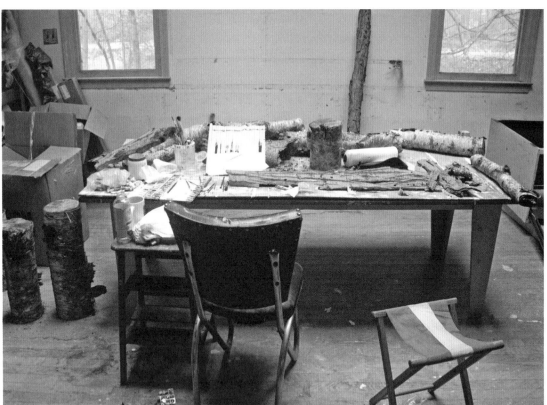

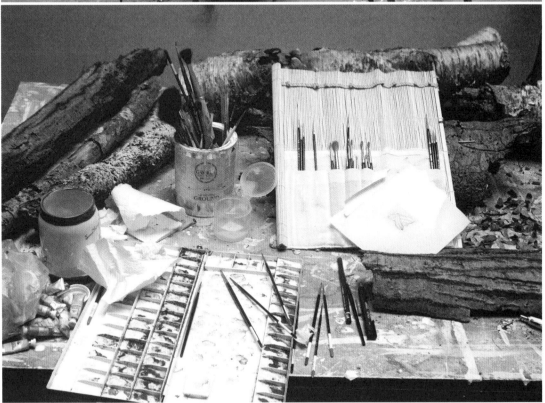

less reflective outdoors than the white. And the tree I'm painting is gray, so I like the idea of using a similar base color for my palette.

**Do you have any special devices or tools that are unique to your creative process?**

I needed something to measure distances and see how everything falls in relationship to everything else within the painting, so one of my models who studied at the New York Academy[4] recommended using metal skewers. Everything in my painting is at a one-to-one scale, so I literally use skewers to measure the distance and relationship between things. I also use these 5/0 brushes. They are Tajmyr, which is the highest-grade sable brush you can get. They are also the tiniest long-handle brushes that are made. I love those.

**So you use the skewers like calipers? Like a sculptor uses to measure body parts because you're doing a one-to-one scale?**

Yes, and I also use it to figure out angles. For example, say the top of the tree is at a certain angle in the painting. Then I will try to put the skewer perpendicular to the angle so that I can see that relationship.

I have my preferred place to get the skewers I like. [*laughs*] I always think they're such a good deal. They're $2.50 for four skewers, and that'll last me a long time. I feel like I would be willing to pay a lot more—they're just metal skewers, but they're great.

**Do you work on one project at a time or several?**

It depends. Out here I'm just working on this one project. But in the city, when I worked with models, they can sit for only so long. So sometimes I had two different models and two different paintings going on during the same period. I would have one model come in the morning and one in the afternoon.

**When you are contemplating your work, where and how do you sit or stand?**

I just got this special Alps Mountaineering King Kong chair. I was not taking enough breaks, because I had nowhere to go. So I had a moment of reflection, and I thought, I need a chair. So this chair is maybe a month old. I can leave my phone here, in this pocket, so that it is out of reach and I can't check email. It's like a home base, a place I can

look forward to taking breaks. I don't use it as a way to contemplate the painting. I look at the painting at night, in my home. I'll put it across from me, and that's when I look at it. That's when I think, Oh, it needs this, and I need to work on that tomorrow.

**It's like your dinner partner.**

Yeah, just me and it. [*laughs*]

**How often do you clean your studio?**

It does get kind of messy out here. I throw a lot of things on the ground, and that doesn't make me happy, because I feel it's desecrating the beauty of the nature. But I have all these old paper palettes and kombucha tea bottles strewn about the ground. Then everything gets wet and dirty. I clean it every couple of weeks.

**Do you have a motto or creed that as an artist you live by?**

My credo comes from Rackstraw Downes.[5] He and I were talking, and I told him that I was experiencing some resistance in making my painting. Rackstraw said, simply, "Let the painting win." I think that will stay with me for a long time.

**What advice would you give to a young artist who is just starting out?**

To really focus on making the work what it needs to be and as true to who you are as you can.

---

4. New York Academy of Art is a graduate school focusing on figurative and representational art. Students are taught traditional methods and techniques.

5. Rackstraw Downes (b. 1939), British. Realist painter known for his meticulously detailed, plein air paintings of landscape and industry.

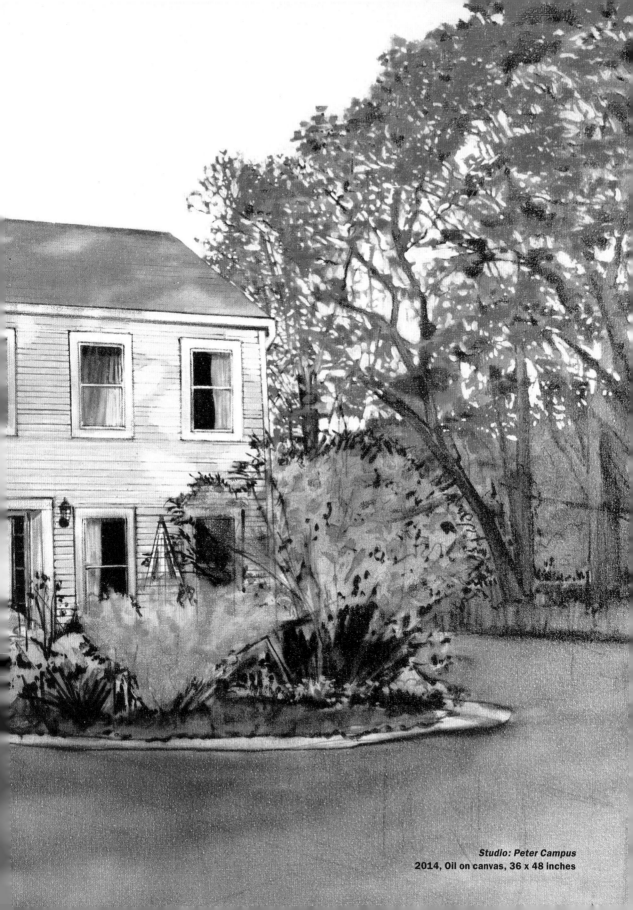

*Studio: Peter Campus*
2014, Oil on canvas, 36 x 48 inches

# Peter Campus

East Patchogue, New York / November 14, 2013

**To start off, can you please tell me a bit about your background?**

I grew up on the Upper West Side of Manhattan near Columbia University, 113th and Broadway. My father was a doctor. We had a ground-floor doctor's office apartment, rather large, and at that time the neighborhood was very safe. The shopkeepers along Broadway would look after the children, and we would walk down and play in Riverside Park. There was a lot of freedom. I went to a private school called Walden School, which I started at the age of three. A very significant tragic event in my life was that my mother died when I was just seven, and I became very depressed as a young kid. Additionally, in school I was picked on terribly—I was bullied really badly. It's something I'll never forget. I'm glad there's a lot of attention these days to bullying because you just don't forget it. Maybe some motivation to succeed came from that bullying?

We had art in our house. My cousins, who were about the age of an aunt and uncle, were artists. We had their art in our house and Baziotes's,[1] which I still have, and Ruth Gikow's[2] work, which I really love. I grew up with art; I grew up going to museums, in particular the Museum of Modern Art and the Whitney Museum.

I started painting at Walden School when I was twelve. I spent a lot of my time just painting. The love of art and making art at that time was so strong that it brought me to being an artist. There was nothing I enjoyed more than that. I don't like calling painting a language, but it was something different from speaking that allowed me to express myself.

One other important thing from that time was that I'd walk to the Symphony Theatre on my own during the day and see movies. That theater showed English films. I was seeing a lot of films directed by Michael Powell.[3] Those films were a big influence on me.

So my father met a woman from the building whose husband had recently died. She asked him if she could care for us boys and the house, and my father said yes, and she moved in. Eventually they got married, and we moved to Bayside, Queens. And it was so different. At Bayside there were no art classes. I was still going to museums and the movies but I was doing it on my own; there was no outside encouragement.

**What's the earliest art piece you made as a child that got recognition?**

It was a picture I made in tempera of a ship's mast with a man in the crow's nest looking through binoculars off into the distance. I was probably thirteen or fourteen.

**Where did you go to college?**

After Bayside High School, I went to Ohio State. At first I studied engineering, and then I studied experimental psychology. It was very interesting

---

1. William Baziotes (1912–63), American. Abstract expressionist painter influenced by surrealism.
2. Ruth Gikow (1915–82), American, born in Ukraine. Painter known for figurative works that reflect the humanity of her subjects.
3. Michael Powell (1905–90), British. Writer, producer, and director of classic British films.

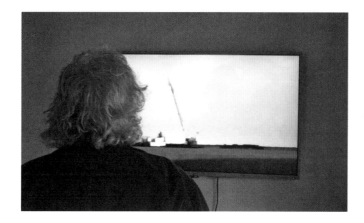

work. I also did very well in mathematics. Ohio State is a big university, very different from New York. It was my first taste of anti-Semitism.

I graduated in 1960. I went directly into the army—there was still a draft at that point. There was a program where you did six months' active service and then six years of reserve, so I did my six months, and I just avoided the Vietnam War. My brother, who was an officer, sheltered me. He took me into his own unit and protected me. When I got out of the army, I lived with my parents for a while back in Queens.

**When did you consider yourself a professional artist and able to dedicate yourself full time to that pursuit?**

When I got out of the army my father asked, "What do you want to do?" I said, "I want to be an artist." He said, "Absolutely not. You'll starve; it'll be horrible. Your brother's in the movie business—why don't you go into the movie business?" I said, "OK," and my brother got me a job with U.S. Productions. I was very ambitious, but the job I got was as a gofer. Periodically I would go to my bosses and ask to do more, so very quickly they made me a unit manager. I worked at that job for about five years.

**What type of productions were you working on?**

Mostly documentaries. I started teaching myself how to edit. One day I asked the company to give me an editing job. I happened to be really good at it. At that time everyone was doing drugs, and the editing room was where people came to do drugs. The top people would come in, and sometimes they'd bring clients to smoke some weed, so we were in this atmosphere breathing in weed all day long. [*laughs*]

I was in my early thirties at that point and said, "Fuck this, if I don't become an artist now, I'll never do it." So I quit that job. I had some money saved up and just lived on next to nothing. I moved into a loft on Twenty-Second Street off of Eighth Avenue, before it was Chelsea, and that cost me $125 a month, and I started making videos immediately.

**Were there other artists at the time working in video?**

I think Nam June Paik, Frank Gillette, Ira Schneider, Beryl Korot, and Andy Mann were a bit before me, and then, of course, the person who interested me more than any of those people was Bruce Nauman.[4] I thought his work was spectacular. In video, if you used a console, the reels lasted one hour, so Nauman was doing one-hour videos. I had come from working in film and everything was cut, cut, cut, so to do one endless take on video for an hour—it was extraordinary! Here I was an editor, and here's someone [Nauman] who's doing something that is not about editing—it's about performance. With video it's start and stop—you press a button and get rolling. It was about as crude as you can imagine. If you wanted to edit video, you'd have to add on. The

---

4. Bruce Nauman (b. 1941), American. Sculptor, photographer, and performance artist working in video. He was a pioneer in his use of video in art. His work incorporates the activities, speech, and materials of everyday life.

work that I did was not edited; it was all about performance. This was around 1969, 1970.

**How did you get your first real gallery show?**
It was very easy for me. I was a thirty-three-year-old man. The ten years I might have struggled to gain recognition didn't happen to me. I put out my videos and almost immediately got a NYSCA [New York State Council on the Arts] grant.

When I decided I wanted to show my work to galleries, I would travel around with these big pieces of equipment. In one hand was this suitcase-type thing, and in the other was a monitor. It was like *Death of a Salesman*, Willy Loman[5] walking around like, "Would you like to buy my videos?" [*laughs*] I had no fear.

One day I saw Klaus Kertess, from Bykert Gallery, and he was interested in my work. At that time I had only shown my videos at museums. I thought, OK, what does it mean to show videos in a gallery setting? It's interesting because most people spend about twenty seconds looking at any work of art. I thought, If I'm going to make this video, people are going to spend only twenty seconds looking at it. So I came up with this idea of using closed-circuit television that had no videotape involved. The first piece I did was called *Kiva*, and it showed at Bykert [Gallery] in 1972.

**Currently we're sitting in your studio, which is in your home. Is that what you prefer?**
There have been very few times that I've had a studio separate from where I lived. I've always liked to be able to get up whenever I want and work. The work I'm doing often requires a very long time on the computer, just processing, so I often do that in the middle of the night.

**Has the location of your studio influenced your work?**
It's probably the other way around. I chose the location for my work. I've been working around Shinnecock Bay for about ten years. The fishermen there probably know me by now and don't mind my presence. The light and the physicalness of the place is extraordinary. I've been coming out to Long Island since the early 1970s.

**Please describe a typical day, being as specific as possible.**

I get up around six o'clock and Kathleen[6] gets up usually about nine; I spend the time before she gets up reading the [*New York*] *Times*. Then we eat breakfast together, and that's all done by ten thirty. That's when I come in here [the computer room]. This is where I spend most of my time. Depending on what I'm doing, I could work into the evening or be finished in a few hours. The processing, even with this very powerful computer, takes hours, even to do a two-and-a-half-minute test strip.

I work in multiple layers: picture and sound. Each of them has all these attributes, and within these attributes are more attributes, so there's almost infinite variety for each layer—it's infinitely complicated. When I feel like it's finalized, I say to the computer, "OK, give me a composite—compress all the layers with the sound." It's a three-stage process that takes about a half hour. Then I present it here [monitor mounted to the wall across the room] and look at it because there's a difference between how video looks on a monitor and how video looks on a computer. So I do a test strip and look at it, make notes, and see what I want to alter. This stage can take weeks, just going back and forth, back and forth. When I finish a piece, I'll sit here and look at it over and over again. I'll leave it on the monitor for a day or even a week until I know everything that's going on. Often enough, I have to go through that whole process again. It's pretty laborious.

The days that I go out shooting video are not so different. After breakfast I'll drive out to Shinnecock Bay and start working. I shoot for about four hours. When I come home I want to look at what I shot immediately, so I start downloading it and converting it to see what the possibilities are. Ninety percent of the time I'm disappointed. These videos are not edited; it's all one continuous shot. The complexity comes in the layers—there's no cut. In German a cut is a *Schnitt*. There's no Schnitt. [*laughs*]

---

**5.** Willy Loman is the protagonist of Arthur Miller's play *Death of a Salesman*; he is a traveling salesman whose career is in decline.
**6.** Kathleen J. Graves (b. 1951), American. Artist whose work is based on nature and technology.

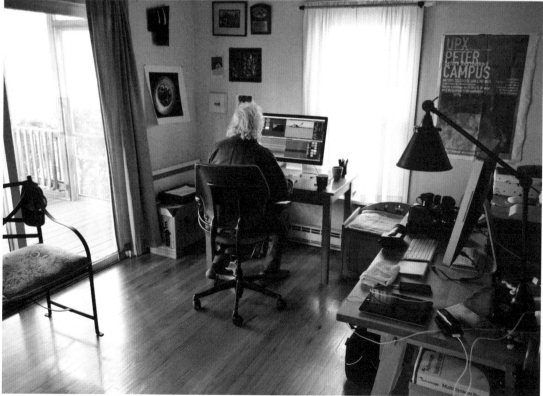

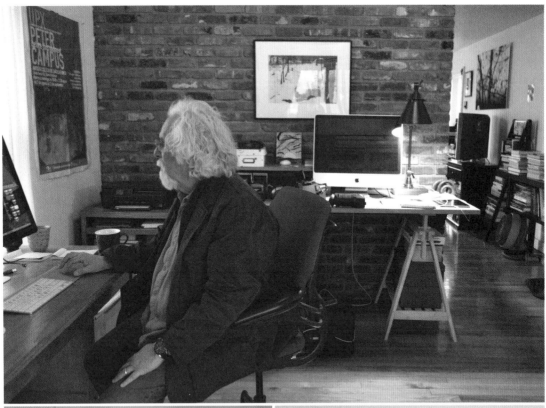

The take in the field is about eight minutes, and then I extend the time. A lot of what I do is adding and multiplying filters for each layer. It becomes very complicated.

**When you go out to Shinnecock, do you know something's going on, or do you go on a whim and see what you can get?**
I want to be surprised. I really try to go with absolutely nothing in mind. A lot of that has to do with what's going on in the present with my psychology; I want to have some resonance between what's inside of me and what's going on out there in the field. I keep thinking of Michelangelo releasing the sculpture from the stone.[7] I have this video footage, and I'm trying to find the piece from inside that footage. I really need to be very receptive to what's out there.

**Is there a difference in light over the seasons?**
Dramatically so. I'm a fan of summer light—it's extraordinary. The winter light is not like Bergman's[8] winter light. Out on the East End, it's much more beautiful than that. It's not gloomy at all, but it's definitely a different color. I think it's bluer, and in the summer it seems warmer, more orange.

**Can you tell me about the materials you use and how they came into your practice? Maybe talk about the evolution of the medium for you.**
Well, my art career started with video. I liked the immediacy of it, and it seemed to me somehow related to painting. What I was feeling when I was painting was: this is happening now, while I'm doing it, and that part was really exciting to me.

**Video is different from film in that there's no cutting. You're doing this in the moment, for an extended period of time—a one shot, which is similar to painting, where you're really in the moment, trying to get that action, trying to get that moment down.**
Initially, the work had a lot to do with what was available at the time; later it became something quite different. My interest became what I call duration versus time. My videos are in duration, and time is really minor. I'm interested in duration, because the land itself has duration. It [the land] isn't particularly interested in this pent-up time, this Schnitt [laughs], these breaks in time. It doesn't

occur in the landscape; it's continuous. It's part of the land. That's the time that I'm interested in. And I manipulate that time; I slow it down, yet it's still duration.

In the seventies I worked in video, for the most part. Then from 1980 to 1995 I switched to still photography. I became digital while working in photography.

**You didn't do any video for fifteen years?**
None. Not a bit.

**Was that a very conscious decision?**
It was a very erroneous conscious decision. [laughs] My thinking was that since my video is still—I didn't move the camera—what could be more still than a still camera? But, slowly and surely, because of the still camera, I got deeply into landscape both physically and emotionally, which I hadn't done in my video work. The photography gave me the experience of being in landscape, and that became really an important part of my art making. I was always good with technology, so it was natural for me to start working with computers, but the first couple of years working with computers really determined what I was doing because of my technical limitations. Finally, I was able to get past that, but it took a while. I do feel that one of the limitations of technology is that it influences people and their work. My advice to my students, and myself, is to go on location, but don't take the camera out of the bag. Just go out there and look and see what's there, then pick up the camera and follow up. I see my looking as a very strong part of what I do, and that wasn't the case before.

**Then how did you get back to working in video?**
After fifteen years it took someone to say to me, "I'm going to give you a chunk of money, and you can do whatever you want. What do you want to do?" I said, "Oh my God, no question—I want to do video!" So they bought me a video camera and a video editing system. I made a couple videos,

---

7. Michelangelo quote: "Every block of stone has a statue inside it, and it is the task of the sculptor to discover it."
8. Ingmar Bergman (1918–2007), Swedish. Writer, director, and producer known for intellectually rigorous black-and-white art films.

but they were very narrative. One of them I even sang on. They were extremely personal. I did that for a number of years, and then slowly but surely I started getting back to this idea of duration and away from the idea of time. The first few pieces I did out in Shinnecock Bay were composed of forty-second chunks, and then two-minute chunks, and then finally composed of just a single shot, so it really evolved slowly.

It's the same thing with the evolution of this current work. Kathleen was in the hospital [for a month in 2009], and I didn't want to be far from her, so I stayed home working on the computer. I took footage that I had previously taken and started fooling around with it, and all of a sudden there was this abstract stuff! I knew abstract art from the twenties, thirties, and forties. I was very interested in [Milton] Avery,[9] for example, so it didn't come out of nowhere. But all of a sudden I was working abstractly on this [video] footage that I had taken, and, as we used to say in the sixties, it blew my mind!

**Hold on—this is amazing to me. Because Kathleen was in the hospital, which caused you to stay home, these new abstract works developed?**

Yeah. But I don't think anything's quite that simple. In science, an abstract is something that derived from this big body of work—it was derived from another thing. It kept occurring to me, and I want things to happen naturally. I really want things to happen in their own way, and not force anything.

**Do you have any special devices or tools that are unique to your creative process?**

Yes. I knew from my still photography days that I really was attracted to Leica lenses, so I started buying Leica lenses to put on my [video] camera with an adapter, and it's worked out really beautifully, particularly for Long Island light. Every group of lenses is responsive to something; Leica's happen to be responsive to a certain area of light that I'm really interested in. I love the tones it conveys. What I like about these Leica lenses is that I'm back to having a depth of field, which means that I can go out of focus.

**I like the size of the monitors you show your work on. How do you choose the scale?**

Since I've been back working in video, I've been against doing anything projected. In 2009, when I started showing this work, some pieces were projected and some pieces were not. The ones that were on monitors looked so much better. I can convey better tones. When an image is projected onto a screen, you're losing all kinds of tones and intensity of tones, even with a really great projector. Ad Reinhardt[10] said a work shouldn't be bigger than your outstretched hands, and there is something modest about this size that I like. I like the idea of people spending time with my work, like they would with a painting, and that means making something small enough to fit in someone's home.

**Do you have a favorite color?**

My favorite color is Yves Klein blue,[11] but this vibrant red really keeps coming back to me. I'm unhappy unless it's in one of my pictures.

**Are there items you keep in your studio that have significant meaning to you?**

This house means so much to me. When I left New York in 1951, that apartment was the last home I had until this house in 1999. Nothing ever felt like a home. This place feels like a home to me. The art that I have around really means a lot to me. I like this cup. I just love it as an object. It reminds me of what I love about art. It's very modest, it's handmade, it makes no pains to hide its construction, and it has a very simple glaze. It's making some connection to the earth that I really admire.

**I'm going to make a broad statement and say your work really is contemporary painting. Your eye is like a painter's; you're deconstructing the image but then reconstructing it. And it's so painterly, but yet it still refers to video or the evolution of picture making.**

---

9. Milton Avery (1885–1965), American. Painter known for his use of simplified forms and an expressive palette.
10. Ad Reinhardt (1913–67), American. Leading abstract painter known for his late works, black-on-black geometric paintings.
11. International Klein Blue is a deep-blue hue in the ultramarine family developed by French artist Yves Klein.

The energy is video. I'm getting down to the pixel level. Before I went back to video I got to a point where I said I really wanted to paint again, but I was afraid to and I wish I had. Painting will never be out of style. Ever.

**How do you come up with titles?**
It's really hard. I'm against the idea of *Untitled* as a title. I like this one—it's called *Barge, Tug, Rig*. It just somehow came to me. It's like everything else: I let it evolve, and sometimes it's okay, and sometimes I get impatient and just let it go. Titles are so hard. One favorite is a video piece from 1972 about looking at yourself: a reflective image and a video image and how they go together. I called that piece *Interface*, and I thought that title was so good; it probably is what made the piece successful.

**Did you ever work for another artist, and, if so, did that have any effect on the way you work?**
In the late sixties I apprenticed myself to Chuck Ross.[12] I helped him with films he was making. I didn't get paid. I was just trying to learn from him and I learned quite a bit.

**Do you have a motto or creed as an artist you live by?**
I have some mottoes. One is about modesty versus grandiosity. I think one should be somewhere in between the two. It's not great as a professional artist to be too modest, because you'll be left in the dust, but I don't think it's great for one's own psyche to be too grandiose. It's not so great for the art, either.

The real motto I have comes from Ananda Coomaraswamy, who was a curator at the Boston Museum of Fine Arts in the 1920s and '30s; he was responsible for their Far Eastern collection. He has a book called *The Transformation of Nature in Art*. In it he talks about the sculpture *The Dance of Shiva*.[13] He said that art should have four equal components: physical, mental, emotional, and spiritual, and I believe in that. I don't know that I succeed in it, but I believe in it. Finding a balance in one's own work is very difficult, and I keep saying over and over: How does my work do with those four attributes? Does it hit all of them? We tend to be pretty good with the physical and mental, but we often forget about the spiritual and the emotional in this day and age.

People don't want to stand in front of an artwork and feel embarrassed. I don't think it's such a bad thing to feel some excess of emotion when you're standing in front of, say, a painting like El Greco's *View of Toledo*. Why should it embarrass me to really love that painting? And also the *View of Toledo* is beautiful spiritually, too.

**What advice would you give to a young artist that is just starting out?**
Be careful. There's so many pitfalls out there: pitfalls of getting too attached to a gallerist and believing what they're telling you. Or supposing you're successful in your work and being afraid to try something new. I wouldn't ever be afraid to fail, because it's not going to last forever. Go out in some direction and fail as much as you want to—for years if that's what it takes. You're going in that direction for a reason, and you better pursue it.

Being successful in the art world is overwhelming, and it can take you over. There's one artist I know, who I won't name, who became very successful, and he started doing copies of his own work. You know, he was making his "name" work instead of actually going out there and making art. That's a trap that you can fall into.

I think the main thing that I would advise is to just really care about what you're doing. You've just got to love it. If you don't love it, you might as well be a stockbroker. You might as well be doing something that you can make a good living at. If you love it, it doesn't matter.

---

12. Charles Ross (b. 1937), American. Sculptor and earthwork artist known for large-scale prisms using starlight and sunlight.
13. *Shiva as Lord of Dance (Nataraja)* is an Indian sculpture from the Chola period (ca. tenth/eleventh century) that portrays Shiva's role as creator, preserver, and destroyer of the universe.

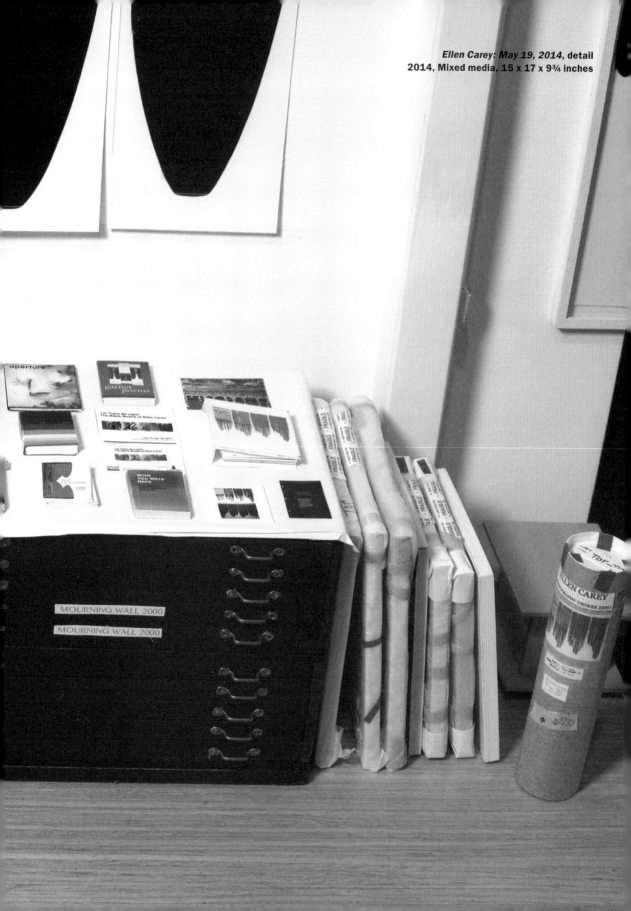

# Ellen Carey

Hartford, Connecticut / May 19, 2014

Photo: Doug Levere

**To start with, can you give me some background information?**

I was born in New York City, the second eldest in a family of five children, three boys and two girls. We lived primarily on the East Coast and in the Midwest, around big cities. I attended all-girl Catholic schools up until the second year in high school; none had art programs. I spent a lot of time drawing from Jon Gnagy's *Learn to Draw*. In 1971, when my parents moved to Buffalo, I left for college, to the Kansas City Art Institute.

**You moved around quite a bit. What effect do you think that had on you?**

I think that moving around afforded me different environments to respond to—the Northeast Corridor, the South, which at that time was still very segregated. My childhood gave me a foundation for learning to be flexible, to take risks, which helped with my work later on.

**How did you become involved with photography?**

In high school my parents gave me a Polaroid Super Shooter. Then, during our freshman foundation classes at the Kansas City Art Institute [KCAI], we had introductions to various artistic areas. I had no response to the blank canvas in paint, couldn't throw anything in clay, nor sculpt, blow glass, or do graphic design—not even weaving in fiber arts! It was quite hopeless. Then I discovered printmaking, through having a superlative undergraduate experience with two great teachers: William McKim, who was taught by Thomas Hart Benton, for lithography, and Marvin Jones for etching.

I had a very generous peer group as well, who were very supportive.

During freshman year a fellow art student showed me the KCAI darkroom and how to print. The darkroom is where I fell in love with the whole process of photography. I would be there ten, twelve hours a day with my peanut butter and jelly sandwiches. The magic of developing and seeing the first image coming up in the amber light was so exciting. It was immediate. The ability to get my creative ideas out there quickly just wasn't happening with any other medium. It was a huge existential relief.

**Did you go to graduate school?**

Yes, after KCAI, I went to SUNY Buffalo on a scholarship and got involved with the art scene there. I met a whole bunch of photographers like Les Krims,[1] who was a boyfriend for a while, John Pfahl, Bonnie Gordon, Nathan Lyons[2] from Visual Studies Workshop, and filmmaker Hollis Frampton. Robert Longo[3] and Cindy Sherman[4] were among the group; we all hung out at the Albright-Knox Art Gallery.

**1.** Les Krims (b. 1942), American. Conceptual photographer known for carefully arranged fabricated photographs.
**2.** Nathan Lyons (b. 1930), American. Artist, curator, and educator who advanced the study of the history and practice of photography.
**3.** Robert Longo (b. 1953), American. Artist known for his large-scale, detailed drawings.
**4.** Cindy Sherman (b. 1954), American. Photographer known for dressing in costume and using herself as the model to create images that explore identity and representation.

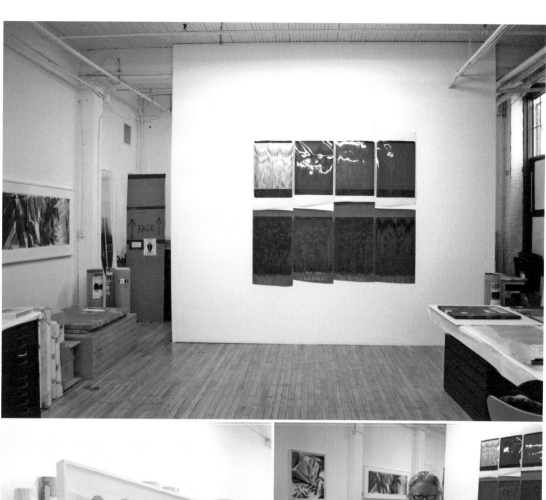

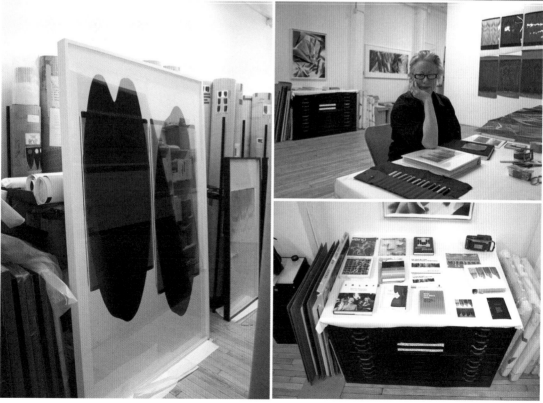

**When did you move to New York, and what brought that about?**

Moving around [in my childhood] helped me realize that moving was not a scary thing or overwhelming. After I finished graduate school I spent a year working with Linda Cathcart as a curatorial assistant at the Albright-Knox Art Gallery on her *American Painting of the 1970s* exhibition. I applied and received a CAPS [Creative Artists Public Service Program] grant for $5,000 and she encouraged me to move to New York.

Those were very much struggling artist years. I got a great waitressing job at Spring Street Bar and teaching jobs at Queens College and ICP [International Center of Photography]. The curator Allan Schwartzman gave me a job photographing installations at the New Museum. So I managed to get through. It was very tough, and tougher because my dad had died suddenly right before I moved. But I loved New York, and I was there in that golden period when the SoHo art and gallery scene was developing.

**Where exactly were you living at the time?**

In Little Italy, at 17 Cleveland Place, in a tiny tenement. Eventually, I established a studio at Spring and Mercer, right across from Donald Judd's[5] building. It was a very invigorating and lively time, while being tough, too.

**What would you consider your first real gallery show?**

Back then I was part of the avant-garde of the 1970s in Buffalo. Alternative places like CEPA Gallery [Center for Exploratory and Perceptual Arts] and Hallwalls [Contemporary Arts Center] were just beginning. The Albright-Knox Art Gallery hired Linda Cathcart, Marcia Tucker's protégé from the Whitney Museum, to be contemporary art curator, and she began the biannual exhibition *In Western New York*. She championed us all. Later she was one of the curators of a 1979 group exhibition at PS1 in New York titled *The Altered Photograph*. I had about ten or twelve photographs from my *Painted Self-Portraits* series in it. [My first one-person show in New York was in] the early 1980s at Concord Gallery.

I had faith, little money, my small portfolio case, and a trunk of clothes—that was it. Cindy Sherman's photograph of herself on the road with a suitcase, a metaphor of the future and the unknown—alone—was often how I felt.

**What brought you to Hartford?**

I was hired by the Hartford Art School in the spring of 1983 as a visiting artist to replace Robert Cumming while he was on leave; he never came back. A few years later, in the summer of 1987, I lost my SoHo studio. I looked around in New York but chose instead a two-thousand-square-foot loft up here in the Colt Building, while keeping my apartment in New York. The timing could not have been better, as the stock market crashed that fall. Black Monday and the art world pretty much closed up. In 1991 I received tenure with promotion.

**Did you have a darkroom in the loft?**

I didn't, because I used the one at school, but I had a big shooting studio. At that time I was using black-and-white film with a medium-format camera. I began to reevaluate my work. My projects often begin with questions: What does an abstract/minimal photograph look like? I began to look at the dawn of photography, the origins found in the photogram cameraless work of William Henry Fox Talbot[6] and Anna Atkins,[7] really looking at the shadow as negative image.

**You have done a lot of work using the large-format Polaroid camera. Can you tell me what a Polaroid studio would look like and explain the process?**

It is fully equipped with lots of lighting equipment, tripods, and so forth. Yet unlike the conventional studio, it has this enormous custom-built camera, circa 1980. It is very special, this Polaroid 20 x 24! There's a big, unique photograph, a positive with its

---

5. Donald Judd (1928–94), American. Artist known for his minimalist and fabricated sculptures.
6. William Henry Fox Talbot (1800–77), British. Inventor and photography pioneer who made major contributions to the development of photography as an artistic medium.
7. Anna Atkins (1799–1871), British. Botanist and photographer considered to be the first woman to create a photograph and publish a book illustrated with photographic images.

negative. I keep and show the individual negatives too. Some of the colors and patinas are informed by the Polaroid film—say, if it's color or black-and-white. My experiments with the film create new forms and vibrant colors. Most of the negatives, which I keep, oxidize and change over time.

**Can you describe a typical day, being as specific as possible?**

When I work on the 20 x 24 Polaroid camera, I have to book time at the Polaroid studio in New York in advance. I have to do preproduction, meaning get everything packed ahead of time: my tubes, the foam cylinders, Bubble Wrap, and so forth. My black portfolio case contains my color gels, drawings for my ideas, color magic markers, my notebooks, white foam board, and a few other things.

Usually, I'll shoot on a Thursday because the negatives have to dry overnight. I can get a lot done in a day. We start getting ready at nine o'clock, and I'll be shooting by ten o'clock. We'll have a working lunch and usually end by seven o'clock at the latest. My dealer may stop by to look, maybe a friend or two, perhaps a collector or a curator. Next morning, off to the studio by six or seven o'clock, pack everything up, and drive home.

**How many images can you get in a day?**

If I get one outstanding artwork, I'm happy. My aim is pure abstraction, minimalism, vibrant colors, and new forms with high visual impact, all about light or no light, exposure or none. I work until I get a great picture, and then I try for another. I want to end the day on an up note.

**With the Polaroid, you're working without a typical negative—they're all individual prints?**

I do have negatives, but you're right—they're not traditional negatives in that they can't be used to print additional pictures. All my works are one-of-a-kind prints. Some people would say I'm not a photographer; I'm a lens-based artist. I would locate my work within the context of the twentieth-century avant-garde, with Man Ray,[8] the Russian constructivists, the Bauhaus,[9] with the lineage of cameraless images in the nineteenth century, as well as the very experimental contemporary artists who happen to have links to photography, such as Adam Fuss,[10] James Welling,[11] Christian Marclay,[12] or Susan Derges.[13]

I have some painterly ideas. I think I'm considered a maverick and a pioneer in photographic minimalism and abstraction. I have been very fortunate to bear witness to the great art movements in America after World War II: abstract expressionism, minimalism, conceptual art, and the social changes brought about by feminism.

**With painters, they're having conversations in their heads with the history of painting. Is the conversation in your head more with the history of photography?**

I always say that if I were in art heaven, I'd love to talk with Talbot, Anna Atkins, and Man Ray, as well as Jackson Pollock,[14] even Eva Hesse.[15] Their relationship and sensitivity to materials and process is embedded in their art. I would like people to think about photography less as a picture sign and more as looking at the possibilities of a picture process.

My role models would be people who break ground. I love experimenting. I was very fortunate to meet other artists when I was in New York;

**8.** Man Ray (1890–1976), American. Visual artist renowned for his photographs and photograms. He was a contributor to the dada and surrealist movements.

**9.** Art school that existed in Germany between 1919 and 1933, known for its avant-garde approach to design.

**10.** Adam Fuss (b. 1961), British. Photographer known for his cameraless technique, using the basics of photography: objects, light, and light-sensitive material.

**11.** James Welling (b. 1951), American. Artist and painter who uses a range of photographic tools and mixed media.

**12.** Christian Marclay (b. 1955), Swiss/American. Visual artist and composer whose work explores the connections among sound, noise, photography, video, and film.

**13.** Susan Derges (b. 1955), British. Visual artist specializing in cameraless photography, most often working with natural landscapes.

**14.** Jackson Pollock (1912–56), American. Influential painter and a major force in the abstract expressionist movement.

**15.** Eva Hesse (1936–70), American. Sculptor known for works using latex, fiberglass, and plastics.

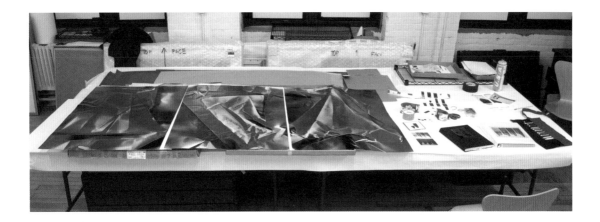

Linda Cathcart introduced me to Nancy Graves,[16] who was fantastic. You meet artists throughout life; you learn a lot from each one. Later examples would be my long friendships with John Coplans[17] and Sol LeWitt.[18]

**Do you listen to music when you're working? Do you feel it affects your work in any way?**

I do. I feel that music has a kinship to the feelings and the spirit in my work. Though I have to be able to listen and concentrate when I'm doing my art. It's an emotional, psychological, uplifting experience, and it's very technical and visual—a kaleidoscope of various forces. Silence also works, especially when I work alone in the total darkness of the color darkroom. To focus like that for hours on end takes lots and lots of experience.

Since my works are unique prints, I only get one chance. Once, after printing for many days, I was down to my last piece of paper. This was the last piece of Kodak precut 30-x-40-inch color paper on the planet! I went into the darkroom and I said a little prayer: "OK, Talbot, Anna Atkins, Man Ray, I really need your help. I only have one piece of paper left." And I got it—I nailed the print! It's about setting a really high performance goal for yourself. It's like you're an athlete, it's the Olympics, and this is what you've been training for.

**Do you have a favorite color?**

I love all colors, especially rainbows. I think my love of color comes from being Catholic, staring at stained glass windows for a long time. But if there is one, it would be blue, what they call in Irish "the violet hour"—the end-of-the-day blue, where the silhouette of the trees is hard to differentiate as the sun goes down. That's my favorite moment of color.

**Are there any specific items that you keep around your studio that have significant meaning to you?**

I like to keep objects that have color in them. I also collect dragonfly imagery. In 1995 my mother was diagnosed with cancer, having about a year left to live. During this time my middle brother, John, had an accident and died instantly. My mother's death followed. I did everything possible in this state of mourning, grieving, but nothing seemed to work. My brother had collected dragonfly imagery. Right after John and Mother died, I would see—either physically, metaphorically, or as a picture sign—rainbows and dragonflies, and that's when I had a breakthrough in my work and my life.

Color is the joy of celebrating, and there's its counterpart in sadness—gray and black. It's a metaphor for the shadow image or, in psychoanalysis, the hidden self or interior life. I had an incredible experience with what Freud calls the uncanny. In the summer of 1996 my mother and brother had just died. I decided to go to the studio and do a picture, a family portrait, never intending to exhibit it. There

---

16. Nancy Graves (1939–95), American. Visual artist known for her focus on natural imagery.
17. John Coplans (1920–2003), British. Photographer who made black-and-white self-portraits that are frank studies of the naked body and the aging process.
18. Sol LeWitt (1928–2007), American. Conceptual artist known for his wall drawings and structured minimalistic sculptures.

were three Polaroid positives that were black rectangles, one each for my father, my mother, and my brother John. My older brother, myself, and my two other siblings were white. The interesting thing was that whether the negatives were exposed or not exposed, they were all a matte, tar-like black.

The first *Pull* came after this group. When it was time to reload the film into the camera we did a test, but the white positive area—which has the Polaroid tulips on the top and a black band on the bottom denoting the picture's end—went a little farther down past the regular cutoff point. I thought that was interesting and did it again, only this time it was made bigger. I knew right away it was major, even though I might not have understood it completely at that time. Then one was made all black, no exposure. I called them *Pulls*.

That was quite a day! I felt completely different in every way. It was visceral, spiritual, physical—everything and nothing. That day was the day I left my old life behind: my old self, all my photographs, all my cameras. I wouldn't use them anymore. I will never forget it. All this love now gone. All these pictures now meaningless. I was thunderstruck but inspired. It was the beginning for what would become *Mourning Wall* several years later. All these were new photographic documents of a different order, with different meanings—all very minimal and abstract.

### How did the recent *Dings and Shadows* series come about?

I had been working on large, abstract color photograms for three years in a series titled *Penlights*. I was completely uninspired, so I tried something new in the darkroom. A little ding [crinkle] appeared on the color paper, which caused a crescent-like sliver of a shadow. I thought, Oh my God—that's it! I had missed the content of my work and forgotten that materials have meaning. The ding, traditionally taboo, became my shadow catcher. Bold forms, abstract and colorful, all done in the dark! My photogram practice is called *Struck by Light*. Literally and figuratively, the only thing that hits the paper is light.

### Have there been recent technologies in the last five years or so that have affected your work?

I love digital in terms of its properties for speed, size, and scale. The iPhone is interesting as an apparatus for expression. It's really universalized the global picture culture. In a certain way, that's going to make it more challenging to make interesting photographs. At the same time, it's incredibly accessible, so everyone can join in. People are taking pictures all the time—they love pictures. I don't care if they are good or bad or indifferent; I just think it's great that people are visually engaged.

### Do you have a motto or creed that as an artist you live by?

I love Polaroid's phrase "See what develops," which reflects my journey as an artist. Approach your work like an Olympic athlete and always go for the gold. For the truth and beauty that Keats[19] wrote about in the poem "Ode on a Grecian Urn."

### What advice would you give to a young artist that is just starting out?

I would not be the artist I am today without my mentors—that's really key. Look at a lot of art. Read about it and about artists' lives. Read books, study philosophy, see films. Engage in the world, travel. Have a sense of humor—have fun, and don't do anything you can't reverse. The grim reaper is going to come along anyway, so I wouldn't accelerate that process. Have a connection to nature and protect your gifts.

---

**19.** John Keats (1795–1821), British. English romantic poet known for works characterized by sensual imagery.

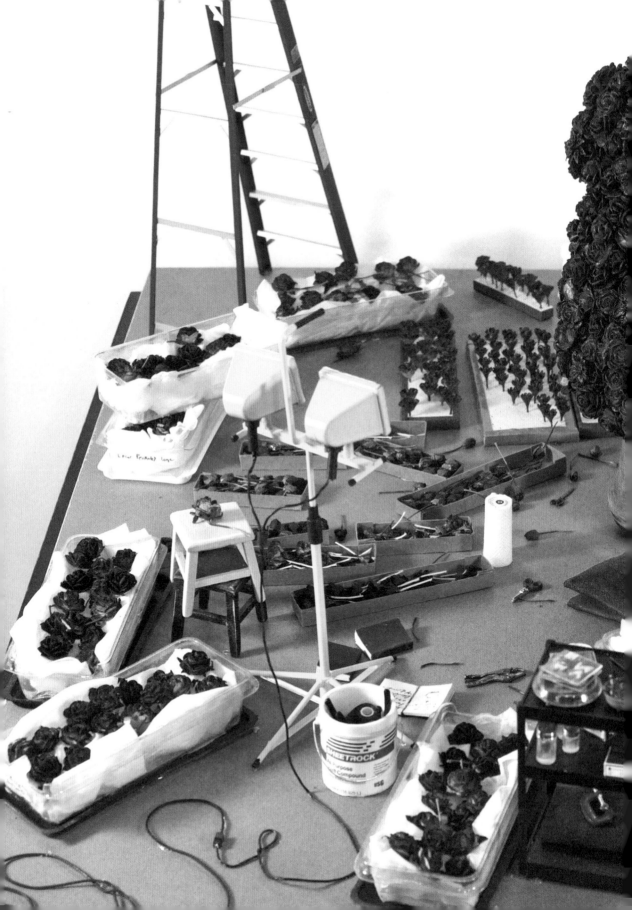

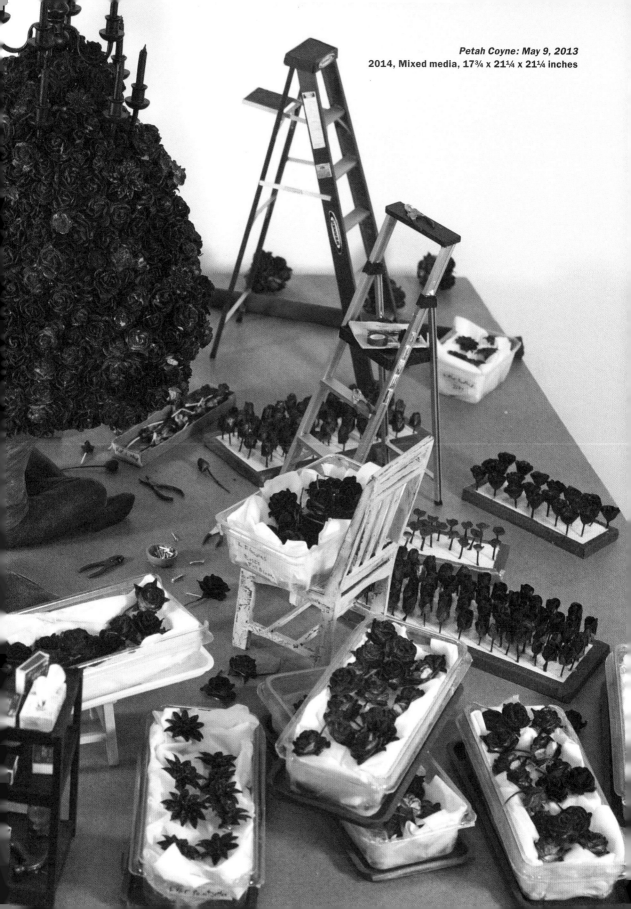

*Petah Coyne: May 9, 2013*
2014, Mixed media, 17¾ x 21¼ x 21¼ inches

# Petah Coyne

West New York, New Jersey / May 9, 2013

Photo: Nancy A. Jimenez

**To start with, can you please give me some background information?**

I grew up traveling the world. My father was in the military, and we never stayed in one place longer than six or nine months. It was an exotic and wonderful way to live. Even when we were settled, we still traveled. When we lived in Hawaii, we went to Japan quite often, for instance. We—my brothers, sisters, and I—thought everybody lived like this, in constant motion.

My parents rarely told us when we were moving. We would come home from school, and the house would be packed, completely empty. In the new house everything would be clean and the furniture we brought with us would be freshly painted with a new color. This table we're sitting at right now traveled with us everywhere. It has hundreds of layers of paint on it, and the glass is the original glass!

My father was an officer, and when it was time to move, twenty men would come into the house and help us. They would even move our car. In Hawaii they put all of our belongings into giant nets and lowered them into these huge boats. I have a very strong memory of watching this. Our very fragile chandeliers were dropped into large shipping containers filled with shredded paper. I learned so much about packing and shipping from watching them. It was so beautiful to me how things were taken apart and then put back together in a way that makes you see everyday, common things differently, much like installation art can be.

As we got older, my father felt that the transitions were getting difficult for us and that we should have stability. He moved us to Dayton, Ohio. It was such a culture shock to be in the Midwest. We went to a school called Oakwood. It felt very conservative, and I found it strange to have a permanent home.

The art program at Oakwood turned out to be very good. My mother was a very generous person and saw my interest in being an artist. She designated what she called "free days," which were days we could take off from school if it got to be too intense or too focused on subjects we didn't care about. We could do anything we wanted on these days as long as it was something special, something we would learn from. We built miniature cities in the backyard and went to art museums to get inspired. Once, we even painted a replica of part of the Sistine Chapel on the ceiling of our basement! I made candles and sold them so that I could buy a potter's wheel, and made pottery and jewelry. I was always into working with my hands. I did bronze casting before I left high school, and lost wax and sand casting at a small industrial place in town. I collaged a fourteenth-century Chinese wall and copied a Degas[1] ballerina. By the time I got to college, I'd already done a lot of experimenting with materials.

**Where did you go to college?**

First to Kent State. I was making sculpture there, but a professor told me I had to learn not only how

---

**1.** Edgar Degas (1834–1917), French. Impressionist painter and sculptor whose works focus extensively on dancers.

to make it, but destroy it. While he was saying this to me, he picked up a sculpture I was working on and threw it out the window! It dropped three stories and was completely destroyed. I was devastated. I thought he had no respect for sculpture, so I transferred schools and ended up going to the Art Academy of Cincinnati. At that time it was small—there were maybe thirteen people in my class—and it was a great little school, very intense. We drew a lot, and we learned color theory and worked from plaster casts—all of the classic stuff.

When I graduated from the Art Academy my classmates thought I would stop making art and have a lot of children. I was so shocked! I wanted to go to New York, and that's what my husband and I did. While living in Dayton, I had heard lectures by Jody Pinto,[2] Alice Aycock,[3] and other artists. They talked about things that were completely new to me. Jody Pinto spoke about holes she was digging in abandoned parking lots in Philadelphia and how she would pour red paint into them to make it look like horrible things had happened inside of them. Alice Aycock talked about crawling inside of one of her early sculptures that was about death and transformation. When I heard them speak, I thought, What am I doing in the Midwest? I have to go to New York; there are so many ideas there.

My brother had graduated from Columbia University graduate school a few years earlier and was living in a five-thousand-square-foot loft in Tribeca. We moved in with him and contributed to the $250 rent, living with five other people, in addition to my brother. We had no means of support, and I needed a job, so I went to the Strand Book Store, but the guy working there said he wasn't hiring. I told him I was from the Midwest and an extremely hard worker and that I would sit and wait in the store until he hired me. And that's what I did. He finally said, "Good God, just come back tomorrow at 8:00 a.m." [laughs]

Then I took a job with an advertising firm for about a year, and eventually, I started working freelance at Chanel. By the end, I could work eight weeks a year freelancing and make enough money to work on my art.

**When did you consider yourself a professional artist, and were you able to dedicate yourself full time to that pursuit?**
I moved to New York in 1978. Around 1985 I started to get grants, and the money was enough to allow me to work solely on my art and not have to work day jobs. We lived very meagerly, which was fine. We walked everywhere—we didn't even take the subway. It felt like a very humble existence. At first I lived off those grants, and then after about eight years, I was selling enough work to live on.

**How did you get your first real gallery show?**
I had very good advice early on from other artists I worked with while in the advertising world. They told me to apply for grants and to send my images to galleries. I didn't know that it's typical to start by approaching emerging galleries, so I sent them to all the top galleries: Leo Castelli, Sperone Westwater, Sonnabend, and Blum Helman, among others. Leo Castelli, to his credit, called me and asked me to meet with him. I did, and we had a nice talk. Peter Freeman from Blum Helman made it perfectly clear he was not interested in showing my work. He was interested in seeing it, though, because at the time, I was working with dead fish, and he told me over the phone that he had to see it to believe it. He came to my loft, where I had thousands of dead fish hanging from the ceiling, and said it was the most extraordinarily weird work he had ever seen. He also told me that no commercial gallery would ever show a work made out of dead fish, and that I should look into showing my work in alternative spaces or to try and find museums outside of New York that would show it and then build my way back to New York museums. So that's what I did. It was the best advice I ever got.

I sent out 250 slide sets that year. As soon as a set was returned to me, I would send it out to someone else. I was very determined and began

---

**2.** Jody Pinto (b. 1942), American. Artist known internationally for her creative integration of art into architecture and landscape.
**3.** Alice Aycock (b. 1946), American. Installation and environmental artist and sculptor. Known for works that often combine an industrial appearance with references to weightlessness, science, and cosmology.

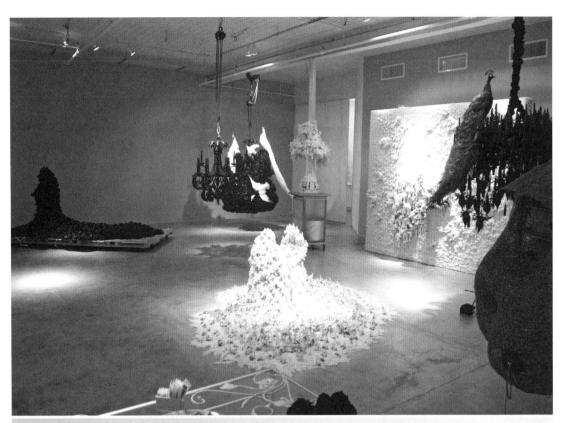

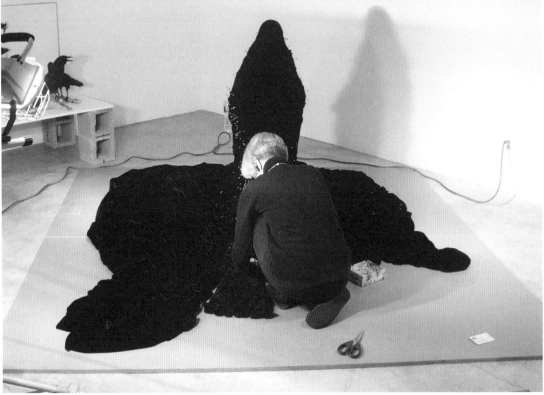

getting shows almost right away, first out of town and soon in New York. The 1987 Whitney Museum show *Elements: Five Installations* and the 1989 installation in the Grand Lobby at the Brooklyn Museum really helped to expose my work.

**How did your relationship with Galerie Lelong come about?**

After I left my first gallery I wanted to carefully consider my next move. At that time I had begun making wax sculptures. People were most interested in the white hanging pieces; they were selling extremely well. I wanted to really push people and further my ideas, so in addition to making the wax pieces, I made some work with dead rats. Everyone who came by had the reaction of "Oh my God!" They didn't even know what to say. Mary Sabbatino from Galerie Lelong came to see the work, and while she said she was quite surprised by the rats, she also said that she always liked to see artists changing and that she encouraged the growth of ideas and found the work very interesting and that she would like to represent my work. I thought anyone who would be interested in showing dead rats and would encourage change is the dealer for me. That was in 1997.

**Your studio is separate from your home? Is that what you prefer?**

Yes—otherwise, I would probably work continually and never sleep.

**Did you have a plan for the layout of the studio, or did it develop organically?**

We gutted the building and made a plan for the space. It's five thousand square feet on both floors. The main studio and work space is on the upper floor and is three thousand square feet. The wax work is done in an adjacent room on the same floor. I also have a private studio, where few people are allowed. It is my personal space for playing and dreaming up ideas. It's the place that gives me the most joy and happiness.

**Can you tell me more about your materials?**

I usually work with found materials. There's always something new to recycle, and the residue of those materials and their former life is most interesting to me, how it lives on through the piece and adds layers of meaning to the work. I have about two thousand square feet solely of materials. Materials to me are like magic. It's the process of adding and subtracting that I love the most—the process of getting my hands into the materials. There is nothing more wonderful. I don't have enough time in the day for what I want to do. Even though I try to get in six days a week, it's still not enough time, and there's always a struggle against the other things that encroach on your life!

**How did the wax come into the pieces?**

At the earliest stage, it was probably from the candles I made as a child. More specifically, in 1990 I was in southern France on an NEA [National Endowment for the Arts] grant and went to Italy to visit a friend. She was an artist and not having any success in the art world, and she was depressed. I told her we should light candles in the church and that she had to light them with intention and energy. We went around to all of these amazing churches and cathedrals, leaving quarters and lighting candles. After we lit about twenty of them she said, "Petah, I've had enough. I'm going back to Assisi to spend time with my husband." But I stayed and kept lighting candles. When I left, I wrote her a note that said: "I lit sixty-four candles for you. You are going to have great success."

When I came home to the United States some time later, there was a box of sixty-four candles from my friend blessed by the Pope. Inside was a note from her that said: "Please light these and blow them out. I can't take any more success!" [*laughs*] She had been in a number of shows and didn't have enough work. She was scheduled to have a show in New York, and I made a sculpture in the shape of a hat for her out of those sixty-four candles. I used hot glue and cat hair and other materials I had been collecting. I asked a friend to wear it and pose for a photograph and told her that I would be lighting the candles. She agreed and put the sculpture on. Upon lighting it the hot glue was like an igniter—the whole thing just went up in flames! I didn't know if I should grab my friend or the fire extinguisher, and I'm thinking, Oh my God, she is going to die. Everything was in slow motion; her eyebrows were on fire. When I put it out with the extinguisher, her eyebrows were gone! I thought she was going

to say horrible things to me, but the first thing she said was, "How did it look?" I couldn't even respond. I was just so shocked. And that's how it was born—that was my first wax piece.

From there I had to figure out how to work with the wax. The first pieces wilted because it was during the summer, and a friend told me to wet the wax down. I did that with a hose, and then my studio was filled with water. It was a disaster! [*laughs*] It took two years for me to learn how to control the wax.

Once I started mastering the wax, the next issue was learning how to move the pieces. We had to come up with solutions to avoid cracking the wax and to brace the sculptures for shipment. I remembered the chandeliers from when I was a kid, how the men would lower them into the nets on the boats, and all these ideas and things I had learned about packing and shipping from my childhood came back to me. Now we have it down to a science—it's fantastic!

**Do you have a favorite color?**

I would say deep purple, like a bruise.

**Do you have any special devices or tools that are unique to your creative process?**

I often have to modify my own tools, like add extensions to needle-nose pliers so I can work deep inside the pieces. Sometimes I'll lose tools in the sculptures and have to fish them out. I came up with the idea of using a double shackle system for the hanging pieces. The two shackles have to stay on the sculptures forever. Anytime a motor hoist is used, the hook of the hoist attaches to the one loose shackle, and then we release the other shackle, so there's always a loose shackle. They are calibrated exactly so that the sculpture is ready to be picked up or transferred without any additional hardware.

**Are there any specific items here that have significant meaning to you?**

Yes. When people pass away, they sometimes leave me things that I keep on my desk. One in particular is from a very good friend of mine; her husband gave it to me. It means a great deal to me. I look at that often because I think when people pass on, you have a responsibility to live up to—to live for them, in a way.

I also have an antique hair sculpture on my desk that was made out of sections of hair that a circle of friends offered as a gift to someone who was passing. It's braided in a really exquisite and intricate way and is really beautiful, both in its idea and execution.

**When you are contemplating your work, how do you sit or stand?**

I usually sit on the floor. I never sit in a chair when I'm working on a sculpture. As you know, when you're working, you're not even conscious of your own body. It's as though you are absent from your physical being. When a work is coming together as it should, it feels as if someone or something else is telling me what to do. When that's happening, it's so beautiful. The older you get, it somehow becomes easier. It just flows in a way that your younger, perhaps more self-conscious self didn't allow. Now I just listen, and it comes, and I don't know where I am. It's a very pure form of making.

**How often do you clean your studio? Does that affect the work in any way?**

I like a clean studio. I am a daughter of a military officer. [*laughs*] It helps me organize. I can be messy with my sculpture if everything around me is neat. We keep the wax materials separate in one room and bring the bodies of the sculpture into the main space. All the prep stuff is done in my personal studio: all the sewing, the handwork on the velvet, the wiring, and braiding and weaving of the hair. Anything intricate, the real details of the sculptures, I have to work with in an intimate way. I can't cross-contaminate or mix any of the materials or processes until I'm putting it all together.

**How do you come up with titles?**

I number them according to the order I make them in and then give them a more personal title in parentheses. Initially, I wanted people to make up their own minds about what the piece was about. But it was hard for my dyslexia to remember the numbers, so I started naming them. There's one in my studio called *Sisters*, because it's a sculpture of my sister and me, and another called *Chinese Wall,* because it's very much referencing Chinese landscape painting. Some are less straightforward, like *Black Snowflake*, which is named after my father, who is still with us but has Alzheimer's. It's about how his mind started to close off and the first time he didn't recognize me. It broke my heart, but I started to think about how he now saw the world and what his altered vision of the world was. I thought of him inside his shell looking out, and an image of black snowflakes came into my mind. The sculpture has beautiful blue and green blown glass bulbs hanging from it, which are the color of his gorgeous eyes. The piece is covered in black wax and the peacock on it is perched up high, ready to take off. Peacocks historically symbolize the transformation from this life to the next. How cruel and awful the disease is—so unnatural, a beautiful mind turning into something else. A museum director saw the sculpture and without knowing the history commented on the heart shapes that he saw repeating throughout the piece. I had never even noticed this, but when he said it, I saw them. The bulbs covered in wax and hanging from the piece suddenly looked like hearts—not the decorative kind, but human hearts. There is wax-covered wire coming from the tops of them that look like arteries, some severed and some connected, and I thought, This is why artists make work, to understand more of ourselves and the world.

**Do you have a motto or creed as an artist to live by?**

Always try to play in your studio and never waste any time, not a minute.

**Lastly, what advice would you give a young artist who is just starting out?**

I wish I could say that I have it all figured out and offer great words of wisdom to the young artists out there, but I personally feel each person needs to look inside him- or herself for answers, to find their own ways of working and existing as artists.

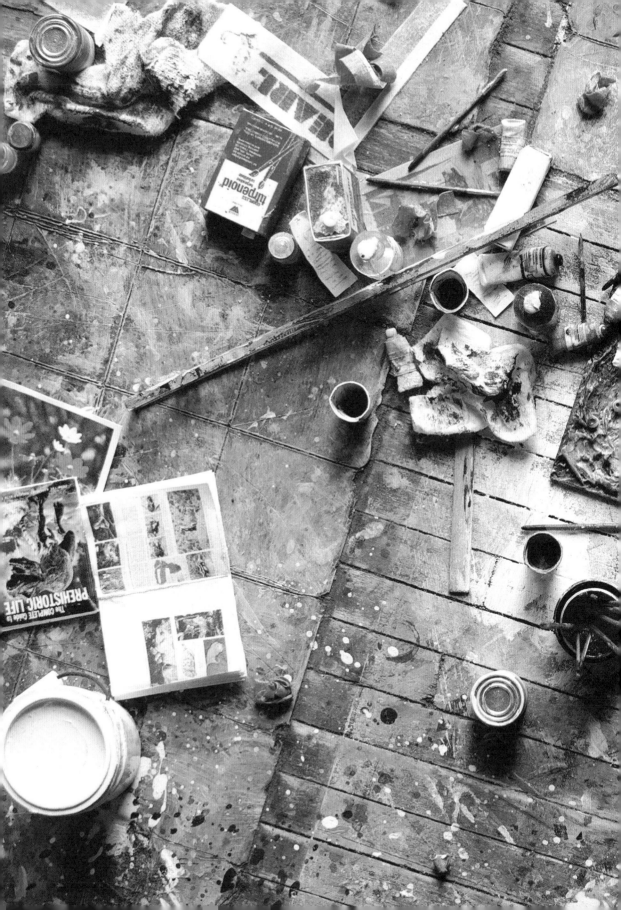

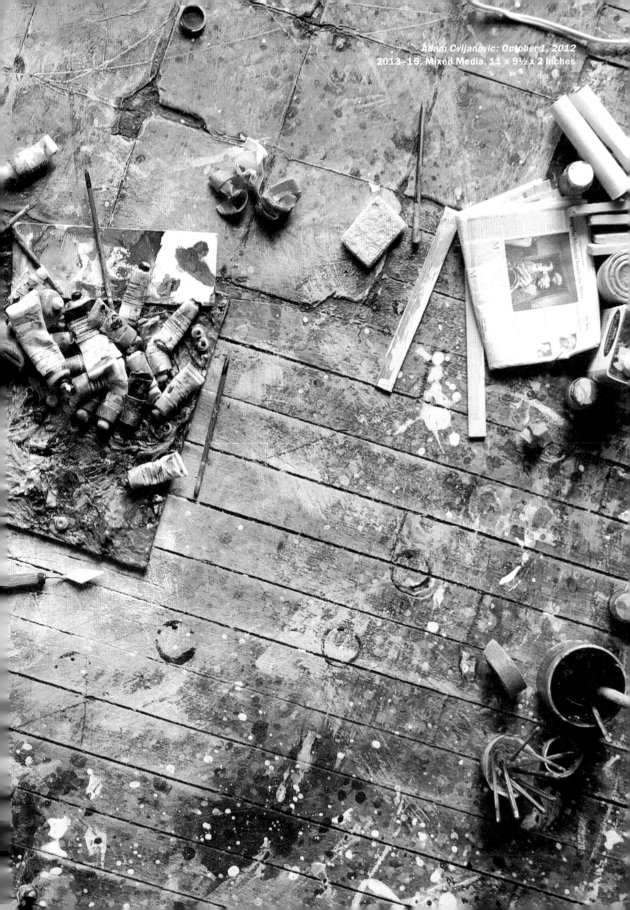

*Adam Cvijanovic: October 1, 2012
2013–15, Mixed Media, 11 x 9½ x 2 inches*

# Adam Cvijanovic

SoHo, New York City / October 1, 2012

**When did you consider yourself a professional artist, and when were you able to dedicate yourself full time to that pursuit?**

I considered myself a professional artist when I was thirteen, but nobody else did. [*laughs*] I think it's more a matter of when other people consider you a professional artist. I've had a very strange career, with ups and downs. The first up happened when I was twenty-two and had my first solo show in Boston. I was twenty-five when I was able to live off of painting, so it was almost right away. Then it all went horribly wrong, and I had to go back to working a job. But then it all went right again. But then it all went terribly wrong again. [*laughs*]

Then there's the question of how professional being an artist is, anyway. One thing about the last art boom that really annoyed me was that some of these students who were coming out of art school were talking about being artists as if they were fucking lawyers. As if they were on a career path. I wanted to say to them, "People, this is not a profession. It's a vocation!"

**Can you talk a little bit about this studio?**

I received the studio as it is. There is a diagonal wall that I built. I angled it, partially to have storage space available behind it and partially so that it was agreeable to the light that comes into the space. It covers up a wall of windows that are on the other side of the studio. I'm trying to be noninvasive. The wall is actually pinned to the structure in four places—it's mobile. The idea is that I'll take it apart and use it to make packing crates when I'm done. So it's not wallboard; it's all made with luan.

Because of the mural-size paintings I do on Tyvek,[1] I have to have a big wall. This is the minimum size: it's ten feet by twenty feet. I've never had a studio that was big enough to hold an entire work of mine, so I'm used to creating my paintings in segments and then piecing them together on site.

**How do you work on the mural pieces if the entire image doesn't fit on the wall?**

I just slide them up and down the wall. I was in Sony Studios in Culver City [California] a couple of years ago for a studio tour. It's great because it's such an old movie studio—it was where United Artists was in its heyday. They have a mural-painting shop the likes of which I've never seen. All the storage was downstairs, and there was this giant space upstairs, and there was a slot in the floor so they could slide the paintings up and down through the floor to work on them. This way you are always working at standing level—for me that would be the perfect studio situation.

They have all their backdrops downstairs, and it's amazing because you could rent them. You could actually rent the backdrop from *Casablanca* for a private party. It looks like something from *Raiders of the Lost Ark*, just this vast room with roll upon roll of canvas. And they reuse them. When I was there they were repainting something for *Spider-Man* that was used in *The Clock*, a Judy

---

**1.** DuPont's Tyvek is a very strong synthetic material made of polyethylene fibers.

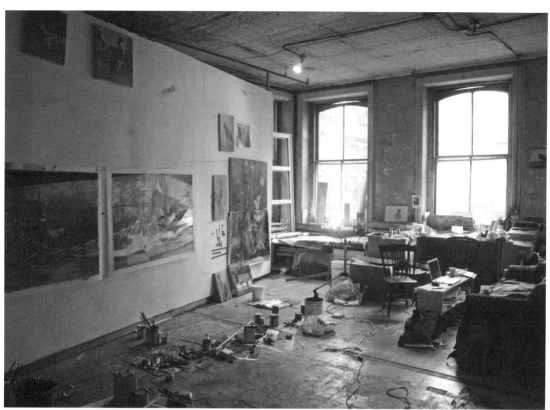

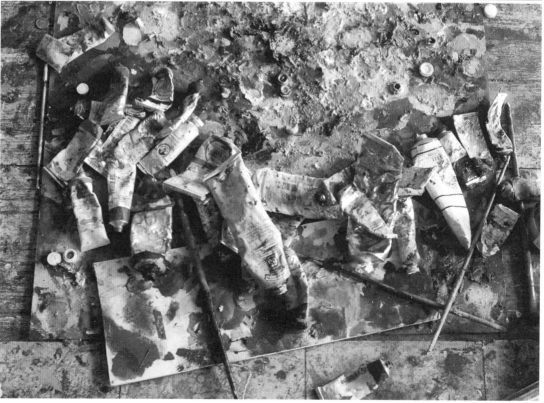

Garland film from the 1940s. It was the old Pennsylvania Station, and they were touching it up and contemporizing it.

**I remember hearing about this thing from the 1800s—a two-thousand-foot-long painting of the Mississippi River.[2] It was held on two rollers like a scroll and the audience would watch as it was unrolled while music played along. It had the effect as if you were on a riverboat ride.**

That was not a unique thing—it was a form of precinema entertainment. You had the stage with the painted scroll, and there was a narrator doing the voiceover as you'd watch the painting of the Mississippi River go by. The only one that I know that survives is in New Bedford, Massachusetts. It's thirteen hundred feet long, and it depicts a two-year whaling voyage.[3] It's truly incredible to see something that long expressed in time. So you have height, length, depth [expressed] in a two-dimensional field, and you also have length number two, which is time. The whaling voyage is interesting because it went from day to night to sunrise. In a given moment in the scroll, the sun would be going down, and all of a sudden it's dark. And then there would be some episode that would happen at night, and then dawn would come, and they would be somewhere else— some island would suddenly come into view. It's really interesting how they figured it out.

**Has location of the studio had any effect or influence on you?**

Not from being in SoHo, but the space itself has definitely had an influence. Part of it is this [angled] wall. It looks like a giant canvas, and I've had a tendency in this space to make Tyvek pieces that fit on this wall as if it were a giant canvas. That's not to say that I don't have schemes for doing things that will take over a whole room. For example, this painting that's on the wall right now is a study for something that will be truly enormous—about a hundred feet long.

**Would that end up being a painting or would it be a construction—paintings attached to freestanding sculptural components?**

It would be a painting mapped onto a construction, so it would be heavily involved with sculptural conceits. The last several shows I've had all involved constructions in one way or the other. They all become—not entirely sculptural, but I've begun to intervene in the space physically, other than just using the walls. [This painting] is sort of like a diptych, but in essence it would just be one giant Bierstadt-ish[4] landscape in collision with another [abstract] painting. It's a head-on collision. I think for that particular concept it really does need a truly epic scale to make it really fun.

**Can you describe a typical day, being as specific as possible?**

It depends where I am with projects. Right now I am working pretty hard on these paintings, so it's what I imagine a standard studio day would be. I get here around ten o'clock and leave around seven o'clock. I take lunch around one thirty. I check the state of the Arctic Ocean every day at lunch. Then I play a game of chess on my computer and then go back to work. Sometimes I'll take a nap after lunch.

If it's a moment when I'm trying to conceptualize things, sometimes I will sit here and play chess on my computer and do basically nothing in terms of the actual activity of painting. Or maybe I'll paint for half an hour and then think about it.

When I'm working on a big project with deadlines, I'll be working fourteen hours straight, and it's solid aerobic work. It really falls into those three categories, and the proportion of time depends on what's going on. The one where I'm just farting around on the computer, playing chess, and thinking about things tends to be the least. I won't do that for months and months, where the other two can go on for months at a stretch.

---

**2.** Beginning in 1840 painter John Banvard created a moving panorama of the Mississippi River Valley. It started at 12 feet high and 1,300 feet wide and eventually expanded to half a mile long.
**3.** *Grand Panorama of a Whaling Voyage 'Round the World* (1848), created by Benjamin Russell and Caleb Purrington.
**4.** Albert Bierstadt (1830–1902), German/American. Painter known for his dramatic, large-scale landscapes of the American West. He was a member of the Hudson River School of painters.

**Do you listen to music or the radio when you work?**

When I had my studio in Chinatown I used to listen to NPR and talk radio. The great thing about painting, as opposed to writing, is that you can listen to talk when you're working. But since I've been here, I haven't, curiously. I totally lost interest in it—maybe because of the blathering on about the state of the economy or whatever. I tend to listen to music at the end of the day. There is no set regimen, but, generally speaking, around three or four o'clock I'll start listening to music. In the morning it will be quiet. When it is totally quiet you really do lose yourself to a different quality of time in the studio. That sort of monastic silence is an unbelievable privilege in the culture we live in now. To be able to go into a room and just keep quiet with yourself is amazing! It is a quality of thought that is truly different.

**You don't get distracted by the computer or checking email?**

No—I'm notoriously bad with email. Anybody can tell you. The only time I'll get distracted by the computer is if I'm looking for images, and I can easily get lost and go off on tangents.

**What kinds of paints are you using?**

I use oil paint to make smaller paintings. On the Tyvek [mural-size] pieces I can't use oil paint. It's a mix of house paint and a kind of paint called Flashe, which is a dead matte, flat vinyl acrylic with a very high pigment concentration. It's an absolutely beautiful paint.

**Do you find it difficult working between the different mediums?**

There was a point where I didn't do any oil painting for about four years solid. I just couldn't make the jump back and forth. The hand has a fierce memory and my hands' memory was oil paints; it took a long time to understand what did and didn't translate in the different types of paint. Now it's easy—I can actually do it on the same day.

**You don't seem to have a painting table.**

No, I have a painting floor. This is the way I've painted for years. I crouch down on the floor, and I have this giant callus on my left hand from leaning on my hand while painting with my right hand.

I have had tables in the past, but they would just get full of crap and then cease to be functional.

**Do you have any tools or devices that are unique to your creative process?**

I don't know if they're unique, but I have tools and devices that pertain to the Tyvek [mural] work. A lot of the Tyvek pieces are collaged, so a sharp box-cutter knife is a very important tool. Things that pertain to wallpaper are all part of my process: rollers, glue, all kinds of weird stuff. House-painting rollers for making a blend [of colors]; for example, if I'm painting a sky, the paint dries so quickly that the only way I can do it is using two rollers at once, going back and forth really, really fast. Other than that, I'm not painting with any specific tool like a striation thing or a sponge or anything like that—unless you have some very specific things you're after, it tends to look a little spatial. It's like a cheat mark. I really like brushes; I can do what I want with brushes.

**Do you use that metal level for making straight lines?**

Yeah, I use that all the time, to level things and make straight lines. I have a couple of sticks as well that I use. It's a four-foot level, and this aluminum is not going to bend. The problem if you use a stick is that it bends over that length, and if it doesn't, then you have a piece of wood that's heavy. The aluminum is really light. For a really long line I have a piece of chalk line—or even better is a piece of monofilament with a pin stuck in the wall. If you pull the monofilament tight, you can actually trace a very straight line by running the brush along the top of it.

**Are there any items in your studio that you keep that have sentimental value?**

I used to have a fair number of items that were little household gods, but over time, changing studios and as a function of living in this stupid city…not so much. But I do have a couple things that I like to keep around. The thing I've had since I've been here is a painting I've done based on a photograph taken out of the periscope of a U-boat sinking a Liberty ship during World War II. A few summers ago I lost my previous studio and I also lost my gallery within two weeks of each other—it was

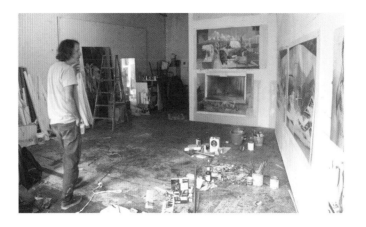

just a disastrous July, and I figured, OK, it's a good painting to document that particular moment in my life.

I try to do a self-portrait every year, just to see how I'm thinking about myself and to check in and see how things change. The one for this year is this bird. That's where I'm at right now—whatever that means.

**Do you work on one project at a time or several?**

Usually five or six things at a time. When I'm working on a big Tyvek piece, it's an all-consuming thing. Just physically, I can't work on anything else because of space constraints.

**When you're contemplating your work, where or how do you sit and stand?**

In this place I sit on the couch. It's actually a little too comfortable for me. For most of my adult life I've had a director's chair, but it's broken, and I have to fix it. That is a talismanic object that I carry around. It really is the perfect chair for me because of the height. You're almost at standing height when you're sitting in that chair. It's actually a really comfortable chair, and you can set coffee on the armrest. You can get paint all over it—it doesn't matter because you can replace the canvas covers. It's also the first thing I bought when I sold a painting in Boston when I was twenty-one. I was very proud of myself for having the money to actually buy an object.

**You have to fix that chair!**

It's true, but I'm a very good procrastinator. I'm very good at not doing things that I should do.

**How often do you clean your studio, and does that affect your work?**

It has a rhythm to it. My studio can tend to get Baconesque[5] in its level of disorder, but it does it like a heartbeat, like a pulse. It gets messier and messier as I'm working toward the end of some bigger project, and then I'll clean up at the end. There's a time when I appreciate working in a relatively uncluttered studio, and then, the more I'm in the thick of things, the more I really like it to be messy. If someone were to clean it, it would be totally distracting. You know, order out of chaos and all that.

**How do you come up with titles?**

I find titling very difficult, and if I think about it too much, they get way over the top and obscure. You would have to read some fucking sixteenth-century Latin text in order to understand what I was referring to. So I tend to be very pragmatic about my titles—you know, some object or some description of what it is. But where I will allow myself to have some poetic license is with the title for an entire show or a body of work.

**Did you ever work for another artist, and if so, did that have any effect on your work?**

I never did work for another artist, but I did spend years working in mural shops, and that did affect

---

**5.** Francis Bacon (1909–92), British. Artist known for paintings of abstracted figures, usually set in a geometric cage against a flat background. His studio was notorious for its piles of debris and detritus; it has been preserved and relocated to Dublin City Gallery The Hugh Lane.

my work intensely. A mural shop is an interesting place because, outside of someone like Jeff Koons,[6] who has a real factory, a mural shop is the closest thing to an old Renaissance studio in terms of the variety of different things and in the degree of specialization. I painted all kinds of shit. I worked on paintings for casinos, theaters, clothing shops. When I started out I mixed the paint. They were the absolute simplest base colors. It was totally humiliating because I was coming to that from having had a full career in the art world, but pretty quickly I got to the point where I could paint very, very fast. But the paint that they used the most when I was there was acrylic, which I absolutely loathe.

The house paint and the Flashe that I'm using now are both flat, and acrylic has that wretched sheen to it. You can pump it with all kinds of mediums, and it still is what it is. The way in which it mixes I find to be very problematic, and it's designed to make an ugly painting in a certain kind of way. The problem for me comes when people think of it as an oil paint substitute and use it as if they're using oil paint.

In mural studios they tend to use eggshell or semigloss paint to give it that kind of oil-painty sheen. When I'm using the Flashe flat paint on the large Tyvek pieces, it begins to mimic a fresco. It really is like fresco painting because it dries instantaneously. It literally dries in seconds. So there's no blending. Almost all the shading is hatchwork.

If the paint is flat, the painting will recede no matter what you do to it. No matter how black

your blacks are or how white your whites are, it is always going to look a little chalky. So it creates a sense of deeper space. It doesn't bear down on you like a ton of bricks, which a big painting would do if you don't do that. That's something about frescoes that was a great lesson to learn. If you want to make a painting that big [mural-size], you really need it to fall back into space from what's around it. At least, I do because the painting is always part of the environment that it ends up in—ultimately it is an architectural installation that has to live with whatever is in the room around it.

The other thing is it's easy to photograph. It is impossible to light a room-scale oil painting. You can't do it—or you can, but you will spend a shitload of money doing it. The works that I do can be photographed with your iPhone, and they'll look good.

**Do you have a motto or creed that as an artist you live by?**
The one thing that pops into my head is something I'll say to myself if I'm in a tight spot or if things are not going great. When I was a kid I was very much into different cultures, and growing up in Cambridge, Massachusetts, I was very lucky to go to the Harvard ethnology [Peabody] museum

---

6. Jeff Koons (b. 1955), American. Artist known for his paintings and sculptures of banal subjects. He employs numerous people to assist with the fabrication of his work.

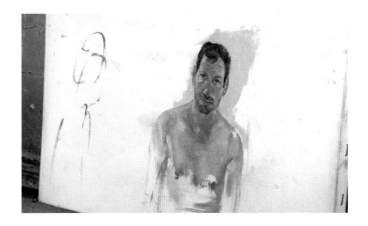

often. I became fascinated with Arab culture. I became most interested in Islamic Iran because of the art and architecture; it's really beautiful stuff. And the motto that I picked up from that is "Victory or paradise." So when I'm about to start something very ambitious, I'll say in my head, "Victory or paradise." The idea of jihad has gotten very muddled up in terms of what we understand of that word, but the original meaning of *jihad* is of a spiritual pilgrimage. By "Victory or paradise" I simply mean trying to pump myself up to feel righteous in what I am doing. I'm either going to win and accomplish something, or I fought a noble fight.

One thing I also think of when I am starting a fairly ambitious project is a scene from the movie *The Right Stuff*. Toward the end of the movie, everybody has been accepted into the space program except for Chuck Yeager. He doesn't fit the right psychological profile, even though he was the best test pilot of all time. So everybody else is off in Cape Kennedy getting huge press and becoming celebrities, and he's sitting in this bar in Nevada. Then he drives to the Air Force base, and there is a brand-new F-15. He gets in the fighter jet and takes off. And he's rolling around doing all these things, and then he throttles back and he aims the fighter straight up into the sky, and it's going up and up and up, and then all of a sudden the sky drops away, and he's in space. There are stars everywhere, and it's spectacular. But then, of course, the fighter needs oxygen for its fuel, and it conks out, and immediately he just falls backwards and goes into this vicious tailspin back towards earth.

To me, that was a metaphor for the fundamental position of being a human and trying to accomplish anything. You're never in the rocket—you're always in the fighter. You can see space, God, or something sublime—something beyond yourself—but your vehicle isn't designed to be there, so it will always fall away. It's always a glimpse, and it's always forcing that machine into something it's not meant to do. That, to me, is the essence of any kind of ambitious endeavor.

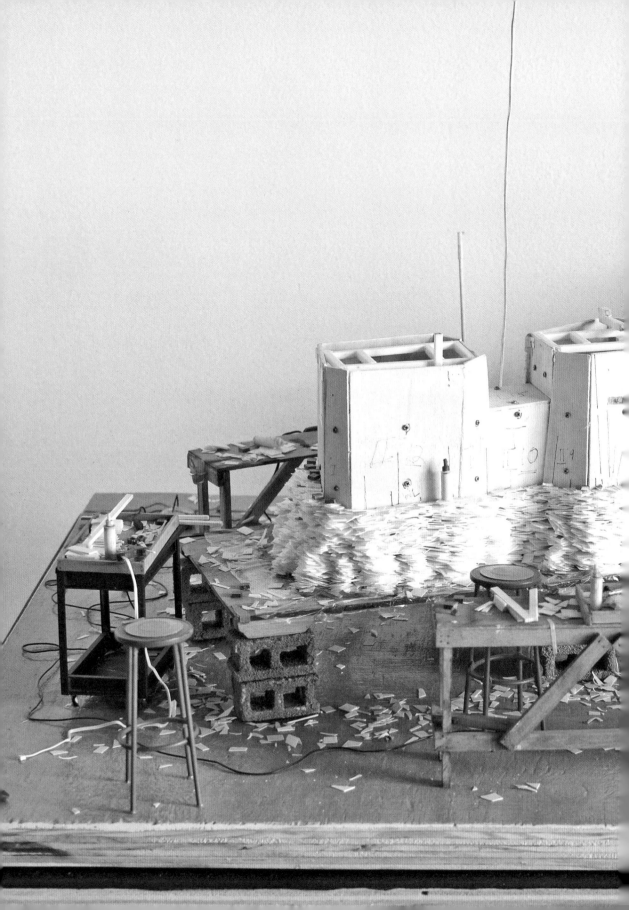

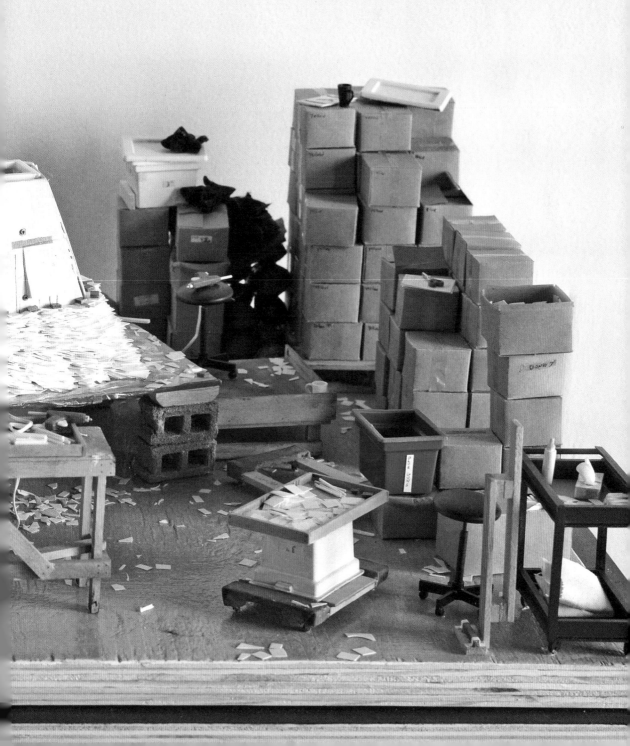

*Tara Donovan: November 21, 2013*
2014, Mixed media, 16 x 17¼ x 22¾ inches

# Tara Donovan

Long Island City, New York / November 21, 2013

**To start off, can you please tell me a bit about your background?**

I grew up in Rockland County, New York, and I went to an all-girl, Catholic, college-preparatory high school in Bergen County, New Jersey. It was a very academic school that wasn't focused on the arts.

**Do you remember an art piece from childhood that got recognition?**

Yes, it was some kind of book-cover design. I did a drawing of a slice of watermelon, but I have no recollection of the book it related to. However, it won the best in my age group. There was an exhibition at the mall. I was probably in second or third grade. I bet my mom still has it. [*laughs*]

**Where did you go to college?**

I went to undergraduate school starting at SVA in 1987, and then I transferred my sophomore year to the Corcoran [College of Art + Design] in Washington, DC.

There wasn't a great deal of encouragement from my family to attend art school. If I wanted to go to art school, I had to live at home, commute, and get good grades. But my mom didn't realize it's not very hard to get good grades in art school… so I excelled! [*laughs*] As soon as I got that first report card from SVA, I applied to other schools. I had visited the Corcoran in Washington, DC, and I fell in love with the city and the architecture. I graduated in '91 and then stayed in DC until I went to grad school in '97. I went to Virginia Commonwealth University [VCU] in Richmond for grad school.

**What did you do in those years between undergrad and grad school?**

Having a fine arts degree doesn't qualify you for much in the real world so I waited tables after I graduated. I had a great time, but I was also driven to get to work and focus on figuring out how to earn money and make my artwork. I worked at two different restaurants doing three double shifts a week. I made more than enough money to live on in DC, and I was able to get a cheap studio in Baltimore. So I would work three days at the restaurants, then drive up to Baltimore for four days in the studio. I did that for a couple of years.

I hadn't really considered graduate school during that time, though I did apply to Skowhegan. While waiting to hear from them—I didn't get in—I felt compelled to look at grad schools as a backup plan. A friend of mine who taught at VCU asked if I wanted to look at it. It was a different time—now, people apply to ten different graduate schools.

For me, graduate school provided this vacation. I had been working really hard. I think it's terrible to go to graduate school straight out of undergrad because it just becomes a continuation of the same thing. I strongly believe that you need those life lessons of having to figure out how to make a living. Stuff doesn't happen overnight. You have to work hard.

**When did you move to New York, and what brought that about?**

I finished graduate school in '99, and then I had a show planned at the Corcoran [Gallery of Art]. At the time they organized solo exhibitions by

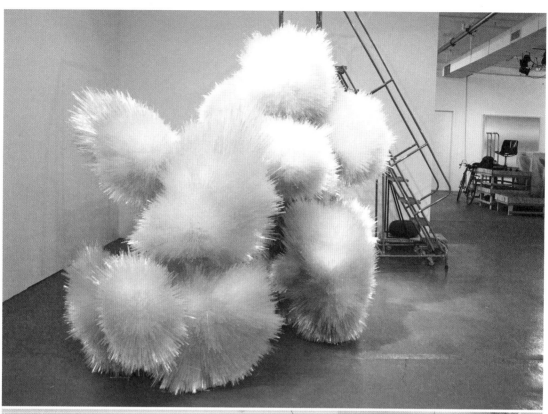

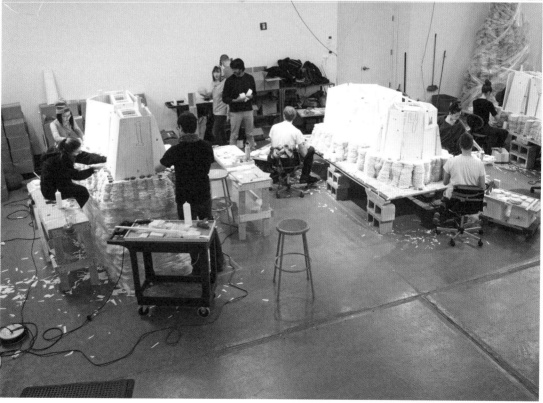

emerging artists. During the course of the show, the curatorial team for the 2000 Whitney Biennial was conducting research in DC and Richmond, which led to my being invited to participate, which just happened to coincide perfectly with my plans to move to New York. I moved here January 1, 2000. The year before I'd received a Sharpe studio,[1] but I had to defer it because of the show at the Corcoran. After the biennial opened in March, I was able to move into my Sharpe studio that June.

**When did you consider yourself a professional artist, and when were you able to dedicate yourself full time to that pursuit?**

I remember trying to get a gallery. I thought nobody was interested, and then Doug Chrismas came calling from Ace [Gallery] in New York. I finally quit waiting tables for good when I had my solo show at Ace in 2003. Doug called me and said, "How long would it take you to install a show in the New York gallery?" I said at least three weeks. He said, "OK, the show is in three weeks." It was crazy and intense, but that show was what really put me on the radar of the New York art world. For the first time, people were able to see the whole language of what I was trying to do.

Context is so important for everything. It is really important for each installation to have its own individual space. I remember once showing a single piece that was all made out of pencils, and somebody thought I just made work out of pencils. This is why I generally avoid group exhibitions. I won't even put two of my own pieces in the same room, for the most part. They really need to be

these sublime experiences. I remember getting in an argument with Doug because he wanted to hang my drawings in the hallway. I felt the hallway needed to just be empty. He said, "The show's going to look thin." I said, "No, the show's going to look sublime!" [*laughs*]

**Taking a step back, how did you get your first gallery show?**

My first real exposure came through an exhibition at the Washington Project for the Arts in DC. It got me some attention from dealers and curators. I ended up participating in a group exhibition at Baumgartner Gallery—then one of the best galleries in DC—where I showed the toothpick cube for the first time, in 1996. I then left for grad school but continued to show in DC, including a solo exhibition at Hemphill Fine Arts, where I showed the tar paper piece for the first time. The show received critical praise in the *Washington Post* and a few art journals and magazines. In Richmond I ended up showing at Reynolds Gallery, with whom I still enjoy a great relationship today.

**Currently you're represented by Pace. Can you talk about how that relationship came about?**

There are a lot of people who like to claim ownership of this. When I had the big show at Ace, Chuck Close[2] saw that show, and he claims

---

**1.** Established in 1984, the Marie Walsh Sharpe Art Foundation/The Space Program (now known as the Sharpe-Walentas Studio Program) provides free studios and career assistance to visual artists.

he brought every single person he knew [*laughs*], including Marc and Arne Glimcher. When I met Marc, they [Pace Gallery] were working with the IBM Building at 590 Madison Avenue, which has this atrium space that's all enclosed in glass with bamboo trees in it. Marc asked me if I would show the tar paper piece there. But I was still represented by Ace, and I was scheduled to do a show at Ace Gallery in LA. I really wanted to do that because that's another huge, amazing space. I guess I flirted with Pace for a year and a half before I joined.

**So you had the show at Ace in LA?**
I had the show in LA, and installing the show was frustrating because everything was so disorganized. It was just a mess. It became clear to me through that whole process that I needed to leave. I left the gallery two weeks after my show opened.

**How long have you been in this studio?**
Less than a year. Originally, I had two studios in Williamsburg: one in the ground floor of my house and one a few blocks away on South Second and Kent. The lease was up on the South Second and Kent studio, so we moved here.

**Do you prefer having the studio separate from your home?**
When I built my house I had a studio built on the ground floor, and I loved that. But then I outgrew that space, so I rented the second space. It was perfect because my kids were really young. It was close to home, and I was able to just walk back and forth. But the second space was not entirely ideal. It was very rough. It barely had heat, no air-conditioning.

I like working at home, but children just change everything. I used to live and work in my old loft, and I loved that. I still miss my old loft. The problem with kids is that nothing is ever done. There's always laundry to do; there's always dishes that need to be cleaned; there's always crumbs that need to be vacuumed up. It just doesn't end. I can only work if all the dishes are away and all the laundry is done. I think it's just part of being über-organized, and I feel like the minute you let that go, everything's going to fall apart.

**Can you describe a typical day?**
I get up at six o'clock and have coffee. I work out in the morning on Tuesdays and Thursdays with a trainer. I get my ass kicked for an hour. On the days that I do that, I don't get to the studio until about ten o'clock. Then Monday, Wednesday, and Friday, I get up, and I drive the kids to school at eight thirty, and then I'm here by nine o'clock.

A typical day here varies. Lately, I've been working on a new sculpture made with Slinkys. We're also on production with the index card piece. So, aside from being an extra set of hands for that project, which is a lot of time-consuming work, I've been focused on this Slinky piece.

So, I leave here at five o'clock and pick up the kids at five thirty. Then I get home and make dinner. We get the kids in the bath, eat dinner, and then

2. Chuck Close (b. 1940), American. Internationally renowned artist known for large paintings of heads, which are broken into an abstracted gridded structure.

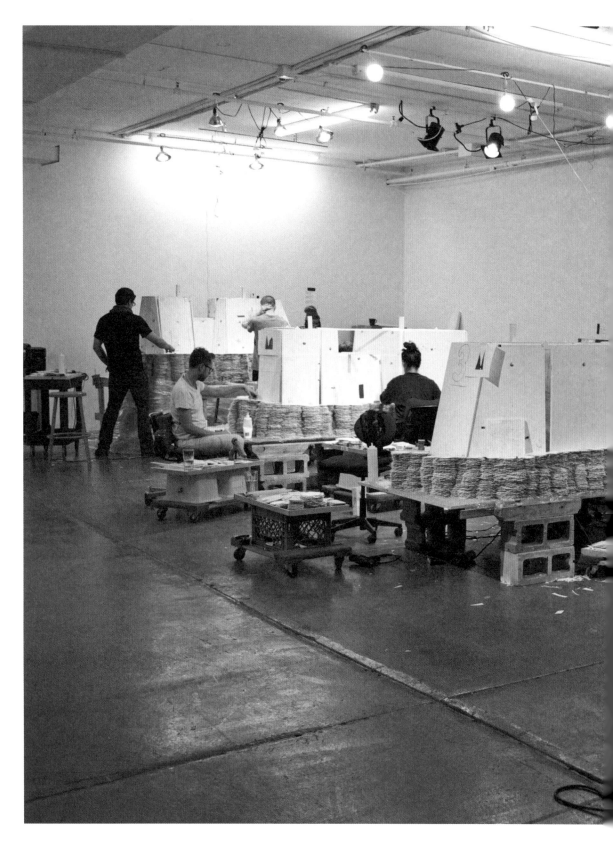

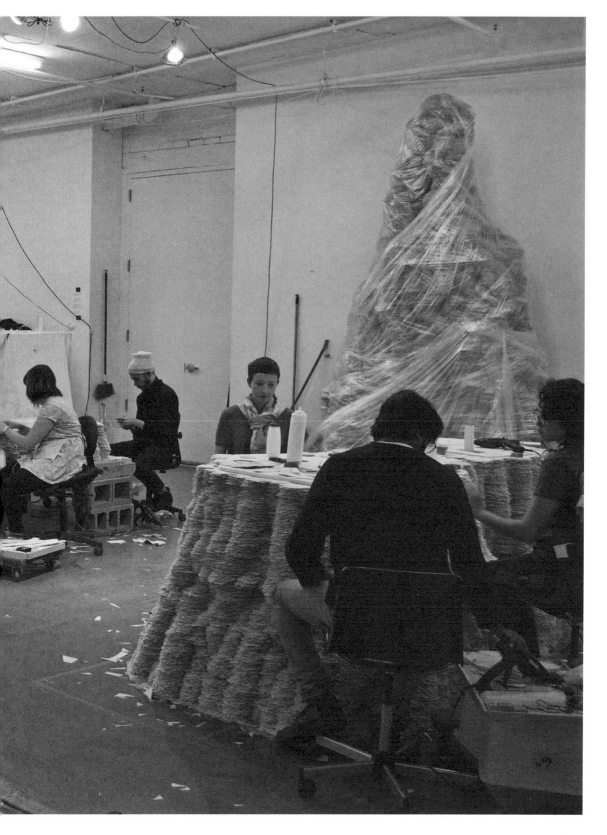

have story time. I'm usually asleep by ten or ten thirty.

**So did you have a plan for your studio's layout?**
I'm a planner. There is a plan. With this new warehouse space the ironic thing is, as big as this space seemed when I first took it over, it's actually quite full and has gotten a bit small. My vision was that the front area would be a clean space to work on the pin paintings. Then the middle room was clean like a gallery to set stuff up. It all depends on when you come to my studio. Sometimes you can come and there's nothing here, and then all of a sudden it's bursting. Right now, it's full. Once all this work ships, maybe we can create that more ideal situation.

**Can you tell me how some of the materials you use came into your practice? For example, the toothpick piece. I know it's an early piece, but can you talk about how that came about?**
At the time I was making porcupiny-looking sculptures out of toothpicks stuck in potatoes, and I got tired of opening all these boxes of toothpicks. So I opened a bunch of them and put them into a bigger box. I accidentally flipped the box over, and when I pulled the box off, it retained a corner. That was basically how I figured it out.

**What about the Slinkys?**
It is my first outdoor sculpture. The sculpture looks like a spiral drawing in space, though it reads as a cloud-like form from afar. It appears and disappears. The piece has constant visual shifts because of the changing reflections off of the flat steel edges. I'm really excited about this piece—I've been trying for years to figure out an outdoor piece.

**Are there items you keep around the studio that have significant meaning to you?**
No, I don't have a sentimental bone in my body. I throw everything away. [*laughs*]

**How often do you clean your studio, and does that affect your work?**
I'm lucky a lot of my assistants have been with me for a very long time—for so long that they can help manage things. This studio has to be clean and organized. There's a system for everything. Every bin, every box, is labeled. We have to know exactly how many man-hours and how many parts it takes to make each project so that we know how to order materials. We use so much volume that everything needs to be as efficient as possible.

**Did you ever work for another artist?**
I did. I worked for Kendall Buster,[3] who is still one of my close friends. I worked for her between undergrad and grad school. She was a huge influence on me. I think the most valuable thing I learned from her was what it takes to make something big—what actually goes into that. Working for her was a good introduction to scale.

**Do you have a motto or a creed that as an artist you live by?**
If it were easy, some other asshole would have done it by now. [*laughs*] That's my favorite line. I say it all the time.

---

**3.** Kendall Buster (b. 1954), American. Artist known for her massive-scale sculptures that reference biological and molecular structures.

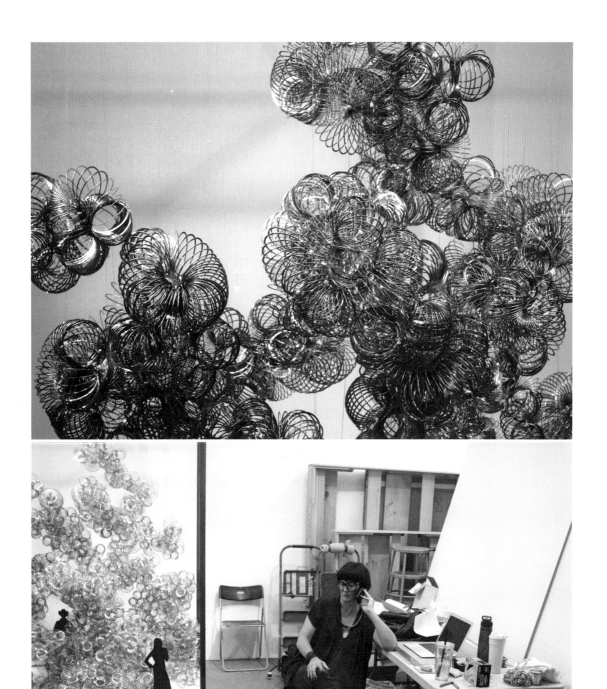

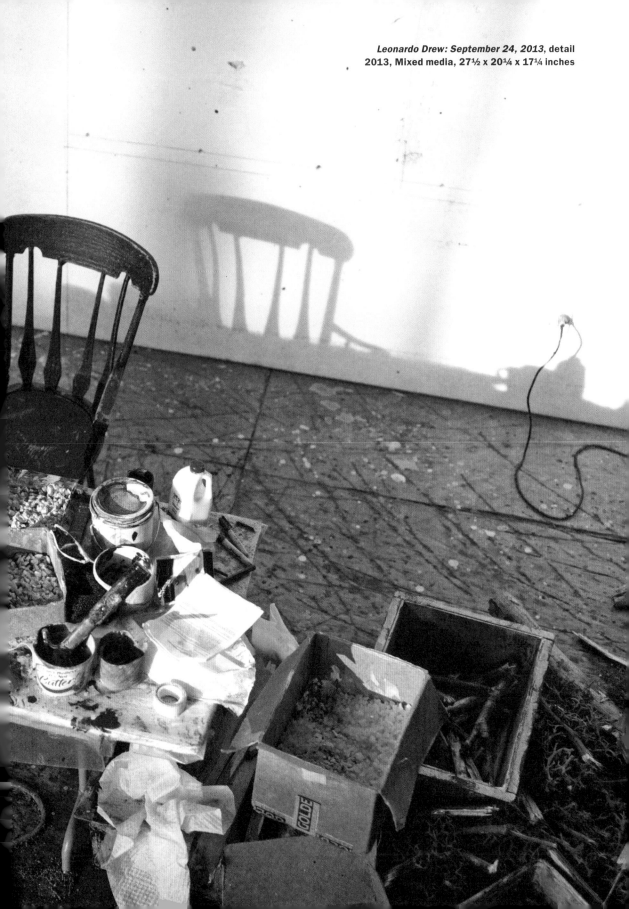

*Leonardo Drew: September 24, 2013*, detail
2013, Mixed media, 27½ x 20¼ x 17¼ inches

# Leonardo Drew

Cypress Hills, Brooklyn / September 24, 2013

**To start off, can you please tell me a bit about your background?**

I grew up in the P. T. Barnum apartments in Bridgeport, Connecticut; at that time it was a ferocious place for a young artist like myself. There was no art program at my school, but there was ABCD Cultural Arts Center.[1] When I first stepped into the cultural arts center, I was probably around eight. They were really crazy about the work I was doing, and it surprised me. They gave me canvas, paints, brushes—things like that. I started exhibiting when I was thirteen years old at the banks and libraries, and I was in the newspaper from 1974 up until my second year of college. I was this fixture making art in Connecticut, starting in Bridgeport, then in Westport. It gave me the opportunity to realize who I was as an artist at a young age. I realized that when people write about you, it's not necessarily a good thing, even if it's positive. You can get caught up in realizing someone else's take on you. I'm grateful I had the opportunity early on, so that's not something that necessarily affects me.

I went to Bassick High School in Bridgeport. There was no real art program there. I was an anomaly, meaning I was one of the only artists. Moving from there to get to today has been an interesting journey. I came to New York to go to college. I first went to Parsons School of Design and then transferred to Cooper Union.

I spent two years at Parsons, and I was at Cooper for three. When I decided I wanted an extra year from Cooper, I had to fight to get it. It was about making sure I took full advantage of the facilities

because I came in as a transfer student. I graduated Cooper in 1985.

**Do you remember an art piece from childhood that got recognition?**

It would have been this larger-than-life painting of Captain America. It was bigger than me. There's this photo of me posing in front of this Captain America, and I'm wearing these tattered clothes. It was an art piece in itself. [*laughs*] The photographer was laughing. He was one of these civil rights guys, this white guy that would work in the projects with little black kids, and he's taking a photo of me and my Captain America. He was laughing because he understood the significance on a political level. I was just a child, and I was like: Why is he laughing? [*laughs*] Of course, as I've gotten older I realized that that was a hot moment…but it was also my beginnings, you know? That was the photo they used in the newspaper for my first exhibition as a child.

**Did you go to graduate school?**

No. I'm not a fan of grad school. For me, it was get your ass out there and start making some work.

**When did you move to New York, and what brought that about?**

I moved to New York in 1980. It wasn't an easy decision. As a child my drawing facility was so good that DC Comics, *Heavy Metal* magazine, and Marvel

---

1. Action for Bridgeport Community Development, Inc., is a nonprofit antipoverty agency for the greater Bridgeport, Connecticut, area.

comics were trying to get me to work for them. It was a choice of either working with them or going to college. But once I had seen Jackson Pollock's work, that pretty much solidified my idea of what it meant to make art.

**Where did you see Pollock's work?**

In the library, in a black-and-white book [*laughs*], and it was still effective! At the same time, 1980 was when the Picasso exhibition came to MOMA, and it was pretty much gravy from there. I said, Forget this—I'm not gonna do this comic book stuff.

**When did you consider yourself a professional artist or able to dedicate yourself full time to that pursuit?**

Maybe a year and a half after finishing college. I worked at Christie's auction house with the idea that I was going to save enough money to take some time off to make serious art. I was working at Christie's but still making art. My time for sleep is usually only four hours a day, so there's always time for me to work [at a job] and make art, but I wanted to make art 24-7. So I saved enough money working at Christie's to take two years off, and things took off.

**How did you get your first real gallery show?**

That was at Kenkeleba House on Avenue B. A lot of artists had their beginnings there. I made art out of my place in Washington Heights. I slept in the bathtub and made art in all the rooms. In the 1980s Washington Heights was crack city, but you could get a real big apartment. Then people hear the story about this guy sleeping in his bathtub, making art [*laughs*]…that's a story. People came from the New Museum, curators, other artists—everybody's coming to see my work in Washington Heights.

**Currently you're represented by Sikkema Jenkins & Co. How did that relationship come about?**

Well, there was a long line of galleries before that. First it was Thread Waxing Space, and then it was Mary Boone [Gallery]. Then after Mary Boone it was Brent Sikkema.

I was with a friend, and I was telling him, "I'm getting the fuck out of Mary's." Eight years with [Mary Boone] was enough. He said, "OK, let's walk around Chelsea and feel out the galleries." We did that, just walking around with a report card, and we graded galleries. [*laughs*] We got to Sikkema Jenkins, and at the time it was small, but there was something about the feng shui of the space. I didn't know the people, but I liked the space. Then, doing my homework, I found out Kara Walker[2] shows there, and I know Kara. When Brent [Sikkema] and Michael [Jenkins] came out to the studio, they were fantastic. Brent is a special kind of man; I think most of the artists stay there because of him. He came up with the idea for my last exhibition at Sikkema Jenkins: living in the gallery space for a month and making work in the space. For a commercial gallery to make those kinds of concessions, that's unheard

---

**2.** Kara Walker (b. 1969), American. African American artist who explores race, gender, sexuality, violence, and identity in her work. She is known for room-size installations of black cut-paper silhouettes.

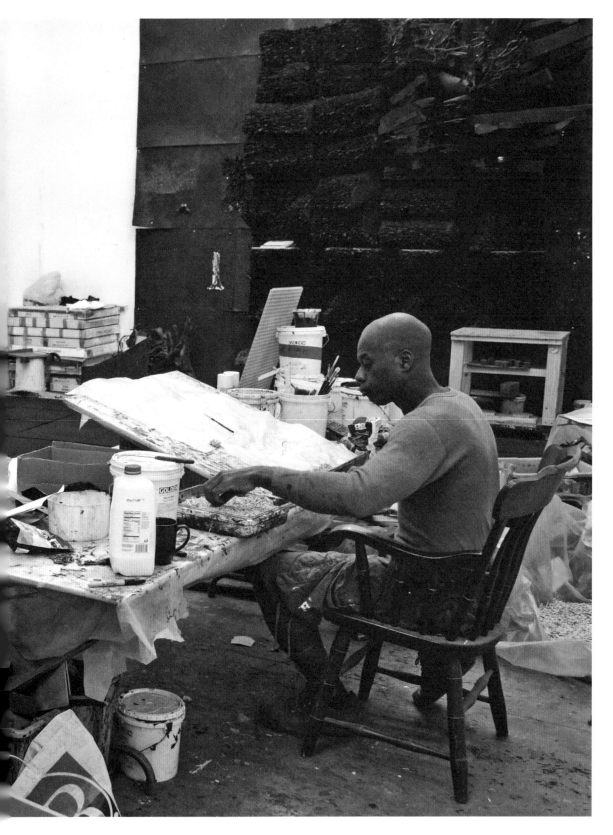

of. You got to love that kind of shit. It's been a lovely relationship.

**How long have you been in this studio?**
Since 2007, and before that fourteen years in Williamsburg on North Twelfth Street, and then, before that, twelve years in Washington Heights.

**Is this studio separate from your home?**
No, I live here, too. I have to live where I work because I don't do much of anything else—I just work. I love working. Now I've got three guys working here plus a secretary to handle office stuff.

**Did you have a plan for the layout of this studio, or did it develop organically?**
Yeah. I saw the space, and it was raw. The plan was pretty consistent in terms of the buildup of the space and the feng shui of it. Eventually, the idea is to buy the building next door, knock it down, and expand the space. I can actually do that, because this area is zoned for commercial, even though I'm the only commercial space on this block. I love it here. And the relationship that I have with the neighbors has been kind of hilarious. [*laughs*] I'm an anomaly here. There's nothing but ham and egg-ers out here, you know. There ain't no artists. The neighbors are like, what's up with him? What the hell is he, a homeless guy with a house? [*laughs*]

**What brought you out here?**
The cemeteries. We have eight different cemeteries. Mondrian[3] is buried out here in a pauper's grave. You would have thought the guy was loaded, but no, he was actually dirt poor and died poor. If you cross-reference my name with Mondrian, an article from [*The Villager*, June 3–9, 2009] will come up on how we found his grave site. Now there's a gold plaque that marks the site, but when we found him there was nothing there. We went to the office and asked, "Is Mondrian buried here?" They pulled out this huge, dust-covered book, went through it, and said, "Yes, he's buried here in the pauper sec-tion. Is he a friend of yours?" [*laughs*] The cemetery is gigantic. But we found him, and now people go to visit him. Houdini[4] is also buried out here. Each cemetery has a different personality. Some are quite beautiful, and I've had picnics at some. Others are so scary you don't want to be there for too long.

**Has the location influenced your work at all?**
Yeah, I think that the trees had an influence. You notice I'm working a lot with branches and things like that: tree parts, roots. I would love to get my tree parts from this area, except you can't go around digging up trees in New York. [*laughs*] My dealer in San Francisco, Anthony Meier, and his sister have land in Napa Valley, and they allow me to take in bulldozers to pull up trees and then ship them back here. A lot of the work comes from the influence of materials here in this neighborhood, but I had to get them from someplace else.

**I was recently in a group show at the Toledo Museum of Art, and another artist used tree branches from the museum grounds as part of his installation. But they wouldn't let him bring them into the museum, because they might have insects. He had to freeze-dry them. Is that something you have to deal with, too?**
Yes, but I microwave. With the materials that I've decided to use, there are always critters that I have to fight. At one point I was working with dead animal parts. Obviously, there were flies, maggots, and stuff like that. When I worked with other things like carpets, that brought carpet beetles in.

The way I came up with the microwaving idea was I saw that movie *Kick-Ass*, and they were microwaving gangsters. But there was no such thing as a giant industrial microwave, so I cut the branches into small enough parts to fit into the microwave and zap any insects inside them. You can pass that tip along to some other artist who might be dealing with the same issues. [*laughs*]

**When did you make the decision to go from working alone to having a number of people working for you?**
It was slow and sudden all at the same time. My first assistant had his beginning as a contractor hired to build out the studio in 2007 when I moved in,

---

**3.** Piet Mondrian (1872–1944), Dutch. Painter known for his nonrepresentational grids composed in black, white, and the three primary colors; member of the De Stijl art movement.
**4.** Harry Houdini (1874–1926), Hungarian/American. Performer and illusionist known for his escape acts.

and he gradually became a permanent fixture. He brought in others to help lift and haul, and then they became a part of the studio. I didn't know I needed help until it introduced itself. It's now symbiotic.

**Can you describe a typical day?**
Well, you have to ask what time I go to bed. That's usually around sixish, earliest 4:30 a.m. My guys come in at 7:30 a.m., so that would give you an idea of how much sleep I get. Today I got three hours. That's not good. They tell me I'm really grouchy if I don't get my full four. I'm usually moving around with them by 8:30.

Clement, the guy who runs the joint, is my confidant, good friend, and foreman of the space. I'll meet with him. He'll have a schedule, and we'll talk about what needs to be done. Usually, that's cutting material, gluing, and things like that. I don't do that kind of work anymore. I do the thinking stuff, trying to figure out where the work has to go. I attack the situation by applying myself to loftier ideas. They work on the things that are repetitive and uniform, and then I have to interject self into it at some point. They leave between 3:00 and 3:30.

**Do you listen to music or the radio or have TV on when you're working?**

The TV is on all the time. Always on the Turner Classic Movies channel. I'm a big fan of cinema. I could teach a class on cinema history. [*laughs*] My work is closely related to cinema in terms of theme and how you build a composition. I'll say, "OK, I love how John Ford[5] did this or Terrence Malick[6] did that. How do I address that in my work?"

A lot of Stanley Kubrick[7] is in my work in terms of my philosophy and how I build the compositions. His films are based on a triangular composition; he composes three strong segments and brings them together to create the overall film. I understand this way of making things. As a matter of fact, I was working on a piece with Merce Cunningham[8] back in 1997. He'll do his thing, which is the choreography and phrasing—the musician does his thing, and the artist does his thing. They're all separate from one another, and then all of those elements will come together to see if that shit can work. It's an interesting way of working. Risk taking, yes, but it's a real art that flies by the seat of its pants.

**Were you a painter at some point? How did you go from painting to sculpture?**
Yeah, I was, and my facility was something. It was a godsend and a blessing, but it was getting in the

---

5. John Ford (1894–1973), American. Multiple Academy Award–winning film director known for his westerns.
6. Terrence Malick (b. 1943), American. Acclaimed film director, screenwriter, and producer.
7. Stanley Kubrick (1928–99), American. Film director, screenwriter, cinematographer, and editor. His films are known for their unique cinematography and attention to detail.

8. Merce Cunningham (1919–2009), American. Dancer and choreographer at the forefront of avant-garde dance. He is known for his collaborations with artists of other disciplines.

way. If you were to look at my work as a child and up until 1982, when I decided to challenge it, it was like, Wow, this is fantastic, beautiful, skilled work. But I never thought it was anything beyond that surface, you know? So I decided that this facility was not allowing me to realize what was beyond. So I tied my hands. I stopped drawing and painting for twenty-something years. Only now, it's started to resurface in a way that's adding a new dimension to the work. What I ended up doing is figuring out how to make art without my facility, which meant getting rid of paints, getting rid of color and all things that were familiar. I started by doing these black-and-white silhouettes that were wall mounted, and from there it evolved into wall sculptures, *Number 8* being the breakthrough in 1988. That's the piece with the dead animal parts and organic materials. That's the mother piece to all the works that followed.

Then I ended up challenging my material because I realized that maybe the decayed parts and all this other stuff were part of some sensationalism that was getting in the way of another level of creativity. So I stripped that away. I started working on just white paper; that's where the cast white paper pieces came from. That was four years of just experimenting with that. Whatever survived from that body of work was what I ended up using as a template for the truth behind my creative self, what my voice was. I knew that it didn't matter what materials I was using—my voice had been realized. I can do whatever I want at this point because I cannot escape me. [*laughs*]

**The work is very labor-intensive.**
Absolutely.

**My own work is very labor-intensive as well, and once a teacher pointed out that that might stem from coming from a working-class background. As if subconsciously I felt I had to invest a certain number of hours into a piece to give it value. I think there might be some truth to it. My father didn't come from much and would get up at five in the morning to go to work, and he worked really hard trying to better himself. I might agree that I feel I have to put that same type of labor into my own work. Do you feel that?**

My mother was not a welfare person. We were living in the projects, but she was one of the only parents that actually got up in the morning and worked hard, worked her ass off to support five kids. She's a force of nature. It's the same with my own working habits. I never applied for any of the awards that are out there, the trinkets of celebrity and achievement. It seemed like welfare to me. I worked at Christie's and saved my money; I didn't apply for grants. Most artists were applying for grants, but I didn't do any of that shit. I've gotten awards, but I didn't apply for them. They had to find me to give me the awards. It's a different way of realizing things.

**Do you have a favorite color?**
I would say aquamarine—blue-green, like the Mediterranean. I spent a lot of time in the Mediterranean. Nine years in a row I went back and forth to Greece, to Crete, from 1990 to 1999. Then I started going to Brazil. There's always a place

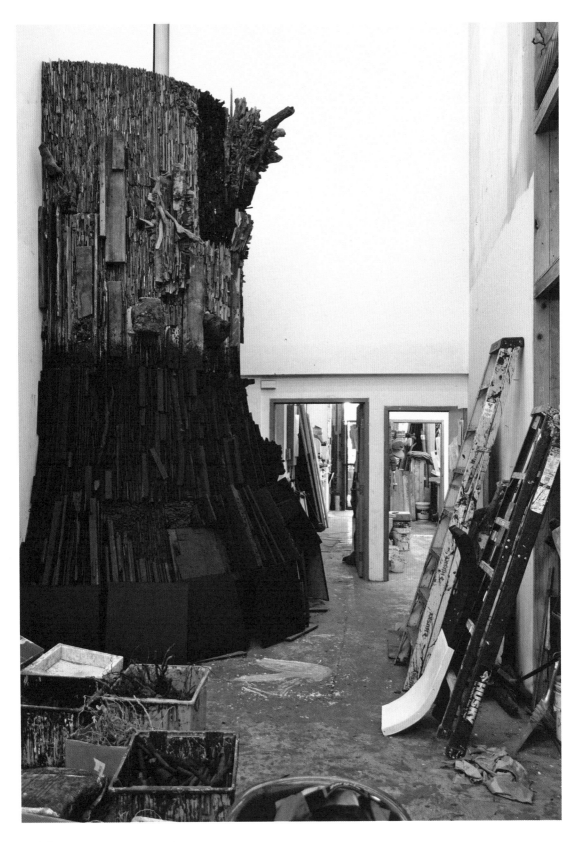

that I go to in order to resolidify myself, to find myself. For two years now, it's been Costa Rica. I go every month just for a few days.

**Are there items you keep in the studio that have significant meaning to you?**

Yes, in the storage area on the shelves you'll see my talismans. They are all Japanese anime things like Giant Robo, Gunbuster, Evangelion, Dragon Ball, Astro Boy, and Gigantor.

**Do you work on one project at a time or several?**

Several. I'm usually rotating seven different works at a time. I'm not going to get into the spiritual realization of why I choose seven, but it's what I can digest in terms of how one work relates to the other and how they feed off each the other. Seven crying babies—that's a lot of crying babies that you have to tend to. They assist each other in arriving.

**When you're contemplating your work, where or how do you sit or stand?**

Just the way I'm doing right now at this table. This is the command center, like on the Starship *Enterprise*. I can sit here and just meditate. Like right now—I'm talking to you and looking at that [work in progress], and I'm getting ideas. I'm always looking and thinking.

**How do you come up with titles?**

I don't do titles. It's always a number. [*laughs*] *Number 8* is the first one; *Number 8* comprises all the numbers that came before eight, one to seven. *Number 14* and *Number 8* are the ones that I own. But there are offshoot numbers too. Numbers like *110D* or *110T*, *105A*. [*laughs*] But the significant

or substantial pieces are all single numbers and no letters attached to them. *S* would be for San Francisco, *T* would be for Texas. Things done with Pace Prints, those are *P*s.

**Do you have a motto or creed that as an artist you live by?**

Yes: time. How to realize time, how to respect time. I tell my assistants, when I go to the theater I usually give the film twenty minutes to get going or I leave. If it's not happening, I get the fuck out. And they'll say, "Yeah but you paid money for the film." And I'll say, "Money we can get—time, we ain't getting that back. They can steal my money, but they can't steal my time!" That's one motto that's used here in the studio.

Death is a part of life. Let's not try to make too much of it. We're part of a constant stream; we're not separate from it. It's not something that we should be afraid of. I say that because my work has to do with birth, life, death, and regeneration.

In the arts, it's an interesting thing: we can actually see and realize the potential for something else, something other. That thing that you cannot describe. We never arrive at it, but that's actually the thrill. The unknown is a great position to be in for an artist, and that's the most significant thing that I can implant onto any young artist. What you don't know is actually the gift because it's that unknown that forces you to keep digging and striving to move forward.

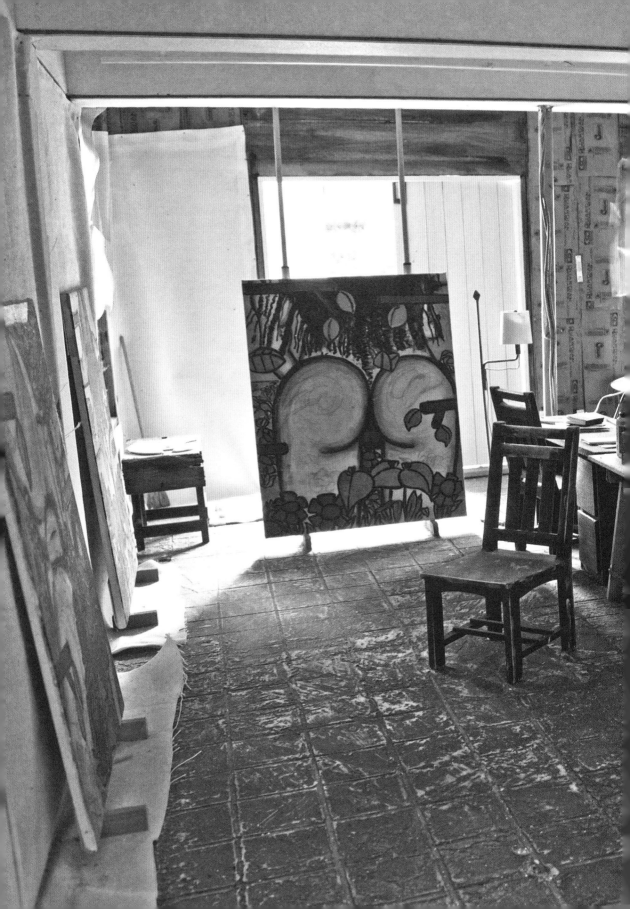

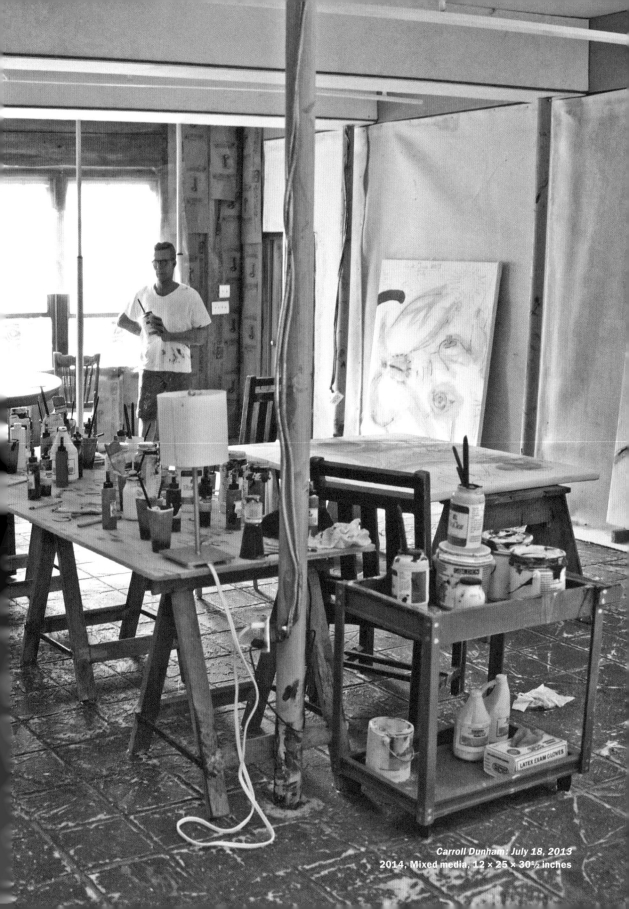

*Carroll Dunham: July 18, 2013*
2014, Mixed media, 12 × 25 × 30½ inches

# Carroll Dunham

Cornwall, Connecticut / July 18, 2013

**To start off, can you please tell me a bit about your background?**

I grew up in two different towns in Connecticut: Southbury and Old Lyme. For high school I went to a boarding school in Massachusetts called Andover, which had a remarkably interesting art program. It was a very positive thing in terms of my coming to art.

**Do you remember the earliest piece from childhood that got recognition?**

I always had a lot of reinforcement from my parents about my art activities, and I remember my Plasticine sculptures of dinosaurs being an enormous hit. I even have one. I found it in a box of things my mother had saved. I was probably five or six when I made it.

**Where did you go to college?**

I only went to undergraduate. I was a major in studio art at Trinity College in Hartford.

**When did you move to New York, and what brought that about?**

I moved to New York right after I finished college. The tiny art department at Trinity, surprisingly, had this program for the studio art majors to spend a semester in New York City—what we would now call internships with various artists and architecture firms. So, I was in New York for a semester when I was a junior in college. I got a glimpse into the downtown New York art scene. After I finished college I don't think I yet knew I would be an artist, but I needed to find out what it would be like to live there. I moved there right after school. That was in 1972.

**When did you consider yourself a professional artist, and when were you able to dedicate yourself full time to that pursuit?**

I considered myself an artist in the way I identified myself to myself by the time I was twenty-seven or twenty-eight. I had realized that I was really serious about it, but I had a straight job until I was about thirty-two.

**What came about to allow you to do that?**

Someone came to my studio and bought some paintings from me—which was shocking. It gave me enough of a nest egg. I knew I wasn't spending enough time on my paintings while having a full-time job, so I made the decision to quit my job, and fortunately, it worked out.

**How did you get your first real gallery show?**

The art world was much smaller then, but I assume it's pretty much always the same. I finally felt I had something I wanted people to see. I had made friends and acquaintances over the years and knew some older people who I respected. People came to my studio, and then they talked to other people about what they had seen, and eventually a few different things were offered to me. It was very organic.

**How long have you been in this studio?**

This room [part of a large, barnlike building] we're in, as it is presently configured—about two years. But I've been working here, or in the house across the lawn, for about five years. I gave up my last studio in New York in 2009.

**So, technically, your studio is separate from your home, even though that's across the**

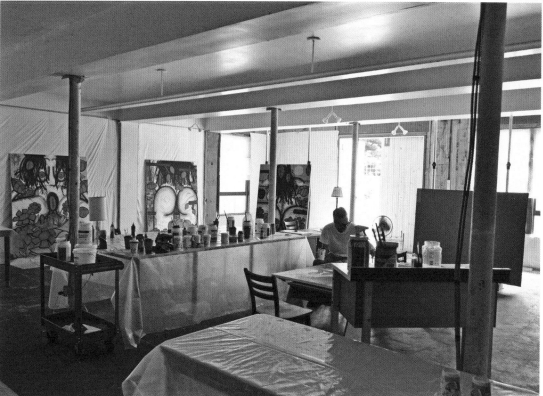

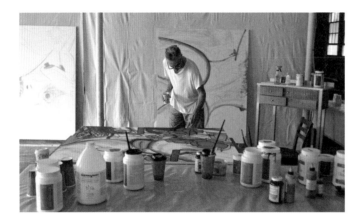

**lawn. Is that what you prefer, and does that affect the work?**

Yes and no. When my children were quite small, I moved my studio out of the place where we lived and have had a separate studio since. When I gave up the studio in New York and came up here, at first I was working on the third floor of my house, and then I started to colonize this building. My ideal relationship between home and work is to walk across the lawn to work. I like there being some kind of separation but not to have to make a big commute.

These are old buildings, probably one hundred years old. This place was originally built as an estate for a family that owned a lot of land in Cornwall. Then in the middle of the twentieth century, it was a boarding school campus. When we bought it, it had been empty for about fifteen years. Where we're sitting now used to be the cafeteria of a boarding school [*laughs*]…or at least part of it. We're lucky. Since this property had such a mixed use, our buildings actually have a unique zoning category within the village, so we would be able to put art studios here as well as have an apartment if needed.

**Has the location influenced your work in any way?**

Everyone seems to think so, but it's very hard for me to see. I've been coming to Connecticut for a long time—ever since our kids were small, over twenty years. I think the biggest effect for me has been the level of focus. It's much greater than in New York; I'm able to keep more things going at once. The usual observation is that my time in the country has turned my work sylvan. That may well be true, but it's probably more psychological than it is actually what I'm seeing.

**I noticed that around 2007 is when trees starting appearing in your paintings.**

That was before we bought this house. I'd had studios in the country for years. Trees either as material or as imagery have been weaving in and out of my work almost since the beginning. It really evolved unconsciously out of earlier things I was doing. I can imagine in ten or fifteen years I might look back and see that it's obvious that committing to life as an artist in the country would have wedded me to those subjects, but it still doesn't feel like the two things have that much to do with each other. Trees are such a generic subject that it's hard for me to see too much autobiography there.

**I know a few artists who started painting trees at certain points in their life. Jake Berthot[1] and April Gornik,[2] for example. April thinks it has something to do with a point in your life.**

I don't know. You're always in this kind of predatory hunt for things that'll allow you to continue to work. It just occurred to me that trees could become a more central subject to use as a structure in my paintings.

---

**1.** Jake Berthot (1939–2014), American. Distinguished painter whose later works are contemplative paintings of trees and mountains begun on a gridded plane.
**2.** April Gornik (b. 1953), American. Artist known for her paintings and drawings of landscapes.

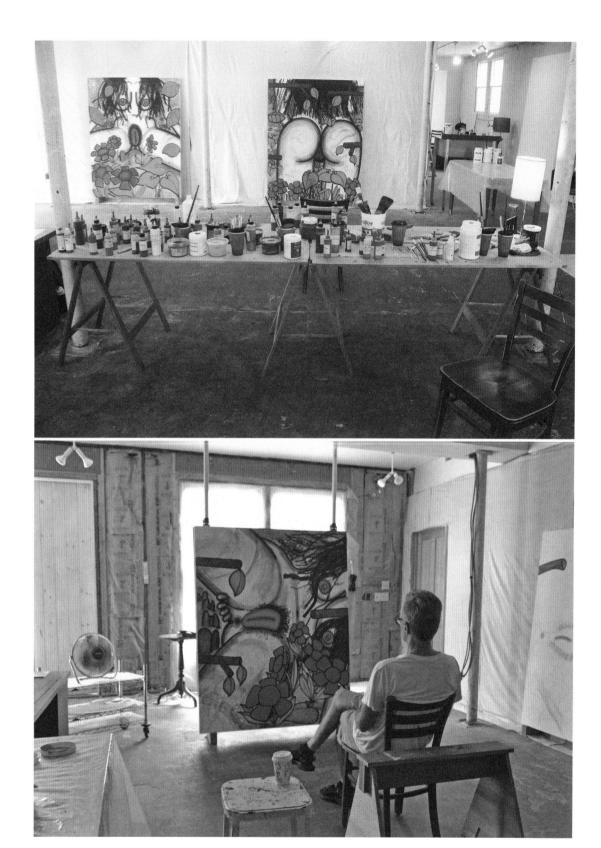

**April Gornik's tree epiphany came while in Rome. She was looking at the architecture and the trees, and that's when she found these umbrella pines very interesting. The way they were torqued and shaped— she got really interested in the way that they break up space.**

That's an odd coincidence, because the first drawings I made that were only of a tree in the middle of a sheet of paper were done when I was in Rome. I was staying at the American Academy,[3] and on the grounds of the academy there are these remarkable, very manicured trees. Those seemed to have something to do with my wanting to make those drawings when I was there, but I didn't think a lot about it afterwards. I hadn't thought about it in quite a while until you just mentioned that.

I think it's a trap to look at art through its subject matter. Subject matter is the easiest layer to talk about in a painting because language fits there the easiest. But I've been surprised at how rich these trees have been for me in terms of generating work. It has virtually nothing to do with observing the real world.

**Can you describe a typical day, being as specific as possible?**

Right now I don't think I have such a thing. Last year I was working a lot. I basically worked for the entire year, and when I'm in a mindset like that, I tend to get up quite early and come over here by seven thirty or eight o'clock in the morning and stay here until lunchtime. Then I usually go and do errands or divert myself in some way

in the afternoon. Then I come back later in the day to look at what I've done and think about it. I had many days like that in 2012.

**Would you consider this long table in the middle of the room your main working station?**

Yeah, but the paints migrate around. I move things around in here all the time. I have this group of seven canvases, which I'm working on now. My intention is to get them done as a series. These two paintings [along the far wall] are finished. I migrate around the room and then will focus my attention on one at a time until they're done. I like to have a lot of canvases around me.

**What kinds of paints are you using?**

Acrylic is the umbrella category, and then within that I use a couple of different kinds of binders and pigment dispersions.

**Do you have any special tools or devices that are unique to your process?**

Probably the most unique thing about my process is that I don't take very good care of my paintbrushes. I tend to develop attachments to these nasty-looking, ratty paintbrushes, and I find that certain kinds of marks lend themselves to a certain sort of ratty paintbrush. My whole approach to painting is pretty much self-invented because I've never liked oil paint. It gives me headaches,

**3.** The American Academy in Rome awards the Rome Prize to select artists and scholars to pursue their work in an atmosphere conducive to intellectual and artistic freedom, interdisciplinary exchange, and innovation.

and I just don't like being around it. So I gradually evolved this way of working with acrylic paint, which I'm sure is neither rocket science nor unique in history. I just figured it all out myself. I'm very focused on developing these paintings to feel like there's quite a bit of depth but to have very little physical thickness.

**Are there specific items that you keep around here that have significant meaning to you?**

I think all of the things in my studio have a certain talismanic quality. I've had a lot of studios—really quite a lot. Very different degrees of size, finish, accessibility, daylight—all the different things you could imagine. A certain amount of things have traveled with me, like that chair that's over there on wheels or my standing desk in the other room. Those things have a certain aura for me. They make it easier for me to work.

**How often do you clean your studio, and does that affect your work in any way?**

Well, I clean it regularly. My assistant vacuums it, and I would say every couple of months I edit what's built up on the tables and wipe them down and just reorganize the surface somewhat. My main thing is to keep order. I think order and cleanliness are two different issues, and with a building like this you can't think about cleanliness the way you think about it in a house. Squalor has a negative effect on my ability to concentrate on my work.

**How do you come up with titles?**

Mostly they tend to be fairly descriptive and generic titles, and then occasionally some burst of poetry will present itself. I do think titles matter, even if *Untitled* is the title. I think titles have some ability to either encourage or shut down certain readings of things, but I don't spend too much time dwelling on it.

**Did you ever work for another artist?**

I did. I think it was my real art school. I was Dorothea Rockburne's[4] studio assistant when I was first living in New York. The work with Dorothea was extremely consequential, and through her I met Mel Bochner,[5] who was an enormous influence on my thinking about art. We've stayed close friends. I was around a lot of older artists when I was young. It was by far the most important aspect

of my growth when I was a younger artist. That generation of artists was a big influence on me.

**Do you have a motto or creed that as an artist you live by?**

The thing I hear myself saying a lot—both to students and if I am in a situation where I'm speaking about my work—is the idea that one should not turn away from things that pop into one's head that one might think are stupid or not worth pursuing. One should really let your imagination point the way. But I wouldn't call that a motto. [*laughs*] Making art is too weird to have a motto. It's solving problems where you don't even know what the problems are.

**What advice would you give to young artists that are just starting out?**

To learn as much about art history as you can and to look at as much contemporary art as you can and to try to meet other artists. To understand that there's a history and a community that revolves around art. Those are the main things that can allow you to find a place for yourself, to work and to grow. I stress this idea of community because everything good in art seems to happen through referral.

---

4. Dorothea Rockburne (b. 1932), American. Abstract painter known for works that draw inspiration from mathematics and astronomy.
5. Mel Bochner (b. 1940), American. A founding figure in conceptual art. His more recent paintings explore language as image, medium, and content.

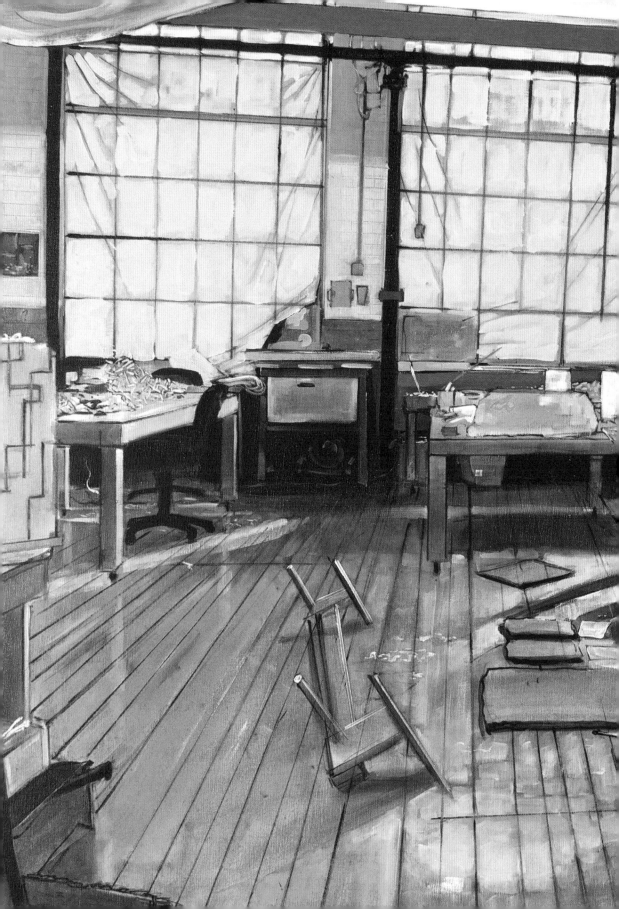

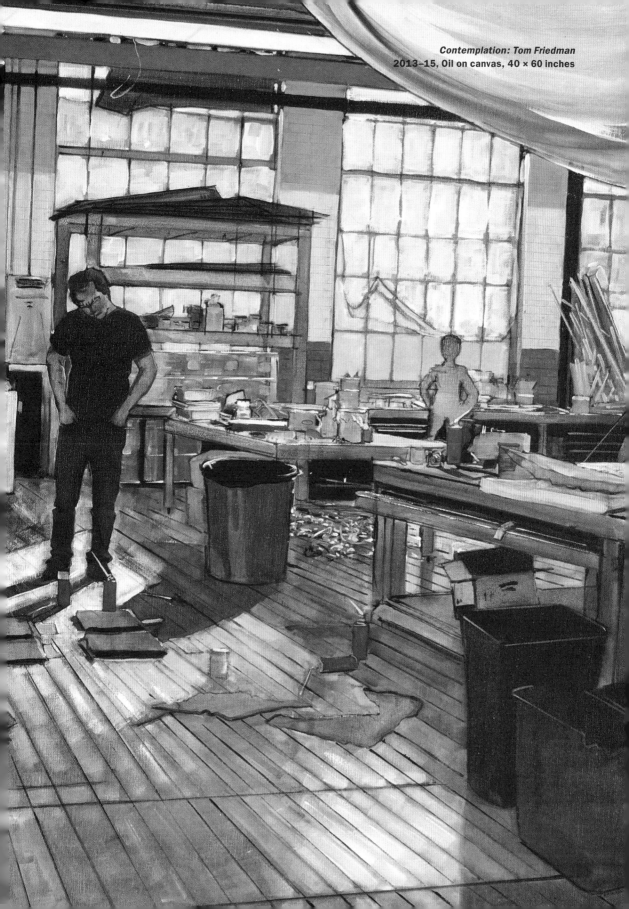

*Contemplation: Tom Friedman*
2013–15, Oil on canvas, 40 × 60 inches

# Tom Friedman

East Hampton, Massachusetts / January 10, 2013

**Can you please tell me a little bit about your background?**

I grew up in St. Louis, Missouri. I went to John Burroughs high school, and they had a really good art program and good facilities, and I spent most of my free time there.

For undergraduate school I went to Washington University, where I studied graphic illustration, and as I was going through that program I started focusing on my own art ideas. I grew up in a culture where there weren't a lot of artists. I've always done art. I probably made or drew something every day of my life.

**Do you remember the earliest art piece you made that got any recognition?**

Yes, I was interested in Robert Arneson,[1] and I was doing a lot of ceramics work at Burroughs. I did a bunch of pieces that were in that vein, that had a certain comical aspect. Faces that were distorted, like a head showing a headache. I would make the bust and then take my hands and just squeeze the clay as much as I could, and then duplicate those hands and have them coming out of the sculpture. I think people liked that. [*laughs*]

**Was there time between undergraduate and graduate school?**

No, I went right from undergrad to graduate school. I went to the University of Illinois at Chicago, Circle Campus, where I studied for two years. For teachers I had Julia Fish,[2] who's a painter, and Tony Tasset,[3] who's a conceptual sculptor. I liked it, but it was difficult for me. That's where I became familiar with contemporary art.

**When did you consider yourself a professional artist, and when were you able to dedicate yourself full time to that pursuit?**

Out of graduate school I got a job at the Field Museum of Natural History in Chicago as an exhibit preparator. I would work there nine to five, and then when I got home I worked on my art. I was offered to do a show in Chicago at Rezac Gallery, which got a lot of press. I was doing work that had a kind of circular logic with a singular material: for example, two pieces of wrinkled paper that were identical, a pencil shaving, a straightened hanger that hangs in the corner.

But then that gallery closed, and Hudson,[4] who was from Chicago, had moved to New York to open up Feature gallery. At the time he was showing a lot of Chicago conceptual artists. He put me in some group shows and then eventually a one-person show in New York.

That was in 1990. He started to sell my work—slowly—and I guess once you start selling your work you become a professional. So after a year

---

**1.** Robert Arneson (1930–92), American. Sculptor who worked primarily in ceramics and was known for his unconventional, ironic, and humorous self-portraits.
**2.** Julia Fish (b. 1950), American. Painter who creates works that record her experience of living and working within the space of her brick storefront in Chicago.
**3.** Tony Tasset (b. 1960), American. Multimedia artist known for playful, often large-scale sculptures.
**4.** Hudson (1950–2014), American. Art dealer and the founder of Feature Inc., an art gallery in New York City known for innovation and experimentation.

of working at the Field Museum, I got so engrossed in my own work that I was shirking my responsibilities. They kept demoting me, and all I did was drive around the museum on a cherry picker changing lightbulbs. It got to a point where I was selling enough of my work so I could quit that job.

**How did you end up moving from Chicago to Massachusetts?**

I met my ex-wife at college. She grew up in New York and really wanted to move back to the East Coast. I got a two-year visiting artist position at Wesleyan University in Middletown, Connecticut. So we moved there, and we liked the area. We used to drive through the Pioneer Valley on our way to Vermont and just fell in love with it. So we moved here from Middletown.

**You never lived in New York City?**

No, I'm not a city person. If I go to New York for a couple of days, I'm fried. When you live out here, it's so quiet that the ability to block out all the sensory input lessens.

**How long have you been in this studio?**

Six years, but I had another studio in this building for four years, so I've been in this building for about ten years.

**Did you have a plan for the layout or did it develop organically?**

This was pretty much one big open space so there were just a couple of decisions in terms of the walls to build. In all the studios that I'd had, even the very small ones, I'd have a work space and a viewing space. This building was an old tool factory for Stanley Works, and the grease had saturated the floors, so I had a new floor put down. Since I put a lot of my work on the floor, I need it to be clean. I needed storage space and a woodshop.

**Has the location of the studio had any influence on your work?**

Yes, it has. I'm not in the middle of an art scene here. I don't talk to a lot of artists, other than my studio assistants. There aren't a lot of artists that show in New York or internationally here, except at the universities, but I'm not really in that scene. I like the quiet, but I do struggle with it. When you're in an art scene and people are talking about ideas and all of that, at least for me, it defines a kind of justification for doing things. You're right there. There's a more immediate response to thinking about something, executing it, ideas, talking about it with people, all of that. Out here, I really don't get much of that. It does make things a bit more existential because I'll work for a year on a show, go and install the work, leave, maybe have some conversations, but it goes into a void. I don't really hear anything about it, other than things that were written about it or things that I hear from the gallery.

Rachel Maddow[5] lives around here. Her partner is an artist. I just had dinner with her, and all I wanted to do is talk about politics, and all she wanted to do is talk about art. She sees art as so important, and I'm like: what you do is so important! [*laughs*]

---

5. Rachel Maddow (b. 1973), American. Political commentator, author, and the host of *The Rachel Maddow Show* on MSNBC.

**Right. You're trying to figure out how to make a giant slice of Wonder Bread. [*laughs*]**

Exactly…and hope that people get something out of it. There's always been this sense of absurdity that I love. It shows both the significance and the insignificance of what one does.

**Currently, your gallery is Luhring Augustine. How did you go from Feature to them?**

Well, I went from Feature, believe it or not, to Gagosian [Gallery]. I'm kind of an extreme person and I just wanted to experience that world.

**It seems like something you can't pass up if that call comes in.**

Yeah, and the way Larry [Gagosian] functions is if he wants something, he makes it happen. So he really wooed me. It lasted for maybe five years, and I realized it was too big. Working with Hudson [at Feature] was just amazing because he really helped to hone you in. It was a place where subtlety lived. When I went to Gagosian I thought that I could have subtlety exist in that realm, and it's just not possible—at least the type of subtlety that I'm interested in. I left Gagosian and have been working with Stephen Friedman from London and then went with Luhring Augustine for my New York gallery. It was finding the right fit.

**Please describe a typical day, being as specific as possible.**

I usually wake up at six thirty, and my wife and I have coffee in bed. We have a golden retriever named Jemmy, and when we're having coffee Jemmy will grab a piece of clothing and come to the foot of the bed and wait for Mary and me to say, "Come

on up!" Then she jumps up. She comes to me and I have to rub her belly for about five minutes. Mary and I will continue to talk about whatever. Then we get up and help the kids get off to school. I shower and come to the studio and Matt Lenke and Justin Kemp [my assistants] are here. I will go online and check out my stocks. I trade. I enjoy it; it's a fun thing to do.

I'll choose a project to focus on; I need to get mentally prepared for it. Then I'll spend most of the day trying to get that to a certain point. Today I've set up some situations with expanding spray foam because we're experimenting with cutting thin layers so that we can make a giant slice of Wonder Bread. I'm focusing on that, trying to figure out how to quantify it and get that to work.

My time here varies. It can be from nine to three. A lot of times I'll go home; it's hard for me to do the thinking here. I have to be away from my work, away from this activity. I live about thirty minutes from here.

**You live and work in separate places. Is that what you prefer?**

When I lived in Chicago it was together. At first I would have a viewing room, and I'd work at the kitchen table. Then I was able to have one room to work, a viewing room, and an extra room as an office. When I moved to Middletown they gave me a studio space at Wesleyan. I did a lot of work at home and used the studio as my viewing room. Then, when I moved here to Conway, I built a studio. It had no windows at all. It was just a big shed, and I arranged it so most of it was clean viewing

space. Then there was a cubbyhole where I would do my work. There were shelves everywhere, and they were built for specific materials. It was very efficient. That was one of my favorite studios.

**Do you listen to music or have the radio or the TV on when you're at work?**

I can't listen to music when I work, but I do listen to talk radio. Usually Stephanie Miller, and then Ed Schultz and then Thom Hartmann. We call it shit radio. I'm a news junkie.

**Can you tell me a little bit about your materials and how they came into use?**

When I went to graduate school I was confronted with a language that I had never experienced before; the way people talked about art was very different from how I had ever thought about it. I was inundated with a lot of contemporary artists through seminar classes and doing my own research. I went through a period of really trying to figure out: Where is my point of departure? Where do I begin this new way of thinking about art?

I came to removing everything from my studio and making this white studio space—just this void—then doing experiments that had to do with one's own empirical experience and trying to dissect the basic object: looking at a cup and then dissecting all the questions you can ask about a cup. It started with a cup—the name of it—then it moved to the space that the cup was in and then to the person experiencing the cup.

I poured honey on the floor one day. Someone thought that I urinated on the floor, and that led me to think about my activity in that space. People would walk through my studio space, so they would always comment on my work. It was perfect. I bought a jigsaw puzzle and threw the pieces on the floor. Just making the puzzle was an interesting activity. It was a metaphor. Then, as I was getting close to being done with it, I thought what I'd do is separate the pieces about an inch apart from each other, so it became a different kind of puzzle. You couldn't initially see the image. You had to look at each individual piece, and then once you figured out what it was, the image would appear.

I started thinking more about metaphors for what I was doing. There were elements of

meditation; I was interested in Eastern philosophy and Buddhism at the time. The next piece was pouring eraser shavings on the floor in the center of this white void. I remember having an end-of-semester critique, and there was just this circular pile of eraser shavings on the floor. There was silence for five minutes, and then all of a sudden everyone started talking. Something seemed to happen at that moment. The material made sense with the space. It couldn't be any other material; it had to be eraser shavings. It was an interesting experience. Then I started doing pieces in that vein with materials that had to do with personal hygiene. That's when I did the soap with the pubic hair, and then it evolved to other materials. The materials that I used evolved from trying to dissect the mundane experience.

**Do you find it hard going from one material to the other?**

There's a lot of problem solving, and since everything is so different, there's an invention that needs to be made, and that's the funnest part. There's a lot of play and experimentation.

It used to be easier for me to go from one thing to the next, but, for example, working on this [tinfoil figure] is so different from working on the giant Twinkie that it takes me a while to make that transition. The way I'm working with this [tinfoil man] is more like traditional sculpture in terms of how I want the form to be, getting the gesture. It's figurative sculpture. Trying to problem solve on how to make a giant Twinkie [*laughs*]—it's very different.

**Do you have any special devices or tools that you use that are unique to your creative process?**

It varies all the time. I have a laser cutter. That's for making these squares of paint and also for some collage work that I've done in the past. The X-ACTO knife and hot glue guns are key. We have a table saw, a hacksaw, and a handsaw—and a wood lathe that I usually use for Styrofoam. I have a big light table over there.

**What would you use that for?**

I have an old typewriter, and recently I did a piece where I typed out the word *verisimilitude*. I spelled

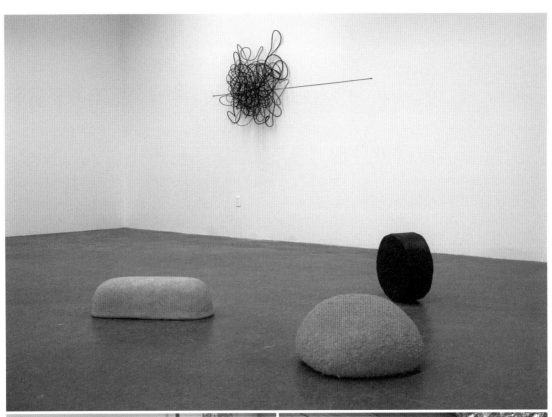

it a bunch of times, and then I used the light table so that I could duplicate it tracing the letters. So it's a drawing that simulates typing. [*laughs*] It was the next layer of the verisimilitude.

**How do you come up with titles?**
Initially, everything was untitled, but then I would get requests like: Could you send me *Untitled 1997*? And I'd have to ask them be more specific. Then I started using subtitles.

Sometimes titles do become important, like *A Thousand Hours of Staring*. I did another piece called *Hot Balls*, which was a collection of stolen balls. But otherwise it's usually *Untitled* and then a subtitle.

**Do you have a favorite title?**
My favorite title was for a piece where I cut cardboard into a burst shape. The title of that piece is *Cardboard!* [*screams the word*] You have to say it really loud. [*laughs*] If you say the title is *Cardboard* [*spoken softly*], that's not the title.

**Do you have a motto or creed that as an artist you live by?**
Authenticity. It's also a life thing: being honest with myself and honest in what I do. Everything flows from that. It's very hard for me to go back and make the same thing over and over again just because people like it and want another one of those. I'll be asked to make another "something," and I'll start it, and it'll become different because I just have to follow where it goes.

**What advice would you give to a young artist that is just starting out?**
It takes a lot of work. It just doesn't happen overnight. You're going to make a lot of people hate you because you're going to be proselytizing to them or talking to them about your ideas. You really have to go through that living and breathing of it for a while. I think that's really important— it's not easy.

The other thing is that you never reach a state of privilege. It's easy to make one good piece. It's a little harder to make two good pieces. It's a little harder to make a really good body of work. It's harder to follow up on that body of work, and it gets harder and harder, and you never reach a state of privilege. Once you think you're privileged and you can just poop and people are going to praise that, then it's all over.

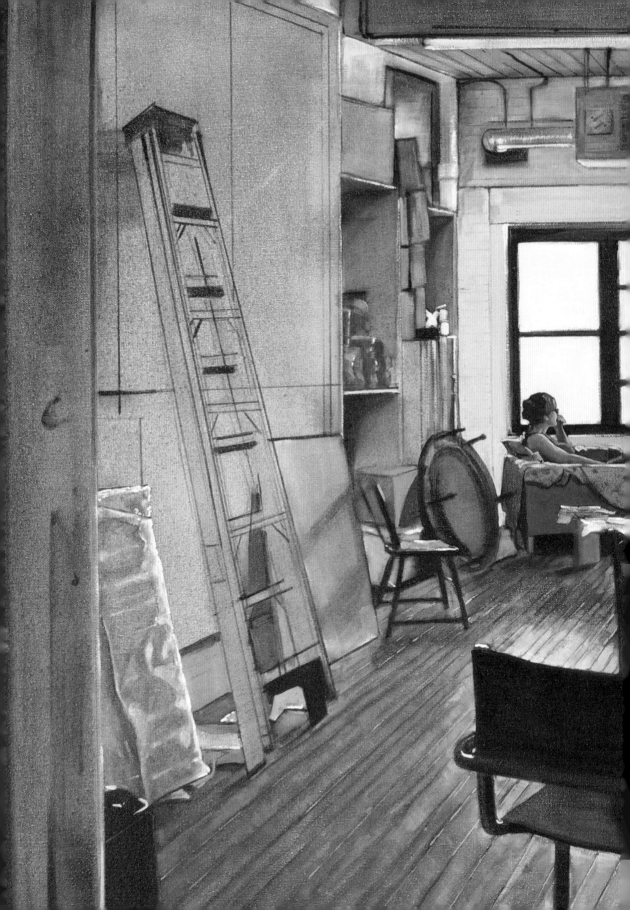

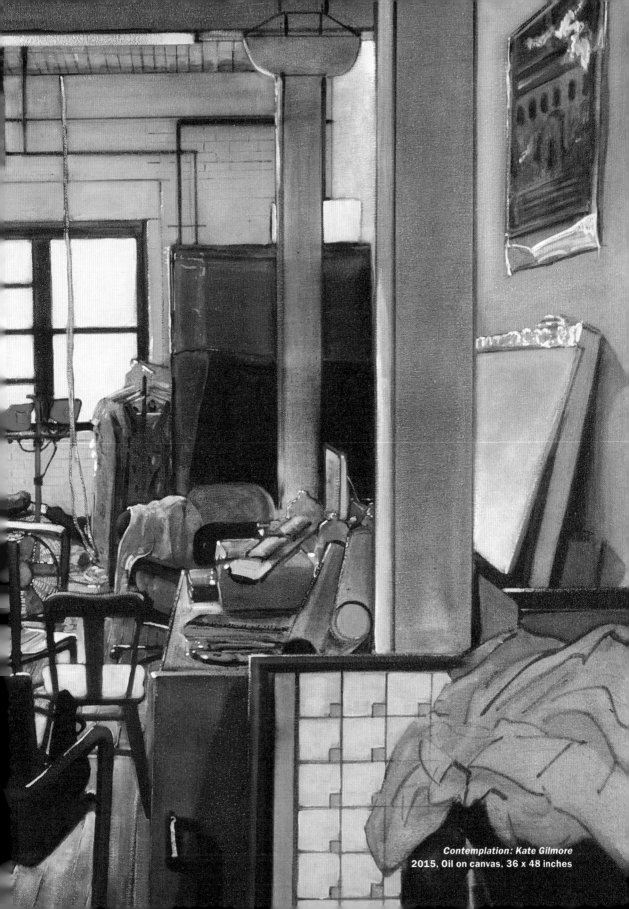

*Contemplation: Kate Gilmore*
2015, Oil on canvas, 36 x 48 inches

# Kate Gilmore

East Williamsburg, Brooklyn / June 25, 2013

**To start off, can you please tell me a bit about your background?**

I grew up in Chevy Chase, Maryland, and I went to a public high school. They had a standard arts program, but I wasn't actively involved in it. It wasn't until college that I really started to make art.

**Do you remember an early artwork from childhood that got recognition?**

I won a short-story contest. It was a story about a rainbow that lost its color. It was a sad story. I would love to find it again, but it was precomputer, and I believe it only existed on real paper! I was probably in second or third grade. I won a lot of awards for this story—lots of ribbons and trophies.

**Where did you go to undergraduate and graduate school?**

I went to undergraduate at Bates College. I was a double major with European history and art, and then I realized I was most interested in art. I went to graduate school at NYU [New York University] for a semester and then transferred to SVA [School of Visual Arts]. I'd thought that I still wanted an academic institution like Bates, but I really needed a heavy studio program, which SVA was. I took two years off between Bates and graduate school.

**When did you consider yourself a professional artist, and when were you able to dedicate yourself full time to that pursuit?**

Well, I've never been a full-time artist. I've been a full-time artist in my head, but I've always had jobs. When I was first starting out I taught kids with disabilities, then I taught continuing ed, then I worked in arts administration, and then in the past seven years I've been a professor [at SUNY Purchase]. I've always had some other income. But in terms of being totally devoted and knowing that I was an artist, that was after graduate school, in 2002.

**How did you get your first gallery show?**

I would say that was at Exit Art, which was a nonprofit space that's now closed. In 2003 they had a show called the Reconstruction Biennial, and they commissioned artists to do really massive projects. I didn't have anything on my résumé, and I applied with the videos that I'd been making. Jeanette Ingberman, who was a founder of Exit Art and a curator, just fell in love with my work and really invested in the project. That got things going for me.

**How did you get that show?**

Open call: you submit your work. That's how I got lots of my shows at the beginning. I've shown at most every nonprofit out there—then museums and contemporary art spaces and lastly commercial galleries. With my kind of work, at least historically, that's how it has worked.

**Are you showing with a commercial gallery now?**

I work with David Castillo Gallery in Miami. I also work with a gallery in Spain called Maisterravalbuena Galería.

**How did the relationship with David Castillo come about?**

I was in a group show there. He showed my videos and was able to sell a lot of my work, which is amazing for a video artist. I just fell in love with him. He's quite brilliant. So our relationship

started because he was able to sell difficult work. Then it became a really good friendship. He's the best dealer I've ever had.

**Let's talk about your studio. How long have you been here?**

I've been in this studio three years.

**Your studio is separate from your home. Is that what you prefer?**

I can't work at home. I'm too distracted as it is, and I need a space that's just mine. I need to be away from everyone and daily life.

**Did you have a plan for the layout of the studio, or did it develop organically?**

It developed organically. I thought I would shoot my videos in here more than I do. I'm mostly experimenting, figuring out how certain objects or materials will break or transform, dealing with color and the design of the performance. I think about what my next projects are going to need. There are a lot of meetings and studio visits. The sculptures and sets in my videos have grown too big for me to do on my own, so I'm always working with an institution or a gallery to produce the works.

After an exhibition is over and the work comes back, I will then transform parts of it into something sculptural. So "traditional" sculpture is becoming a bigger part of the work.

**Has the location of the studio had any influence on your work?**

I don't think so. It's Williamsburg; it's industrial. I do spend a large majority of my studio practice looking out the window, so maybe? I just shot a video piece that looked exactly like that [view], now that you

mention it. It was just these rooftops. So maybe this location is more of an influence than I realize.

**Can you describe a typical day, being as specific as possible?**

Now that I have a kid it's a little different. I'll wake up at the crack of dawn after not sleeping at all, and then I have breakfast and coffee—lots of coffee. Ideally I leave home before rush hour. I get here around 8:30 a.m. I go through the list of everything I have to do, most of which involves responding to emails, dealing with people who are making stuff for me—conversations about how structures are going to be fabricated, possibly sending drawings over or doing measurements, video stuff. I'll be in touch with people who I have upcoming shows with, talking with them about potential ideas. I do a lot of research. If someone's asked for videos, I have to send them out. Sometimes I have people in here helping me, but generally I don't have assistants. I just hire people for the things that I need done. Occasionally, I'll have studio visits or friends come by, maybe a lunch. Drinks are even better.

I do lots of dealing with the studio, trying to make sense of a space that's seven hundred square feet when I really need two thousand square feet. I'm constantly trying to get rid of stuff but not being able to get rid of anything. [*laughs*]

I never work at night. If I could, I'd be in here at 6:00 a.m. I would just love that. No one is here in the morning—there are very few artists who work at eight in the morning. I have a bunch of jobs and a child who I am obsessed with, thank goodness, so it never really ends. I'm always working. I'm still

working when I'm home. I'm multitasking all the time. I just try to do it all.

**Can you tell me about the materials you use and how they came into your practice?**

I've been using basically the same materials since I started making work. I use really traditional sculptural materials: wood, plaster, Sheetrock, ceramics, paint—anything you can find in a hardware store. I'll transform these materials to make objects that are used as players in some sort of narrative—the sculptural objects become characters. I am definitely a maker, but I am interested in using these traditional objects and materials in a more contemporary way.

The pieces that make up the site-specific performances come back to me, and then they become other things. For example, these pots came back to me. I don't know what I'm going to do with them, so I kind of fuck around with them. I have this yellow platform that was the floor piece that came from the Bryant Park performance.[1] It has this painting quality but also conveys the history of the performance, and it's a process. It's quite beautiful. I'm trying to figure out how these objects can exist in the world outside of the performance. I'm really attached to them, and also I feel connected to the act of making sculpture. It's where my work comes from.

**You had gotten tired of making sculptures?**

I got tired in the beginning, and that's why I went into video and photographs. When I was in graduate school I didn't care about the [sculptural] objects. What I was making at the time was really not that interesting. I was just making to make. Obsessively, compulsively making.

**I thought what you were doing in graduate school was pretty cool. I loved your black and white pillow room.**

It was like making the same pillow over and over again, just to be making. And I realized through very harsh critiques, where everyone would try to make me cry, that there really wasn't a lot going on besides making. I started thinking about what that labor actually means and how it can be processed and translated in a conceptual way. Those pieces were superphysical; there were a lot of steps involved. I had to walk across town carrying a hundred pounds of clay on my back. There was a real physical strength in the way I was making my work, and so how could I incorporate that into what it meant?

But now I miss the objects. I never really considered myself a video artist—I considered myself a sculptor. Really most of what happens is either sculptural or performative, and then it exists in video.

**What are you working on now? These projects you're doing at institutions would end up being a performance piece that's done on site and documented, then the video is shown there amongst the detritus of the performance?**

Let's use the piece I just did at MOCA Cleveland as an example. It's an hour-long video—the longest I've made. It's a set of risers lined with pots that are filled with paint. I go up one set of risers, drop something down, then the pots break and explode in hot pink and black paint all over the place.

The process begins with a long conversation with the institution about what I'm planning to do and then what I need made. A series of drawings go back and forth between me and the fabricators because I'd say, "Oh, a piece of wood should be this big," but because I'm not a fabricator, I don't know. All I know is it needs to hold a lot of weight. It needs to fit into the frame of the camera. I know what I want aesthetically, and then I know how the modules [stage] will play into it. So that becomes a long conversation [with the institution] before we know what will actually be in the show.

Then the building of the piece begins, but I'm still in Williamsburg. So, for instance, at the MOCA Cleveland show there were 250 clay pots that had to be bought—and the paint. All that was happening while I was still here. Then I went out there for two days and performed the piece. In the end, the

---

**1.** *Walk the Walk*, 2010. A performance-installation piece in which groups of women dressed to resemble office workers walked around on a yellow podium during the hours of a regular workday. The Public Art Fund, a nonprofit that brings contemporary art to New York City, sponsored the project.

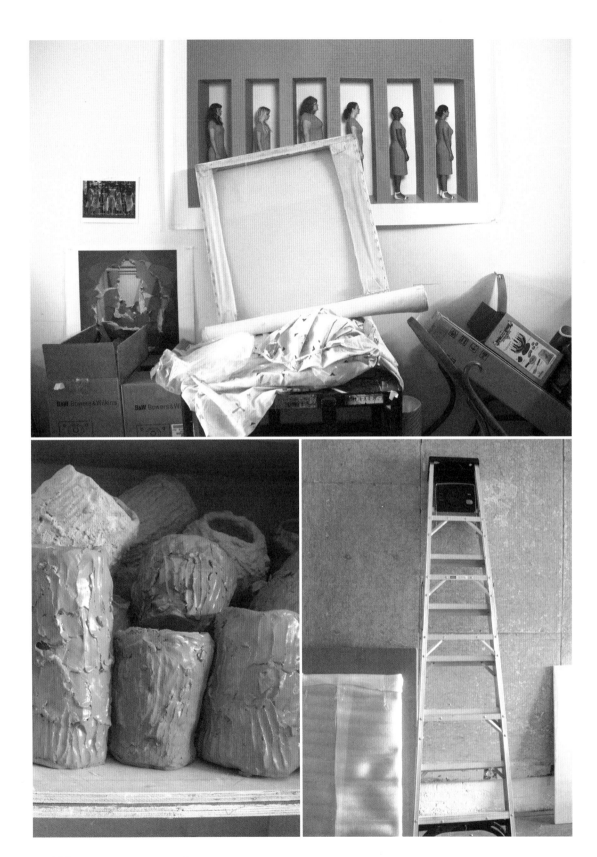

sculptural remnants of the performance are left there, and the video is shown.

**Speaking of paint, do you have a favorite color?**

Hot pink.

**Do you have any special devices or tools that are unique to your creative process?**

I would say my body—everything is about the way the body transforms something. Special tools… I guess sledgehammers, good shoes, a drill, a chop saw. Mostly it's about the body…and my dresses, of course.

**How do you go about choosing the dresses you wear in your performances?**

Well, that's changed. When I started making work I was very specifically dressing like Hillary Clinton or Martha Stewart, these very well-known female figures. But now it's about the idea of a female figure. So it's someone who's appropriately dressed or someone who wouldn't stick out at a party or who might be sitting behind a doctor's desk, like a secretary. These are formal decisions, because they—the women/me—become part of the sculpture. If I find a really cool pair of shoes that I like, I'll scan them and get that color, which will become the paint [in the piece]. If I know I want to use a hot pink, I'm not going to wear a hot pink dress; I'm going to wear a black dress. But if I'm working in a black and white environment, I know I need something to pop, so I'll probably wear red. It's the same way you would deal with painting: What will pop, and what will move forward, and what will move back? The video is very much a conversation of painting, especially now, when people are showing them on flat screens. You're dealing with a rectangle. You're dealing with what it means for things to move in and out of a frame.

**Are there items that you keep in the studio that have significant meaning to you?**

Everything has a lot of meaning. But this floor from the platform of the Bryant Park performance is very important. It was my first performance that I wasn't physically in. I had seven women walking on top of this platform for an entire workweek, for ten hours a day. The platform started out really clean and painted bright yellow. Over the week of the performance, the walking has become the drawing that happens.

**Do you work on one project at a time or several?**

Several. It all depends on my schedule. Right now I'm working on four different projects. But it's not like I'm a painter who's in here making five different paintings. I'm in conversation for five different projects to be happening.

**How do you come up with titles?**

Pop songs. I drive a lot [for my teaching job] to Purchase, so I'm always listening to cheesy radio, a lot of eighties pop songs. Or I use a lot of clichés or things that are catchy that you can manipulate in a way to make a little darker. I love titles. That's probably from my writing background, and my sister [Jennifer Gilmore] is a writer. [The title] adds a little bit of a twist. It guides you, and it makes you kind of laugh. It brings you in in a different way.

**What are some of your favorite titles?**

*My Love Is an Anchor*. That's a good title. I just shot a piece that's called *Love 'em, Leave 'em*. The hard part comes when I propose projects and have to come up with a title before the piece is made. Ideally, the title would come at the end.

**Do you have a motto or creed that as an artist you live by?**

I teach, and I have many young artists whom I really like. But I really hate hearing young artists bitch about how hard it is, that they have to work a million hours and still go to their studio. They feel they should have success right after school. But the art world is hard—it's so hard. You either care enough to continue despite the difficulties or you don't. Anything good and of worth should be a challenge.

**What advice would you give to a young artist who is just starting out?**

If you're not a hundred million percent into what you're doing, don't even do it. Get out. But if you're a hundred million percent into what you're doing, do it and devote your entire life to it and love what you do and be happy in making stuff. Be persistent and confident and get as many people as you can in your studio. Be a good person. Be a kind person. Be humble when you get things, because tomorrow you won't.

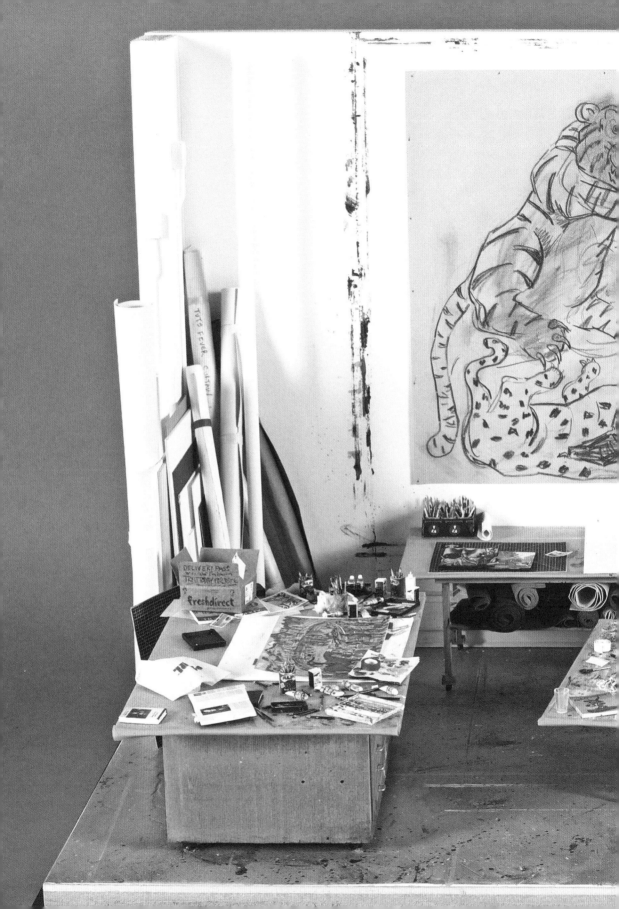

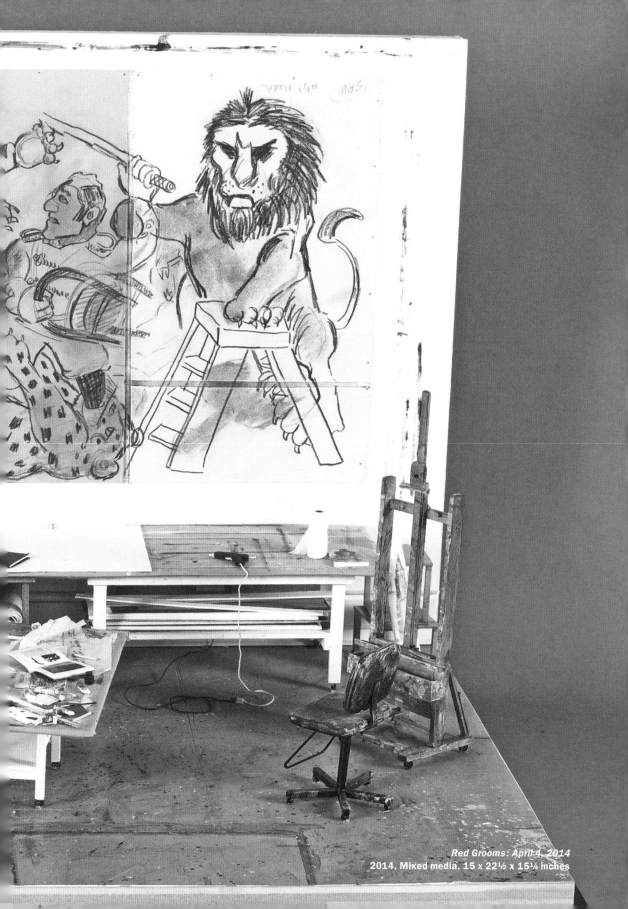

# Red Grooms

Tribeca, New York City / April 4, 2014

**To start off, can you please tell me a bit about your background?**

I grew up in Nashville. I was born at Vanderbilt Hospital in 1937. I went to Hillsboro High School, where art was my major. I graduated in 1955 and went to the Art Institute of Chicago. My intention was to get a four-year degree, but I didn't make it past the first semester. The courses were very basic: figure drawing and still lifes, that kind of stuff. I had taken private art classes since grammar school, going through high school. I was poring over books in the school library on Dubuffet[1] and Giacometti[2]—I wanted to jump right into modern art. Plus, I was a huge fan of *ARTnews* magazine, reading it all the time. I bailed out of Chicago and headed to New York in 1956.

**It sounds like you had a lot of support growing up.**

My mother and father both supported me. I didn't have the problem some people have with their parents objecting to their plans. In fact, my parents bought me the Famous Artists School's[3] correspondence course, illustrated by the likes of Jon Whitcomb,[4] Adolf Dehn,[5] and Norman Rockwell.[6] In my freshman year of high school I won a Regional Art Award[7] for a carnival scene. Carnivals, circuses, popular entertainments were my preferred subjects. That gave me a lot of encouragement.

**What brought about your move to New York?**

My mother was quite involved in my strategies for life. She was trying to figure out how I was going to make a living. In Nashville at that time you were either a commercial artist or a teacher. My choice was to be a commercial artist until I discovered European modernism. Then I wanted to be a modernist. That didn't look too profitable to Mama. She was pushing teaching, so I shipped out to New York for art classes at the New School with social realist painter Gregorio Prestopino.

I was staying at the McBurney YMCA on Twenty-Third Street and in my spare time was going around town to see a lot of art. I was very fortunate to catch the last wave of the abstract expressionist period and the beginnings of happenings and pop art.

---

1. Jean Dubuffet (1901–85), French. Painter and sculptor who used everyday objects and materials to make art.
2. Alberto Giacometti (1901–66), Swiss. Artist most known for his elongated figurative sculptures and paintings that conveyed alienation, anxiety, and human suffering in the post–World War II era.
3. Famous Artists School has offered correspondence courses in art since its founding in 1948.
4. Jon Whitcomb (1906–88), American. Illustrator known for his pictures of glamorous women.

5. Adolf Dehn (1895–1968), American. Lithographer known for works that were high-spirited, droll depictions of human foibles.
6. Norman Rockwell (1894–1978), American. Painter and illustrator most famous for his covers of the *Saturday Evening Post*, which depicted hopeful and homespun images of American culture.
7. Scholastic Art & Writing Awards sponsors a yearly competition that provides teens with recognition, exhibition opportunities, and scholarships.

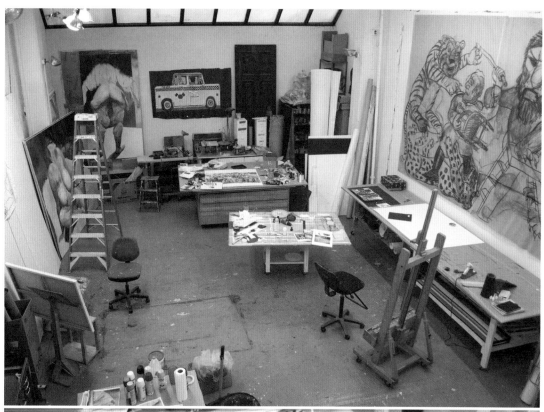

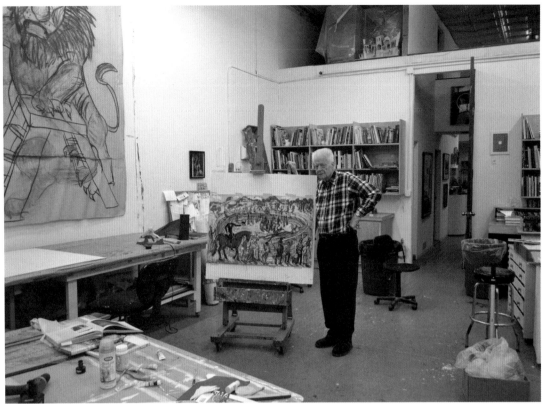

**When did you consider yourself a professional artist?**

Very early. Lyzon's, a frame shop and gallery in Nashville, was a lively meeting place for art enthusiasts. After I won the Scholastic prize, my mother and I brought the prizewinning picture to Lyzon's for framing. Myron King, the proprietor, liked my carnival scene. During the summer school break he proposed that I work in the back of his shop and paint anything I wanted, and he would sell it. I took the job for the summer of 1953. Sometimes I wouldn't do much, and sometimes I'd make three or four watercolors a day. No matter how much I did or didn't do, he paid me $45 a week just to make my own work! That was the beginning.

**Were you ever interested in making abstract works?**

My mother read in *Time* magazine about Hans Hofmann's[8] classes in Provincetown. She said I should go and take the summer class. So I did, and that became very important to my future. I only lasted two weeks with Mr. Hofmann. I tried a few abstractions and I can appreciate abstraction, but I'm a storyteller.

While there I got a job as a dishwasher at a restaurant called the Moors. On my first day I went in through the back door to the kitchen and ran into the pot washer, who was Val Falcone. He immediately called me "Red." I had never been called Red before. I was called "Charlie," "Chuck," or "Chas." About two days later I took the name Red on permanently. Through Val I met Yvonne Anderson. We became friends right away. They ran the Sun Gallery. Meeting them became a life-changing experience.

We really became a family. After the summer we all went to New York and got a loft on Twenty-Fourth Street. I got a job as an usher at the Roxy Theatre on Seventh Avenue and Fiftieth Street. Bob Smithson[9] lived across the street. We started to meet people. Yvonne and Val wanted to show Alex Katz,[10] so we met Alex and Ada. Through Alex I met Rudy Burckhardt.[11]

**At that time was it hard to summer in Provincetown?**

No, we were like Okies. Artists in general are like outsiders. We'd make this migration to Provincetown. Once, we stopped at Val's parents' in Salisbury, Massachusetts. Salisbury is an amusement park town and his parents had a parking lot right next to a really nice wooden roller coaster. Val's idea was to put up three billboards mounted on telephone poles next to the coaster. Lester Johnson, Yvonne, and I each made a painting on a billboard. They were up there for quite a few years.

**Can you walk me through the galleries you were with and how those relationships came about?**

The first work I exhibited in New York was in a group show in 1958 at the March Gallery on Tenth Street. Then Jay Milder[12] and I started a gallery called City Gallery, on the corner of Sixth Avenue and Twenty-Fourth Street. That lasted a season. The following season [1963] Jay, Bob Thompson, and I started the Delancey Street Museum on Delancey Street and Suffolk Street. At the same time I began showing with the Reuben Gallery. In 1963, after a year-and-a-half stay in Europe, I joined the Tibor de Nagy Gallery on [East] Seventy-Second Street. In 1970 I moved across Fifty-Seventh Street to the John Bernard Myers Gallery and stayed there for four years until he closed. I went east a few doors to the Marlborough Gallery; I've been there for thirty-seven years.

**How long have you been in this studio?**

Forty-five years. I bought the building in 1969.

---

**8.** Hans Hofmann (1880–1966), German/American. Abstract expressionist painter known for investigating pictorial structure, spatial illusion, and color relationships.
**9.** Robert Smithson (1938–73), American. Artist known for his earth works and land art; most famous is the *Spiral Jetty* (1970), located in the Great Salt Lake, Utah.
**10.** Alex Katz (b. 1927), American. Painter known for representational works with a flattened surface and economy of line.
**11.** Rudy Burckhardt (1914-99), Swiss/American. Painter and filmmaker.
**12.** Jay Milder (b. 1934), American. Figurative expressionist painter known for works that convey themes of the Old Testament and the Kabbalah.

**Has this location influenced your work at all?**

Very, very much. I had to control myself not to make work based on the first New Yorker character I saw when I went out the door. I still find inspiration around the corner.

**Did you have a plan for the layout of the studio or did it develop organically?**

This studio has always been an organic place. After I bought it, I didn't have any money left. I had joined the Marlborough Gallery, and there was a demand to keep working nonstop. One of the wildest times here was the making of *Ruckus Manhattan*. On that project I worked with Mimi Gross[13] and the Ruckus Construction Company. The full ninety feet of the ground floor was open— there were no partitions. The subway car started in the back and ran the thirty-seven feet. The life-size subway riders, which were made of cardboard and plaster, were sitting around all the way to the front door.

We had artists working for us on a tight deadline, and we had horrible hours. We were working from ten o'clock to ten o'clock. It was very grueling. We only had nine months to complete the whole portrait of Manhattan. We were improvising the whole time because we couldn't spend the time to do shop drawings or maquettes.

**How long was the show up for?**

Three months. A hundred and forty thousand people came. It was a popular success. We got tremendous press coverage.

**Your work is very accessible.**

Some of it is. When I make the large-size, walk-through sculptures I call "sculpto-pictoramas," I'm hoping to reach a big audience.

**Well, there aren't many art pieces that you can actually walk into and through.**

On the low-end art scale I was thinking of fun houses; on the high-end one, Robert Wilson.[14] He was one of the artists that inspired me back in the seventies. His workshop on Spring Street was called the Byrd Hoffman School of Byrds. His projects were done on a very large scale. His ambition was an inspiration to me.

**Tell me a little about the history of the sculpto-pictorama.**

I went to Chicago in 1955 to study at the Art Institute. I remember picking up some driftwood on the shore of Lake Michigan. I made a sculpture with it, my first sculpture. It started building up from there. Yvonne Anderson worked with tar, chicken wire, and wood— stuff like that. She was my mentor in carpentry. Building tree houses and digging tunnels was my thing as a kid. I didn't have skill, but I had enthusiasm.

**What was your first show of the sculpto-pictoramas?**

*The City of Chicago.* That came about in part because I had made a film with Val and Yvonne in Lexington, Massachusetts. We rented a space there and shot a film called *Fat Feet.* For that I made a set in the round of a city street. I loved doing that. I loved Hollywood. I wanted to create something like the set for *Fat Feet,* but as a stand-alone sculpture. When Allan Frumkin asked me to fill his gallery in Chicago with a sculpture, I knew what to do.

**Can you tell me a little bit about the materials you use?**

Beginning in New York, street finds often determined what the piece was going to be. You see something on the curb that's just right, and bingo—you're in.

One of the greatest breakthroughs for me was the hot glue gun; it changed everything. Often I use light material like Styrofoam. The first electric tool I got was a saber saw. Cutting with that saw was like drawing. It's been the root tool for practically everything I've done in 3-D.

**Do you have a favorite color?**

Naples yellow. I know that's terrible, especially for a redhead. My mother was a redhead, too. She always said a redhead shouldn't wear red and would look best in green or blue. I also like purple. I think it's a very questionable color, but I'm partial to it.

**Can you talk a little bit about the *Home Run* feature you recently created for the Miami Marlins baseball team?**

---

13. Mimi Gross (b. 1940), American. Artist known for her 3-D constructions as well as set design and costumes.
14. Robert Wilson (b. 1941), American. Experimental stage and theater director, designer, choreographer, playwright, and video artist known for his collaborations with other artists.

It seemed like I could have some fun with it, but I wanted it to be a little complicated. I thought about that wooden roller coaster back in Salisbury, Massachusetts. I could visualize the arc of the marlin jumping over the hump of the coaster in and out of the water. You could pull the fish out of the water with a chain, just like that old roller coaster used to pull up the cars.

Miami's art deco district influenced the multiple arches, which set up the possibility of having action behind them. It would be theatrical. It has a backstage area and things coming up and some surprise elements like a water cannon and fireworks. I was thinking, too, of that vertical baseball pinball game I had as a kid. It was just pure fun.

**Are there any specific items that you keep around your studio that have significant meaning to you?**

I have a few pieces of furniture from my earlier studios. There's a stepladder that's got saw marks from a handsaw. My dad gave me a wooden box painted a ships' gray made for World War II PT boats. That's probably the oldest treasure. I love to live with other artists' work. This [*pointing to a stepped pedestal full of sculpture*] is my Tom Otterness[15] shrine.

**How often do you clean your studio? Does that affect your work?**

I'm pretty messy, and I don't clean as I work. When I stop working I leave the studio as is; that way when I come in the next day it is exactly the way it was when I left.

**Do you have assistants?**

My first paid assistant was Rusty Morgan. That was in 1967, when I started work on the *City of Chicago*. His skills really expanded what I could do. Tom Burckhardt has been my longest assistant, for twenty-five years.

**Do you have a motto or a creed that as an artist you live by?**

Keep your head down and keep working.

**What advice would you give a young artist who's just starting out?**

When I was young in the 1950s, my peers were telling me that you couldn't be great now—you've got to work at it. There's that Japanese saying that you have to do a certain thing for a hundred years before you're able to say that you're capable of doing it. I don't believe in that philosophy at all. I don't agree with that, and I think, historically, I'm right. You have to be as good as you possibly can be immediately! Look at Bonnard[16] and Vuillard:[17] those guys were twenty-one, and they were never any better than they were then. In other words, go full force as soon as you can, right off the bat.

---

15. See pages 146–57.
16. Pierre Bonnard (1867–1947), French. Postimpressionist painter known for his domestic scenes.
17. Édouard Vuillard (1868–1940), French. Postimpressionist painter known for images of family and friends in warm interiors with patterned backgrounds.

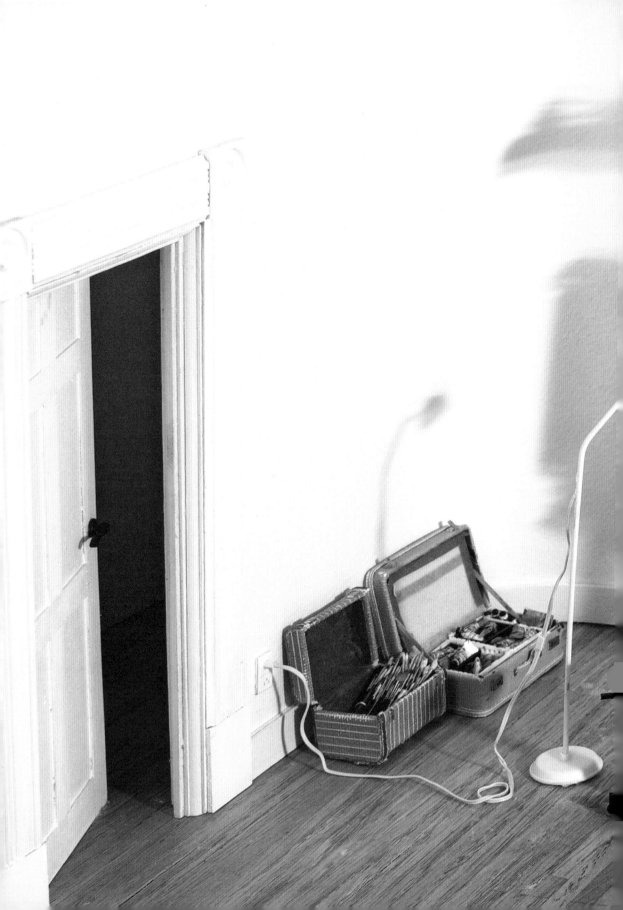

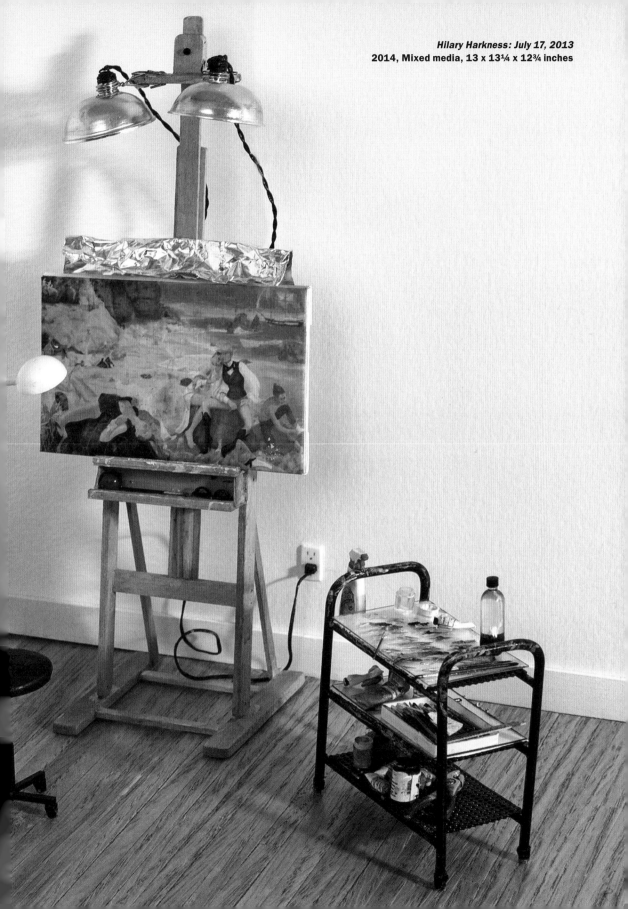

*Hilary Harkness: July 17, 2013*
2014, Mixed media, 13 x 13¼ x 12¾ inches

# Hilary Harkness

Prospect Heights, Brooklyn / July 17, 2013

**To start off, can you please tell me a bit about your background?**

I grew up in Kalamazoo, Michigan. I had access to forests and fields to run around in. I was very much a girl Davy Crockett; I had a really free childhood. My dad worked for a paper mill. As a result, my play closet was stocked with paper samples—large, textbook-grade paper. I spent a lot of time in my basement with my big sheets of paper spread out over a Ping-Pong table, and I would get lost in my drawings and imaginings for hours.

When I was in kindergarten I remember being frustrated with the quality of crayons and taking a black crayon and filling an entire sheet of paper in with it. I worked as hard as I could, but crayons suck—they're really flaky, and you can't get a good density of color—so I just kept going and going. That got me into trouble, as my teacher contacted my mom because of my depression, evidenced by the black crayon–filled paper. [*laughs*]

I went to a public high school, and because I was ahead in math and science I had a lot of free time. I would wander out of class and go hang out in the art room. I could work on whatever I wanted. That kind of freedom was amazing at that time.

**Do you remember an early artwork from your childhood that got recognition?**

I can remember being in first grade and making little wallpaper books. I illustrated what I thought was *The Wizard of Oz*, but it was really a mash-up of different fairy tales. I was a maximalist even then. I put in every little detail that I could find.

**Where did you go for undergraduate school?**

I went to UC Berkeley. I did pre-med, and I was playing violin. I did not want to be an artist. I really wanted a liberal-arts education that included science and math. I like the objectivity of math and science— it helps me feel grounded. I had already enjoyed so much art stuff as a kid, I didn't want to waste a college education on painting.

At the end of my third year of college, I intended to declare a major in biochemistry, but I couldn't find my advisor. I kept missing him, so my registration for biochemistry got blocked. I had two art classes behind me, and I begged the art department to take me into their program. Fortunately, I was able to squeeze in the art major right at the end of college. I thought I would still go to med school and that the art major would be a nice break.

**How did you continue to pursue art?**

I didn't do that well as an undergraduate artist. Nothing felt right, but my professor, painter Drew Beattie,[1] strongly encouraged me to keep at it and convinced me that med school wouldn't make the greatest use of my interests and talents. Even back in college, I wanted to do something that gave me access to interesting people and the freedom to pursue my ideas, so I decided med school was not for me.

---

**1.** Drew Beattie (b. 1952), American. Painter and sculptor whose early work was part of the collaborative Beattie and Davidson and whose more recent work juxtaposes flat surfaces with three-dimensional materials.

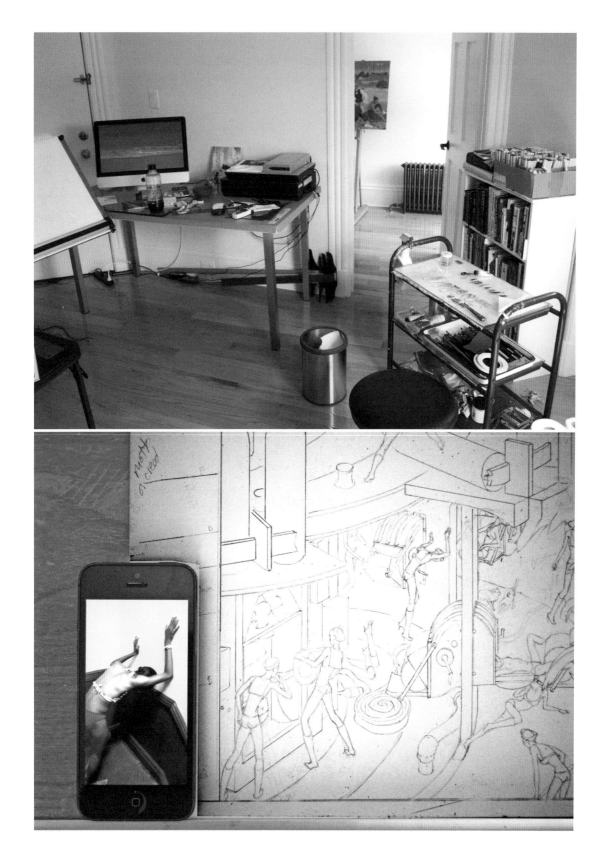

In the year I took off before going to grad school, I got a job at the best wedding cake shop in the San Francisco Bay Area. The first task they gave me was to write on cakes with melted chocolate, the old-fashioned way. But my handwriting sucks, and I could not pass that test. [*laughs*] So I applied to grad school for art. I applied to twenty schools and got into a handful.

**Where did you go to graduate school?**
I went to Yale, where I did fairly badly. I could not wait to get away from there. There was a lot of East Coast painting dogma. I moved back to California as soon as I could and spent the next three years thinking I was not going to have any kind of career as an artist. And yet, for some reason I chained myself to a drafting table, and I painted eight hours a day. I was really happy. Then, finally, I got myself in a group show, but I realized I couldn't quite break in in San Francisco. Medical school was still an option, and I was playing in a professional symphony for extra money. Finally, I thought, Before I quit painting I need to get rid of any ghosts and go for it. So, I moved to New York City with this idea: let's burn this dream to the ground and get it over with, so I won't be haunted by regret.

**What year was that?**
I moved to New York at the end of 1999. I looked at what galleries were reviewed in the *Village Voice*; I made up slide packets and went door to door to those galleries.

**Who hasn't done that? [*laughs*] So, when did you consider yourself a professional artist, and when were you able to dedicate yourself full time to that pursuit?**
I didn't devote myself to it full time until I got to Yale. If I try to get in the head space of a professional artist and actually take myself seriously, the muse deserts me. I just shrivel up. That's part of the reason I have to work at home. I tried the six-hundred-square-foot-studio-in-Greenpoint kind of thing; it was just me and my easel and this feeling of vacuum. Home is where the feelings are, so home is where I need to work.

I started making real money from my paintings in 2000. The body of work I did in San Francisco sold quickly in New York City.

**How did you get your first real gallery show?**
[While I was] taking my slides around to all the galleries, there was one dealer who didn't have his assistant working at the front desk the day I stopped by. I showed him my slides, and he said, "Oh, this looks interesting—maybe I'll do a studio visit sometime." So every two weeks, I'd drop by or make a phone call or write an email to him. Finally, I put two paintings under my arms and walked into the gallery. That kind of pushiness will make a person sputter with annoyance. The dealer seemed pissed. [*laughs*] He looked at one of the paintings and said something like, "Oh, I've already seen that in slides." Then he looked at the other painting and said, "This is more original. Let me keep it over the weekend."

So I left the painting with him at the gallery with no paperwork, no proof, no idea what he was doing with it. But luckily, Beth Rudin DeWoody, a major art collector, came by. She bought my painting out of his back room.

**Which gallery was this?**
Bill Maynes Gallery. I had my first solo show with him. I had so much work I had painted back in California that hadn't been exhibited, and he sold it all.

**Currently you're with Mary Boone. How did that relationship come about?**
In 2001 curator Max Henry put me in a group show called *View (Five): Westworld* at [Mary Boone's] gallery. I didn't realize this was an opportunity to meet a dealer. I didn't have the good manners to even say "thank you" to Mary. In 2003 I was following my best friend Pearl Albino[2] around Chelsea to art openings. Pearl is brilliant. I was feeling shy, so I pretty much tied myself to her apron strings. [*laughs*] Pearl decided to drop by a Mary Boone dinner party at Bottino. I panicked because it felt like we were crashing, but Pearl was unfazed. Mary noticed me hanging back in the entryway and glided across the room toward us. I thought, She's going to kick my butt for crashing

---

2. Pearl Albino is an art advisor specializing in contemporary painting, photography, drawing, and sculpture.

her party. But surprisingly, she asked me to join her gallery. I couldn't believe it. I've been really fortunate with Mary Boone.

**That's an incredible story. Let's talk about your studio. How long have you been here?**

[Since] January first, 2013.

**You work and live here. Is that what you prefer?**

It's what I prefer because I like to work at odd times. I like the comfort of home.

**When you moved in here did you have a plan of the layout of the studio, or did it develop organically?**

It was just going to be that small room. Then when the ex-girlfriend left with most of the furniture, the whole apartment became beautifully empty. What a relief.

**Has the location influenced your work in any way?**

I'm really happy here, and that's always a good thing. Misery can be inspiring, but it's not good for the daily slog through the practice.

**Can you describe a typical day, being as specific as possible?**

I get into my studio in the morning because I enjoy that mental clarity. I have coffee or Indian chai tea with fresh ginger. I tend to graze, going back and forth to the kitchen, because I don't want to take time for a meal. Late afternoon is the dark night of my soul. I don't know if I'm getting tired or if there are demons, but working becomes a real pain in the ass. But as the sun is setting it's like the opening bell of the New York Stock Exchange going off in my head. I suddenly feel like a new person. That second wind is everything. That can go until 1:00 a.m., and if I'm getting ready for a show, I will work around the clock.

**How long have you had this table for your paints?**

This little rolling cart is my palette. I bought this the first week I moved back to San Francisco. It's a TV stand from the community thrift shop on Valencia Street in the Mission. I haven't been able to replace it, because it is twenty-four inches high, and it's hard to find a rolling surface at that height.

**Do you have a favorite color?**

Cerulean blue.

**Do you have any special tools or devices that are unique to your creative process?**

I have this green iron World War II field-drafting table. I would probably not have a career doing what I do if it weren't for these Schaedler Precision Rules. They're very thin and transparent and help me make precise lines. If I need to paint a straight line, I'll tape a ruler to my painting as a guide for eyeballing it. I'm not looking for a superprecise line; it's all a dream world that I'm painting. I don't want a very hard edge.

**Are there any items you keep around that have significant meaning to you?**

Actually, there is something. I love to play squash. In my easel I have a little shelf; I keep this squash ball there. It's kind of like an eyeball; it has a dot on it. I'll look at it as a reminder to keep my eye on the ball.

**When you're contemplating your work, where or how do you sit or stand?**

When I'm painting I'm on this stool. I am generally fairly close to the image. I am constantly double-checking by looking at it backwards with a hand mirror. Another thing I'll do is I'll leave [the painting] somewhere in the apartment where I won't think of it. It will surprise me, and I'll be like, "Oh my gosh—I can see what's wrong."

Sometimes I'm just standing in front of it daydreaming about something else. Since a painting often takes a year or more to finish, all that stuff accrues somehow in the subconscious. The detail that comes to me on the last day that everyone loves is probably the product of a year of daydreaming.

If something I'm painting isn't going well, I will take a picture of it on my iPad and flip it backwards and look at it magnified. Since the figures are so tiny in my paintings, it helps me to see more clearly when something's blown up. When I started using a camera to examine things closely, I really slowed down as a painter. Some of my paintings out there are over-the-top, micro-obsessively perfect kinds of things.

**How do you come up with titles?**

If the title doesn't come first, then the title is never going to come in a nice fashion. I have my filters out for ideas all the time. One of my largest paintings is called *Fully Committed: Mighty Mo'*. It's this scene of

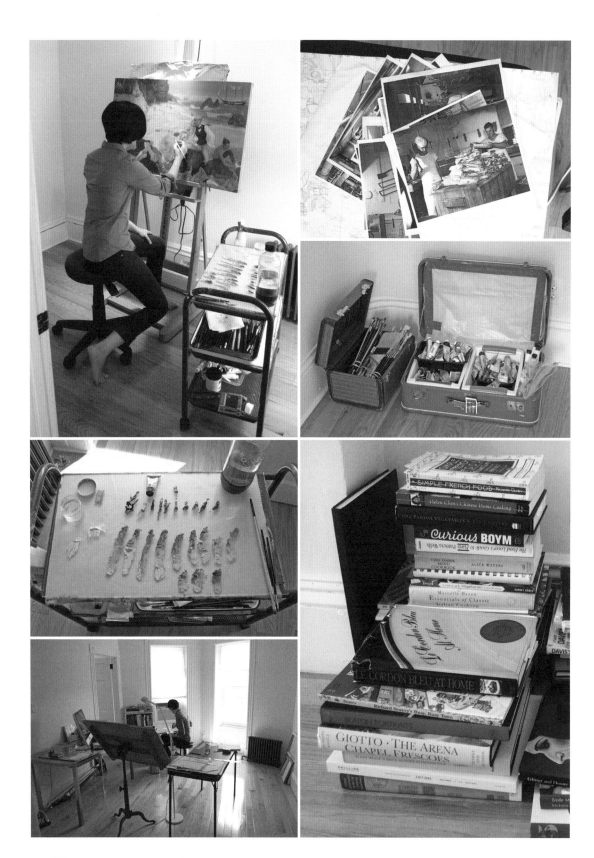

a U.S. battleship under a kamikaze attack. That title came to me when I was talking with Mary [Boone] on the phone. She was telling me that she was fully committed to doing such and such; it went on my list. I do have little sketchbooks with all kinds of ideas, but when am I going to do a painting called *Myrtle Beach Bitches*? [*laughs*]

**Do you have any assistants?**

I once had an assistant who came one or two days a week. She was helping me with labor-intensive panel production, and I thought that she could also help me transfer my drawings to panels and proceed to block in areas of underpainting color. It might take five layers to build up a good density of color before I start painting in details. It seemed smart to have someone aid me with the grunt-work part of painting. But it didn't work out, because it didn't speed up anything in the end, though my former assistant, Colleen Asper, is an exquisite painter who has gone on to teach at Yale. She is one of the most hilariously funny people I've ever met, and when she was working for me she'd have me laughing so hard I'd do embarrassing things like accidentally blow snot on my painting or catch our lunch on fire. [*laughs*]

**Can you talk about the process? You have a preliminary drawing, and then how does that get transferred to the painting surface?**

I scan my preliminary drawing. I print it out and then use Saral Transfer Paper, which works much like carbon paper. I won't transfer all the details—just the very basics. Next I'll put down a light monochrome ground. Then I'll go through and very precisely but simply put in the figures. They won't be modeled—just shadow figures.

Then I'll start painting the walls or the landscapes around the figures and they'll get painted out, for the most part. Quite often I'll have to paint them over and over again or move things around. There's a lot of correcting.

**When do you work out the color? Is that during the painting process, or do you do that beforehand?**

I tend to work things out beforehand. I don't plan fully, but I need a cohesive palette. I need to narrow it down before I start.

This painting on my easel [*Sexologists of the Galapagos*, 2013] will have ochers, Cobalt Violet Light, Terre Verte, Cerulean Blue, and maybe Cerulean Blue Turquoise. I might have to use an iron-oxide pigment like Mars Yellow to paint the brass buckles on the figures' shoes. If I'm on a beach, painting sand, I'll use Yellow Ocher, but if I'm in California, painting in gold-mining country, I'll need to use Mars Yellow to capture that iron-rich, rocky soil. It's weird how when you squeeze them out of a paint tube, Yellow Ocher and Mars Yellow look like the same color, but they behave so differently in pictures. I had to go paint on location to figure this out.

So much of my reference is from fuzzy black-and-white photos—you can't really see what's going on in them. It gives me more freedom to make stuff up. I guess that's when I can access my intuition.

**Do you have a motto or a creed that as an artist you live by?**

I think Stephen King summed it up in his book *On Writing*: you have to chain yourself to your table and work at it the same time every day, and then the muse will show up. You can train her to come.

**What advice could you give to a young artist that is just starting out?**

Don't feel pressure to get a style. Be greedy, and try out a big range of things so you'll have more to work with later. It's your exploratory time. Everything you can grab is going to be rolled into your work in some way or another. Don't try to make your work add up into something that makes sense. Have faith that it will all eventually fall together.

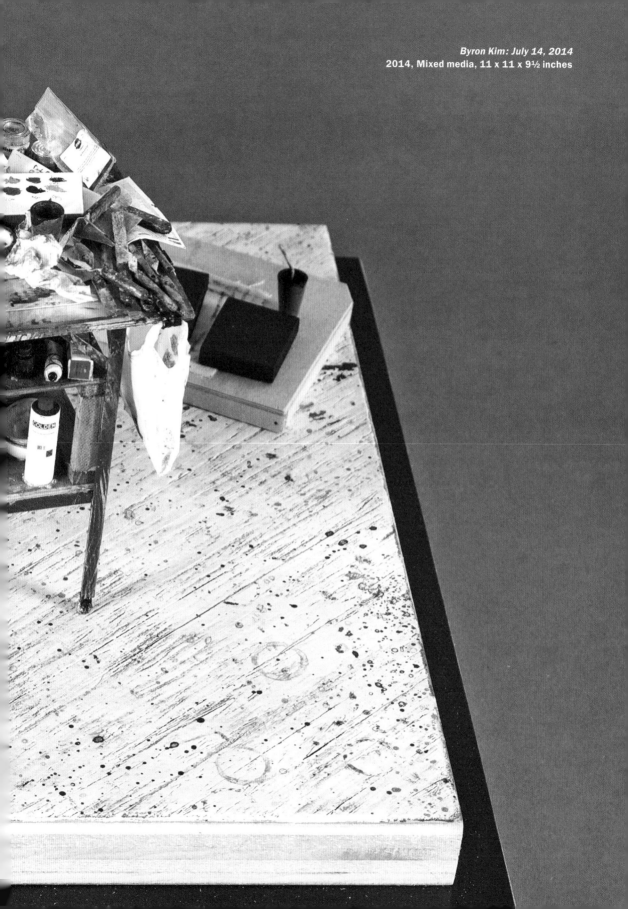

# Byron Kim

Gowanus, Brooklyn / July 14, 2014

**To start off, can you please tell me a bit about your background?**

I was born in La Jolla, California. I grew up there and in Wallingford, Connecticut. I went to a small private high school, La Jolla Country Day School. It did have a pretty good art department by virtue of having a couple of good art teachers. William Goodell, at first, and then Carolanne Gano. The thing that I still take from her is that she would say, "Just start. If you don't know what to do, just get started." That advice has been really helpful because that tends to be my particular problem.

However, I wasn't that much into art when I was a kid. In fact, I wasn't that much into art in high school, either. I didn't start to think about becoming an artist until after college.

**What was an early art piece you made that got recognition?**

Even though I didn't have much interest in art, while at high school I did make a sculpture that was installed on the campus of the high school until just a few years ago. It was a four-part sculpture depicting growth, this progression of a plantlike form. I did it as my senior project.

**Where did you go to undergraduate school?**

I went to Yale. At first I studied science and did most of the pre-med, but I liked to study things that were difficult for me. That's how I ended up becoming an English major, because I found it really challenging. I graduated in 1983. I did take some studio art classes. One art professor at Yale, Robert Reed,[1] was really quite inspired. I'm so grateful to be doing critiques alongside him thirty-five years later.

**Did you go to graduate school?**

I went to Washington University for a semester, and it just didn't work out. I had gotten into Skowhegan[2] in the summer of '86. I went to Skowhegan without really knowing that I wanted to be an artist, but once I got there, that summer changed everything. I realized this is what I wanted to do. Bill Jensen[3] was on the faculty that summer. He had a slow, thoughtful, uncompromising way of looking at things, which affects my studio life and my own way of teaching to this day.

**Was there a particular piece you made where you thought, This might be something I want to continue to pursue?**

When I was at Yale I wanted to be a poet, but I understood how daunting the task would be. By chance, during my senior year I took an art history class called Art of the 1970s. Getting introduced to conceptual art really opened things up for me, and somehow I saw that as an alternative to poetry. I thought maybe I could do this, and I could be a poet somehow in this way—you know, Vito Acconci came from poetry. But I didn't pursue conceptual art immediately. Because of my Yale

---

1. Robert James Reed Jr. (b. 1938), American. Esteemed artist and educator. He has been on the faculty of Yale since 1969 and has helped foster many studio programs and residencies.
2. Skowhegan School of Painting and Sculpture, established in 1946 and located in Madison, Maine, is an intensive nine-week summer residency program for visual artists.
3. Bill Jensen (b. 1945), American. Artist whose abstract paintings are praised for their unconventional compositions and profound sense of color.

education I thought I had go through the steps, so I started by making very conservative still-life paintings. Somehow I got into Skowhegan with those, and that's when I started to experiment.

The first thing I made that I thought, "Oh, maybe this could be something" came about because I had this notion of making a painting that was too thick, that had way too much paint on it. I called paint manufacturers, and they [told me that with] a gallon of paint, once all the volatile stuff evaporates, there's really only a little bit of solids left. One guy from Sherwin-Williams in Ohio—I still remember his name, Joseph Biber—told me that artists' oil paint retains the highest percentage of solids. Then I realized that encaustic retains full volume. So I made this small painting that was just a block of encaustic coming off of the canvas. But I only made a few of those because there was this German artist with the same idea making paintings that were way more sophisticated than mine. [*laughs*] That's when I came up with the belly paintings. Those were the first ones where I thought, OK— this might be something. I wasn't thinking about bellies, but everyone who came into my studio said, "Oh, it's a belly painting." I found that incredibly annoying because I was trying to make something more theoretical. I thought it was about process and materials. Calling it a belly painting seemed so silly. I swear to you there wasn't one person who came in my studio and did not call it a belly painting, and that was the first big lesson that I learned in being an artist—that

you should listen to your audience. You don't have to do what they say, but you should listen to them.

Anyway, what I did was I took a panel and stretched linen over it and then stretched rubber over that. I'd leave space on top for a funnel, and then I'd pour three gallons of a special latex paint that I had made behind the rubber. The rubber would bulge off the bottom of the canvas, and it looked like a belly. People couldn't help touching them. They would bounce up and down when people touched them. But they never lasted very long, and a couple of them exploded. So eventually I made an encaustic one in an effort to make an archival version, and that led directly to the skin paintings.

**It brings the narrative or the figurative content into the work.**

Yes, and I didn't think of myself as a figurative artist at all. That led me to make a [ten-by-eight-inch] painting of the skin color of a friend of mine. After I painted his "portrait," I made maybe twelve or fifteen more skin paintings of my friends. Then I started thinking about paintings that looked like modernism but had some other content. I've been working on that for twenty years now.[4] They weren't originally conceived primarily with race or social issues in mind. But again, listening to what people

---

4. *Synecdoche* (1991–present) is a series of hundreds of small monochromatic paintings; each canvas is painted the color of an individual's skin tone. These paintings sit somewhere among abstraction, conceptualism, representation, and pure painting.

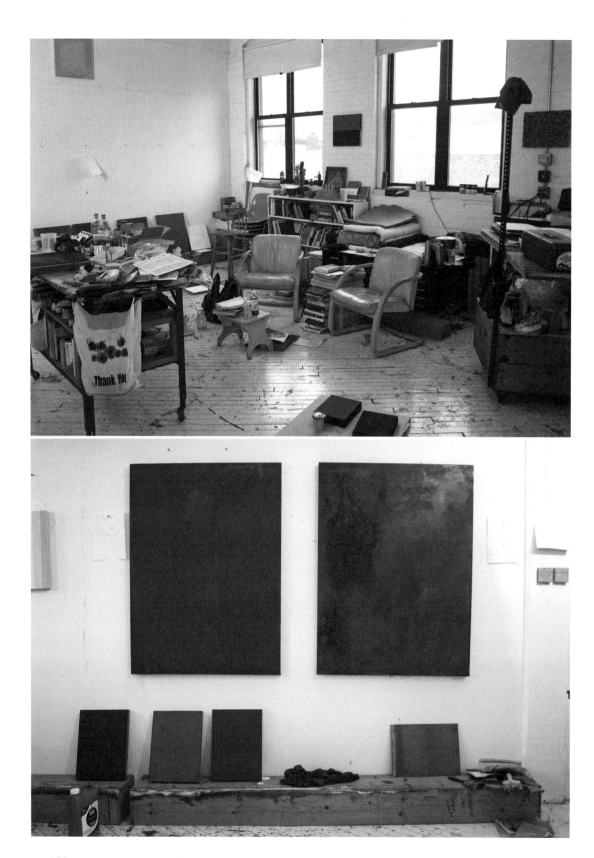

had to say, I completely understand why there's that reading of that work.

**I know the skin paintings are often referred to as portraits, but you call them portraits?**
I approached them just like you would a portrait. I think I used that term in the beginning, and I think it's perfectly apt. I'd go up to a person and ask them if I could copy their skin color. Surprisingly, almost everyone said yes. Then I would literally use a French easel, get out my oil paints, look at the color of their arm, and try to copy it. That's so much like a portrait.

**Actually, I've always been interested in portraiture, but portraiture has been around for thousands of years. How do you make it contemporary and fresh? Part of my own work has been trying to figure that out. Do you think your work fits in the history of portraiture?**
What you're talking about in your work made me think that, in a lot of ways, my evolution has been exactly the opposite. I started out relatively abstractly because I had this interest in having very concrete content. A lot of my work is about a specific subject matter, just like a representational painter. Most of my paintings look abstract and are often severely abstract—they'll be just a flat color—but by and large, they're trying to represent a very specific thing.

**Right, and even your *Sunday* sky paintings could be considered a type of landscape painting.**
They are. I think of them as landscapes.

**In a way, you're a landscape and portrait painter. [*laughs*]**
I think I am. [*laughs*] The only thing that's missing are still lifes, but that's sort of how I started, and, in a way, I'm still a still-life painter, too.

A very formative part of my art development had to do with being Philip Pearlstein's[5] studio assistant right after college. It was really brief, but it was really influential. I wasn't thinking about it back then, because I was twenty-one years old, but he is such a representational painter, and he's such a modernist. He was originally an abstract painter, actually an abstract expressionist.

I had this very romantic notion of what it meant to be an artist, and I think he's an exemplary artist, but he doesn't fit that romantic notion at all. He wakes up really early. He's got this very set schedule: he'll set up the models and paint that situation until lunchtime. Then, during lunch, he'd be working on a watercolor commission. Then I'd come back from my lunch break and set up another scene with the models, and he'd paint that until dinnertime. Then often there was even a night session. It's crazy. [*laughs*] I remember realizing that this person got to where he is by hard work. Not that he wasn't inspired, but he was very methodical.

**So then when did you move to New York, and what brought that about?**
I came to New York right after college because Julia Pearlstein asked me if I would be interested in working for her father, Philip Pearlstein. That was the first time I moved to New York, but it was premature, and I left because I felt overwhelmed by New York. I was thinking about being an artist, but I found the whole art scene big and overwhelming, which is ironic in retrospect because now it seems so small.

It was after Skowhegan and that failed attempt at grad school that I moved back to New York for good. I had met the artist Lisa Sigal[6] at Skowhegan and moved to New York to be with her. We made a life together with our three kids. We both hit New York with the idea of having a go at being New York artists.

**How did you get your first gallery show?**
I was working at an art-moving company called Art Cart, and Paul Bloodgood[7] was running this little gallery space in the office of Art Cart. He called it the AC Project Room. One day he came to my studio because someone said he should look

**5.** Philip Pearlstein (b. 1924), American. Modernist artist known for paintings of nude figures in a studio setting; the works are composed and cropped in unconventional ways.
**6.** Lisa Sigal (b. 1962), American. Artist who creates constructions that insinuate themselves into a built environment. The works question the formal and philosophical stability of structure.
**7.** Paul Bloodgood (b. 1960), American. Artist known for abstract paintings that often relate to the works of earlier artists.

at the belly paintings, and he saw the skin paintings in the corner. He said, "I'm much more interested in those, and if you can make enough to fill the wall in the project space, I know the perfect Kiki Smith[8] piece to go with it."

I spent the next few months getting as many skin paintings done as I could. I got a couple hundred of them altogether, so Paul got the Kiki Smith, and sure enough, that was a really great piece to pair with it. She made impressions of every square inch of her body and displays it in a grid. This was 1992. Then the curators for the Whitney Biennial came. Once people heard I was going to be in the biennial, dealers came over and offered me shows. I ended up showing with Max Protetch for seventeen or eighteen years, up until he closed.

**Who are you showing with now?**

James Cohan Gallery, which is great. It's a difficult situation for a midcareer artist to find a gallery. Sometimes it takes a while. I made it known to Jim, through a friend, that I was interested in showing with him.

**How long have you been in this studio in Gowanus?**

About a dozen years. I moved into this building along with fellow artists Glenn Ligon and Janine Antoni. We moved here together, all at the same time.

**Can you describe a typical day, being as specific as possible?**

A typical studio day would begin with getting up at 5:30. I'll meditate for an hour, and then I go to the Y and exercise. Then I either ride my bike or walk to the studio, and I'm here by 9:00 a.m. We have three kids, so there's all kinds of getting them to school and all that kind of stuff, but it's a pretty normal nine to five schedule. I don't know if that was influenced by Philip [Pearlstein] or just that I'm a morning person. Usually around 2:30 I'll try to meditate for an hour. I wrap up here around 5:00 or 6:00 p.m. After 5:00 p.m. I'm pretty useless, and my brain starts to melt. [*laughs*] I'll head home, help with dinner, hang out with the kids.

**Do you listen to music or the radio while you're working?**

I listen to the radio a lot, mostly public radio, WNYC. I've also been listening to Spotify. The last two playlists I made were Pere Ubu and Massive Attack. I play a lot of seventies music because that's my era and what gets the juices flowing. I used to listen to a lot of blues and am getting back into it, so there's Lightnin' Hopkins, Mance Lipscomb, Muddy Waters, Sleepy John Estes, Robert Johnson, Howlin' Wolf, John Lee Hooker.

Talk radio influences me negatively—it's a way for me to procrastinate. If I listen to music, I can work better. I like being distracted—that's just the way I work. Having no distraction is too much pressure.

Here's a weird thing about the typical day in my studio that's fairly recent but I'm a little reluctant to divulge it…I used to have this problem with food.

---

8. Kiki Smith (b. 1954), American. Artist whose work addresses themes of birth and regeneration.

I would bring my lunch, and I would eat it all by 10:00 a.m., and that would make me really tired and then really hungry. So for the past year, I eat three bites of food every half hour. It works perfectly. I have a timer set to go off every half hour. The timer goes off, and I take my three bites, though the bites can be as big as possible. [*laughs*]

**Can you tell me a little about your painting table?**

This table I made during that brief period I was in St. Louis in grad school. It's pretty crappy, but it works perfectly. There's nothing special about it or unusual except maybe the postcards that are under the piece of glass that sits on top, where I mix my paints. I don't know when I started it, but part of it might be a slightly childish rebellion against having gone to Yale. It's such a Yale-painter thing to have postcards of Piero della Francesca[9] or Italian or French painters pinned up for inspiration. I was never interested in that, so I have postcards of what I'm interested in. There are some very serious blues figures, such as Lead Belly and Robert Johnson. I love great comedy, so there's a postcard of Lucy and Ricky [from *I Love Lucy*]. There's a Cindy Sherman film still—she's from that generation just ahead of me, and I think she's one of the great contemporary art figures. There's an Albers[10] painting and a good depiction of Rothko's Chapel,[11] which is a special place for me. Also, there's a photo of the man standing in front of the tanks in Tiananmen Square, to remind me that there are people with incredible conviction and courage.

The most recent addition is a postcard from the Lygia Clark[12] show at MOMA. I went to MOMA to see Sigmar Polke,[13] which was also a great show, but I found the Lygia Clark show to be much more interesting and helpful and informative and useful.

**Can you tell me a little bit about the materials you use and how they came into your practice?**

I have very little material training in art. It's only now, at this late stage, that I'm starting to become an expert because I'm making my own oil paint, just for this particular project I'm working on. I'm starting to become very sensitive about what colors and pigments I use, but before, it was just anything. When I was making *Synecdoche* [the skin paintings],

I would purposely be inconsistent about my palette. I didn't want to automatically grab the three colors that I always used to paint the skin color. I would paint with whatever brands were on sale, which would sometimes make for a difficult situation because I would mess up a lot, but it kept me on my toes and kept me honest about how to mix colors.

[*pointing around the room*] Those paintings are done with acrylic; those paintings are made from an oil paint that I'm making. Those paintings are made from hide glue and whiting. I use egg tempera. I'd say I'm somewhat experimental with my materials, despite the fact that they are mostly very historical.

**Do you have a favorite color?**

My favorite color is Cobalt Violet Light. I'll look at the night sky, and it looks violet.

**Do you have any special devices or tools that are unique to your process?**

This is a spatula that a bakery would use to frost cakes; I make my skin paintings with that. At one point I was making these sky paintings that required being made in one stroke, so I made this brush by screwing a bunch of smaller ones together to make it ridiculously wide. This is a meat thermometer that I use to judge the temperature for encaustics; this red paint mark indicates when the temperature is just right for the wax encaustic for the belly paintings. These scissors are a particular weird kind of scissor that I think a seamstress uses? That's what I cut rubber with.

---

**9.** Piero della Francesca (1415–92), Italian. Early Renaissance painter whose work is notable for its serene humanism and incorporation of geometry and perspective.
**10.** Josef Albers (1888–1976), German/American. Abstract artist, educator, and theorist. He is best known for his color theory and his paintings of nested squares.
**11.** The Rothko Chapel is a nondenominational chapel in Houston, Texas, founded by John and Dominique de Menil. On its walls are fourteen paintings by Mark Rothko.
**12.** Lygia Clark (1920–88), Brazilian. Artist best known for her paintings and installations; sought to redefine the relationship between art and society.
**13.** Sigmar Polke (1941–2010), German. Artist who experimented with a wide variety of styles, materials, and subjects. His works range from the intimate to the monumental, the abstract to the figurative, the heroic to the banal.

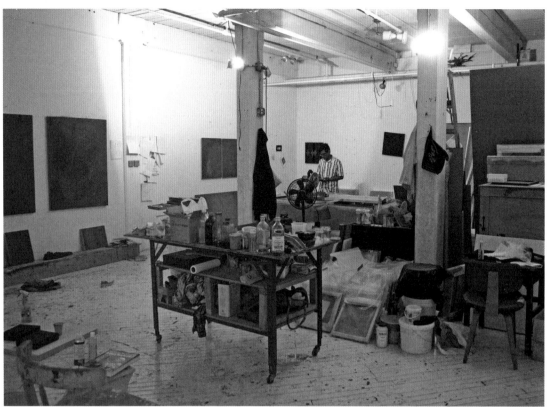

**Have there been any recent innovations in technology that have affected your work?**

I don't think anything's affected my work directly because I seem to be going backwards technologically, like mixing my own oil paints. I think that technology has affected me adversely in terms of being a huge distraction. I'm addicted to my iPhone. For a while I was trying to turn it off from 10:00 a.m. to 4:00 p.m. I've been trying to stick to the spirit of it, but I haven't literally been turning it off.

**How do you come up with titles?**

Despite the fact that I wanted to be a poet, they're not very interesting. My titles are pretty matter of fact. Maybe they can be somewhat poetic in their simplicity or in their relation to the facts or some kind of minimal aesthetic.

A lot of my work ends up being very personal or sentimental. This isn't a conscious thing, but maybe it's to counteract how cool they look. A lot of [the work] tends to have very personal subject matter, and sometimes in the title that's reflected.

**Do you have a favorite title?**

Yes: *Delacroix's Shadow*. It has to do with an anecdote about Delacroix[14] wanting to figure out the color of a shadow under yellow drapery. So he wanted to go to the Louvre and look at a Rubens[15] to see how Rubens would have solved it. He leaves his studio and hails a cabriolet, which were painted chrome yellow. A cabriolet is a horse-drawn taxi, and that's where we get the word *cab* from and why cabs are yellow. So he sees the shadow underneath the yellow cabriolet, and he notes it, and that's all

the information he needs. He doesn't go to the Louvre but goes back and finishes the painting. I made a painting about that, about yellow and its shadow.

**Do you have a motto or a creed that as an artist you live by?**

I finally realized there are only two things I need to do in my life, in the big picture and on a day-to-day basis. All I need to do is to make a good painting and to be a good person. It's so simple and so easy, but it's superhard to make a good painting, and it's really hard to be a good person all the time.

**What advice would you give a young artist that is just starting out?**

Don't be a slave to money, think as strangely as possible, and do everything for love. Maybe also— and I hope this doesn't sound too negative—I'd say don't come to New York. It's financially so difficult. You have to spend so much time working [at a job] to support yourself, which then makes it difficult for you to do your own work or have your own studio. I know that's not very positive, but it is really practical.

---

14. Eugene Delacroix (1798–1863), French. A leader of the French romantic school. His expressive brushwork and study of optical effects of color shaped the impressionists.
15. Peter Paul Rubens (1577–1640), Flemish. Baroque painter who emphasized movement, color, and sensuality in his work.

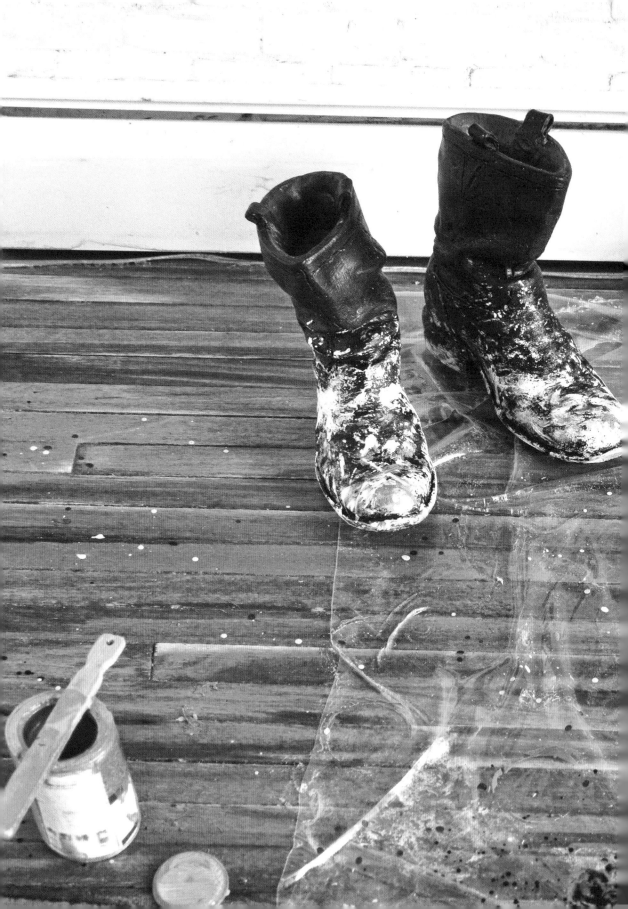

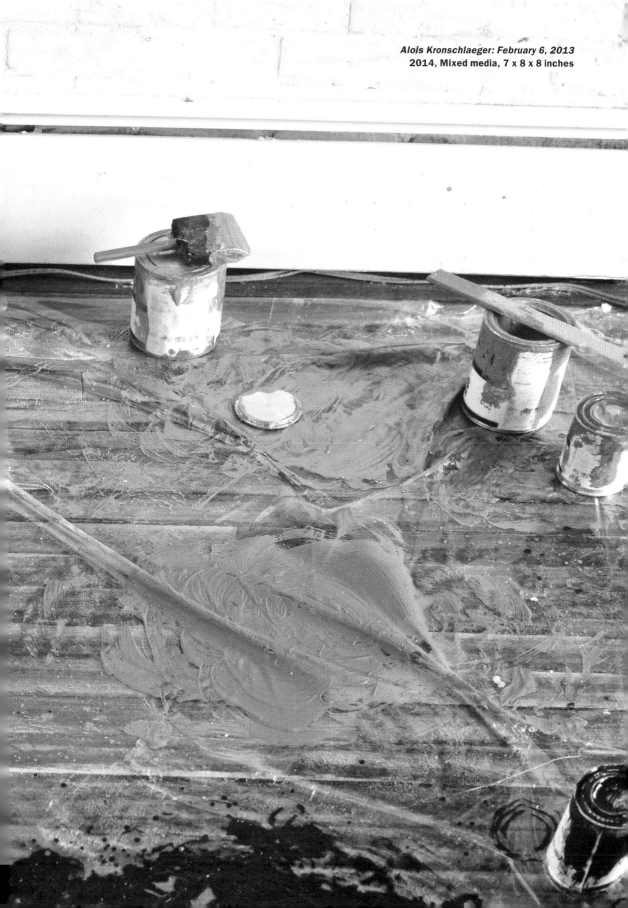

Alois Kronschlaeger: *February 6, 2013*
2014, Mixed media, 7 x 8 x 8 inches

# Alois Kronschlaeger

Greenpoint, Brooklyn / February 6, 2013

**To start off, can you please tell me a bit about your background?**

I was born in Grieskirchen, Austria. I grew up in a small town in the countryside. I never imagined becoming an artist; I thought more of becoming a theater or stage designer. However, I knew many artists because my brother Hans was in the scene. In 1986 I left Austria, and I hitchhiked through Canada and eventually ended up in New York. Three years later I had the idea that I would become an artist.

**When you were a kid you weren't into making art?**

I was not really making art, but I made drawings. I was growing up in the countryside, so I was building a lot of structures, little houses. My father was always doing drawings, but I, myself, I was playing in the fields.

**Where did you go to college?**

In 1997 I went to undergraduate school at SUNY Empire State College in New York City. I got my bachelor of arts in 2000. While I was still an undergraduate, I applied to graduate school. I applied to two schools: Columbia, which said no, and SVA, which said yes. I went to school for six years straight. When I went to SVA I was thirty-four years old, and I had done a lot of different things prior to going to college. Being an autodidactic person, I was traveling a lot, getting my own shows, my own site-specific work. If you would have asked me twenty years ago, I would have said, "Hey, fuck school." But now I must say I really loved it.

**When did you consider yourself a professional artist, and when were you able to dedicate yourself full time to that pursuit?**

I considered myself a professional artist when I got my first large, site-specific installation piece in 1997. Then I did another one in 2001, the *Longitude* project. It was a competition. The public supported it and it was funded. That was definitely a big deal for me, to work with an engineer who figures out the feasibility of the sculpture and have meetings with government officials about permits. The first site-specific piece was in Graz, Austria. That piece was a riff on a sundial, but a sundial measures the shadow within a day. I traced the shadow over an entire year, and on the day of the equinox, the gnomon—the pointer—casts a shadow, and the tip of the shadow makes a perfectly straight line.

Luckily, on that day it was sunny and the shadow could be traced, and the tip of the shadow followed the boundary of my demarcation line for the sculpture. I had an engineer calculate how tall the pointer needed to be in Austria on that day of the equinox when the sun is exactly above the equator. It was a complex piece.

**What would you consider your first gallery show, and how did that come about?**

The first real solo show was with Ed Winkleman [Winkleman Gallery], and this happened in part because of you. We were classmates at SVA, and you were showing with Ed. A number of SVA classmates were in a group show at Winkleman called *Transmotion*. After that several of us got

solo shows with Ed—that was in 2005. My solo show had work from my *Repercussion* series: paper crunched up with latex caulk lines, dealing with rectilinear to curvilinear topographical compression.

**And currently you're showing with Cristin Tierney [Gallery]. How did that come about?**
Winkleman fired a lot of his artists, and then I was in a show at Hendershot [Gallery] in their project space, when you had your solo show there. Cristin Tierney had a lot to do with Hendershot's program. She and I started talking, and she asked if she could do a studio visit. I was elated. I showed her a tiny scale model of a proposal that I'd intended for Winkleman, a ceiling installation. A few months later she called and offered me a show.

**How long have you been in this studio?**
Since 2007—five years.

**You live and work here. Is that what you prefer?**
I do prefer this situation. Right now I'm a workaholic; I like being surrounded by the work. I work with paint, and it has to dry, so at two o'clock in the morning I can put down another layer [of paint]. I go to bed, and in the morning I continue working, so I'm more productive in this situation.

**Did you have a plan for the layout of this studio, or did it develop organically?**
I had a plan because I was fortunate to see this space before it was divided. The double door I specifically ordered because I knew I had to have that to bring out sculptures.

The layout was basically two-thirds studio and one-third living space. Also I picked this space because of the very large window, the southeastern exposure. I wanted to have light because in my previous studio I only had frosted glass bricks for windows.

**Has the location of the studio had any influence on your work?**
The location, not directly, but the light, yes. I had been working with paper, but the first piece I did here, I used aluminum wire mesh mounted on a frame that sat in the window. It created certain transparencies where the light filters through my sculptural material. The paint layers [on the mesh] create shadows. It was a huge transition for me. The window piece has the effect of clouds, or you could say smoke or moisture. It's compressed. There are two layers: the silver mesh on the outside and the black mesh on the inside, and its appearance constantly changes, so throughout the day, depending on how the light filters through, it changes drastically like a moiré pattern. At night it creates a huge sculptural void because you don't know how deep those compressions are and what's the spatial depth.

**Can you describe a typical day, being as specific as possible?**
I get up around seven o'clock, make some coffee, check emails, jump in the shower, and then I start working. I usually work until one or two o'clock at night. There are a few things I do here in the studio: I work on small sculptures, I work on photograms—where I turn the entire studio into a darkroom—or I build scale models for large, site-specific installations. I would say that half of my work is site-specific.

**While you're working, do you listen to music or watch TV?**

I haven't had a TV in thirteen years. I listen to a lot of music, mostly Pandora. The Pandora stations I have are the Meters, New Orleans funk, then, of course, Johnny Cash. The Cramps—I love the Cramps. Sometimes Elvis Presley or Janis Joplin. Gal Costa, a Brazilian singer; a lot of funkadelic music; and even Maria Callas, classical, and Miles Davis. When I listen to music I'm tempted to dance. The music has to fit, or otherwise it would throw my concentration off. Sometimes you need a kick in the butt, and music can do that.

**Can you tell me about the materials you're using and how they came into your practice?**

What I'm using now is aluminum wire mesh. New York Wire Company in Pennsylvania produces it. There's a large roll—it's about six feet wide. That's the largest one they make, and it's thirty yards long. I really love the product, and it has a very good weave. It's very flexible.

I came across this product years ago when I built a scale model for a proposal in Austria. I used it over a wooden platform and wooden dowels to re-create the topography of a landscape. Now it's like my canvas.

**What kind of paints are you using on these pieces?**

A lot of different paints, from oil-based paint to acrylic to polyurethane and Polycrylic by Minwax. It has to do with viscosity. I love oil-based paints because they run really, really fast. Latex paint is like slow-moving lava; it creates a slow pool that

runs down. It creates something like landmasses. The oil-based paint is more linear—it runs faster—and the fastest-running paint is Polycrylic, which dries totally clear. It looks like water that's trapped in the mesh. That's where initially I worked out the idea of pouring paint onto these mesh sculptures. One day it rained on my mesh piece in the window, and I thought, Hey, actually this is interesting. What would paint do on the surface of that piece?

The paint makes you decipher the intricacy of a shape. For example, when you look at the piece in the window, you just see the mesh compressed. You don't really know how the shapes go—you can't see the depth or shadows. As soon as you start pouring the paint onto it, the composition suddenly becomes very readable and traceable.

What I'm now doing with the paint is mixing the colors but also creating different patinas. For example, this silver one is very, very bright. I would go with a chalky white latex paint on top of it. Then I use the spray bottles to wash it off, which creates a very thin layer. It allows me to have more control over the surface.

The earlier works were all monochromatic [paint] pours, in which case the lighting creates the shadows. Now I play more with things like how the light reflects within the piece and then pour on top of it. I have different cross pours. For example, on this one, you already have two pours. The clear goes horizontally, where the black goes vertically over the mesh, so there are multiple layers.

The wire mesh doesn't wrinkle or crease. I want to have very smooth folds, like baroque-

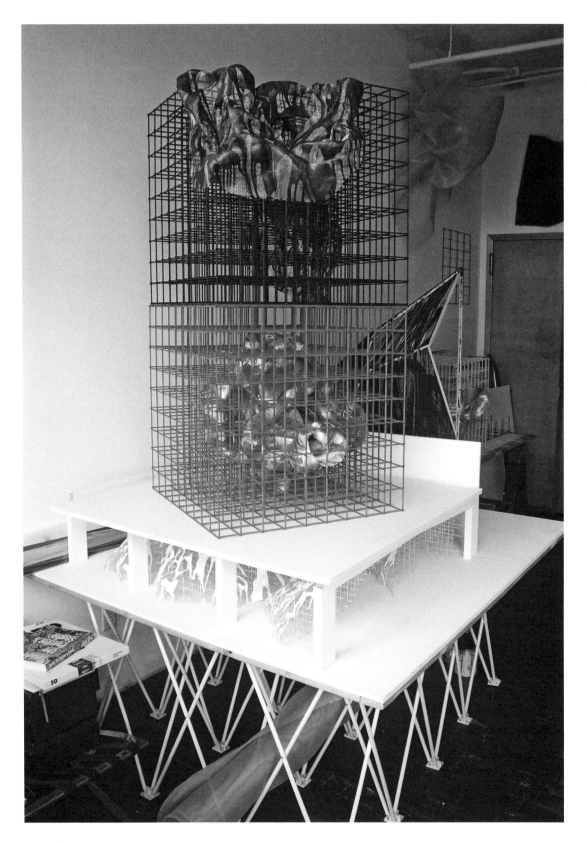

or rococo-type swirls, like swivels, where you don't have that hard edge. Within my earlier *Repercussion* series you have hard-edged creases, ridges, and crunches. With this work I want to have very smooth transitions.

I'm juxtaposing the 1960s with the 1990s. I'm thinking about Gilles Deleuze's book *The Fold: Leibniz and the Baroque*. I'm talking about the idea of how you map out space, creating biomorphic cavities that eat into that structure.

**Do you have a favorite color?**
Right now, I would say indigo blue. I find certain metallics or certain color combinations extremely interesting. I feel like I know too little about color, but that indigo blue really works nicely.

**Do you have any special tools or devices that are unique to your creative process?**
I do, and it relates to the paint and how I pour the paint. Right behind you is a funnel and hose; I use this to get the paint into crevices where the pouring cup won't fit. And then, for the very large, site-specific pieces like *Spire*, [a four-story installation] I did two years ago with SITE:LAB in Grand Rapids, my friend Florian made me a special tool that is a six-foot pole that can be extended up to sixteen feet. Mounted on the end is a gallon bucket with a string and a release mechanism. I can pull the string to release and pour the paint.

**A large part of your work are these enormous, site-specific installations that take up floors of buildings and hundreds, if not thousands, of square feet. How is working on something like that different than working on the smaller pieces, and how do you go about visualizing the large pieces and then actually go about building them?**
I absolutely love the shift in scale. I can work on a piece that's two feet by two feet by two feet and then work on a piece that's seventy-two feet tall by thirty-six feet by thirty-six feet. With the large, site-specific pieces I start by going to the location. I take photographs and measurements, and then I come back to the studio and I build a scale model. I've done three large installations so far, and I've found that there is a direct correspondence from the model to the full-size installation. For example, this project. [*points to a scale model for* Basin and Range *for* MOCA Tucson] The scale model took me two months to build. I know now it will take me two months to install the actual piece. On *Spire* there was this question of, "Would you build a structure from the top down or from the bottom up?" Because it was four stories tall, everybody would say from the bottom up. But no—actually the scale model taught me that I had to build it from the top down. If you have a piece of wood twelve feet long, it only takes one screw at the top to plumb it straight, then gravity plumbs the rest of the construction itself. If you were to build it from the bottom up, it would sway left to right and be much more difficult to make level.

I also learn from the scale model how much material I'll need to use. For example, this will need 1,500 two-by-twos, twelve feet long. The scale models are very exact. People ask, Why don't I do a SketchUp drawing or a computer-generated image?

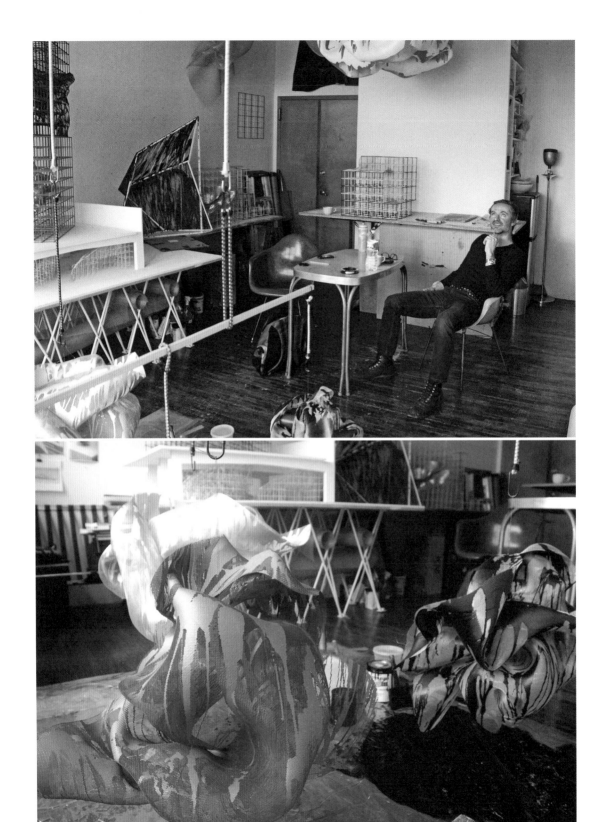

Because using the scale model, I can also figure out the lighting: how the lighting affects the mesh, the paint, the grid, et cetera. So I figure out the material and then how many assistants I need. I get a good sense of what it's going to entail. It's easy to place yourself within the scale model and let your assistants know where and what you are working on. That's where I build the grid structure, and then I cut into it. I shave it. I sculpt it. Then I tweak it, and when I install the real thing, I always have the scale model; it acts as a reference.

**Do you work on one project at a time or several?**

Several. I like switching from one to the other. While one's drying I'll work on something else or do drawings or work on photograms. With the photograms it's a little different because I have to shut down the entire studio to turn it into a dark-room for two days. But then while one thing is drying, I'll work on something else.

**Tell me about your assistants.**

I have assistants on the large installations. On the last project, *Habitat*, my wife, Florencia, helped me for about three weeks, and then I had about three or four people helping me for three weeks. With the big installations, there are always about four people helping me for about a month or three weeks or six weeks. In the studio, I have none.

**Did you ever work for another artist, and if so, did that have any effect on your work?**

I was in collaboration with another artist many years ago. Her name is Yumiko Kokubo. We collaborated for about three years, from 1989 to 1992. I started off being an assistant, but then got more involved, and then suddenly it was collaboration because it dealt a lot more about design. A lot of screens, mesh, Japanese paper, sculptural objects…that was extremely interesting. I learned a lot from her in the sense of work ethics and what's a mock-up and what's a real thing.

**Do you have a motto or a creed that, as an artist, you live by?**

Yes. Coming out of graduate school and preparing for my first show with Ed, I was doing a lot of freelance work on the side; I divided my day into three seven-hour units. I call it seven, seven, seven.

[*laughs*] Seven hours of sleep, seven hours of making money—teaching, the gallery selling work, or freelance jobs—and seven hours in my studio to do my art. The other three hours are used for traveling between the three locations.

I've been in New York for so many years, and I've seen people become extremely successful or really fuck up royally or become very sinister. If you put everything on the same priority list, then there's not an excuse why you cannot do your work, because everything is an equal priority. There's no reason why you wouldn't have time with that balance.

**What advice would you give to a young artist that is just starting out?**

Go for it! See a lot of shows. I think graduate school is really important to meet your peers, to create your own network. There is that social fabric of knowing other artists that are producing work. One thing that I got out of graduate school is what David Shirey[1] said. Within thirty-five thousand years of art making, where does your work fit? Within what time period, and why are you doing it now? So if you can think about that and reflect upon that, then you also have to realize that you're in it for the long run. Your work has a certain trajectory, and how does your work evolve within certain historical relevance?

---

1. Founder and former chair of the School of Visual Arts MFA Fine Arts program.

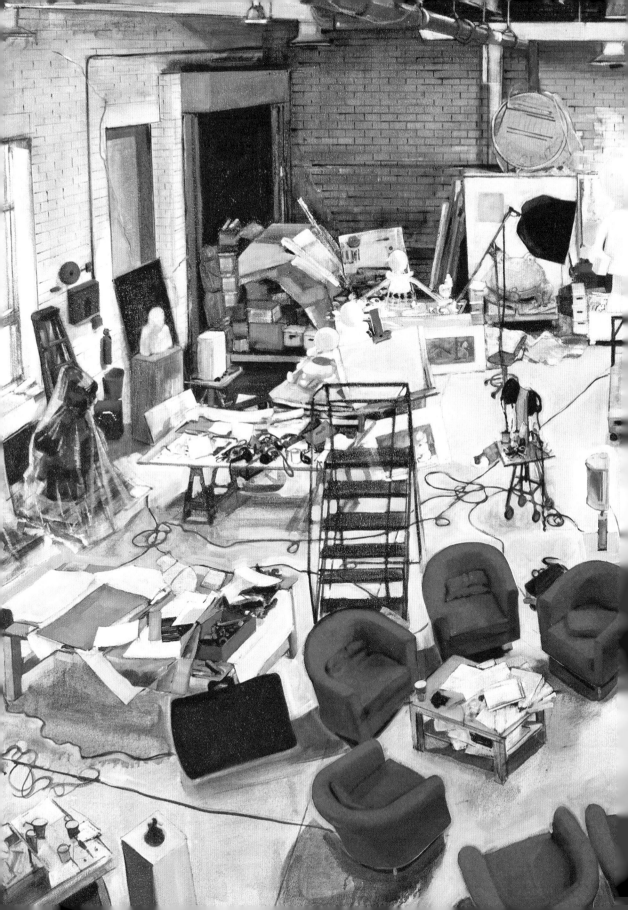

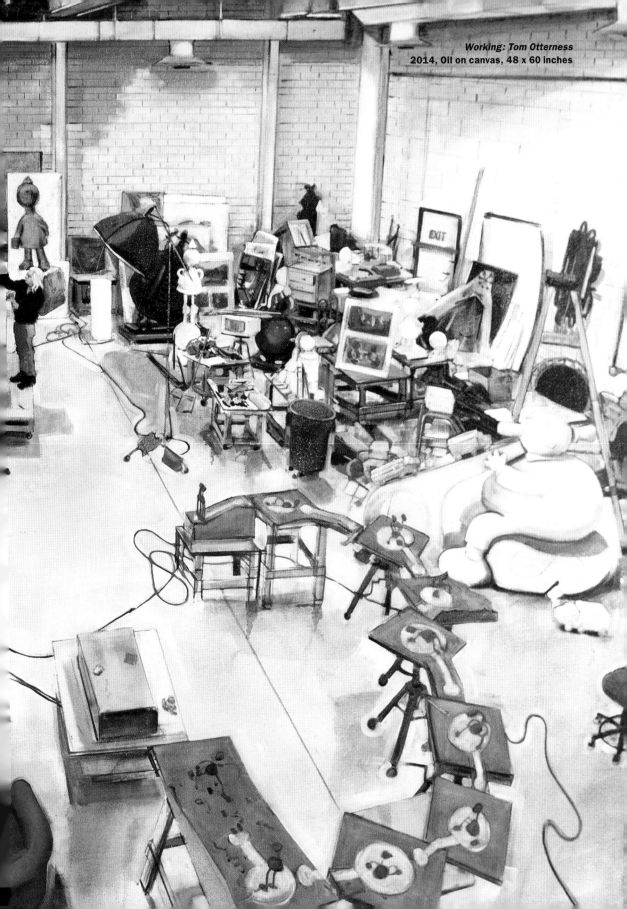

*Working: Tom Otterness*
2014, Oil on canvas, 48 x 60 inches

# Tom Otterness

Gowanus, Brooklyn / January 24, 2014

**To start off, can you please tell me a bit about your background?**

I was born and grew up in Wichita, Kansas. I went to Southeast public [high] school. My art teacher, Don Weddle, gave me a lot of support. In senior year he would let me leave school to go to my studio. Also, there was an extraordinary couple, Bill and Betty Dickerson, who taught at the Wichita Art Association, an independent art school. They had almost-naked models who wore little tiny bikinis. My mom first took me there when I was eight, and I was looking at the floor, saying, "I can't do this!" [*laughs*] But I went back at thirteen. For painting class we did really sophisticated stuff for the time, sort of à la Diebenkorn,[1] and studied theories from the Bauhaus. Betty had *Artforum* magazines. They knew the Hoppers.[2] David Salle[3] and I both studied with the Dickersons and shared studios during these years. This would have been from 1965 to 1970.

**Do you remember an early art piece that got recognition?**

The earliest was a little lion that I made in the third grade. It was sort of my Jackson Pollock. I dripped every stain, every glaze onto it. I still have it.

**Where did you go to college?**

I didn't go to college. I hated school. I decided after high school that I would go to art school. I ended up with a scholarship to the Art Students League in New York. I just came straight to New York, not knowing anybody or anything. Then I went for one year to the Independent Study Program at the Whitney [Museum of American Art]. I may be the only person to get in without a college degree. That really changed how I looked at the art world. I met my wife, the filmmaker Coleen Fitzgibbon,[4] there.

**Where were you living at this time?**

In a loft on Mott Street with no internal plumbing. I showered in the sink in the hallway.

**When did you consider yourself a professional artist, and when were you able to dedicate yourself full time to that pursuit?**

[It took] ten years before I could do that. At that time there was no way to make a living inside the art world. We all had jobs. I worked at the [American] Museum of Natural History. I was a night watchman for five years. I Sheetrocked. I did odd jobs. Jenny Holzer[5] was a typesetter. Kiki Smith did some EMS work. Coleen worked in a microfilm lab.

---

**1.** Richard Diebenkorn (1922–93), American. Painter identified with the San Francisco Bay Area Figurative Movement of the 1950s and '60s.

**2.** Edward Hopper (1882–1967), American. Prominent realist painter and printmaker.

**3.** David Salle (b. 1952), American. Postmodern painter whose works combine what appear to be randomly juxtaposed or overlapping images.

**4.** Coleen Fitzgibbon (b. 1950), American. Experimental abstract film artist and cofounder of the alternative arts collective Collaborative Projects, Inc., or Colab.

**5.** Jenny Holzer (b. 1950), American. Contemporary conceptual artist known for her LED signs and projections.

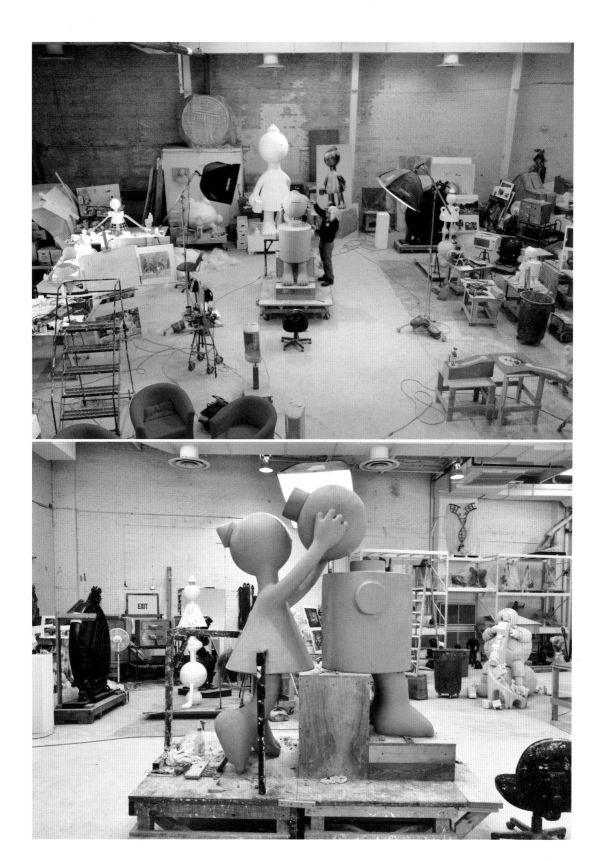

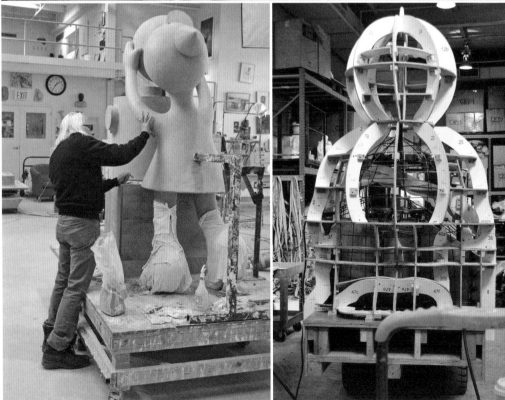

**How did you get your first real gallery show?**

I joined a group of fifty artists called Collaborative Projects,[6] or Colab, in 1976. We started having exhibitions at Robin Winters's and Coleen Fitzgibbon's lofts. Then larger shows—*The Real Estate Show* and *The Times Square Show*—followed in 1980. At Times Square we took over an old massage parlor on Forty-Second Street, a whole building. That was a big, public event. Nobody was known at the time; Jenny Holzer, Kiki Smith, Jean-Michel Basquiat, Keith Haring, Coleen Fitzgibbon, David Hammons, Jane Dickson, John and Charlie Ahearn all came out of that show.

After that show Brooke Alexander came and selected some artists from our group and supported us. He offered me a show at that time. That was 1982. I got a stipend from Brooke, and that's when I could quit my job. I was thinking a lot about Sheetrock walls and decorative plaster. I did a plaster frieze around the gallery with a narrative about a kind of sexual revolution. We sold it by the foot. Before that, in the 1970s, I sold these little plaster sculptures for $4.99 out on the sidewalks. That was my first major public work. [*laughs*]

**You did mention earlier that you were painting. Was there a transition from painting to sculpture?**

In 1970 at the League[7] I studied with Ted Stamos,[8] and I did big black paintings. Rothko[9] was God to me. Then I got into the Whitney. At that point, in 1973, painting was dead. You read it in the newspapers. [*laughs*] So, I did some film; I did photography; I did conceptual art. The first sculptures started almost like a conceptual art joke: I'm going to make mass-produced sculptures like I see in botanicas on the Lower East Side. I taught myself.

**Currently you show at Marlborough Gallery. How did that relationship come about?**

Brooke made radical changes to his gallery at one point, and I felt that I had to make a switch. Red Grooms[10] contacted me and made the connection to Marlborough. I've been there a long time.

**How long have you been in this studio?**

About eight years. I moved from a slightly smaller studio in DUMBO. I'd been there for fifteen years.

**When you moved into this space, did you have a plan for the layout, or did it develop organically?**

Because I'd done so much architectural work, I made a model of this studio on the computer, and then we built a foam core model. I based the structure of it on what I liked at Dick Polich's foundry [Polich Tallix].[11] The way he did it was to have offices and a mezzanine divide the enormous space in half. Above the offices was a walkway so you could look down on production from above— it gives you the feeling of being Il Duce overseeing your employees. [*laughs*] It's also a good sound barrier between the noisy stuff on one side and my quiet studio on the other.

**I am surprised by how quiet it is in here. Also the lighting is fantastic.**

It is beautiful. This place used to make Hoover vacuum cleaner bags.

**Can you describe a typical day, being as specific as possible?**

These days I'm not working as long and late hours. I get up maybe sevenish. I like the mornings. Coleen and I have breakfast: oatmeal and tea. I'll get to the studio at eleven o'clock. I might go to the gym. I might have another breakfast—some eggs—and then I come in.

---

6. Collaborative Projects, Inc., known as Colab. Artists' collective formed in 1977; the group created its own exhibitions and became a nonprofit entity supporting exhibitions.

7. The Art Students League, a New York City art school founded in 1875, offering classes for both amateurs and professionals.

8. Theodore Stamos (1922–97), American. Abstract expressionist painter known for his passion and originality of vision and for exploring the role of nature in the creation of abstract art.

9. Mark Rothko (1903–70), American. One of the most famous abstract expressionist painters, known for paintings of soft rectangular forms floating on fields of stained color.

10. See pages 110–17.

11. A fine-art foundry located in upstate New York, known for superb craftsmanship and technological excellence.

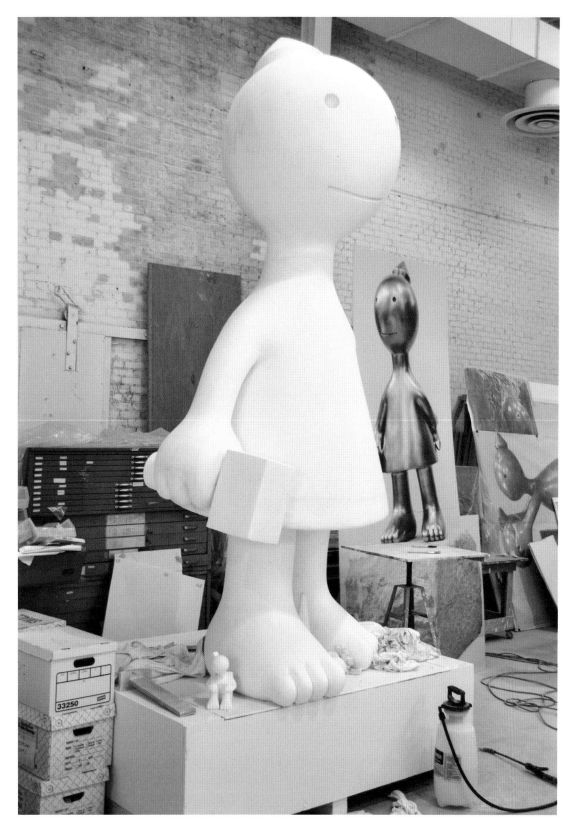

Often it's office work for the afternoon. That could be four to five hours. I think the office work is as much a part of making sculpture as building armatures: getting the jobs lined up, fixing the details. These are long jobs—five years or more. I often say that inspiration comes from cash flow meetings. [*laughs*] We've got targets about what sculptures I need to finish by what dates so I can meet some payment schedule in the contract. Whether I'm depressed or not, I work. You can't wait for inspiration. You've got a job; you've got to get it done. I find the work turns out the same whether I'm depressed or happy. There's no difference.

Then everybody goes home and I get the studio to myself. It's quiet. I can play the same dumb music over and over again. I can work. Some nights I might work until 2:00 a.m. Some nights I get home by midnight. In the past I was more obsessive and could work thirty hours straight if I got into it.

Some days I'll go to the movies in the middle of the afternoon. I'll go to William Chen's tai chi classes a couple days a week. My chief guy here at the studio, Necmi Murat, describes it as us being two football players running down the field with the ball, and I'll pass him the ball during the daytime. He'll organize the crew to work in the mornings. I can come in late and pick the ball up from him and carry it through the night. I'll leave him written notes, and we understand each other. I'll mark the clay and tell him what to do. Then he'll get the crew and work on it the next day while I'm sleeping. That will go back and forth until the job is done.

**This is a big operation, and yet you still come to that solitary time of just being with the work alone.**

I do a lot of the formwork that's very subtle—it's pleasurable to me. I don't have other people do that. It's a kind of a meditation. It does let your mind roam. I'm in an atmosphere with all of my other sculptures around me. You start making connections. It's not just the mechanics of the work but the new work comes out of those quiet times.

It's like I have this little guy on my shoulder. You have to relax to get in touch with him, but there's an intuition that says, "Tom, you have to take off a little bit over there and adjust that part over here." When the little guy stops talking, you're finished.

**Can you tell me about the materials you use and how they came into your practice?**

They're mostly traditional materials. Instead of going to college for sculpture, I bought Louis Slobodkin's book *Sculpture: Principles and Practice*. He was a WPA [Works Progress Administration] sculptor. It cost $8.95. He had everything in it. It's all water-based clay, very traditional. It teaches you how to do reliefs, enlarge, make armatures—all these different things. I would learn step-by-step. At the time I was Sheetrocking at Excalibur Foundry in Brooklyn. I would learn from the mold-maker guy how to make molds. I stayed on that very traditional path. When I did my first bronzes I went to Italy and worked in Pietrasanta for a year. It's even more traditional there—real old school.

**What did you think when you saw your first work cast in bronze?**

It was very difficult because politically I was on the side of plaster and concrete. Bronze has a lot of upper-class baggage. I sold it to myself when the Battery Park commission came along. There are other materials that are interesting for sculpture, but I haven't found anything that matches bronze for long-term durability. The more it's handled, the better it looks. I remember being in Italy and seeing the Giambologna doors [at the Pisa Cathedral] and seeing the head of the baby Jesus rubbed to almost nothing after five hundred years of people touching it. They looked great.

**The same could be said of your work at the Fourteenth Street [and Eighth Avenue] subway station.**

Almost nothing else would hold up in that situation. So then bronze became a mainstay for me.

The studio works in tandem. I get commissions on the one side; I guarantee them a large complex work and won't reproduce the whole thing anywhere else, but I retain the rights to edition the small-scale work out of it. And the sales from the private sector then subsidize the public work so that I can almost always put more money into the public work than I get from the commission.

**Do you have any special devices or tools that are unique to your process?**

I do like staying generic. I like a number 2 pencil.

**Are there any specific items that you keep around the studio that have significant meaning to you?**

Yeah. I don't throw things away. That oil pastel over there I did in high school—it was part of the portfolio that got me the scholarship that brought me to New York. In the office I have the lion from third grade. I also keep my friends' work. There's a Kiki Smith cast-iron intestines on the wall, a collage by Coleen and Robin,[12] portrait busts by John Ahearn[13]—all work from that original Colab gang—or others from Whitfield Lovell[14] and Fred Wilson.[15]

**Are the pieces you're currently working on for a show?**

This is for a show, but almost without exception, most everything that I do results from a public commission. These originally were models that I made for a limestone project at MAG [Memorial Art Gallery] in Rochester, New York, called *Creation Myth*. That was for me a new area. Twelve-foot-high limestone pieces. The idea was the Pygmalion myth.[16] Normally the guy is carving the woman out of stone and kisses her and she comes to life. But this is a gal carving a guy out of stone. I'm doing bronzes, stainless steel, limestone, and white marble. From the beginning I've liked the idea that I'm taking a public client instead of an upper-class client.

**What was it like to see your first giant public sculpture?**

The one that jumps to my mind is this commission in Germany at the state library in downtown Münster [*Die Überfrau*, 1993]. It's a sculpture about making sculpture that was inspired by pictures of the Statue of Liberty half-assembled. It's thirty feet high. It's big. I remember standing under that for the first time in the foundry. It was at night, and the stainless steel was lit. It was like, "Ohhhh." But even with the earliest sculptures, like these little plasters, I thought, I'm making little monuments here. I always had that in my mind—that they were small-scale models for huge sculptures, and these were the souvenirs.

**How do you come up with titles?**

At the very end, under enormous pressure. [*laughs*]

---

**12.** Robin Winters (b. 1950), American. Conceptual artist known for installations with an interactive performance component.
**13.** John Ahearn (b. 1951), American. Original member of Colab known for life-cast portraits of everyday people, especially residents of the Bronx.

**14.** Whitfield Lovell (b. 1959), American. Artist known for his drawings of African American individuals from the first half of the twentieth century.
**15.** Fred Wilson (b. 1954), American. Artist known for works that reconsider social and historical narratives and raise questions about the politics of erasure and exclusion.

Often I've got to have a main title for a very complex work. I try to get something with double meanings. For example, *Life Underground*—because the subway's underground, but it might be the political underground. I look for titles that amuse me in some way.

**Did you ever work for another artist?**

I worked for the neo-dadaist Sari Dienes.[17] When I worked for her she was a big part of A.I.R.[18] She gave me a sense of how women get cut out of history. I liked her a lot, but in general I avoided working for artists. I didn't want to work inside the art world. I wanted to have something distinct from my practice. Working at the Museum of Natural History I liked a lot. Sheetrocking was rough, and you wanted to get out of it and make more money and get more time for yourself. There's a distinction, a clarity, between what you're doing for money and what you're doing in your studio.

**Do you have a motto or creed that as an artist you live by?**

There was the motto from the Art Students League, which says in Latin, "Never a day without a line, never a day without drawing." But I don't practice that. [*laughs*]

There is a Chinese saying I do follow: "Be as careful at the end as you are at the beginning." That has saved me from disaster many times.

**What advice would you give to a young artist that is just starting out?**

Persistence. One of my favorite teachers was Robert Beverly Hale[19] at the League. He would try to discourage people from becoming artists because he'd known so many brokenhearted artists. So that might be the first bit of advice: you have to have enormous resilience.

---

16. According to Greek myth, Pygmalion was a sculptor from Cyprus who falls in love with an ivory statue he has carved and brings it to life.

17. Sari Dienes (1898–1992), American. Artist who worked in a variety of mediums and used experimental processes. She is known for drawings that challenge the traditionally held views of that medium.

18. A.I.R. Gallery was established in 1972 as the first all-female cooperative gallery in the United States, founded to provide exhibition space for women artists.

19. Robert Beverly Hale (1901–85), American. Artist and curator of American painting at the Metropolitan Museum of Art. He is well known for his book *Drawing Lessons from the Great Masters* (1989).

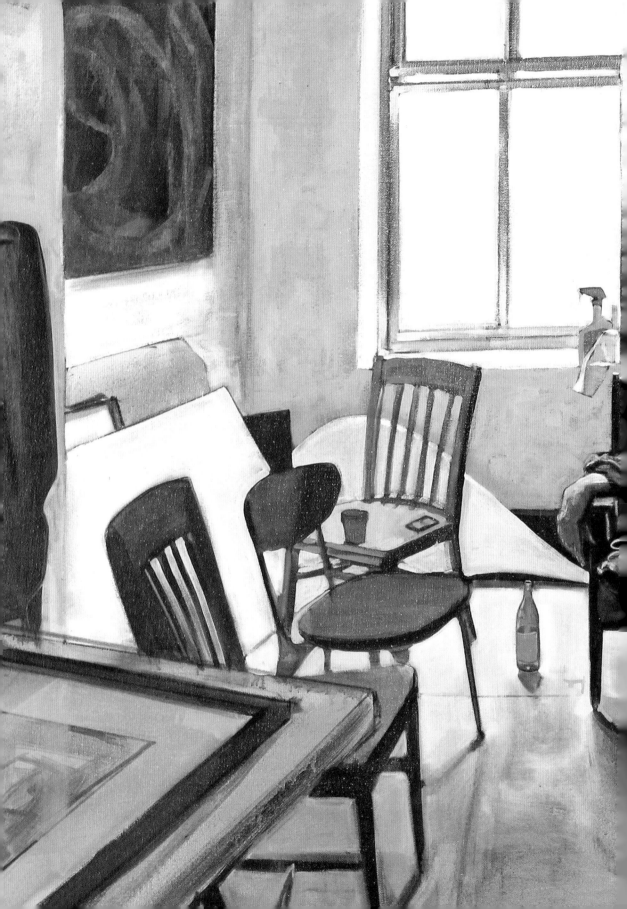

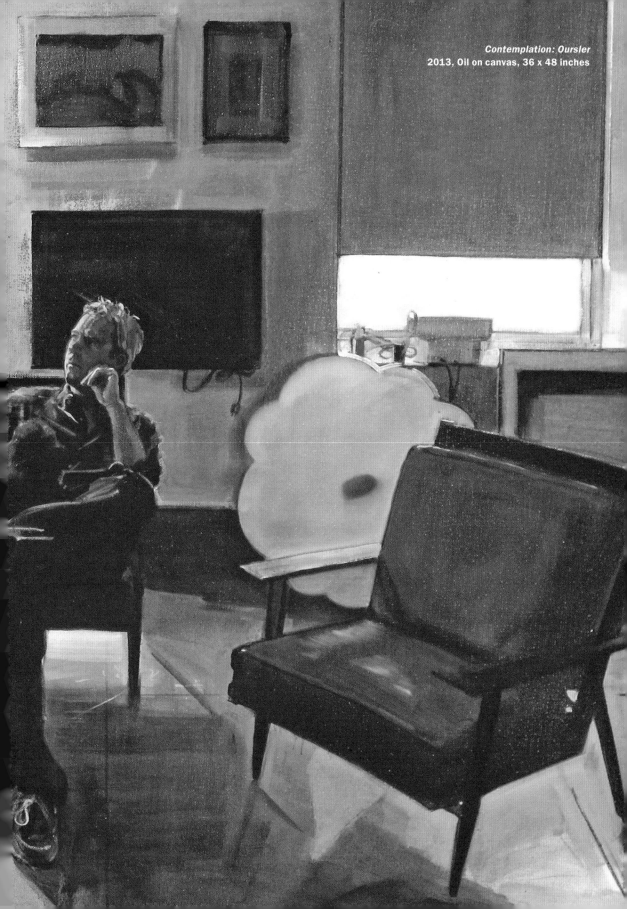

*Contemplation: Oursler*
2013, Oil on canvas, 36 x 48 inches

# Tony Oursler

Lower East Side, New York City / May 7, 2013

**To start off, can you please tell me a bit about your background?**

I grew up in Nyack, New York. My junior high school had a pretty good art program, but at Nyack High School it was a bit dodgy, although they used to paint the store windows in town every Halloween. I always helped with that, and that was really fun. I liked something about it being this weird public space: painting in front of the shoppers, and the ritual involved with Halloween, and marking up these windows with these Goth images—even the destruction of the images by the rain afterwards [because we used tempera paint]. They looked so amazing as they were melting—that made a big impression on me.

I was already painting quite a bit by the time I was in junior high school. I had a group of friends who were into art as well, and it was like a think tank. My mother took me to museums and art classes from an early age. I was already into Jasper Johns,[1] Rauschenberg,[2] and Salvador Dalí[3] and making oil paintings. I was very serious about it. I was lucky because that town is a very artistic town. I worked in a frame shop with Leon Alamon and

his wife, Joan, who were both painters. They were giving me books such as Kandinsky's[4] *Point and Line to Plane.*

I see my life as a bunch of lucky coincidences—that I worked in that frame shop and met the Alamons and that Nyack happened to be where Edward Hopper and Joseph Cornell[5] both grew up. Also, Nyack is so close to Manhattan.

**Do you remember an early art piece from childhood that got recognition?**

It would be a painting that I still have from when I was three, of the Tappan Zee Bridge in the rain. I remember it somehow being a good experience, maybe because my parents liked it—they must have, because it somehow has survived all these years.

I used to sell my paintings for seventy-five bucks when I was a kid. I probably sold five or six paintings. When you're a kid it's all about skill. Of course, I wanted to be an artist, but I also wanted to be many other things, and it didn't seem that realistic to me at the time.

However, I had a great-aunt, Zita Melon. She was always presented as "Aunt Zita—she's an artist." She was a schoolteacher, and in her retirement

---

**1.** Jasper Johns (b. 1930), American. A central figure in the contemporary art world since the 1950s. His paintings, sculptures, and prints appropriate popular iconography such as flags, targets, numbers, and letters.

**2.** Robert Rauschenberg (1925–2008), American. A seminal figure in the contemporary art movement, known for works that combine painting and sculpture, as well as for large-scale screen-printed works.

**3.** Salvador Dalí (1904–89), Spanish. Artist known for his wildly imaginative surrealist masterworks.

**4.** Wassily Kandinsky (1866–1944), Russian. Painter and art theorist who analyzed color and form in relation to the painter's inner experience. He was one of the first artists to explore abstraction.

**5.** Joseph Cornell (1903–72), American. Artist influenced by surrealism who is known for his intimate boxed assemblages.

taught painting to locals in New Jersey and then South Carolina. She did everything: knitting, plate painting, and any kind of craft. So I had that image of someone who actually was an artist, making a living doing that. I think it's really important for young people to see someone like that.

**Where did you go to college?**
I transferred to Rockland Community College for my senior year of high school. There were a lot of guys who taught there that were functioning artists from New York City. I had a serious design class with Kaare Rafoss.

I wanted to go to Rhode Island School of Design because in the early 1970s that was the place. Everybody on the East Coast went there. Kaare said to me, "No, you really don't belong there; you belong at CalArts in California." I thought, No way—everybody that goes to California is a pothead and dropout. Turns out, I didn't get into RISD. Kaare called up CalArts for a late application, and with his help I ended up going to CalArts.

That was the luckiest thing that ever happened. I didn't know anything about conceptual art. I'd never even heard of it. There was a strong contingent of California conceptual artists there: [Jonathan] Borofsky, [John] Baldessari, Michael Asher, Douglas Huebler, Susan Rothenberg, Ellen Phelan, John Cage, Laurie Anderson. I see now that this was a decisive moment in my life.

My big thing was the transition from painting to video or the combination. That happened really quickly, within the first year that I was there. At CalArts the academic environment had a rigorous

level of inspection of what your ideas were and the premise of what you might be creating. That challenged me. Being in school was an explosion of all these premises and starting anew, which was just what I needed at the time, although quite painful. Becoming an artist is about a relentless kind of reality check. To really make a move [creatively], you have to abandon certain ideas and pull other things forward. Also the notion of the moving image being something that people could play with.

**So what year is this around?**
1976, '77. At that time there was no access to video—none. Instant playback was impossible. You could have gotten a film camera and projected images, but that took days to develop. I knew how video sort of worked, but it was mysterious. It was a gestalt moment for me. Being a TV-generation person, I watched TV all the time. To be able to move through it, into it, and be able to manipulate that was a real eye-opener. It was the beginning of my use of technology. There were only a handful of people who were doing the same thing at that time. If it had been ten years earlier or later, my story would've been very different.

**You mentioned growing up on TV. I hadn't considered the relationship of video art to television.**
I had seen some of William Wegman's[6] work in college, but it was really early times for that medium.

---

**6**. William Wegman (b. 1943), American. Pioneer video artist, conceptualist, photographer, painter, and writer.

**When did you consider yourself a professional artist, and were you able to dedicate yourself full time to that pursuit?**

It was my primary identity when I went to CalArts. At that time there was no notion that you could make a living as an artist, which is the big difference between now and then. It was a state of mind; it was not an economic thing. You had a job, which you had to do. You made work in your spare time, which is what you wanted to do. That's what I did for many years. When was I able to only make art? That was in the mid-1990s.

**Did something come about to allow you to do that?**

I was able to sell work. I had a lot of activity with my work showing in alternative spaces and museums. In 1983 *L7-L5* was shown at the Kitchen[7] and then went to the Stedelijk Museum in Amsterdam. It was an incredibly thrilling time for me: I was doing installations with video, single-channel videos, and some performances. With video you can just send a cassette to be included in a show, so I was having shows in Japan and Europe.

**How did you get your first real gallery show?**

John Baldessari[8] told me to send videotapes to different people. I was in a show when I was in school at LAICA in LA;[9] I showed a video called *The Life of Phyllis*, which was a soap opera with handmade sets and dolls. Then I showed at the Kitchen.

Gallery shows came later. I worked with Diane Brown for some time. Metro Pictures gallery was interested; and I had a lot of friends who showed there. I met David Maupin, who was working for them at the time. Then he opened his own gallery [Lehmann Maupin Gallery] with Rachel Lehmann, who also had a relationship with Metro. We always kept in touch, and so I have a weird circumstance where I have two galleries in New York. Soon I'll have three because my London gallery is opening up here, too. Oops.

**How long have you been in this studio?**

I've been here for twelve years.

**Do you live and work in the same location, and does that affect the work?**

I live upstairs. I like it. I've always lived and worked in the same place. It started out economically because I couldn't afford a studio, so I worked in my home. When I was broke I worked in the same room that I slept in. It used to be that I would work at weird hours, but not anymore, since I've had a kid. I'm locked into the school schedule.

**Did you have a plan for the layout of the studio, or did it develop organically?**

It's not planned—it's reactive. I consider it a malleable space because many different things happen at different times: I do the video shooting here, the audio recording, the performative elements, the painting and sculpting.

The cool thing is that it's two buildings that are attached, so it has a very catholic digital bifurcation—much like the occupant. This side of the first floor has the office with my books, printers, and photo archives and our meeting area with some inspirational objects. The room next door has flat files but is primarily the shooting studio; it's where I stage installations. It's organic because oftentimes I'll have to stage in two spots. I need a lot of flexibility. The basement is used for editing and the archives. I also have a small room for metal and woodworking, as well as the video archive and the computer area.

**Has the location of this studio had any influence on your work?**

I don't think so, except for the fact that it has incredible light. It's a very peaceful area to live and work in. It's a unique part of the city. When I'm upstairs and look out the window, I'm looking at trees. You could be anywhere. I like that this area has history. It's old New York, and it's off the grid—the streets actually move on a different axis. This building has this really great New York

---

7. The Kitchen, located in New York City, is a nonprofit, experimental performance space founded in 1971.
8. John Baldessari (b. 1931), American. Conceptual artist known for his work incorporating found photography and appropriated images.
9. The Los Angeles Institute of Contemporary Art was an exhibition venue that showed experimental work. It operated between 1974 and 1987.

immigrant history. And of course the Henry Street Settlement, the first altruistic organization in America, is right on this block. I like that. I'm proud of that. I'm always thinking about the connection of space and history; that has in some abstract way affected me.

**Can you describe a typical day, being as specific as possible?**

I get up a little before seven, have coffee, get my kid breakfast, work out, begin thinking about what's going to happen in the day. I make a list, read my email, and communicate with whomever I need to. I make a game plan for that day.

Today…I'm looking for birds. I need to shoot two crows, so I'm trying to find these crows. Yesterday I was shooting a chorus of women for a cave installation that I'm making in Oslo. I've been working on this script for a while. Before the shoot I have to fine-tune the script—I'm feverishly working on that. I'm working on a project for Venice, one that I'm finishing editing, so I'm working with my editor on the flow and overall mix of things. Then balancing a certain amount of grunt work in technical emails.

It's a battle between creativity and the basic detritus of day-to-day existence. How does that thing sit on that wall? What's that wall made of? Do we have the right electrical splitters for this piece? Stuff like that: battling that minutia while trying to keep my eye on the magic moments. I always try to spend as much time as possible each day moving forward creatively in a kind of dream space, if I'm lucky.

**Can you tell me about the materials you use and how they came into your practice?**

The hydra-headed beast known as the computer has taken over our lives. It processes everything from the photographs to the video animation to the video recording to the audio mixing, blah, blah, blah. So it's all computers all the time. It's a hateful process, but it's there.

Then I'm doing a lot of glasswork. You see a lot of glass sculptures lying around here. I'm just in love with that material, as I use it as both a screen [to project onto] and also as a sculptural object.

New materials are always really exciting. We recently did a lenticular invite and are trying to work with graphene, a new transparent flexible screen.

**The big plaster-looking pieces that you project onto, what material is that?**

That's Aqua-Resin. I use a lot of Aqua-Resin, which is a nontoxic resin. It's pretty easy to use, fast-drying stuff, which I work with, coating various things, such as wood or foam. There are also a lot of found objects I use. I find a lot of stuff on the Internet.

**Do you have any special devices or tools that are unique to your creative process?**

I don't know of that many people who project on glass. I'm always trying to bring more materials in. A lot of the physical properties of art are based on the way we see, which involves light reflecting off the surface. I was always interested in the moving image and combining it with sculpture and looking into worlds that I build. I'd been turning

this world inside out: screens into sculpture, sculpture into painting, back and forth and back and forth for the camera. Setting the video monitor to reflect onto the surface of water or mirrors or glass, and working with that Pepper's Ghost[10] effect.

When these small video projectors came out, it clicked that I could project onto the surface of objects. That was a big breakthrough. Now I see it as an interruption in the way we see, which I didn't think about so much in the beginning, but I now I realize it's really important to me.

**The video world is a little foreign to me. There's so much expensive equipment involved. Is that something you personally buy, or do you have the gallery or the place you're showing help fund that?**

It could be a combination of things. For example, this piece [in the studio] is going to Louis Vuitton's space in Venice. They have a budget for equipment and production costs. They were generous enough to get the gear and help with some of the glass production and things like that.

Then sometimes I have to have my own gear. We have the printer, the computers—things like that. I try to defer the cost as much as I can; in fact, that will be the make-or-break aspect of whether I can get involved in a project. I'm not independently wealthy, so I can't just buy a giant stack of monitors. I keep prototypes around. I have a few projectors around that are the basic workhorses. I try to keep it lean.

**Are there specific items that you keep here that have significant meaning to you?**

Oh, yeah. All this stuff has meaning to me. I'm a mad collector. The things in this room are only the tip of the iceberg. I have work by artists such as Nam June Paik[11] and Rudolf Schwarzkogler[12] that have really inspired me, as well as artist friends who also inspire me, such as Mike Kelley, Jamie Cameron, Ericka Beckman, Constance DeJong, and Jim Shaw.

But then there's a lot of pop culture vernacular. I've got some [Margaret] Keane pictures up there. I've always loved Keanes, you know, the paintings of the big-eyed girls. They're spooky and have inspired pieces I've done through the years. There's an actual Haitian voodoo doll. This piece I've wanted for a long time—it's a Tibetan ritual object. Let's see...I've got a Coca-Cola camera from an artist friend, Tony Labat. Then, that's a Georges Méliès[13] film still, and here's a picture of my old dog that lived to be twenty-one. A painting by my wife, Jacqueline Humphries,[14] from when she was pregnant with our son. I have some of my kid's art from when he was really little. Some magic ephemera. There's a magic lantern projector up there. I'm actually doing a major project now related to spirit photography and the debunking of psychics by magicians. So the collecting is more than just a hobby.

**How do you come up with titles?**

There's a lot of language in my work, and the language usually is around a cluster of ideas. I'll first look at the scripts that I write and try to pull something out of that. I also keep a running list; I picked up that habit from my wife.

**Can you read off some title ideas?**

*Dark Horse. The Shape of Failure. Identity Theft. Fool's Errand. The Emotional Contagion*—that's pretty good. *Amygdala*, which is a fucking favorite. [*laughs*] The amygdala is the kind of lizard area

---

10. Pepper's Ghost (named after nineteenth-century British scientist John Henry Pepper) is an illusion technique used in theater or magic, where objects appear to fade in or out of existence or transform into different objects.
11. Nam June Paik (1932–2006), American. Artist who worked in a variety of mediums and is considered to be the founder of video art.
12. Rudolf Schwarzkogler (1940–69), Austrian. Performance artist known for his photographs. His work often involved the experience of pain and mutilation.

13. Georges Méliès (1861–1938), French. Illusionist and filmmaker known for technical and narrative innovations in early cinema.
14. Jacqueline Humphries (b. 1960), American. Artist known for abstract paintings. Her works use reflective paint and iridescent surfaces that reflect the colors and tones in their surroundings.

of the brain. I'm thinking a lot about the amygdala because people with smaller amygdala have less empathy for people.

Do you know about mirror neurons? It's the part of the brain where if you smile, I smile. If you're shaking your head, I'm shaking my head. There's something about art making—at least for my art—that's based on subtleties of body language. There's all these mirroring, mimicking events occurring, which is how we automatically download information about one another.

**Have you watched people watching your work?**

Oh yeah. One time someone came to me and said, "You got to watch that kid looking at your piece— he's talking to it." This three-year-old was talking to my piece, trying to help it, thinking that the piece was alive. I really liked that, but it freaked me out a little bit.

**Do you have a motto or creed that as an artist you live by?**

I guess I have an unspoken motto. I try to get to the edge of the artwork. I try to bring my work to fruition. I try to get each one of the works to have a life of its own.

**Lastly, what advice would you give a young artist that is just starting out?**

My advice would be: Don't compromise. Avoid drugs. Don't expect to make money. If you're making work, you're a success. That's it. Period, full stop!

Right now there's so much emphasis on financial success. I think it's a really dangerous and a destructive thing to completely equate the two. As an artist you have to be aware of your overall position within a social framework and insulate yourself from it. Many artists live on the praise reflected back from the rest of the world. Being an artist is the strangest proposition because you make things no one tells you to make. You put

things out in the world, and then you expect the world to reward you in return? It's a bit like being a beggar on the street. It's a setup for enormous disappointment and self-destruction if you can't modify that system in some way to protect yourself. The reward must be internalized and in the work, and after in the world. Easier said than done, believe me.

People are attracted to energy. I've noticed a lot of young artists waiting to get that grant or to show at Socrates Sculpture Park,[15] which is all good—to be ambitious—but also misses the point. One must be self-generative, to initiate your own exhibitions, to find an empty space, to do it on the street or on the Internet, to make it happen somehow. The YBAS[16] did this with empty construction sites; there's a great tradition of this.

Some of my favorite artists, like Bruce Nauman, designed hundreds of projects that were never built; he wrote them up, dated them, and put them in a file. That's the intelligent energy to have. If he can't physically make it, he's going to make it on paper, and then somebody will make it someday. People came to his studio and looked through his files; now they're going to make an installation by Bruce Nauman from 1979.

If you're a young artist and you can eat, you have food, you have your studio or your corner of your dining room, and you're making your work, you're contributing to the world…that's success.

---

15. Socrates Sculpture Park, located in Astoria, Queens, New York City, is an outdoor museum and public park where artists create and exhibit sculptures and multimedia installations.

16. Young British Artists is the name given to a loose group of visual artists who first began to exhibit together in London in 1988. They became known for their openness with materials, perceived shock tactics, and entrepreneurial attitude.

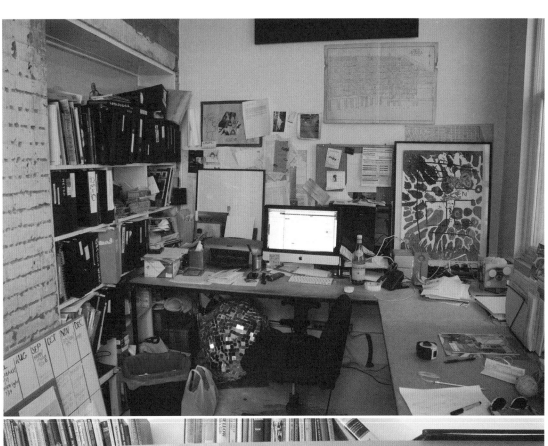

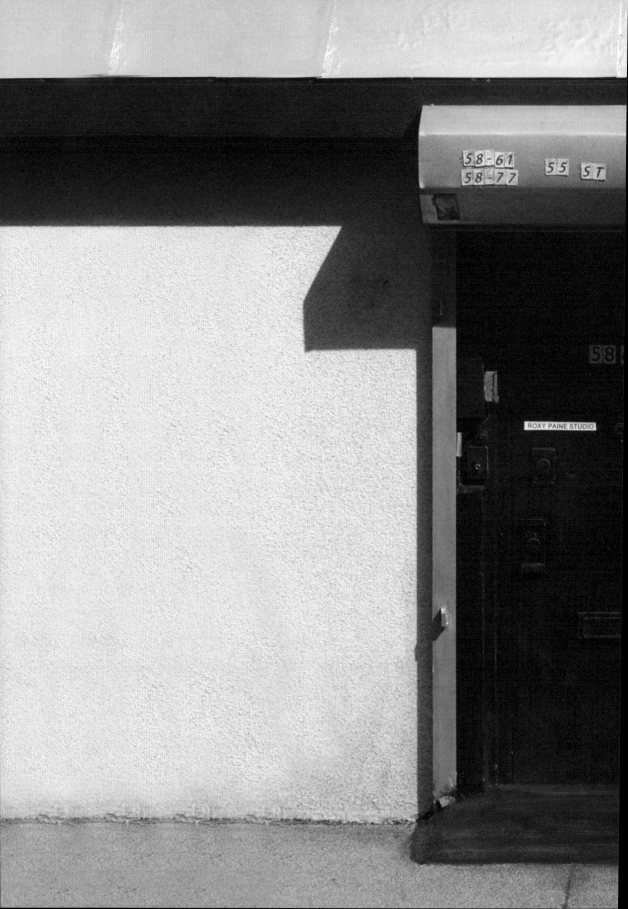

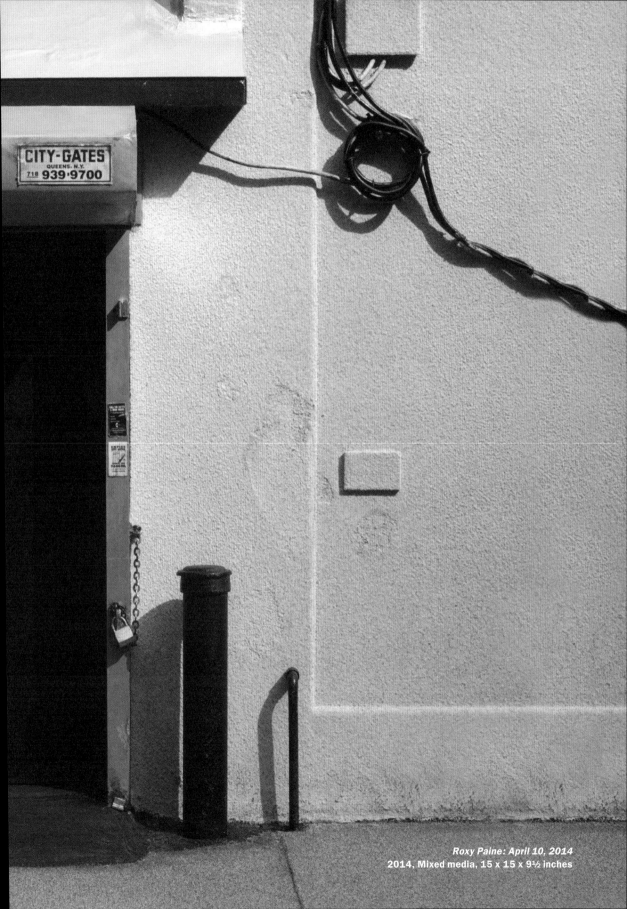

CITY-GATES
QUEENS, N.Y.
718 939·9700

*Roxy Paine: April 10, 2014*
**2014, Mixed media, 15 x 15 x 9½ inches**

# Roxy Paine

Maspeth, New York / April 10, 2014

**To start off, can you please tell me a bit about your background?**

I grew up in the suburbs of Virginia, and I couldn't wait to escape. I dropped out of high school, and I ran away. I hitchhiked out West and roamed around for a couple of years. I got involved with the Grateful Dead scene and made T-shirts to support myself. It was good. It was a little micro-economy you could tap into and survive. This was around 1982. Eventually I got my GED and then went to art school at Pratt, but I dropped out of college as well, to be consistent. Consistency is an important quality. [*laughs*]

**Do you remember an early art piece from childhood that got recognition?**

Yes. I was thinking about that recently because I've been doing these drawings with overlays of words. It's a continuation of a series of drawings I started in the 1990s. I'll take a word such as *asshole* or *fuck* and draw it out with different fonts, overlaying word upon word, one on top of the other. I was thinking how calligraphy was the earliest kind of artistic thing I did. It seems like such an arcane thing, but it was the first thing I was good at. I remember getting requests from family and friends to write out poems and other texts.

**When did you move to New York, and what brought that about?**

I moved here in 1986 to go to Pratt. I was living in New Mexico at the time, and I was starting to work intensely on my drawings and paintings. New York was the best place to go to be an artist.

**That's a big decision, to go to college after dropping out of high school. How did you get going making your own art after traveling around with the Dead?**

It was a very conscious decision. I really got serious after I was dumped by a girlfriend. [*laughs*] It precipitated this real desire to throw myself fully into my work. It may have come from an attitude of "I'll show you!"

**That's always a good motivator. [*laughs*] When did you consider yourself a professional artist, and when were you able to dedicate yourself full time to that pursuit?**

I left Pratt and started a collective gallery in Williamsburg with several people I knew from Pratt; they had just graduated. In 1990 the commercial art world was imploding; the opportunities for a young artist seemed remote, at best. We decided to take things into our own hands.

It was called Brand Name Damages. There were a couple other alternative spaces in Williamsburg at the time; there was Minor Injury and a space called Epoche. We all knew each other, and it was a supportive scene. I was running the collective and showing my work in the gallery, as well as at other alternative spaces, such as Minor Injury. I was also working almost full time in a metal shop. I was doing some freelance metalwork, and that continued for three or four years. I did some house painting for a while, too. Then the Ronald Feldman gallery picked me up in 1993. At first I was in a group show, and then I had three solo shows: '95, '97, and '99. I was able to support myself with the work at that time.

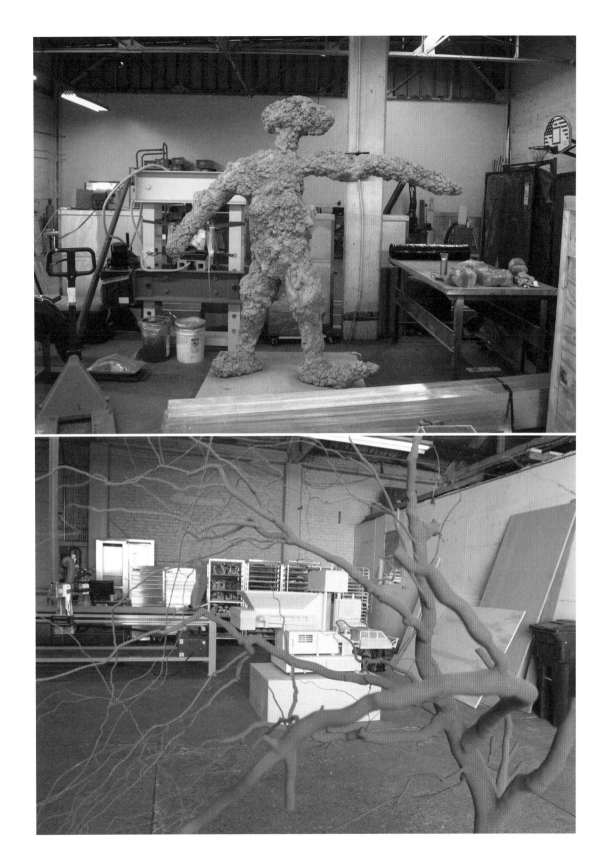

**What was your first real gallery show, and how did that come about?**

My first show was at the Knitting Factory[1] on Houston Street. I got the show because I knew the bartender. [*laughs*] I showed these weird trumpet forms that had metal brackets that were mounted to the wall on the main stage. But the first real gallery show was in 1992. Annie Herron, who had run a gallery on the Lower East Side, started a gallery called Test-Site. It was the first attempt at a larger gallery in Williamsburg. She was such a great lady and so crazily into art. She had a financial backer and so had some money to make the space up nice, and she put on some great shows. But she couldn't sell work. It was a commercial gallery in name only.

**You're having your first show with Marianne Boesky Gallery in September [*Denuded Lens*, 2014]. I saw the maquette for the show inside the office [a diorama of an airport security checkpoint made entirely of wood and set in deep perspective].**

Yes. Right now, this [work in progress around the studio] is just the raw canvas. We're adding complexity and intricacy as we work.

**You just showed similar new work in Chicago at Kavi Gupta gallery?**

Yes. Two dioramas. One showed a fast-food restaurant—or an amalgam of fast-food restaurants—and then the other was of a control room—or again, an amalgam of control rooms.

**How did you start making these new pieces?**

It's been something I've wanted to do for a while, and, in fact, I had drawings of dioramas that I had worked on back when I was with Ronald Feldman. *Carcass*, *Control Room*, and now *Checkpoint* encapsulate a particular moment in our contemporary landscape and are about translation and transformation. What I am interested in with the diorama is its epistemological language of knowledge and representation. How do ubiquitous objects of our everyday landscape inform us about ourselves? These dioramas become discussions about time, material language, data, and classifications, which are ideas I started grappling with in the nineties with works such as the specimen cases and machines. The idea continued to percolate and then take other forms.

Often there's a proofing process with my ideas. I'll make a drawing and then come back in a week and ask myself, Is it still compelling? I come back in a month and ask, Is it still compelling? I come back in six months: Is it still compelling? It's a filtering process.

**Have recent innovations in technology affected your work?**

Actually, we got this CNC machine[2] just recently. But the pieces for Chicago were all constructed by hand.

One thing that's important to me is to embrace technology but never fall in love with it. Whatever new technology I use in my work, I keep a skeptical or critical eye toward it. Our approach is that it's just one of many tools we use.

**This studio is relatively new for you and is separate from where you live. Is that what you prefer?**

Pretty much every studio I had until 1999, I lived in as well. I'm happy not to live in my studio now. In the nineties I was using a lot of materials that I shouldn't have been breathing in. When you have epoxies curing and you're sleeping ten feet away, it's probably not a good idea.

**Did you have a plan for the layout of this space?**

It's developing organically. We're going to have to alter this studio a little bit. It's basically going to be the same setup, just with some more walls and more ventilation. The electrical is a mess. That whole woodshop is running on one fifteen-amp circuit, which is not enough. When you're sanding something and someone else turns on the table saw, your tool just goes "whrrrrrr…" and slows down. It's not good for the tools.

Then we have a separate metal shop. You don't want to be doing metalwork in the same space as woodworking. All the metal dust will get into the

---

**1.** The Knitting Factory is a music venue and concert house in New York City.
**2.** CNC (computer numerical control) machining is a process that uses computers to operate machine tools. It is generally associated with lathes, routers, grinders, and mills and produces very precise components.

wood, into the tools, and into the blades. It's generally bad for all the tools.

**Can you describe a typical day, being as specific as possible?**

I used to be pretty nocturnal, but these days I get up early. Kids do not let you sleep past seven o'clock, so if you do stay up late, it means you're going to be getting very little sleep, and that gets tiring. Plus, kids themselves are tiring. We have a four-year-old girl and a one-year-old boy.

So I really don't like to think about anything else besides the work, so every morning I just have a bowl of Corn Chex cereal and coffee. Every morning. Every day it's the same thing. I have a number of identical work shirts and pants that I wear every day to reduce that decision making. I reserve problem solving and decisions for the studio and everything that has to go into making the new work.

I drive here with my main assistant, so on the drive, we're talking about what we're going to tackle for the day. When we get here we can dive right in. I don't check the computer. I'm just working the whole day; sometimes I don't lift my head up for hours. I don't know if that's healthy or not, but it's just the way I end up working.

If I'm working on drawings or ideas for pieces, then that's usually on the weekends or at night. During the day, when I'm here, it's run full tilt. Generally, I set up pretty large challenges for myself. It requires a lot of focused energy.

[For the upcoming show there's] one thing I want to make sure that I can do. This is something I've rarely had the luxury of: I really want the piece built and set up well in advance so that I can make adjustments. Usually I'm working like crazy until the last minute; I'm barely done in time, and then it's installed. This time I really want to build the full diorama in here so I can live with it and look at it and make those microadjustments.

**In the maquette, everything shoots back in deep perspective. The floor tilts back, the ceiling shoots back. You have to build the entire room, soup to nuts?**

Right, and to obtain that deep perspective, there are no 90-degree angles in that piece at all. In fact, every angle on every piece is different, depending on where they fall within the perspective lines. It's like a 37.2 [-degree angle] and 80.9 [-degree angle]. It's just every angle imaginable; it's enough to drive you mad. I like to design pieces that are guaranteed to make me go insane. [*laughs*] This one is definitely pushing me over the brink. Actually, with this piece, I am not interested in perspective. The forced perspective was a means to build the diorama within a depth of fifteen feet.

**[*talking over insanely loud music*] This question is obvious: Do you listen to music or the radio when you're working, and does that have an effect on your work?**

No. It's dead silent in this studio. [*laughs*] Yeah. Usually we trade off between my assistants and me; each day one person curates the music. We share common interests in krautrock and psychedelic music. It's good because you're always being exposed to musicians you didn't know. We've gotten into Spotify; you can listen to twelve different albums by Can. It's pretty vast.

**Can you tell me a little bit about the materials you use and how they came into your practice?**

I work with various polymers, epoxies, thermoplastics, thermoset plastics, steel, stainless steel, aluminum. Wood is a material I've been working with a lot over the last year or two, and it's a relatively new material for me. In the past, if I used wood, it was always in a supportive role, for a table or a case. After so many years working with stainless steel, it was a relief to work with wood. Working with stainless is brutal. It's insanely loud. It's insanely dusty and toxic. It's very hard on your body, constantly lifting massive pieces of heavy pipe.

But more than that, I'm very attracted to the qualities of wood and playing with the grain structure and bringing together a very hybrid approach to it. We're employing every possible way of working with wood. In each piece we use cabinetry and lathe work and carving and every conceivable tool. That kind of hybrid multiple approach to the same material is very interesting to me.

**It's amazing how malleable you make the wood look. It's an interesting contrast to the stainless steel *Dendroids*.[3]**

Yes. The *Dendroids* are taking an industrial material and translating it into an organic language. These are a reversal of that—taking this organic material and translating it into industrial scenarios. All of the wood pieces I've been working on have something to do with machinery and aspects of production, from food production to the processing of humans through a security system.

**Do you have a favorite color?**

I would say that gray is my favorite color. Gray is a very broad term, but I like a lot of grays. It has a lot of range.

**Do you have any special devices or tools that are unique to your creative process?**

With each project we are always making our own jigs or tools. I'm constantly making tools for a given problem or given circumstance or making a fixture that will be used in a hydraulic press, for instance, to solve a problem.

**How did you become so skilled at working with so many different tools and materials? I know you were welding early on.**

That gave me a good foundation for the metalworking. It's mostly a matter of being propelled by an idea to investigate how to make this idea happen.

**How often do you clean your studio, and does that affect your work?**

Every day we do a cleanup. Keeping very organized and clean is very important to me. Working with so many different materials and with different ideas, I find if I don't, the madness creeps in very quickly, and I really need to keep it at bay. During the day it inevitably becomes chaos in the shop. I need to come into the studio in the morning and have the tables totally clear, including dusted off. I need to be able to put my hands down on the table and not have them be gritty. It's psychologically important to have that clean slate to start the morning.

**Did you ever work for another artist, and if so, did that have any effect on your work?**

I did work for an artist; her name is Alice Aycock. It was actually a little bit frustrating for me. Mostly because I wanted to work for an artist and really learn as much as possible and be put through the wringer and work intensely. But she wanted someone to have conversations with and drink tea with. It was nice, and she was great, but I actually wanted to be a slave to somebody. I was like, "Come on! Abuse me. Make me stay up until ten thirty putting this together." [*laughs*] But she just wanted to hang out.

**Do you have a motto or creed that, as an artist, you live by?**

I have a few. "Nothing good is easy" is one of them. "No sculpture is light." However you wish to interpret that. [*laughs*] Persistence is one of the creeds that I live by. It's generally an undervalued attribute. People overvalue newness and undervalue persistence. You need to be persistent with your ideas, persistent with your vision, persistent with your work ethic. There's so many times during a project when you feel like giving up. There are so many ideas that at certain points in the process might seem like they are not going to work out. But so many times, if you are persistent and continue on, something incredible may result. You'd never know that if you didn't push through it.

**What advice would you give a young artist that is just starting out?**

Work your butt off. This sounds really stupid, but don't go out partying. Work incessantly, and don't worry about the networking bullshit. Focus on the work, and everything else will or should evolve from that.

---

**3.** Paine's *Dendroids* are a series of treelike sculptural works made of stainless steel.

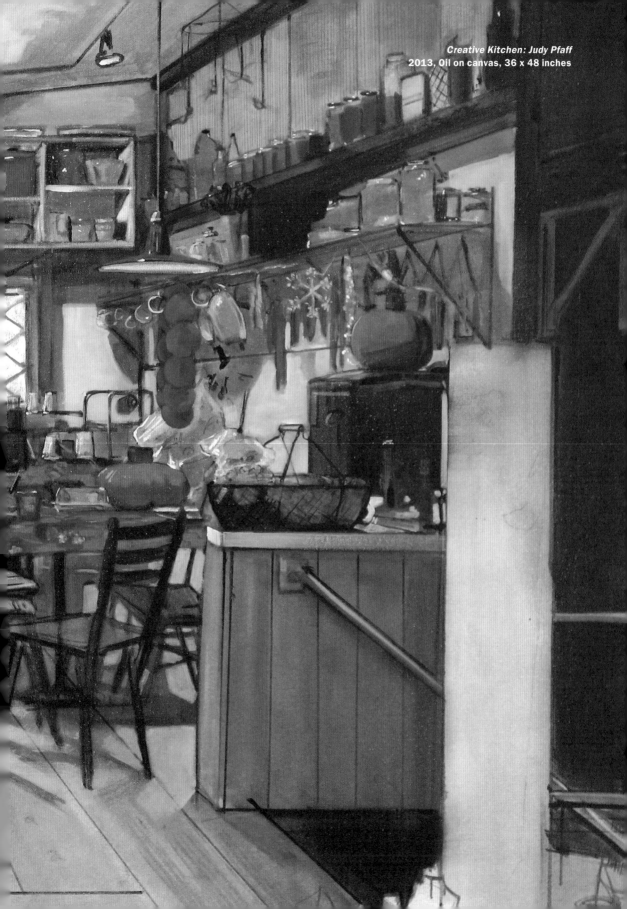

# Judy Pfaff

Tivoli, New York / November 30, 2012

**To start off, can you please tell me a bit about your background?**

I was born in 1946. I grew up in London. We, meaning my grandmother and my brother, came to America and lived in Detroit. I went to what at the time may have been one of the best art high schools around, Cass Tech in downtown Detroit.

I got married in my last year of high school and went on to college at Wayne State University. I went to Wayne in 1964 to '66, during a time when Detroit was incredibly vital, with poets like John Sinclair[1] and the band MC5[2] and Motown. Wayne had incredibly talented artists. The Cass Corridor artists were intense and had a real Detroit tough-ness…then came the '68 riots. That changed the energy and potential of the city in one fell swoop.

**Do you remember an art piece from childhood that got recognition?**

Yeah, it was a papier-mâché elephant. It had this great howdah on top, full of ornament and color, and it was quite big. I really focused on the detail and fantasy. I wanted to make this amazing, strange, wondrous thing. I was probably thirteen.

**When did you consider yourself a professional artist, and when were you able to dedicate yourself full time to that pursuit?**

I came to New York directly from Yale; Al Held[3] nominated me for a show at Irving Sandler's Artists Space. Then, a little later, in 1975, I was in the Whitney Biennial, chosen by Marcia Tucker.[4] Al had just had a retrospective at the Whitney curated by Marcia. Things were happening fast…I started getting real jobs teaching. I taught at Ohio State,

I taught at Tyler School of Art. I was teaching at CalArts in the '70s. I enjoy teaching. All of these places had such different students, and I'm pretty cognizant about who I'm teaching and where I'm teaching, so I got pretty good at adapting and paying attention.

**You went to Yale for your MFA. What prompted you to move to New York?**

That I went to Yale was a miracle of sorts. Robert Reed, who ran the Yale Summer School at Norfolk, encouraged and championed my application. I do have a kind of luck, and art teachers, from the time I came to America, have changed my life. They certainly had more confidence in me than I did. Being the only woman in my graduation class at Yale, I was offered great jobs around the country, but I only wanted to go to New York City. I still have a romance with the city. It was the right choice. Barks Frameworks was the first real job I got. Jed Bark was the framer to the few galleries and all the artists in SoHo. It was a great education. The restaurant FOOD was on the corner; it was run by Gordon

---

1. John Sinclair (b. 1941), American. Poet, writer, and political activist. He is known for his jazz poetry, which has musical accompaniment. Most of his poetry was released on audio format.
2. MC5 was a rock band with political ties and an aggressive style of music. It was a precursor to punk.
3. Al Held (1928–2005), American. Abstract expressionist painter well known for his large-scale hard-edge paintings.
4. Marcia Tucker (1940–2006), American. Art historian, art critic, and curator. In 1977 she founded the New Museum of Contemporary Art in New York City.

Matta-Clark, Carol Goodden, Tina Girouard, and Bob Kushner. So I walked into a perfect education of artists and the art world. You could drink at the Broome Street Bar, and you could go to Magoo's, and you could go to FOOD. It was my idea of what an artist's life looked like. The art world was small—the artists were there and we were friends.

**How long have you been in this studio?**
I got this in 2001, so twelve years.

**Your studio is separate from your home. Is that what you prefer?**
Basically, I lived and worked in all my studios. In my last space my living area was one hundred square feet. But now I live separately in a six-thousand-square-foot Victorian home. I learned what rooms are for. [*laughs*] If you live in lofts your whole life, you only have one room! Now I have a dining room, I have a library, I have a guest bedroom. There are seventeen sinks. I domesticated myself, and I did enjoy the scavenging and hunting for the right stuff. The house itself is a kind of installation.

My prior studio was this most wonderful space. It was the Cornell tugboat factory, and it was right on the Rondout Creek [in Kingston, New York], a working river off of the Hudson. It was the most remarkable building I've ever seen. It had sixty-foot ceilings. It looked like you were in Italy. When I had to leave that place I couldn't find another where I could live and work.

**Your studio is really a compound of numerous buildings on a beautifully situated piece of land with a gorgeous view of the Catskills.**

**Did you have a plan for the layout for the studio, or did it develop organically?**
It has just developed. I think the previous owners, like any good farmer, kept adding on to the property and the buildings, so it fit my sensibility perfectly. In time, the east side will feel more domestic and will be my house. The chickens make it sweet and homey. I've replaced four buildings. It was quite a derelict property, but it sits on a beautiful road.

**Has the location of the studio influenced your work?**
Oh yeah, but you put me anywhere and I'm influenced by it. Here I've got land, I've got gardens. The work is much more, for lack of a better word, organic. When I lived in the tugboat factory, the work had gotten quite Zen-y and serene. There were all of these images that were flowing, very horizontal, not much color. When I was in Brooklyn, the work got Brooklynesque. I like getting cues. When I was restoring my Victorian home its history sunk into my bones. I started paying a lot of attention to all the architectural detail and imagining the lives that had occupied it.

**Please describe typical day, being as specific as possible?**
I usually watch *Morning Joe*. There are always televisions on, twenty-four hours a day. They're always around, and sometimes I do watch. I commute from Kingston to Tivoli. It's about a half hour, and on my way I pick up supplies. I usually do emails and paperwork in the mornings. There are three to five part-time assistants. They help with everything: framing, crating, archiving, mowing,

and weeding…it's a big place. The day is long, 9:00 a.m. to 9:00 p.m. But honestly, I get the most done and the decisions are made when no one is here—after 5:00 and on the weekend. For the past four or five years I don't have assistants helping me in the studio. In the studio it's just me, and that has changed the work in that it's made of much lighter materials: there's a lot of paper, there's a lot of plastic—less architecture.

**Can you tell me about the materials you use and how they came into your practice?**

My materials change all the time. Usually I add a material to the existing ones, and with the new material the imagery changes with discovering the nature of that material. Right now I'm using more expanded foam, honeycomb cardboard, and I'm back to resins and every kind of plastic, coupled with the need for more light, as in fluorescent, incandescent, and neon.

**Can you tell me a little bit about the galleries you showed with?**

First I was with my favorite gallery, Holly Solomon Gallery. [Solomon] was so original and subversive. She loved art and artists. She was mischievous and had great courage for the time. Then for a short while I was with Max Protetch. For some strange reason, André Emmerich, who represented blue chip artists and mostly men, was interested in my work. He had seen an installation in Cologne in 1981. The gallery was known for being the home of lyrical abstraction. None of these facts about the gallery made sense for my inclusion in it, and everyone was of another generation. When that

fell apart, the director of Emmerich opened a gallery called Ameringer/Yohe, and now it's Ameringer/McEnery/Yohe. After twenty years with them, I felt like it was no longer the right place and it was time to move on.

**Your work is very painterly. Did you go from painting into sculpture?**

My degrees are in painting. When I was at Yale, I was upset with the education there, but now I owe everything to Yale. It made me aware. Al Held was my teacher; I loved him. He was tough, brilliant, and a great artist. You had critiques in this area called the pit, and all these guys who've known each other for years would start talking about your paintings. It wasn't about your work—it was about abstraction and figuration or Darwin versus creationism. And you're sitting there useless.

So I had this idea that I would make things that couldn't be moved and brought downstairs to be torn apart. I started anchoring and building everything I made into the walls of the studio. So they became more sculptural—I think out of survival. I would get into a huge fight with these guys, including Al.

But at that time there were things going on in the art world, a lot of process work. Alan Saret made lots of wire sculptures and he was an architect and a philosopher. You also had Robert Smithson. There were new things coming into being, which weren't really part of the gallery thing. It was in situ or built in place or built in the landscape. I didn't understand that, but I was more comfortable thinking about that than I was about

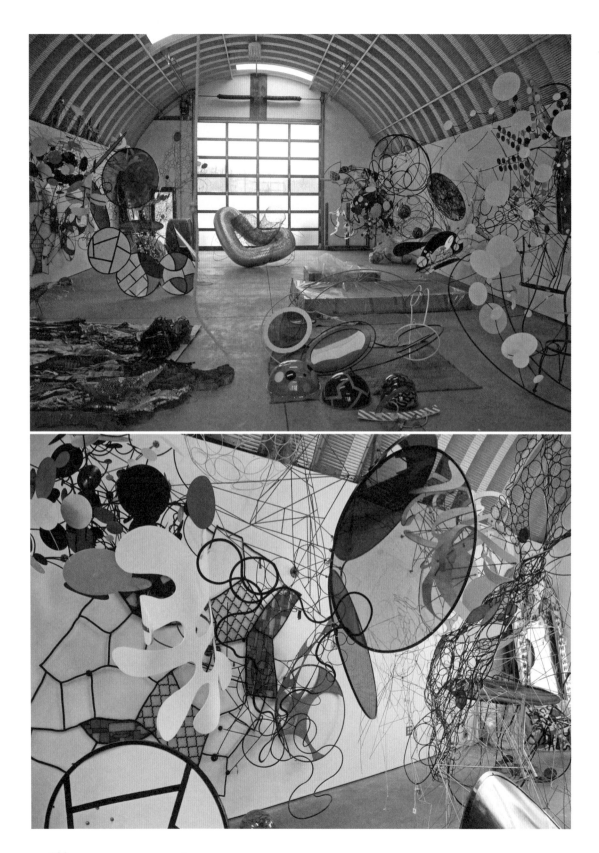

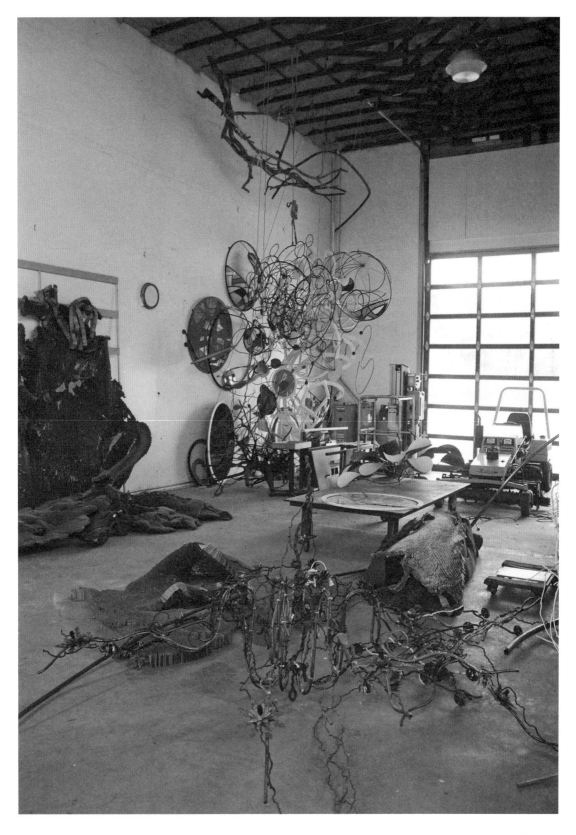

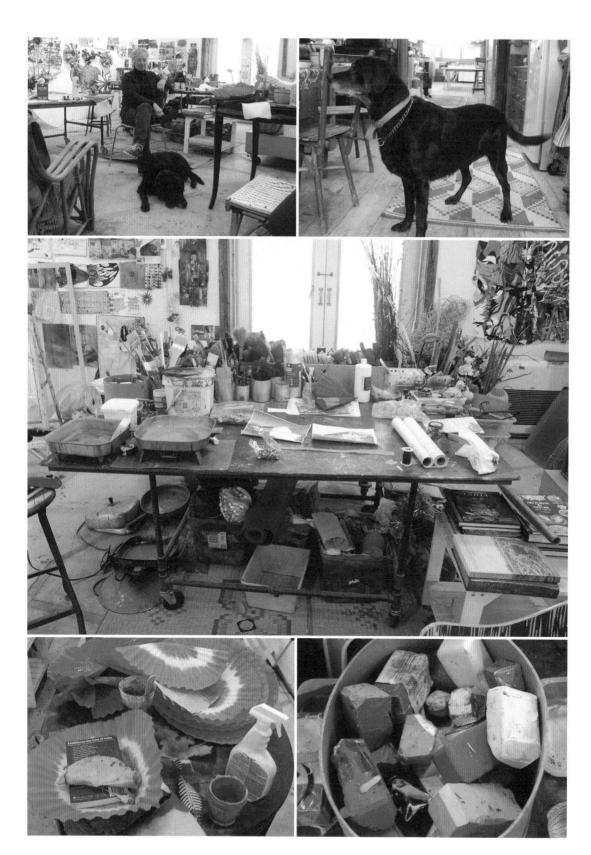

having someone talk about space in a painting. So I became a sculptor because I didn't like the conversation that painters were having. I thought the most interesting things were being done not in painting.

**Do you think more like a painter or a sculptor?**
I think I think like a painter. No, I think I think like a little kid. I want this! I want that! There is something about putting a dream together.

**Do you work on one project at a time or several?**
I work on lots of things at the same time. But there'll be a moment when I will stop fooling around. If there's a show coming up, I'll focus. I don't think clearly months in advance; I think clearly twenty-four hours before the show opens. If I'm given any time at all, I will circle around it.

**When you're contemplating your work, where or how do you sit or stand?**
I'm usually walking around with a coffee cup; I very rarely sit. The difference between painters and sculptors is painters sit. They sit and look at a painting for a long time, and I used to think, What the hell are they looking at? [*laughs*] I'm not being facetious; I really don't know. Are they waiting for something to dawn on them? Are they problem solving? Because the way I make decisions is: I open the door, I look in, and I think, YES! NO! If it's a "NO," it'll come to me, but not by looking at it. If I stare at it, I get dumber. It will come to me by changing this or that. I'll talk to myself, saying, "You were too conservative here. You are playing it safe. It has no spirit, and it's dry as toast."

**How do you come up with titles?**
It's very difficult. Titles are really hard for me, really, really hard. Lately I've been stealing from Borges[5] and the Jataka tales[6] and Emily Dickinson.[7] Sometimes they get a little cosmic. Sometimes they're Chinese. I do like the sound of Spanish, so there are moments when I will title everything in Spanish. [*laughs*] The titles always, always come late. Bob Dylan is a favorite. I can take anything from a Bob Dylan song, and I think it sounds perfect. Joe Cocker lately sounds good to me.

**Do you have a motto or creed that as an artist you live by?**

Stay alive. The work has to be generous and interesting. If someone is taking the time to look at your work, you have to give them something back. I cannot stand work that feels as if I didn't read the right French philosopher to understand it. I don't like things that yell at me. I don't like work that is aloof. I do like beautiful work. I can look at minimalism; I have no trouble with that. But I don't like stingy work, and I don't like work that's too political. I think all artists are political, and all artwork is probably political, but I don't like it if it feels like there is a right and a wrong side to be on. For me, there's usually a kind of a fission that goes on, a kind of activity that is really about activity. I can't do that slow thing. I can do the fast thing.

**What advice would you give to a young artist that is just starting out?**
All the things that [young artists] really need, I can't give them. They need to get their shit together. They need to market themselves. They need to have artist's statements that are written well. They need to do all the business stuff that I still have not been able to figure out.

The need to have a very lively conversation is very, very important. Get really good friends. Talk a lot, drink a lot, and eat a lot together. Talk about your ideas, be honest with each other, and have a community. I think you grow like a big organism.

---

**5.** Jorge Luis Borges (1899–1986), Argentine. Writer best known for his fantastical short stories.
**6.** Group of Indian fables developed between 300 BCE and 400 CE describing the previous lives of Siddhartha Gautama, the Buddha.
**7.** Emily Dickinson (1830–86), American. Poet known for using unconventional imagery and formal devices, as well as for her extreme reclusiveness.

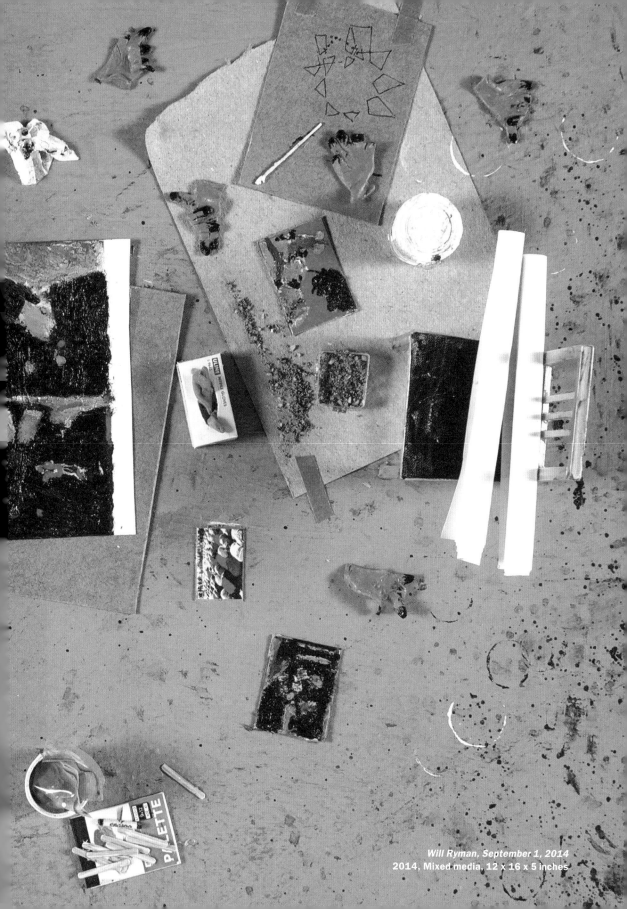

*Will Ryman, September 1, 2014*
2014, Mixed media, 12 x 16 x 5 inches

# Will Ryman

Williamsburg, Brooklyn / September 1, 2014

**To start off, can you please tell me a bit about your background?**

I grew up in New York, Greenwich Village. I went to high school at the McBurney School, which was a small school on the Upper West Side. It was mostly a sports school.

**Do you remember an early art piece you made that got recognition?**

I made a pinball machine when I was six years old. It fell apart over the years, but I still have parts of it. It was great. I also made a Sleestak from [the TV show] *Land of the Lost* when I was eight; I still have the head. It was made of papier-mâché. Also, from the ages of six to ten I turned my bedroom into a huge installation with all kinds of crazy figures and graves and stuff. I wasn't really sure what I was doing, but my parents were encouraging and supportive.

**Did you go to undergraduate school for art?**

No, I graduated high school and did some college. I wanted to be a writer. I wanted to start living and start learning about the world, and so that's what I did. I was eager to pursue a career in the arts as a screenwriter and playwright.

**I can see there is often a narrative, especially in your early work and with this new piece, *America*.[1]**

Well, the cabin is a conceptual piece. And to make it I used objects that reference the growth of the American economy. Starting with the African slave trade to agriculture to the Industrial Revolution to the auto industry to communications to the current digital age. I used slave shackles and chains, corn, cotton, bullets, car parts, train parts, coal, telephone parts, iPhones, iPads, and computer parts. I multiplied them and arranged them into geometric abstractions. The work is about the arc of American capitalism and also about the relationship and contrast between the figurative object and abstraction. From the outside it is minimal and sleek. The interior is controlled chaos—multiple objects arranged together to become one entity. I use mundane objects in my work a lot. [Jean] Dubuffet's a big inspiration to me and [Ed] Kienholz,[2] too, especially the political components.

**Ah, I love Kienholz. He's one of the first artists whose work really struck me and made an impact. The first time I saw his work was in Amsterdam; I must have been twenty. It was *The Beanery*.**

That's where I saw his work for the first time, too! It was incredible. I just couldn't take my eyes off any of it. My eyes were about twice as big as they normally are.

**What was your first real gallery show, and how did that come about?**

My first gallery show was in 2004 at Klemens Gasser & Tanja Grunert, Inc. At the time I had all these sculptures, and I was trying to invent a style

---

**1.** *America* (2013). Life-size replica of Abraham Lincoln's log cabin coated in gold resin, which explores the role of capitalism in U.S. history.
**2.** Edward Kienholz (1927–94), American. Installation and assemblage artist whose work was highly critical of aspects of modern life.

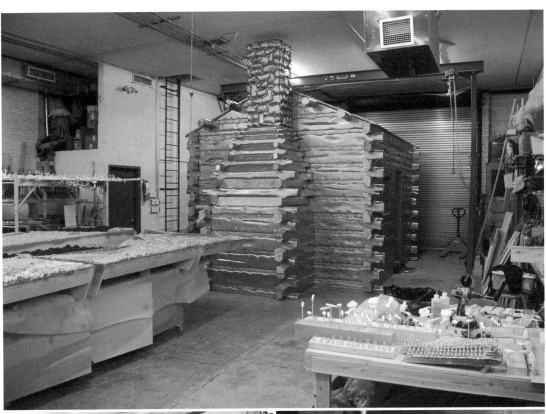

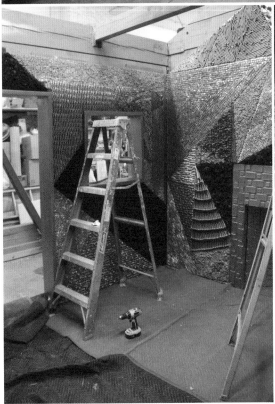

of theater that had never been done before. I created an installation and called it a play. I invited everybody I knew over to see it as a silent play. I called it *The Silent Play*. Tanja Grunert came. She's a friend of a friend, and she really responded to the work and asked if I wanted to show them in her gallery. The sculptures had to do with absurdity in modern-day culture. I was making work that was cathartic and psychological. Humorous and melancholy.

**How did you end up working with your current gallery, Paul Kasmin?**

When the city approved my project *The Roses* for the program Sculpture on Park Avenue,[3] I didn't have a gallery. A friend of mine brought Paul over to the studio. I knew he had worked with artists who had shown on the malls of Park Avenue before, so I thought it was a good fit.

**So you pursued the Park Avenue project initially on your own?**

Yes, I was trying to change the cultural experience [of Park Avenue] by changing the meaning of commercial symbols. For example, the rose represents the elite, romance, commercialism, et cetera. Park Avenue also represents the sophisticated, also the elite and the cultured. And I thought if I changed the meaning of one of those symbols by making it cartoonish, very large in scale, humorous, and absurd, and put them on the avenue during the wintertime, then maybe the experience of being in that neighborhood would change. That was the idea, at least.

**How long have you had this space?**

I have been here since 2005. I used to work out of my apartment.

**So, your studio is separate from your home. Is that what you prefer?**

I try to keep my work separate, but I fail. I seem to be working all the time. Even if I'm not in the studio, I'm thinking about it or sketching or writing.

**How many assistants do you have?**

It fluctuates. I've had anywhere from zero to nine. Nine was way too many for my liking. Right now I have three.

**Do you listen to music or have the radio on when you're working?**

I might listen to talk or sports radio or an audio book. I listen, but I don't really hear what they're saying. It's white noise, anything to block out the surrounding sounds. But when I'm researching and working on the development of a project, I like it totally quiet. I have to go to my own room and have privacy. I often wear earplugs.

**Your process seems heavy on research, reading, and writing. Does that come from your background as a playwright, and is that important to you?**

Yeah, it is. Most of my process is research and sketching and doing material studies. I carry a little sketchbook and pen with me everywhere, and I like

---

**3.** The Sculpture Committee of the Fund for Park Avenue and the Public Art Program of the City of New York's Department of Parks and Recreation, in collaboration with arts organizations and artists, present artworks on the Park Avenue malls.

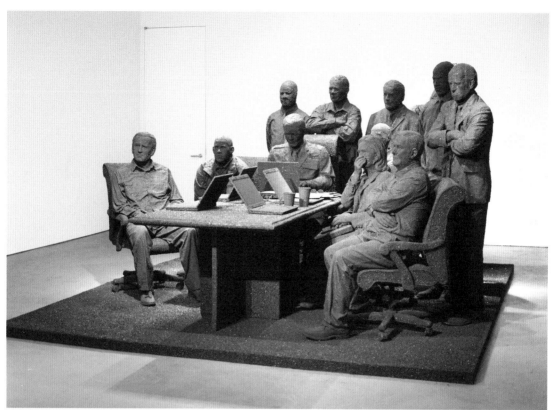

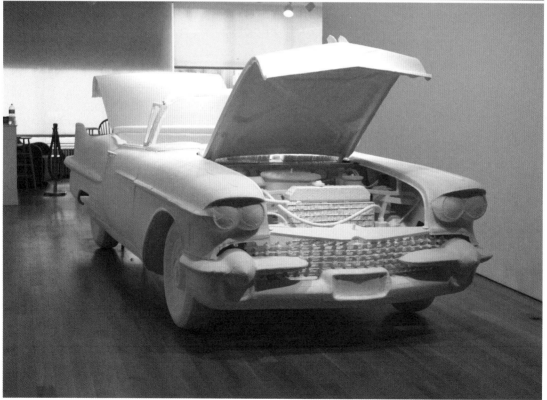

to keep my hand moving. It keeps me grounded. And when I have something that I want to explore, I try to read whatever I can to understand the subject. The work is always 80 to 90 percent completed conceptually before anything is produced.

**Do you have any special tools or devices that are unique to your process?**

I like to make my own tools and create my own techniques. The techniques have to do with whatever material I am interested in. I watched an interview that Richard Serra[4] gave on Charlie Rose. He said that artists should stay out of art supply stores and make their own tools because when you make your own tools, it changes what you're doing. So I like to do that. Right now I am working on making my own crayons out of materials that are relevant to my next body of work. We are using crude oil and silicon and cobalt and other things from the periodic table of elements to make large crayons.

**How often do you clean your studio, and does that affect your work?**

We clean the studio after every show or installation. I like to start with a fresh space. In fact, the sculpture *Infinity*[5] came directly from cleaning my studio after the *Roses* project. I had all these chip brushes everywhere from painting those roses, and I was cleaning and stacking the brushes up, and I started to see them becoming a shape. I wanted to stack them as high as the ceiling. I wanted to make these caves out of the stacked brushes. So that piece came directly out of cleaning the studio. It's funny—my dad[6] always said, "If you're stuck, clean your studio."

**Did you ever work for another artist, and, if so, did that have any effect on your work?**

I have never worked for another artist. I wouldn't want to. I like jobs that are not in the art world because I don't want to be influenced by another artist or trends in the art world.

**Do you have a motto or creed that as an artist you live by?**

It's a marathon. Not a sprint.

**Lastly, what advice would you give a young artist that's just starting out?**

First, do what interests you. And don't let the market-driven art world influence what you make. Artists' lives are often difficult, even for the ones who are successful in the market, so make the work that you want to make, because in the end, it always comes back to how you feel about your work.

---

**4.** Richard Serra (b. 1939), American. Minimalist sculptor known for his huge, imposing steel sculptures.
**5.** *Infinity* (2012). Installation made up of two hundred thousand stacked paintbrushes.
**6.** Robert Ryman (b. 1930), American. Abstract painter known for his white-on-white paintings. He is associated with the movements of monochrome painting, minimalism, and conceptual art.

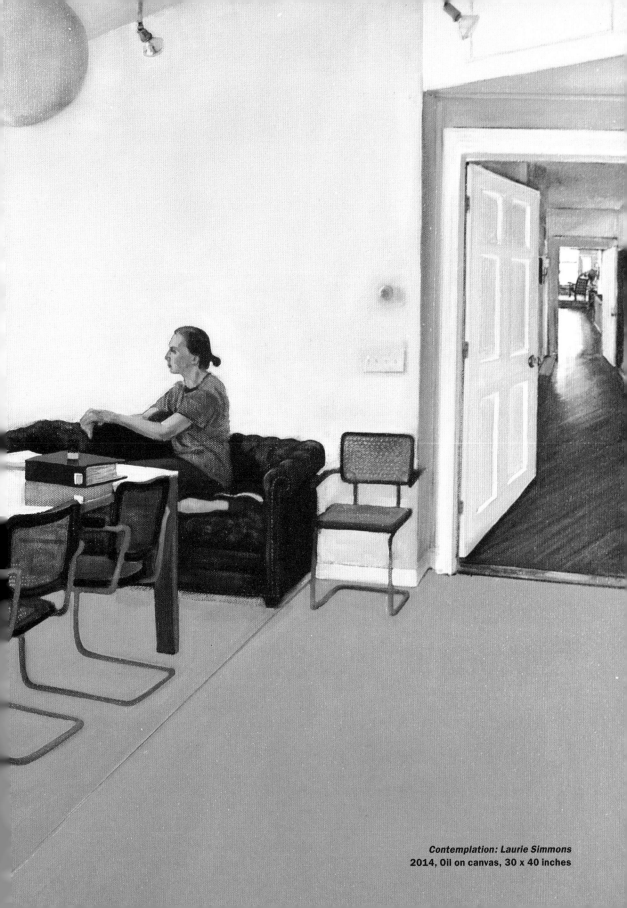

*Contemplation: Laurie Simmons*
2014, Oil on canvas, 30 x 40 inches

# Laurie Simmons

Cornwall, Connecticut / July 10, 2014

**To start off, can you please tell me a bit about your background?**

I grew up on Long Island. I went to Great Neck North High School, which was very large and was considered advanced in all of its programs. But the only teacher I remember liking was my senior-year art teacher. I remember he showed us the movie *Painters Painting*.[1] But I really didn't like school, no matter how good the school was. I could not wait to get out.

**Where did you go to undergraduate school? Did you also go to grad school?**

For undergraduate school I went to the Tyler School of Art, part of Temple University in Philadelphia. I was a printmaking major. For graduate school I got into the University of Wisconsin's printmaking program, but at the very last minute, I bailed out. I'm really glad I did. At that time, I didn't understand that the world of printmaking was a separate world [from the contemporary art world]. I realized that the most interesting prints I was seeing were being made by artists; they were not being made by a separate community of printmakers.

**So when did you move to New York City, and what brought that about?**

I graduated from art school in 1971. I didn't know what to do with myself. I had friends who were living in a quasi commune in upstate New York, and I thought, OK, I'm just going to land here in Roscoe, New York, with this group of people. We were like the little lost boys in *Peter Pan* or *Lord of the Flies*. We grew marijuana, we grew our own

food, and we really had a great time. And then, all of a sudden, that came to an end for me, and I thought, I have to go be an artist somewhere. I had friends in New York, and I ended up there with the intention of starting my grown-up life as an artist. That was 1973.

**When did you consider yourself a professional artist and able to dedicate yourself full time to that pursuit?**

I was trying to be a professional artist the whole time. I was really committed to never having a full-time job. Doing odds and ends to support yourself is so much harder than having a full-time job, which I didn't know at the time. I didn't have my first show until I was twenty-nine, and I didn't sell out a show until I was thirty-seven. So it really was a pretty slow haul. But I managed somehow in a very hand-to-mouth way to keep going.

**How did you get your first real gallery show?**

In 1978 my husband, Carroll Dunham,[2] was having a studio visit with Rags Watkins, who was a curator at Artists Space. Carroll said, "You should see Laurie's work," and I showed him this little box of photographs. He asked if he could show them to Helene Winer at Artists Space. She called me right away and said, "I'd like to give you a show." That was January 1979. It happened kind of casually.

---

1. *Painters Painting: The New York Art Scene 1940–1970* is a 1972 documentary directed by Emile de Antonio. It covers American art movements from abstract expressionism to pop art through conversations with artists in their studios.
2. See pages 82–89.

In those days it was so much cooler to have your first show in an alternative space. Having a first show in a gallery would have been embarrassing. There was a way you did things then, and you really wanted to start in an alternative space. I was completely delighted to start there.

When I went to collect my box of photographs, Cindy Sherman was the receptionist. She had a box of photographs, too. We were like: "I'll show you mine if you show me yours." [*laughs*] I looked at her little box of film stills and she looked at my box of color interiors of dollhouses. That's how I met her, and we became great friends.

**Currently you're showing with Salon 94. How did that relationship come about?**

I met Jeanne Greenberg Rohatyn at least twelve years ago, and we always wanted to do a project together. She had a gallery at the time, but it was considered more of a project space. In 2006 she and I made a movie together called *The Music of Regret*. She produced it. It started out as a video project, and it ended up much nearer to a full-scale Hollywood musical. It was kind of a puppet fantasy musical—somewhere between a puppet story, a Broadway musical, a movie, and a child's story. Basically, three aspects of my work came alive. There's singing and dancing. It's very cool. We had a passionate, contentious, really intense relationship around the movie, and we managed to stay friends. When Jeanne's gallery became more serious, it seemed like a logical match.

**How did you transition from printmaking to photography?**

I walked out of my photography class at Tyler because I didn't think photography was art. When I moved to New York, everything I saw was conceptual but I felt most connected to work that documented experiences or conceptual art that needed to be documented in some way, so the camera was used in a very nontraditional, nonphotographic, offhand way. It seemed to me you could use the camera without calling yourself a serious photographer and without knowing so much of the technical side of it.

My father had been an amateur photographer, so there was always a lot of equipment around the house. I can remember my father saying, "The bigger the number, the less the light. The smaller the number, the more the light." It just seemed really ridiculous. [*laughs*] There was one lightbulb moment: I went in to see a Jan Dibbets[3] show at Sonnabend Gallery. The show included a series of small [photography] prints that added up to something bigger. I asked the person at Sonnabend how all those little pictures were made. And they told me that Jan Dibbets just sent the photographs out to the corner drugstore and got the prints back. And I thought, Wow, I could do that. So the first pictures I ever took, I just sent them out to the drugstore, and that got me interested.

---

**3.** Jan Dibbets (b. 1941), Dutch. Conceptual artist known for pushing the boundaries of the photographic medium.

Eventually, I set up a darkroom. I have a well-documented friendship with my neighbor at the time, the photographer Jimmy De Sana.[4] He taught me everything, basically—he and the Kodak hotline. If you had a problem, you could call them and there was always a guy on the other end that sounded like an astronaut. He was always calm and helpful.

**How did the first photo project develop?**
I got a job taking photographs for the B. Shackman catalog; they were a toy company that made miniatures on lower Fifth Avenue. I took a few of the little toys, like a little sink. I set it in front of some vintage wallpaper, and that was my first photo. I still love that photo. It was so simple. If your work is a train you get on, and you never get off until the day you die…that's the day I got on the train.

There are things you can do [with your work] when things are raw, when things are fresh, that are just incomparable, that you can't do again when you're seasoned, and you have to appreciate that. Maybe that's why I jump off and do other things: because it's so great to be new at something. You can't get that back. It's like first love. I could never be that naive again. Imagine how you feel, making work just for yourself.

I'm in the process of making a film, and I've been meeting with producers, and a potential producer for my film asked, "Who's your audience?" In my thirty-some-odd years of being an artist, I've never thought about who my audience was. I don't think artists really work that way. You really don't imagine who's passing by your work. How could you?

But I knew I was interested in small things. Oddly, my father [an orthodontist] had all this equipment for taking pictures of mouths. I used to bring my toys in and ask him to do close-ups. So there was something I was trying to do when I was little that I still tried to do when I was more grown-up.

**Do you look at your work in the context of the history of photography or more the history of art?**
The history of photography is very short and kind of separate. I see myself as an artist who uses a camera as a tool. I've made it my business to know the history of photography as well as I can, but I don't see myself as part of that history. However, I'm always thrilled when I'm included in it. I've always felt like an outsider in that world because I never formally studied photography. I was recently nominated for a big important photography prize—the Prix Pictet[5]—and I was really pretty pleased.

**I think people look at printmaking and photography maybe like glassblowing or ceramics— as very specific tracks within the broader scope of art making. They fall somewhat outside the ordained art world.**

4. Jimmy De Sana (1949–90), American. Photographer and key figure in New York's East Village punk art scene of the 1970s and '80s. His photography is known for staged scenes of nude men and women bound S&M–style.
5. Award founded by the Swiss banking organization the Pictet Group in 2008. The Prix Pictet recognizes outstanding photography that confronts today's pressing social issues and environmental challenges.

Photography, in terms of space that's allotted to it in museums, is often very ghettoized and segregated. It's usually on a separate floor. The ceilings are lower. Certain photographs, perhaps dictated by scale, do make it into painting galleries. It's interesting to see how that works and what determines that.

**How do you determine the scale of your work?**
Well, initially, I just blew things up because it was so important to me to hang my art near paintings. But I do feel like every picture has an internal logic in terms of how big it should be. I try to listen to that. It's totally intuitive and a visual kind of thing.

**How have recent changes in technology affected your work?**
I love film so much, but whenever I do something that's not for my own [art] work, anything that's for a magazine or for a quick turnaround, I shoot digitally. But lately there have been more and more art things that I need to do quickly, so I'm almost completely digital now. I have so much film in my refrigerator. I don't want to be digital. I love film, but I'm impatient and want to get my results. My last few exhibitions were digital. The printer I work with is phenomenal—he does magical things with my prints, and he can get so much more from digital files. So there you have it.

**Let's talk about your studio. How long have you been in this studio?**
Less than a year.

**Your studio is where you live. Is that what you prefer?**

It's always where I live. I wouldn't even like to walk across the lawn. I just want it to be as close as possible. For a while, I had a studio in Red Hook, and I would leave home to go there, but the only thing that made me go was a good bakery that was nearby. [*laughs*] My father worked at home. He was an orthodontist, but his office and his little darkroom were in the house. I think that was a model for me. It just didn't seem right to leave home for work.

**Has the location here in Cornwall influenced your work in any way?**
Totally. My last two series have been about rooms and sets that I could only find in this area. This house is like the gift that keeps on giving. I knew it would be inspirational; the house is like a big dollhouse. The place where I shot my last show is a little abandoned house that's twenty minutes away. So everything I do is really about this part of the world now. Although it's still about interior spaces—it's not like suddenly I'm shooting out in the green grass with the green trees.

**Can you describe a typical day, being as specific as possible?**
A typical New York studio day is that I get up really early, around 6:00 a.m. I meditate every day, make coffee, and that's my private time to write or to answer emails. And then my studio manager comes in at 9:00 a.m., and we do everything administrative. Every day is completely different. We'll get things together for benefits, we get things printed, we deal with gallery stuff. I have to say that no two days are ever the same. I've found this to be true of most

photographers. When you're a painter, you really have to log in painting time, but when you're a photo-based artist, there are huge periods of time when you're not shooting. Ideas are gestating. I have to find props, I'm planning out a shoot. There's so much preparation.

With the *Love Doll* series, over the course of three years there were only thirty-five shooting days! There's so much work that goes into the final presentation: editing, getting things printed, visiting the lab, getting things mounted, getting things framed. That takes up a hell of a lot of time. It's different than being a painter. There's more freedom. You're not shackled to your work in the same way. If the set is complete and the light is right, then the photography part is one click of the camera, and you can get your picture.

**What about a typical day up here?**

Again, it's completely different every day. There are probably days I don't even come into this studio. Right now, at this moment in time, I'm prepping for preproduction for a film. Next week I'm shooting an entire installation for a show at the Jewish Museum. The following week I'm shooting a beauty story for *W* magazine. I'm as excited about the beauty pictures for *W* as I am about the pictures for the Jewish Museum. Every project is really different. I love it. I would go crazy as a painter.

**What's your favorite color?**

Red. There are so many great reds. I base it on lipstick. Sometimes I like red with a punch of orange. Sometimes I like red with blue. I just love red. I love color in general. I feel like I'm an extreme colorist. I wear a lot of red. I'm not afraid of red.

**Do you have any special devices or tools that are unique to your process?**

In my early photographs, when I made dollhouse sets, the walls were independent of the dollhouse, and I needed something to prop them up with. I used huge, heavy cans of Crisco and this generic shortening that was in a red, white, and black can. I felt like my huge cans of shortening were my most important tool. [*laughs*] I found them by chance. I saw them at the grocery store and I was like, "That's it!"

**Are there specific items that you have in the studio that have significant meaning?**

So many. [*pointing around the studio*] These are happy-faced breads I got in Japan. These small kitchen appliances are props that I use in photographs. This is the artwork set from my Kaleidoscope dollhouse, it has a mini Lisa Yuskavage[6] and John Newman[7] and Allan McCollum.[8] This is an ashtray that my tarot card reader gave me. These are my mother's

---

6. Lisa Yuskavage (b. 1952), American. Painter known for figurative works that portray young, angelic, but also cartoonish and vulgar female nudes within fantastical landscapes or dramatically lit interiors.
7. John Newman (b. 1952), American. Sculptor who uses a broad range of materials and is known for tabletop-size, intricate works.
8. Allan McCollum (b. 1944), American. Artist known for using different varieties of mass production, often creating thousands of objects that are each unique.

shoes—they're just sculpturally so beautiful. This is one of the many pairs of legs I've used in my work. This is a latex outfit one of my [anime] Kigurumi[9] girls wore. A guy at the local cafe gave me this picture from the side of a fruit box. These are marshmallows that I got for Christmas that nobody ate that have become a very valuable prop.

**How often do you clean your studio, and does that affect your work?**

I have to make it straight before I can think. One of my favorite things is to have a shoot. After the shoot it looks like a cyclone has ripped through the studio. And I love that. I love that things are in just complete chaos; it's like a job well done. That said, I can't work again until everything's back in its place.

**How do you come up with titles?**

They're very straightforward. They're very descriptive, and I always have slashes in between the words. It's very simple. For example: *Yellow Hair/Red Coat/Umbrella/Snow*. In the end, it becomes a kind of word soup, a poetry that I really like. There was one series where I lifted heavily from Shakespeare. I don't know what came over me. The titles were all like *Calumny/The Hum/ The Shrug/The Ha*. I still like it, but it was this brief moment when I was thinking, Titles! I can do that! But they're kind of silly.

**Did you ever work for another artist, and did that have any effect on you?**

I did. I worked for an artist named Susan Hall for a long time. I think that working for an artist made me see the way an artist could live. I knew a lot of artists and was a keen observer of how people did

things. That's the way I learned, just by watching, because I've never really had any mentors.

**Do you have a motto or creed that as an artist you live by?**

Interestingly, I went to a psychic when I first came to New York, and she kept saying, "Keep your eyes and ears open." After that I decided to look at everything and go to everything I could possibly go to performancewise and see everything I could possibly see gallerywise. By keeping your eyes and ears open, everything you needed to know would come to you. But that's just one of a hundred things that I would tell people.

**What advice would you give to a young artist that is just starting out?**

I know this might sound corny, but to persevere no matter what. It's different now than it was when I was a young artist. It's a different kind of world where you make a different kind of art. If you self-identify as an artist, there's a reason for that. Figure out what you have to say and say it. I've heard older artists giving lectures at schools and saying, "Why would you want to do this? Find something else to do." To me that seems like such a bummer, so I would just say, "Go forth, young woman or man, and do it."

---

9. *Kigurumi* is the Japanese name for costumed performers who represent cartoon characters. *Anime Kigurumi* is a subset in which humanoid characters are represented using masks, wigs, and bodysuits. In 2014 Simmons created a series of large-scale photographs of models wearing custom-made Kigurumi masks.

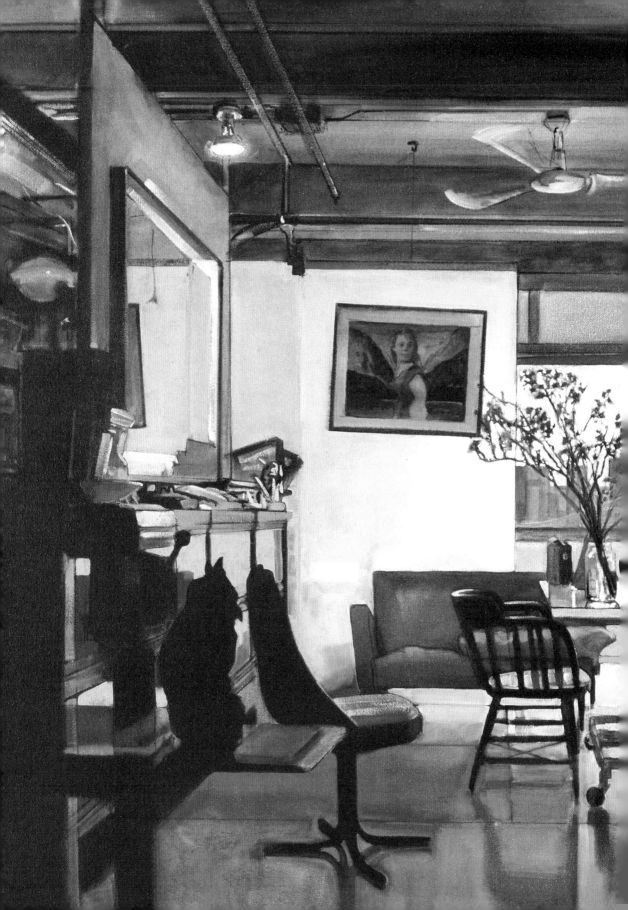

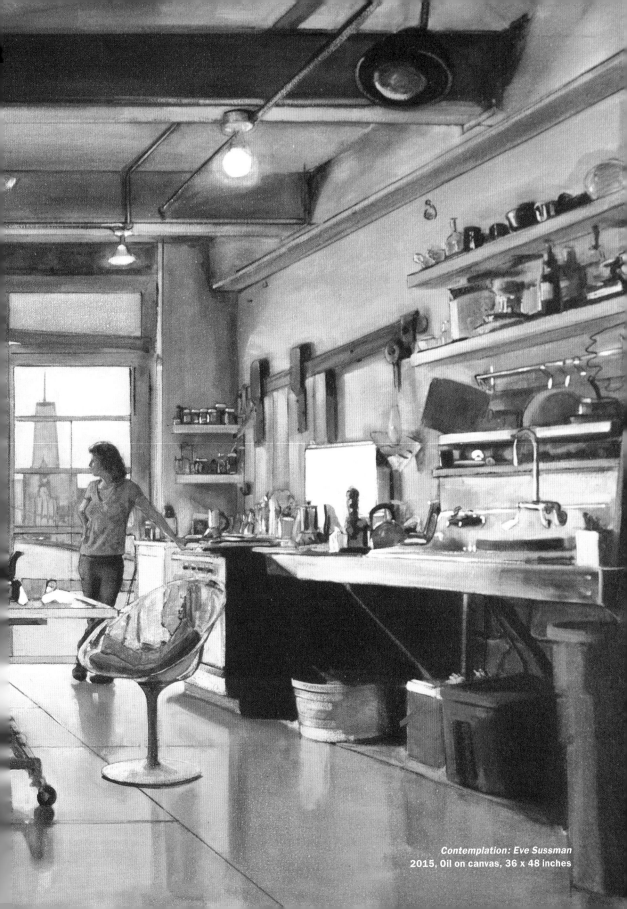

*Contemplation: Eve Sussman*
2015, Oil on canvas, 36 x 48 inches

# Eve Sussman

Williamsburg, Brooklyn / November 21, 2013

**To start off, can you please tell me a bit about your background?**

I grew up in Lexington, Massachusetts, and a bit outside the U.S. When I was a little kid, we lived in India and Israel. When I was a teenager, I spent a year and a half of high school in Istanbul, and I returned for my senior year in the U.S. I think the fact that my family traveled a lot when I was young has informed a lot of what I do now.

**Do you remember an art piece you made in childhood that got recognition?**

I made things from childhood through my teenage years, and people complimented those things. My mother was encouraging; I had teachers that were encouraging. I spent a lot of time in the art studio or in the metal studio or in the darkroom. If you're fifteen years old and spending a lot of time in the workshops in school, people notice. You get known as a person who makes things; that in turn gives you an identity.

**Where did you go to undergraduate school?**

I went to Bennington College in Vermont, which was a great place in the 1980s. It was an experimental place. It's one of the few places where you didn't have to show SATs. They didn't give grades.

**Did you go to graduate school?**

No. I find that whole system highly suspect.

**When did you move to New York, and what brought that about?**

I moved to New York the year I graduated from college, in 1984. It was a fluke. Initially, I went to Maine with my friend, the painter Marilyn Gold, who I'm still close to. I thought that was where I wanted to live, by the seaside in Maine. She was from the Bronx. Suddenly, she needed to rush back to New York; we were together, and I said, "OK, I'll go, too." So in the middle of summer of the year I graduated, without ever intending to, I found myself in New York City.

I moved to Avenue D between Eighth and Ninth Streets in 1984 and lived there in a loft on and off for about five years. That loft and the people who passed through there had a profound effect on me, and I'm still close with some of those folks. Before I moved there I had no desire to be in New York—I didn't see the point. It didn't take long—maybe two weeks—before it was obvious to me that this is where I needed to be. It was easy then to develop a community. The squatter scene was happening. There was the DIY Lower East Side art scene going on. To be twenty-two on the Lower East Side in 1984 was exciting. That was a significant time to be in Alphabet City. I felt very lucky.

**When did you consider yourself a professional artist, and when were you able to dedicate yourself full time to that pursuit?**

Initially, you always feel a little cagey about naming that as an identity, especially in America, where the profession is meaningless in mainstream culture. It probably helped when in 1989 I went to Skowhegan—that was my grad school. I went there pre–Internet era. When you left they'd hand you this stack of paper with all this information about grants and programs to apply for, helpful ways to put yourself out there. I religiously applied for everything. I got my first grant after that. I got

invited to do these funky shows, most of them in really weird, off places in the Lower East Side or in abandoned buildings.

I don't know when I would have actually said, "Oh yeah, this is what I do—I'm an artist." I certainly worked a lot of shitty jobs. I didn't make any money for twenty years. So if by "professional" you mean that you live on your work, then that took twenty years. If you mean the summation of your identity and your career—and take the economic thing out of it—then I would say that was within five years of moving to New York, when I felt comfortable identifying myself as an artist.

**How did you get your first gallery show?**
Totally by working outside of the system. I got my first gallery by doing things under the radar or outside of the ordained art world—self-made, underground stuff. Simon Lee[1] and I and four other artists took over this beautiful townhouse in the West Village. The crazy shrink who had owned it had died. Our friends got the job of house-sitting while it was for sale. They said to the owners, who were in London, "Could we put on a little art show here?" I think they thought we were going to hang some paintings or put a few things on pedestals, but we were all installation artists and sculptors. They didn't know we were going to hang gigantic pieces of steel in the stairwell. Simon piled up every carpet in the house in the basement and tunneled a hole through it. He titled his piece *Who Has Enlarged this Hole?*, from a note he found scrawled on the wall by the crazy dead owner. That became the title of the show. Each artist took a different

section of the house. I took the spiral stairwell and a tiny maid's room in the attic and made a sculpture-video installation. I put a pendulum in the stairwell. It was pressure-fit into the walls. A structural engineer would have probably closed us down.

That little DIY show got a lot of attention. To our complete surprise, we got written about in the *Village Voice*, which was a big deal for us. One of the people who came to that show was Bronwyn Keenan. She became my first gallerist. She was really ballsy, and she had a good eye. She started in a tiny space on Broadway in SoHo and then moved to Crosby Street. I did a couple shows with her—never sold a damn thing, but she always let me do whatever the hell I wanted. She was always encouraging.

I was more of a sculptor then. I did a lot of big installations, but they couldn't travel. They were one-off, site-specific pieces. That makes it hard to work with a commercial gallery. I just didn't think at all about how to make work into a commodity or how to make it so the work could travel or how to even make something repeatable. Recently I've become interested in that again: things being one-off, more performative, less tied to object or commodity or the market. For twenty years I worked that way. I didn't give a fuck, and that was very freeing. But I also lived on less money, and New York was cheaper then. When you're younger,

---

1. Simon Lee (b. 1956), British. Artist known for his experimental work in photography, film, and installation.

you can call up five of your friends and get everybody to stay up until three in the morning putting a show together. There was a community of people that would do that. Then there comes a point when you realize you're going to burn your friends out.

**You mean to help you with installing your work?**
Yeah, like suddenly you're doing this really difficult installation, building this twenty-foot tower out of the back of a gallery that has to reach the third floor. It's dangerous, people are getting tired, and you're using power tools. Then there comes a point when you can't push the boat out quite so far in the same way. And you start realizing that it would be good if you could pay people. That starts changing the way you work.

**Who are you showing with currently?**
In New York, nobody. I'm really excited about not having a commercial gallery in New York. Going it alone. Like I said, for twenty years I worked outside of the commercial gallery system. The showing "with" doesn't interest me. It's so ordained and curtailed and not experimental and doesn't take into account a lot of the stuff I care about, which is to get back to work that is more alive. I'm not saying I never want to sell art, but I come from this history of making stuff that was uncommodifiable, and now I'm curious about ways that might work again.

I've done a lot of big projects, meaning I'm working as the producer. Whether that means doing a big film or running our little theater or renovating a building, I know how to run a business. I don't need somebody to run the business for me or take 50 percent of my sales. I'm capable of doing that.

**How long have you been in this studio?**
Simon Lee, Lee Boroson,[2] and I came here together in 1998. This building was empty and we built it out. I do everything pretty organically. So with the layout of the space I probably did a couple scribbles. When you walk into a big empty space, the first thing you think is that you want to keep it big and empty. A lot of it's about being in the space for a while and getting a feel for how it flows. After a while you realize it would be good to be at the level with this window [a wall-size window with a stunning view of downtown and the New York Harbor], so you raise the floor up.

**Has the location of the studio influenced your work in any way?**
It has. There's one short film that I made in 2001 that was very much about this location and the view. I thought I'd like to do more work that uses the view because the view is so spectacular and special. I've worked in a lot of buildings in New York, and I've been in a lot of fancy, really expensive apartments, and I always feel that this view beats most of them. I made a piece about September eleventh, and that was very much about this view.

**Can you describe a typical day, being as specific as possible?**
I don't have a typical day. I'm not one of those people that have a schedule. We just got back from

---

2. Lee Boroson (b. 1963), American. Artist who creates large-scale installations using inflatables, fabric, and light to create immersive environments for the viewer.

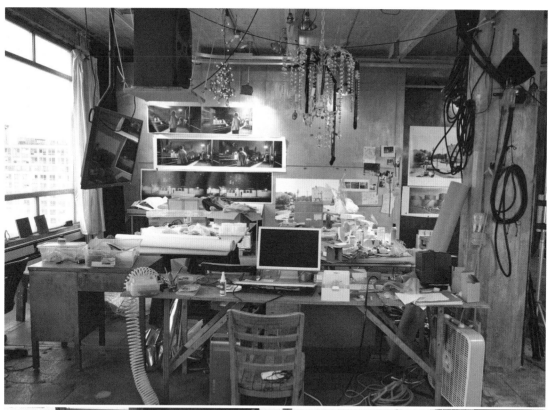

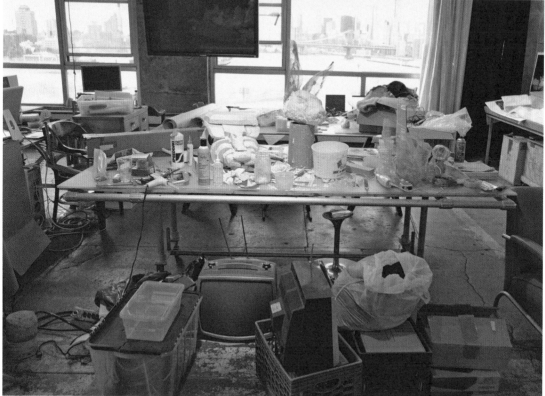

Europe, so lately I'm on European time and I'm up early. We're renovating a warehouse down the street. I roll with the punches. Today I'll spend half the day doing my banking because we have to pay a ton of people in the next week. Yesterday it was working on lenticular prints we're getting made in Poland. Searching for 1970s TVs we're getting off eBay that we have to ship down to Miami without breaking. There's a bunch of video that needs subtitles to go to Moscow. A lot of what I do in the studio is office work, although I also build things here. I shoot here occasionally, but a lot of the time I shoot in other locations.

I don't have a typical day, though. It's get up, make a list, figure out what's most pressing, and deal with that, because that's how projects work. Demystifying the romantic aspect of being an artist. I say I also run a business, and that business is my studio.

**Can you tell me a little bit about the materials you use and how they came into your practice? How did you learn to do all the film work/editing and use all this equipment?**

Aside from how to print black-and-white photography, everything else since, I taught myself, especially with technology. Nonlinear editing didn't exist before the 1990s. I bought my first Adobe Premiere editing system in 1999. I've learned things by osmosis, from learning to edit and use computers and cameras to renovating buildings and running a crew and running a business.

I think that's the way with a lot of artists. That's certainly the Lower East Side DIY culture that I moved into. Then it became the Brooklyn DIY culture. It was very much: you want to do something, you do it yourself.

**If you're doing a [video] show, I imagine there are a lot of expenses. Who would be responsible for that?**

Well, actually, the cost keeps getting smaller, and the work is getting easier to travel. I can take my entire exhibition with me on a hard drive in my backpack. I don't even need to bring a computer anymore.

But that's part of the reason I have a studio manager. She negotiates all of that. We have a stipulation agreement and riders that we send out when we get a request for a show. There is a hire fee for the piece and a tech fee. The rider includes all the equipment we need and includes who needs to go, what needs to be done. The installation requirements are based on the architectural renderings of the space. They send us schematics and we send them back drawings. It's different for every place—if somebody has a theater or if they have a gallery or if they're showing in a raw space or if it's a museum.

**Do you have any specific items that you keep around here that have significant meaning to you?**

I try not to think that I'm incredibly sentimental. I'll be like, "Oh I should purge this stuff," and then I don't throw something out for a reason. You go through piles of images, and you realize you shot these ten or fifteen years ago, and there's a reason not to throw it away. You make things with a certain attitude, and sometimes you have to get back to that attitude or get back to that consciousness. Especially when you use cameras—it's about a certain type of presentness. If you can recall the moments of that presentness, it can remind you that certain things are possible.

**Do you work on one project at a time or several?**

Often it's not one project at a time. Right now, Simon and I are working on a proposal called *Stalkerpooh* or *Roadside Picnic*. I'm working with a group doing a dance/drum/installation piece called *Skinner Box*. And there are other little, smaller things I'm working on.

**Speaking of that, how do you come up with titles?**

I don't really have a method for that. I'm really not that good at coming up with titles. Often they're just a line in my head about how I feel about something or what's going on. Often they're very dry.

**Do you have a favorite title?**

Well, there's a title that I've used in two different instances for two very different pieces called *How to Tell the Future from the Past*. That title encompasses a lot of what I'm interested in: a questioning of how the future and the past are really not that different and a lot of what we think of as new is repetition.

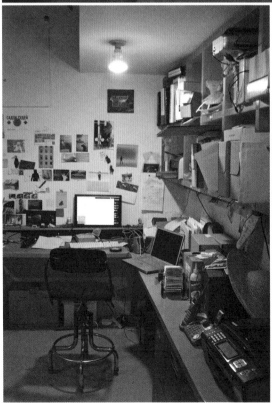

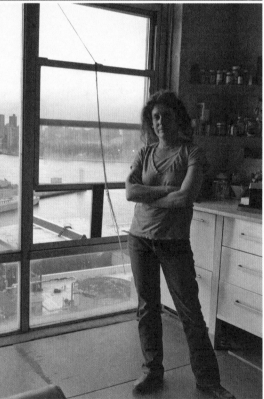

**Do you have assistants?**

Catherine Mahoney is my studio manager. She does much more of the real business management side now: negotiating contracts, doing sales, writing grant proposals. If we're in production, she's working as line producer, so she's dealing with all of the crew and hiring actors and paying people. I don't have somebody who comes in regularly to do physical stuff in the studio. I've had that occasionally—I've had interns—but I actually find it distracting.

**Did you ever work for another artist?**

I worked for Richard Artschwager[3] for a short time when I first moved to New York. He was brilliant. I thought he was an amazing man. He lived in an old bank on Avenue C and Seventh Street. I got the job by wandering into his house one day when the door was open. I was with a friend of mine, and we walked in and stood at the end of this long hallway. This really tall, imposing, skinny man looks at us and growls, "What are you doing here?" We said something lame like "We just came to say hi." Surprisingly, he asked, "Do you want some tea?" But we were intimidated and excused ourselves. When we walked around the block I said, "We just got invited to tea with Richard Artschwager— we should take him up on that." So we went back and knocked on the door and said, "We'll have that tea now." We ended up hanging out with him for about five hours. He pulled out a huge bag of marijuana, and the whole thing struck me as surreal. [*laughs*] Finally, at the end of the day I said, "Well, if you ever need help, I wouldn't mind working for

you." Two days later he called, and I worked for him for a few months while he got ready for a big show at Leo Castelli.

After that I worked for Ursula von Rydingsvard[4] for a while. Working for those two was great. They were really inspiring, really supportive.

**Do you have a motto or creed that as an artist you live by?**

We live within a certain culture, so we are living by mottoes whether we know it or not. Having integrity in what you're doing and trying to insure the thing you're doing is the thing you really want to be doing. Often, if you get pulled into this market-driven art world, you find yourself doing things you don't want to be doing. That shows in the work. We all know when work is coming from a sincere place.

**What advice would you give to a young artist that is just starting out?**

Be honest. Do what you think is important. If you're driven to do it, then it's worth doing. My advice is to be real. If you're not being real, everybody's going to know.

---

**3.** Richard Artschwager (1923–2013), American. Artist known for his stylistic independence and his use of utilitarian and industrial objects. He has created works that cross through conceptual art, minimalism, and pop art.
**4.** See pages 242–51.

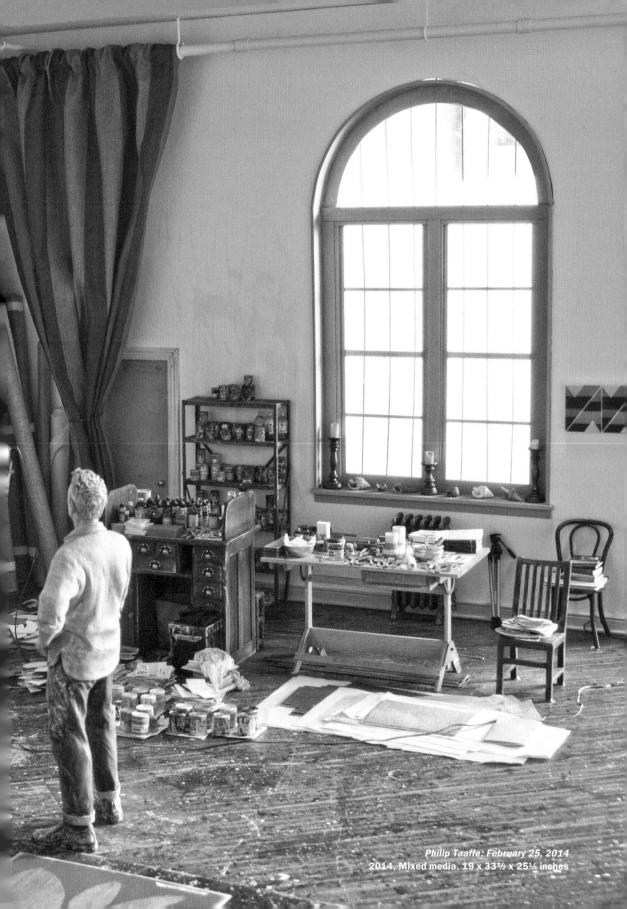

*Philip Taaffe: February 25, 2014*
2014, Mixed media, 19 x 33½ x 25¼ inches

# Philip Taaffe

Garment District, New York City /
February 25, 2014

**To start off, can you please tell me a bit about your background?**

I grew up in Elizabeth, New Jersey, and I went to an all-boy Catholic high school. At first there wasn't even an art program but then they hired an art instructor named Nick Florio. He was a zany guy, very affable and nurturing. He encouraged me. The art room was a great place to hang out. I was always the class artist as long as I can remember, ever since kindergarten. I didn't have such a good time in high school, so art was a nice escape for me.

**Do you remember an early art piece you made that got recognition?**

When I was four years old, I did a fairly realistic charcoal profile of Abraham Lincoln. I have to admit it was pretty good for a four-year-old. I labored over that. I put red and white stripes behind him. I was pretty enterprising. When I see what my own kids are capable of at that age, I was fairly precocious. [*laughs*]

**Where did you go to undergraduate school?**

I started at Parsons School of Design and went for one year, but I needed a more intensive atmosphere, and I transferred to Cooper Union. That changed my whole approach to art because my mentor at Cooper Union was Hans Haacke,[1] who was deeply opposed to painting, so I had a period of exceedingly critical analysis. Another teacher who was very important was Andrew Arato—he is a sociologist, a Frankfurt School scholar. Between Haacke and Arato, I became interested in cultural critique. I met Joseph Beuys,[2] who was a friend of Haacke's. I was doing some painting, but mostly

filmmaking, sculptural installations, photography, and a lot of writing. A lot of cultural analysis.

I graduated from Cooper in 1977. I did not go to graduate school. I thought it would be better for me just to stay in New York and get to work. I was living in a cheap, cold-water flat in Jersey City. I had a part-time job, I did a lot of reading, and I'd come into the city to see films. I was able to support myself in a very modest way.

**When did you consider yourself a professional artist, and when were you able to dedicate yourself full time to that pursuit?**

In the early 1980s. I had friends who had a framing shop on Union Square, and they were manufacturing these lacquered, pentagram frames for Robert Mapplethorpe.[3] I was working on some very labor-intensive, very austere constructivist pieces. I called my friends and asked if they would make a frame for me. Well, Robert Mapplethorpe saw my work at their shop and asked, "Who made it?" My friend and schoolmate Curtis Anderson brought Robert out to Jersey City to my little cold-water flat. He bought a piece of mine for $800. He was my first collector.

---

1. Hans Haacke (b. 1936), American. Conceptual artist known for works that incorporate lists and are critiques of social and political systems, focusing on the art world and the exchange between museums and the commercial market.
2. Joseph Beuys (1921–86), German. Artist, theorist, and teacher known for his performances, installations, and sculpture. He was associated with the conceptual and Fluxus art movements.

I had a 1957 broken-down Chevy that I kept at my parents' house in Scotch Plains, New Jersey. I used to drive it around Newark to these waste-paper disposal sites looking for material. I found some very unusual off-printed pieces of paper. I had one big wall in my apartment that I worked on. I decided to make big works on paper, reusing these beautiful old rolls I'd found.

The first ones were on found striped paper. I did two of those; they had a certain pulsating quality to them. They were very large. That led me to make optical reconstructions, kind of a riff on Bridget Riley's[4] work. I was doing research into her background, and her great-grandfather was a scientist who worked on the invention of the lightbulb with Thomas Edison. Coincidentally, some of the paper I found was lightbulb packaging paper. I made linoleum carvings of these Bridget Riley waves and printed them onto the back side of this lightbulb paper, so you'd see the faint image of a lightbulb behind the black wave structure of this painting. I thought that was a nice coincidence.

I realized at that time I really didn't like my part-time jobs, especially being in an office. So when you say "professional artist," well, basically, I wasn't suited for too much else. I had to invent my own existence.

**How did you get your first real gallery show?**
A friend of mine that I went to school with introduced me to Roger Litz and in 1982 I had a show at his gallery in SoHo. My opening was the same night as Keith Haring's[5] first big extravaganza at Tony Shafrazi Gallery, which was right next door. CBS News was there—there were balloons and all these graffiti kids. Here I was showing next door,

making these austere works. There was certainly a disconnect between what I was doing and what was being embraced in the art world at that time.

After that show I changed direction. I knew Donald Baechler,[6] I knew Ross Bleckner,[7] Peter Schuyff,[8] and a few other people who knew Pat Hearn. Pat had just opened her gallery on Avenue A in the East Village, and that scene was starting to heat up. I was renting a space in a building in Times Square. Pat visited me there and asked me to do an exhibition.

Actually, just before that I did a show in Hamburg [Germany] with Ascan Crone in the spring of 1984. Donald Baechler introduced me to Ascan Crone. It was like the Beatles—my first gig was in Hamburg. [laughs] When I came back, that's when I showed with Pat. That was a very successful show for me; I got a lot of attention. Pat was wonderful.

**Currently, you're with Luhring Augustine Gallery, but before that you were with Gagosian for a long time. How did those relationships develop?**
I got a show with Paul Maenz in Cologne [Germany], which Pat helped to organize. I wanted to take some time off. I went from Germany to Switzerland to Northern Italy down to Naples, and then from Naples, I took a boat to Tunisia.

I had met Lucio Amelio in New York; he was a gallerist from Naples. Lucio invited me to do a show in Naples. Lucio Amelio was like the king of Naples. He brought Warhol to Naples. He did shows with Cy Twombly;[9] I met Cy through Lucio. He showed Joseph Beuys and Robert Rauschenberg. He was larger than life, a tremendous character. So I was

3. Robert Mapplethorpe (1946–89), American. Photographer known for his large-scale, highly stylized black-and-white photographs. His most controversial works were images of sadomasochism and homoeroticism.
4. Bridget Riley (b. 1931), British. Painter known for her op art works that combine a wide variety of geometric forms and colors to produce a sensation of movement.
5. Keith Haring (1958–90), American. Artist known for his graffiti-inspired drawings and paintings that dealt with issues of birth, death, sexuality, and war.

6. Donald Baechler (b. 1956), American. Painter known for works that incorporate childlike imagery and themes, everyday objects, and simple figures.
7. Ross Bleckner (b. 1949), American. Artist known for large-scale symbolic paintings that deal with remembrance and loss and often address issues surrounding AIDS.
8. Peter Schuyff (b. 1958), American. Painter and sculptor known for his involvement in the neo-geo movement.
9. Cy Twombly (1928–2011), American. Artist known for his large-scale paintings of freely scribbled, calligraphic, and graffiti-like works on solid fields of gray, tan, or off-white.

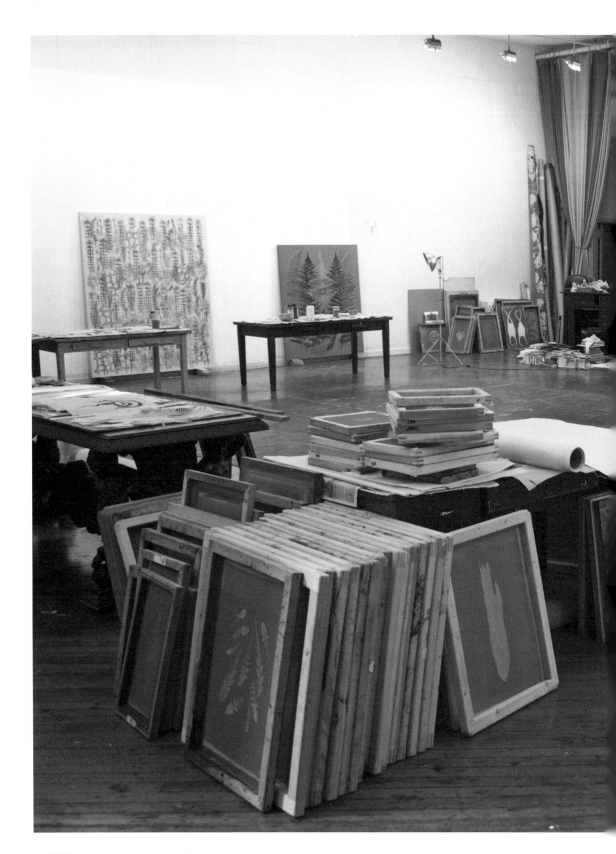

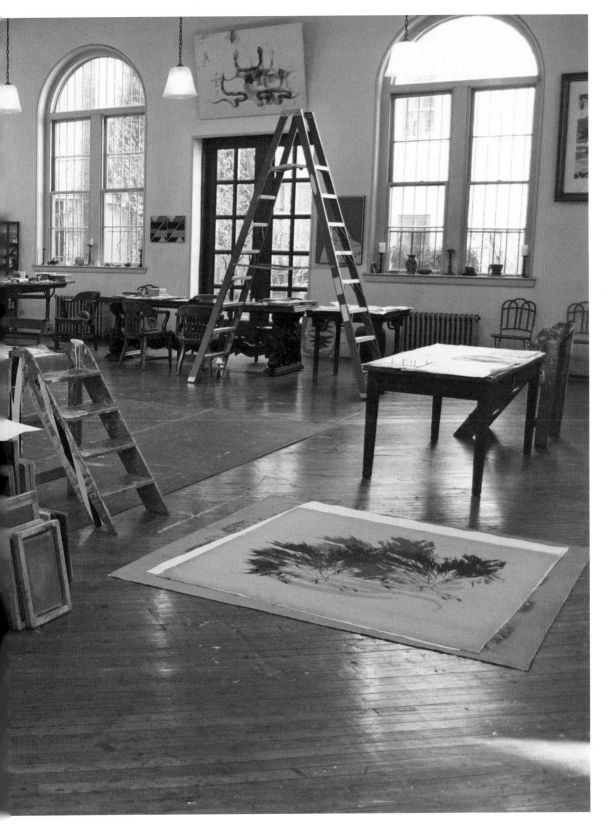

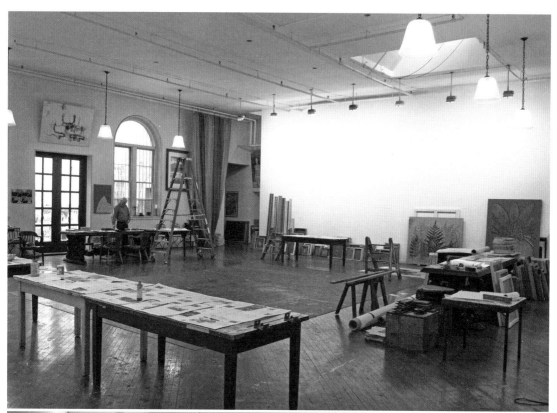

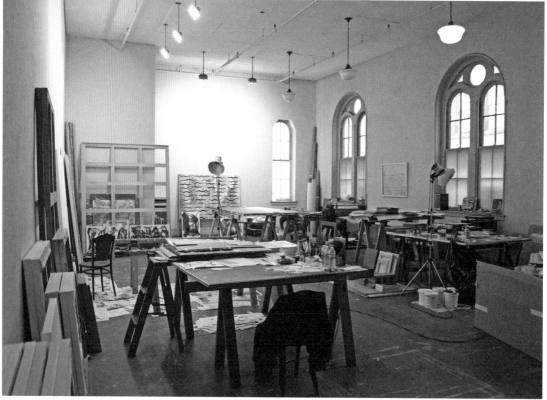

very excited to go to Naples. I had an Italian friend who found this incredible villa in Posillipo for me to stay in. I ended up staying three and a half years in this villa! I never went anywhere; I just stayed in this villa working.

Larry [Gagosian] came to Naples to meet me. I had done a show with Mary Boone and Pat Hearn simultaneously. Larry insisted that I do a show with him. I agreed. It was very difficult for me to tell Pat that I would do this. I did a show there at the very end of 1991.

**How did you meet up with Luhring Augustine?**
I had a fairly healthy situation for a long time with Larry, but it was time for a change. I'd known Lawrence [Luhring] and Roland [Augustine] for ages. I always liked them very much, and we agreed that the moment was right. I've been very happy to have a real, personal relationship with them.

**And how long have you been in this studio?**
I've been here for twenty-three years, since 1991. I moved from Naples back to New York, living at the Chelsea Hotel.[10] I was looking for a space within walking distance of the Chelsea. This has been my circuit for the last twenty-some-odd years. It's a ten-minute walk.

**When you moved into this space, did you have a plan for the layout, or did it develop organically?**
It suggested itself. What I liked about this space initially was that it had a similar layout to the villa in Naples. In Naples I had lots of separate rooms, which I would devote to different activities: printmaking, drawing, collaging, and storage. I had this gridded floor that I would use to size canvases and do layouts. I had a system. When I saw this place, it reverberated in terms of the Neapolitan villa. It felt good.

When I came here all these windows were bricked up, and there was a drop ceiling. There was a raised Formica floor and stairways and offices everywhere. It was a courier service, although previous to that it had been the gymnasium for a school for Afghani immigrants. I had to do a lot of work to make this place suitable.

**Can you walk me through what happens in the different rooms?**

Things tend to originate in this main room. I lay out the canvas and I start to build up the images by doing some initial screening or painting. Then I bring the canvases to the smaller room around the corner, where I'll do staining. Then they come back in here to the main room. Normally, this floor is completely covered. I work on the floor building up the images. They'll go through months and months of work. Then I decide on the size, crop them, and they get stretched. Once stretched I'll often do further work. I'll collage on them, paint them, and add to them—or they might just exist as is. For example, these fern paintings: I decided the size and then stretched them, and now I'm just touching them up.

**You do all the screening in here?**
For the most part, yes. That's what this Masonite on the floor is for. It makes a smoother surface to lay the paintings on. I'm on my hands and knees a lot.

**Has the location influenced your work in any way?**
I can't say that it has. However, I would say this place is a sanctuary. It's an oasis for me. When I close that door I breathe a sigh of relief just to be here. It's like a monastery; it's a cloistered situation.

**Can you describe a typical day, being as specific as possible?**
I'm up with the kids between seven thirty and eight o'clock, and I help get them ready for school. I do a little reading, take a bath, and have breakfast. I walk here. When I come in I'll make coffee, smoke, read the newspaper, and gather my thoughts. I've already determined what I have to do for the day at the end of the previous day.

I'm always looking for new imagery. I make new relief plates, screens, or stencils. I do research so I can transfer images onto paintings. I have a history of this, so there are earlier sets of images that I often come back to—earlier vocabularies or discrete languages or partial languages that I can bring into

---

10. The Chelsea Hotel (built between 1883 and 1885) is a New York City landmark notable for its residents, who have included some of the most famous artists, musicians, writers, and actors of the past century.

future works. I'm always recycling images and going back and rethinking and moving forward.

**It doesn't seem like you throw anything out.**
I can't, because I never know when I'm going to need a particular image again. I try to be encyclopedic and inclusive.

**If you needed a [screen of a] snake, would you know where that screen is?**
I would. I don't want to sound as though I'm terribly organized; I'm as organized as I need to be. But I'm not overly fastidious about it because a little disorder enables me to discover things. When I'm looking for a particular screened image, sometimes I can't find it. In searching for it, I might discover a silk-screened image that had not crossed my mind. So I try to be organized, but at the same time I like a certain degree of chaos—a creative chaos, an organized chaos.

I'll have a morning session, where I'll do screening or painting or printing. It's hours of intensive activity. Then I'll break for lunch, and in the afternoon I'll have another intensive session. Then at the end of the day I get to look at what I've made. I tend to stay late unless I have somewhere to go. I'll stay until 8:00 or 9:00 p.m. It's very nice here in the early evening. It's very quiet; I can do a lot of thinking and recapitulation. There are different speeds in the making of a work. Things often happen very quickly, and the consequences can last for quite a long time. Part of staying late is understanding how to deal with what I've done earlier in the day. I need to understand it and see its potential or the negative side of what it is. What do I want to eliminate? What do I want to save, and what do I want to do the next day?

**You have a lot of tables here. Can you tell me a little bit about some of them?**
These are late nineteenth-century Italian replicas of baroque library tables. I bought these in Newport, Rhode Island. I've put wheels on them so they can easily be moved around. I use these as anchor points in the studio. I do screening on that table over there. I might make a hundred screen prints in an afternoon. All monoprints, but changing the color as I proceed. I plan the printing out in advance and approach it systematically.

**What kind of paints do you use?**
I'm all-inclusive. Recently I made my own gouache with dispersion and gum arabic. We use enamel, acrylic ink, fluid acrylic, oil paint, litho ink. I use marine enamel. There's no paint that I don't use. And I like the full range of color. Each pigment has a certain chemistry and weight, so you really get to understand the chemistry of color because they really react differently. You have to experiment a great deal.

**Do you have a favorite color?**
I think red is the most relative color. I like Indian Yellow a lot. Historically that yellow is made from camel piss. They feed camels mangoes, and when the camels piss they collect the piss and it gets dried. It's this deep, transparent yellow; it's beautiful.

**Do you have any special devices or tools that are unique to your process?**
I've invented needle rakes for marbling. I like old paintbrushes. I use a lot of squeegees in gestural ways. I combine rollers, squeegees, brushes, and things like this; I'll combine all these things in one piece.

I have invented these pads that I print with. I'll design shapes, like an arabesque. Then I trace it onto foam core and cut out the shape. On the other side of the foam core I'll attach felt. I'll saturate the shaped felt pad with paint and then press that onto the surface of the paintings. It's a type of printmaking. I have hundreds of these padded shapes.

**Have there been any recent innovations in technology that have affected your work?**
In a negative sense, yes. I'm an analog guy. I'm going to have to adapt. I used to use Kodalith film to make the screens. I could use a found object like a feather; I would put the feather on a sheet of acetate and make a film from that for the screens. You can't get these big sheets of film that I used to use, so I have to improvise. I don't like any pixelation in my images, and now, very often, because of digital, I get pixelation in the screens that I have to eliminate. These new technologies make more work for me, in fact.

**Are there specific items that you keep around that have significant meaning to you?**

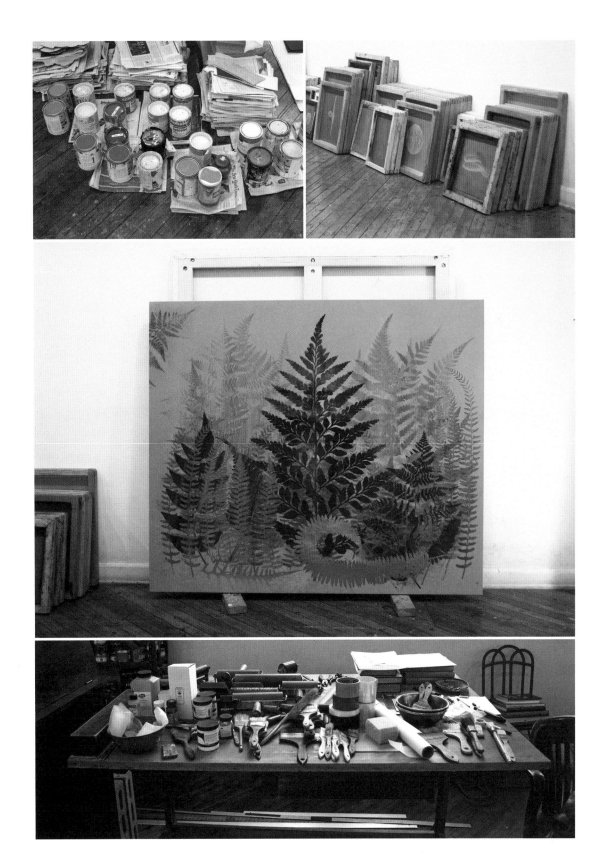

The old books in the library are the most significant things.

**How do you come up with titles?**

That's a good question. I'm working on titles right now for these fern paintings. I have an eight-volume work called *Ferns: British and Exotic* that was published in the late nineteenth century. It gives you a loose layman's interpretation of the Latin names. Some of the species and subspecies names are interesting, and I was able to glean a few things and recombine things. This painting is titled *Strata Asplenium*. I've made about twenty of these fern paintings over the years, so I have to go back and review my earlier titles and come up with new titles. This is titled *Phasmidae*, which is very straightforward, because it's images of walking-stick bugs. That's the scientific name.

Some titles are purely imaginary or they're extrapolated from actual names. I've used music. I love Henry Cowell's music, and his titles are very interesting because he'll change the wording— like the word *toccata*. He'll call that "Toccanta," which implies a toccata that has to do with voices. He extrapolates in that way. Titles are very significant.

**Do you have a favorite title?**

There's one painting I made when I was living in Naples; it's titled *Herculaneum*. I visited Herculaneum and Pompeii. Herculaneum was also buried by the eruption, but it's a smaller, patrician village, closer to the sea. I love Herculaneum. So I was riffing on some of the objects that were uncovered there. It's one of my favorite paintings that I've made, and the title, I thought, was very fitting. It's historical and it's geographical. For me, paintings are places. They're like geographical locations. So I try to give them names, to identify that place.

**Do you listen to music while you're working?**

Sometimes. Mozart is very good when I'm feeling stuck or things aren't flowing. It really opens things up and clarifies things.

**Do you have a motto or creed that, as an artist, you live by?**

Love and do as you will. It's from Saint Augustine.

**What advice would you give to a young artist who is just starting out?**

To try to understand what the culture needs and what you are uniquely capable of delivering to the culture.

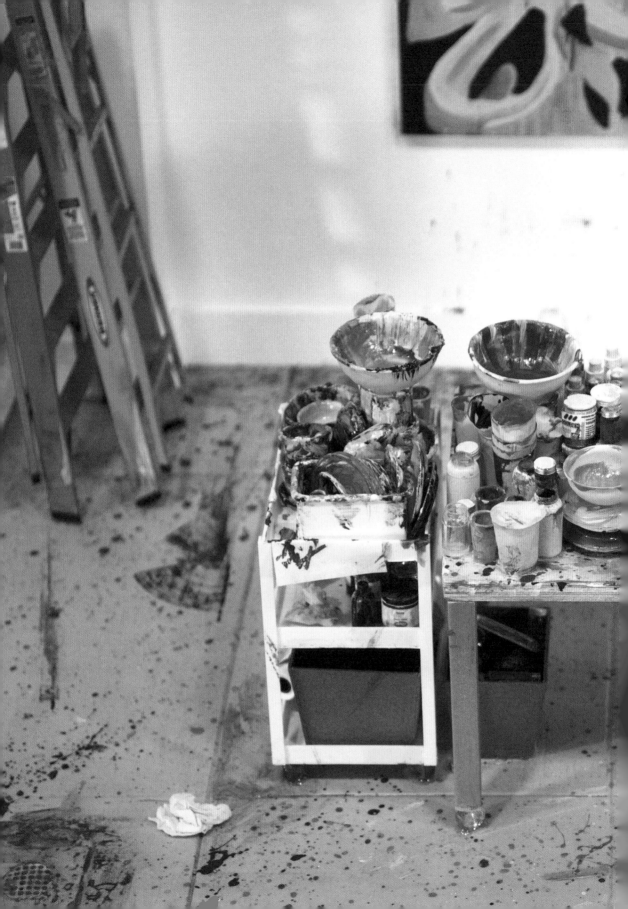

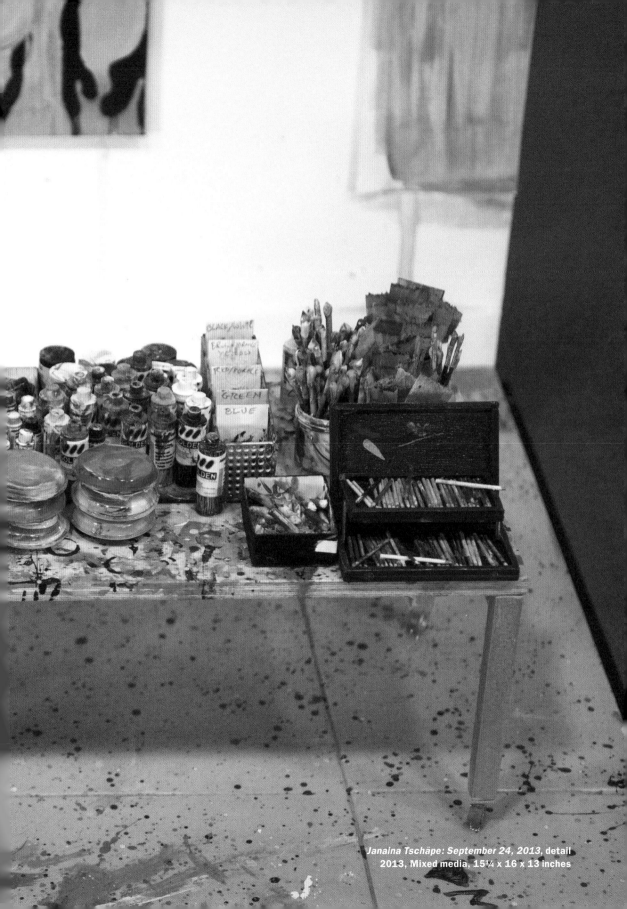

*Janaina Tschäpe: September 24, 2013*, detail
2013, Mixed media, 15¼ x 16 x 13 inches

# Janaina Tschäpe

Bedford-Stuyvesant, Brooklyn /
September 24, 2013

Photo: Barney Kulok

**To start off, can you please tell me a bit about your background?**

I was born in Munich, Germany, but I grew up in Brazil. When I was eleven we went back to Germany and lived there for five years. Then we went back to Brazil for a year, and finally back to Germany when I was seventeen.

I wanted to apply for the art academy in Hamburg, but I had to wait until I was eighteen, so I moved to Berlin for the year. It was right after the wall came down. In that year I realized how I wanted to prepare my portfolio because art schools in Germany are very different, especially the one in Hamburg, which was more of a conceptual academy. It was superhard to be accepted as a student. But I did and moved back to Hamburg and started the art academy in 1992.

I finished in 1996, and I moved to New York to go to graduate school at SVA. I went for a year, and then I stopped. In Germany the academy was very free and open. We just had a studio, a mentor, tutor, and workshops, but there were no classes, no grades, and no tests. It was all about the work that you were producing. SVA was a different system, which I really didn't get into. So I went back to Hamburg to finish up my master's degree and finally moved back to New York for good.

**Why did you travel back and forth between Germany and Brazil? Did you have a preference?**

My dad was German and my mother is Brazilian; he moved because of his work. They are very different cultures, for sure. I noticed it especially when I moved back to Brazil at the age of fifteen. At the time Brazil was still a military dictatorship; it was rigid, more traditional. Their art schools were really old-fashioned. In Germany Martin Kippenberger[1] and Sigmar Polke were professors. [Joseph] Beuys really changed the system of art education in Germany, and I was really drawn to that. The whole structure there helps you to become independent quickly.

Hamburg was a very conceptual school, which was hard for me in the beginning because I was painting. Besides Polke there were not many painters as professors. It was difficult. I actually stopped painting for a couple of years. It made me question everything. It was a healthy process to step away from painting because I did not know how to finish a painting. I would get so emotional and dramatic about it that I would ruin the painting. So to step back like this was a good thing. I gave it more thought and looked at it from a distance. I questioned, "Why am I painting?" I was literally chopping off my paintings and experimenting a lot. I started making sculptures, and from there I started doing performances with the sculptures. That's when photography started coming into the work, first as a tool to record the performance, than as a medium.

---

1. Martin Kippenberger (1953–97), German. Artist known for his prolific output in a wide range of styles and mediums, as well as his hard-drinking public persona.

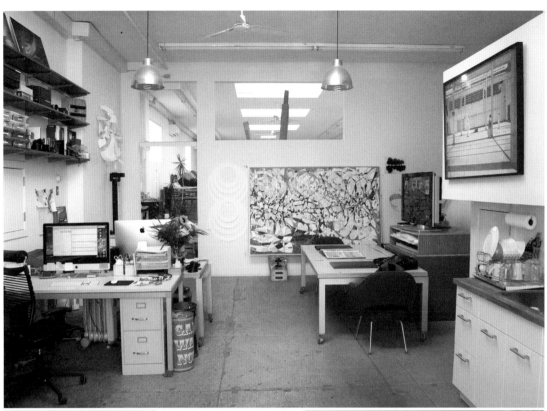

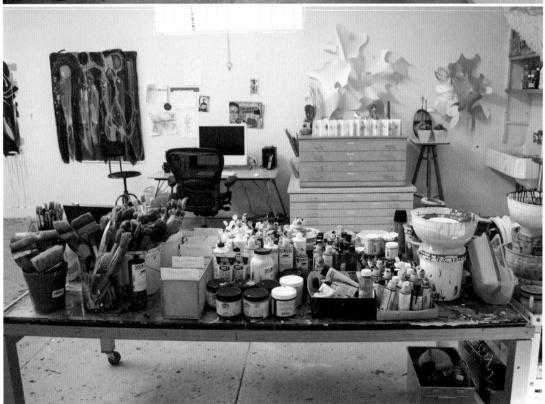

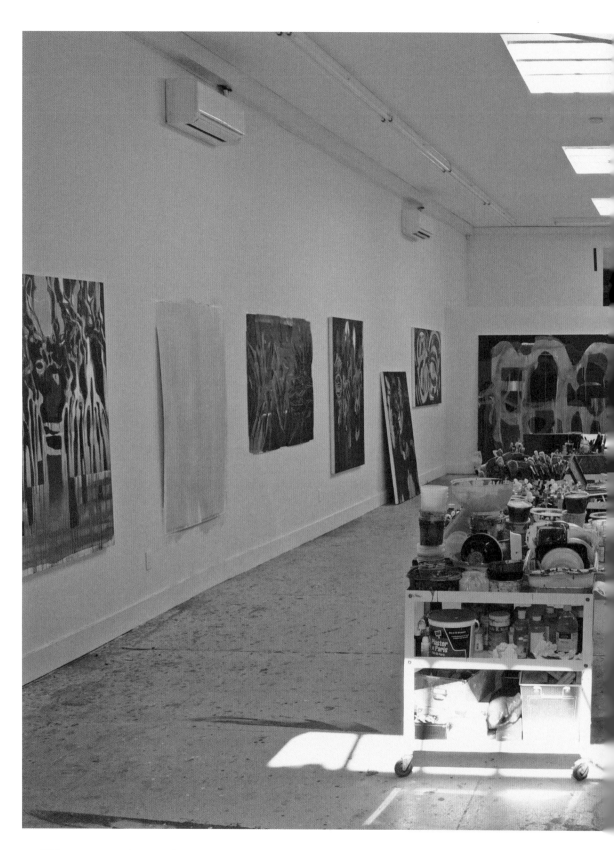

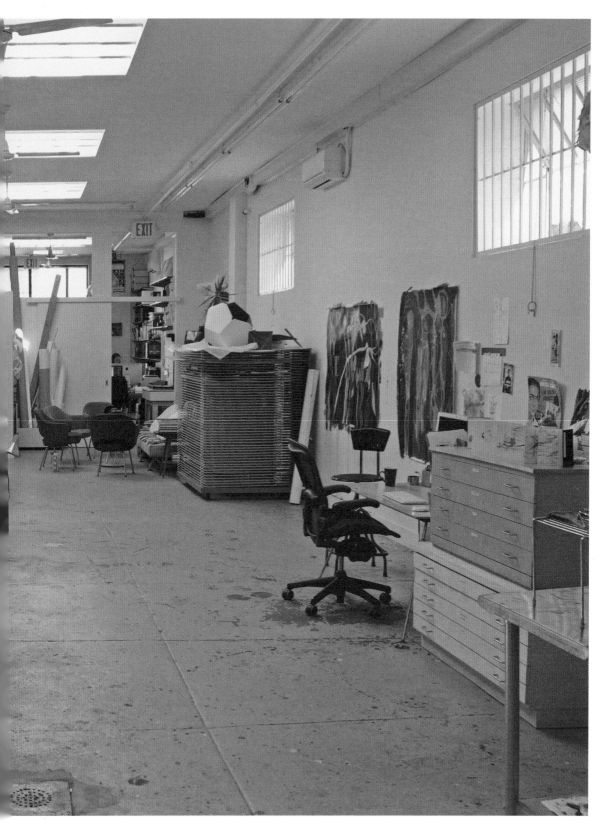

When I moved to New York I had two suitcases: one with clothes and one with these latex sculpture-objects that were inflatable. I began doing video because after using photography to capture the performances, I thought I needed movement and I needed to record sound and have more history in time. I realized that my performances were really not for the public. They were very intimate and personal, and, in fact, the photography was becoming the art. My generation looked at the photography of performance art from the 1960s and 1970s through books, really just as a record of the performance. I was aware that what I was doing was a performance, but I was looking at the photograph that captured it as the art piece, too. It was an evolution. In the beginning I was doing only slide shows of my work, and then I started looking at the images in a different way and printing them. Then with the video I started editing it. In the end the work became a whole new piece instead of just a recording of the performance.

**When you were describing the sculptures and the performances you did from art school, I had a flashback to how much fun art school can be—isn't it?**

It is. You stay overnight in the studio at school, and there's all this talk and all this debate. It's really nice. I never want to lose that ability to try everything because if you corner yourself into a medium, sometimes you can't get out so easily. I was always afraid of that.

As I continued with video and photography, I found it became very much a production. I went from using a little camera and doing it all alone to using a much bigger camera, and then I needed assistants, and then I'm printing, I'm editing. Everything became a production, which removed me from that first intimate relationship with art making, and I started questioning it again. While doing the performance you're hands-on and it's very exciting, but once the recording of the performance is done, then you have a hundred thousand digital images you have to go through. It's a slower process that is still interesting but is a lot drier.

So I was missing art making as an intimate thing, and I started drawing again to get back to

this and to think. The drawings became bigger and bigger because I was just having fun doing it and not thinking about it. That led me back to painting. I had a fear of going back into painting, but now I just keep everything open. I continue to work with photography, video, and painting. You don't need to corner yourself with one medium.

**In my own practice I've always felt—going back and forth between sculpture, painting, and photography—that each different medium helps and informs the other. It's a way of keeping it fresh.**

It's really nice, and they're suited to go back and forth. I was just in Brazil, and I went on a trip to the Amazon where I was shooting video and taking pictures, and it was supernice to be out there and not in the studio. But then I miss the studio, and I go back. One thing feeds into the other.

**Did you stop doing sculpture and then concentrate on the drawings and paintings, or did you go back and forth?**

When I was in art school, I did a lot of things with wax and cubes and latex. It was very Eva Hesse–inspired. After a while the sculptures morphed themselves into costumes and inflatables. They became props. I never looked at them as objects.

Now I'm doing paper cuts. I like the nature of them and how they are popping out of the wall. I don't know where it's going, but it will sort itself out. My paintings are a lot about pattern, about repetition. I don't know if you saw that movie *Flatland*? It was inspired by Edwin Abbott's[2] novel. It's kind of a cartoon where the two-dimensional world becomes three-dimensional. I feel these paper cuts are starting to pop out of the paintings and off the walls in a similar fashion. I'm trying to go inside the piece to work with the idea of landscape.

**Do you remember an early artwork from childhood that got recognition?**

---

2. Edwin A. Abbott (1838–1926), British. Author who published *Flatland: A Romance of Many Dimensions* in 1884. The novella used the fictional two-dimensional world of Flatland to comment on the hierarchy of Victorian culture. Its lasting contribution is its examination of dimensions.

Yes, this would be in Germany when I was about thirteen. Mother Teresa was in town. It was a huge event, and the church held a competition for a painting of Maria, the mother of Jesus. I did a painting that was very surreal, with a big Jesus cross and a very small Maria, and I won the first prize from Mother Teresa! She shook my hand—she gave me the prize. My mom was so proud. I got some money for the painting as well, and it was placed in the church. It was a very big deal.

**Can you tell me more about why you decided to come to New York?**

New York felt like neutral ground. Culturally, Germany is a giant. The culture, the history, it's too heavy as a mentality. Brazil, on the other hand, is almost the opposite. I was always in between both. New York felt like a relief. I didn't have to decide if I was German or Brazilian.

**When did you consider yourself a professional artist, and when were you able to dedicate yourself full time to that pursuit?**

When I finished art school, my money was running out and I was always thinking, What am I going to do to survive? I wanted to keep doing my art, but I gave myself a time limit. I thought, If I'm thirty-two or thirty-three and I'm not making a living off my art, I'm going to stop and not become a frustrated and weird person. I was very rigid. So I did little jobs and things to make money. I was totally focused on making my life work out. I had my first gallery show when I was twenty-seven.

**How did you get your first gallery show?**

There was this project space called Clinica Aesthetica in the Meatpacking District run by Elizabeth Fiore and Yvonne Senouf. A common artist friend introduced me to Yvonne, and she liked my work and introduced me to her partner. That was my first gallery show. It wasn't a commercial gallery. Stepping into the arena of showing my art was superimportant and felt scary, too. I had a show where I inflated one wall, and I had photographs. I worked with them for a couple of years, but then they dissolved.

After that I started showing with Galerie Catherine Bastide in Brussels. I met her also through a friend. I was her first show in Brussels when she opened in 1999. Then things started moving from there. I started showing in Brazil at Galeria Fortes Vilaça, and slowly I started to be able to pay my rent.

**How long have you been in this studio?**

Almost five years.

**Your studio is separate from where you live. Is that what you prefer?**

It's not what I prefer. Because I have a daughter—that was the main factor. My daughter is now a seven-year-old little girl, and she's begun to understand and respect what's going on in the studio. But because of the size of the work and the way I work, it needs to be separated—it's very messy in here. There's a lot of paint. I do miss working at night and on the weekends. It's challenging to have a nine-to-five schedule, but life changes, so we have to adapt.

**Did you have a plan for the layout of the studio, or did it develop organically?**

This was a big garage. The only thing that I did was separate the office up front from the work space. I can close it off and have privacy if I want. I also put in skylights and the glass window on the front of the building. It's very basic because all that you want is light, space, and walls, right? [*laughs*]

**Has the location influenced your work in any way?**

If I work in Brazil, I'm in my family's farmhouse. It's a different feel than working here. Here it's a white cube, which has become messy with time. I feel when I am here that I have a lot of reflection on memories of other places. And it's nice, actually, that it's a neutral space. It's very quiet. .

**Can you describe a typical day, being as specific as possible?**

I get up at seven because of my daughter. I make breakfast for her, and I usually just drink coffee. Then I drive her to school, and from school I drive directly to the studio. I drink more coffee, and I talk with Teresa [LoJacono] about what we're doing for the day. I look a little bit into emails and stuff like that.

Then all I want to do is come back here and paint or work on things that I have in progress. The walls are always covered with work. I never like finishing

things—I love starting things. I love having all the work up and looking at everything and being able to switch from one work to the other.

I stay in the studio until around five, and then I go home because the nanny leaves, and I spend time with my daughter. Last spring I taught at ICP once a week. That was a nice change—to get out of the studio and see young people's work. It keeps you thinking. Other than that I try to be in the studio most of the time.

**Can you tell me about the materials you use and how they came into your practice?**

I start my large paintings with watercolors because I like the challenge of the size. Most people think watercolors are made with little tiny brushes and are these little precious things. I love the idea of blowing that out of proportion. I used to work in oils, but I found I like water. I like how pigment dissolves in water. I started adding acrylic, and I started adding gouache and tempera to the mix. I like the texture of canvas, so I now mix all those mediums together on canvas.

There is a range of materials. I use watercolor sticks, crayons, a lot of watercolor pencils. They're all on that middle table there, and then on the back table are pigments and brushes and acrylic paints and watercolor paints and lots of buckets. [*laughs*]

**Do you have a favorite color?**

Prussian Blue. It's funny because my dad was born in Prussia. Now it's Poland. It's my favorite color. It always has been.

**What brands of paints are you using?**

Right now I'm using Golden, but I use a lot of pigment from Guerra paints, Rembrandt watercolors, and Faber-Castell for the sticks. The Guerra paint I started using when I painted a mural in Florida. I wanted to mix my own paints, and they have pretty cool pigment.

**Do you have any special devices or tools that you use that are unique to your creative process?**

The costumes [used in my performance pieces] were all made with latex and inflated with balloons. Then I started using condoms instead of balloons because of the color, the transparency, and because they don't pop that easily and they shape differently. They look like tears. Recently I was in the Amazon shooting a video and I had all these condoms with me to fill up the costumes. But people there were wondering why I was traveling with all those condoms. I said, "It's for the work!" [*laughs*]

**How do you come up with titles?**

That's the worst. [*laughs*] Sometimes a title pops up in the beginning, but if it doesn't, then it becomes a really difficult issue. It is supercomplicated, and it takes me a long time, and then at some point it pops up. But it takes a long time.

**You have a show coming up. What's the title of the show?**

*The Ghost in Between.* I was in the Amazon on the Rio Negro, the black river that reflects all the forest around it. The first thing I heard was that people love to try to find the ghost inside the reflection, where the water meets the forest. While I was surfing around trying to find a title for the show, I kept going back to that.

**What advice would you give the young artist that is just starting out?**

You have to keep focused. When you start out you have to work for money, but you have to keep focused. When you have a project in your head but you don't have the money to develop it, that doesn't mean the work doesn't exist. You have to separate yourself from the material and money aspect of it. It's like having a studio in your head. Even if you can't buy the material, you have to continue thinking as an artist because that's what keeps you alive and keeps you going. You have to be very strong in your head that if you want to be an artist, you can be an artist, no matter what and no matter what you're doing!

# Ursula Von Rydingsvard

Bushwick, Brooklyn / February 6, 2013

**To start off, can you please tell me a bit about your background?**

I was born in Germany in 1942, which was almost the middle of the war. In December 1950 we came to this country. I'm one of seven children. We were nine altogether when we came to the United States. I went to Plainville High School.[1] It wasn't much of a town.

**Did you go to college for art?**

I went to the University of New Hampshire for two years, and I did take an art course there with Christopher Cook and an inspiring art history course. Abstraction was in full swing then. After two years I went to the University of Miami. At that time they didn't have much of an art department.

Through a long process of going to California, then Connecticut, working at jobs that I didn't necessarily want to be in, I came to New York City in 1973, and I felt like that was the time when I was born. I came to Columbia University and got my MFA. It wasn't necessarily the spectacular faculty that turned me on, but some of the visitors, like Philip Guston,[2] who spoke in a way that felt very vulnerable and so full of doubt. It was the time when he was changing from his more expressionistic mode into something that he was pummeled by the critics for. He would say things like, "I don't know what I'm doing. It just feels like this is what I need to do" because one can be honest to students in a way that you can't be to a regular audience or even to your peers. We were not competing with Guston.

The art history department had Meyer Schapiro,[3] who was able to talk about medieval art,

how it was applicable to everything that you know about life in general, as though it were as critical and as pertinent as contemporary art or as Greek art. It felt like I was listening to this earnest boy who spoke not just with his mind, which was certainly brilliant, but through something that was full of feeling, through something that most of us would call "heart"—that his information went with an ability to make all these great parallels with all the things that you could understand and grasp. While Schapiro was lecturing, this was '73, '74, '75, he would wear handknit mittens—they were gray—because his hands were already arthritic, and it felt good for him to warmly wrap his hands, adding to his impact.

**When did you consider yourself a professional artist, and when were you able to dedicate yourself full time to that pursuit?**

Before I made the decision to come to New York City. I was a painter for many years. Then I did sewn pieces with muslin. I think they're all gone, probably eaten by mice. Seeing women artists for the first time making their own work really amazed me. The first one that I encountered was Jean Linder, who did sexually oriented art. She did things that were

---

1. Located in Plainville, Connecticut.
2. Philip Guston (1913–80), American. Artist who at first was a main player in the abstract expressionist movement and later changed direction to create cartoon realist paintings.
3. Meyer Schapiro (1904–96), American. Critic, teacher, and art historian who was an important proponent of modern art. He is known for his interdisciplinary approach to the study of art.

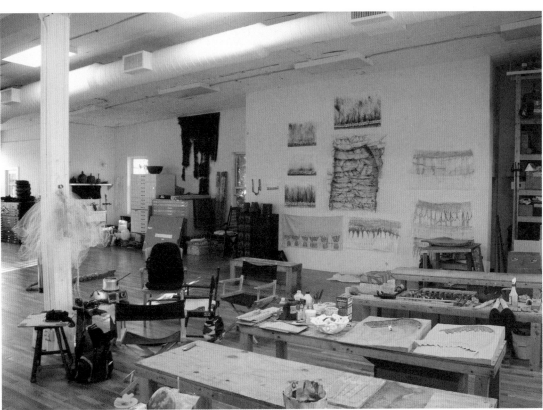

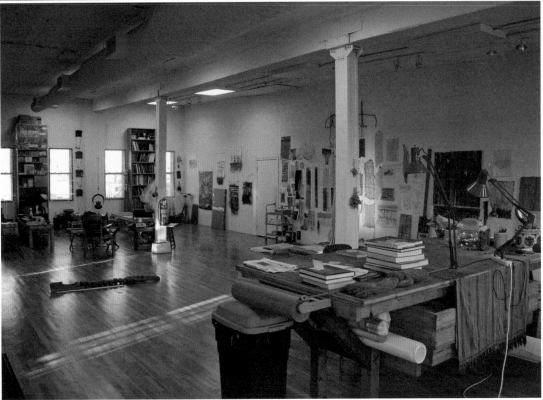

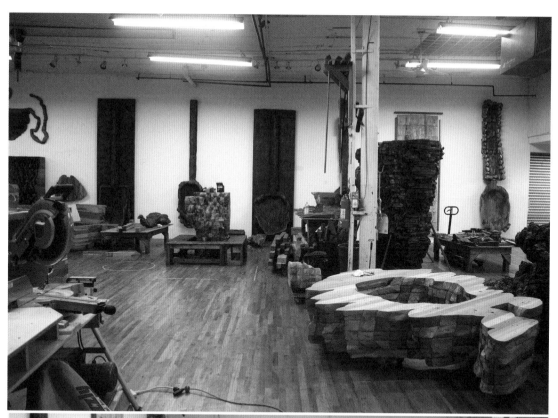

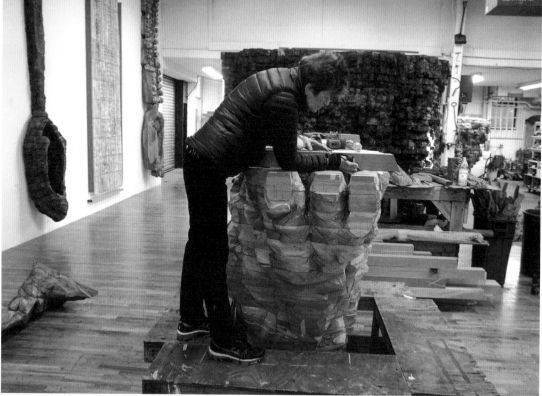

vacuum formed; she did things out of plastic before others, and installation pieces. They had a degree of sexual content that made me think, Wow—she's getting away with this?

New York City just felt spectacular to me. I owe a tremendous amount to this city, to what this city gives birth to. It's not just the number of artists, but how fiercely they pursue what they're doing and how unrelenting they are and how much they need to do this thing called making art, and the huge range of it.

**Where were you living around this time?**

I was living on Claremont Avenue, which is 116th Street, and the studio was on 125th Street. I had a child, also named Ursula. I brought my child with me [to New York] in 1973, and we lived together, just she and I, until 1982. There were the two of us forming this emotional core, and then there was the world outside of us that we would both put our dukes up to fight, and we did the best we could.

**When did you get your first gallery show, and how did that come about?**

I showed with somebody named Jock Truman for a while. Rosa Esman was my first dealer; I worked with her for six years. Then I was with a gallery called Bette Stoler on White Street for a little bit. The most major step really was in 1992; that's when Mary Sabbatino saw my show at Storm King.[4] I've been with her gallery [Galerie Lelong] ever since. She has been a dealer that I trust, that works tremendously hard, that helps make a condition by which I feel like I can make good work. She has artists who have not yet reached their ceiling, which gives breathing room for everybody.

**How long have you been in this studio?**

I've been in this studio for eleven years. This neighborhood is industrial, which is where I belong. When I first moved into this neighborhood, 95 percent of the people walking by my roll-up door were immigrants. The day that I moved in a murder occurred; it wasn't that unusual. As the years went by, more and more artists moved here.

I was for twenty-four years in Williamsburg proper before I moved here. That was on South Fifth Street and Union. That neighborhood underwent a change, from my getting bullet holes in my windows and prostitutes to complete gentrification. I had to move because it got too gentrified.

**You live separately from your studio. Is that what you prefer?**

I live separately from my studio because I breathe in stuff here that I don't have to breathe in at home. My home is another kind of sanctuary. I don't want to be looking at my artwork all the time. I need the studio tremendously. It is the place where I feel enough comfort to take on and work with my visions of what feels consequential to me.

**When you moved into this space, did you have a plan for the layout, or did it develop organically?**

It didn't develop organically, because the building was horribly run-down when I first moved in. The cement floors were torn apart, as though an earthquake had hit. The roofs were torn open, enabling huge colonies of pigeons to make settlements on the floor. Previous occupants used the space to fix ambulances, and before that pine coffins were made. It took a while for me to make the building functional for art.

**Has the location of the studio influenced your work in any way?**

The kind of autonomy and the kind of peace I have is great. Many trucks go down Ingraham Street in front of my studio, and when the pavement shakes it shakes my intestines in all the right ways, and I feel alive. I feel happy to be here; I enjoy seeing all the artists walking by. I go to some of the restaurants that have sprouted in this neighborhood. I'm just hoping it doesn't change too quickly.

**Can you please describe a typical day, being as specific as possible?**

I leave my home at 7:20 every morning and arrive here at 8:00. I have a short meeting with my assistants and we talk about what's to be done for the day, but usually they know because the preceding day dictates what they do—but not

---

4. Storm King Art Center is a five-hundred-acre sculpture park located in the lower Hudson Valley of New York State. Storm King showcases over one hundred carefully sited sculptures from world-acclaimed artists.

always. Then we talk about any problems that came up. I'm always looking at ways of saving time because my work is so time-consuming, so labor-intensive.

We have lunch at exactly 12:00. I have a very kind friend named Betsy Sosland that comes in and makes lunch for us. She goes to the farmers' markets, and she chooses the best of the beets and the lettuces, and she's marvelous. She's like our den mother. After lunch we go back to work again, though I run too often upstairs to the office to do administrative work. That's the stuff that really gives me headaches. We wrap up around 6:00 or 7:00 p.m. I'm glassy-eyed by that time. Oftentimes I have things that I have to go to in the evening, but I'm not very good company. During some of those fund-raisers, my head feels like it's going to fall onto the plate.

**When you're working do you listen to music or the radio?**

No, I can't have music or the radio. It's all I can do to focus on work that I'm making. I never work from maquettes or drawings. I hate them. When I have to have a maquette—which is rare, but federal or state proposals require them—I never refer to it while I'm making the sculpture. Just the fact that I have a visual idea of where I want to go enables me to be so much more alert and alive while I am building the sculpture. I'm doing this because the process of reaching toward and the process of trying to figure it out is exceedingly important to the aliveness of the piece. I don't know nor want to know how the sculpture will end, even though I establish a kind of system within it. I make so many variations and go on so many tangents.

**Can you tell me a little bit about the materials you are using and how they came into your practice?**

I use western red cedar, and it comes from Vancouver, British Columbia. The use of cedar came to my practice during my student days at Columbia University. There was a monk, a student friend, by the name of Michael Mulhern, who at the end of my two-year stint came to the metals studio. He brought a bunch of [four-by-four] cedar beams. That's where and when my use of cedar began. I don't love cedar. That's an erroneous statement—

I feel I can really push it and manipulate it. I feel I have some degree of control over it, even though it also fights back.

**Why cedar over other wood?**

Cedar is soft. It can be cut in ways that are amazingly detailed, incredibly sharp-edged, and you can get a tone that feels soft, a tone that feels harsh. To cut it is not like cutting hardwood. Hardwood fights you just by its physical density. Cedar welcomes the slash, the cut, much more readily.

**Do you have any special tools or devices that are unique to your process?**

Yes, we invent some of our tools. Tools that have a long handle that scrape some of the glue off large, flat areas, and we also invent tools that enable us to reach deeply into the bowls if we're graphiting inside the bowl, when you can't put your body in there. The tool that is our main glory is the circular saw. We use it in ways that are very unorthodox. The people that I have as cutters are the princes of my studio. It takes a courageous human being to cut the cedar the way we cut it. We do not do the straight-line cut. We nibble away with the circular saw, following my drawn lines on the cedar. Many, many, nibbles make the organic external surfaces. There have only been a small number of people that have done my cutting. Ted Springer is a superb cutter; he's cut a tremendous number of my pieces.

**How do you begin a piece?**

If I make a bowl, for example, I make a circle on the floor, which in part heralds the height of the sculpture. Then I put the four-by-four down, and I draw a line on each of the ends of the four-by-four. The line indicates the cuts to be made on each of the four sides. Once I have this cedar board cut, it becomes a given that I react to. It's not exactly row by row, but it's something that grows organically.

**Are there items that you keep in your studio that have significant meaning to you?**

I have a lot of African things. I've been to Japan many times, so I have things from Japan, like that hanging rice bowl and those little handheld weaving looms. Next to them is a Polish peasant's shoe that one puts on when one goes into the garden.

I have a lot of objects like that at home that give me great pleasure. I moved three years ago to the

apartment that my husband and I have now. My anxiety level in that apartment was high until I put the objects where they belong. I think I feel the same in this room as well. Downstairs I usually have just the tools, old tools that are really dysfunctional that I hang on the columns. They bring me comfort, as well. Maybe *comfort*'s the wrong word. My father used to use a scythe. He was a peasant farmer; I come from Polish peasant farmers. There's a part of who I am that belongs to that world, which preceded me.

**When you're contemplating your work, where or how do you sit or stand?**

I'm not big on contemplating. I usually have an image, and sometimes it grows out of the previous piece. To have an image is not a hard thing, but to actually realize it is not an easy thing. Often the image that I had in my head needs to be changed enormously. There are things that I say to myself that are so simple minded that it's almost embarrassing: "No, not this! Try to do it another way! Lighten it up!" Like somebody that's reprimanding you or coaxing you in the right direction. It's corny.

**Tell me about your assistants?**

My assistants are as good as assistants get. They are really dedicated to the artwork. I control the visuals of my artwork fiercely, and it's totally acceptable to them. We sometimes redo and redo and redo, and they totally get it. I hire people that have tucked-in egos, so I don't need to worry about nurturing them. They're just wonderful to be with. This is my other family. I am very loyal to them. I'm proud to say they all have medical insurance that I provide. We're all very conscious about safety. I think I have the best team I've ever had.

**How do you come up with titles?**

Sometimes they come up before I even think of what the piece is going to be. I have many, many art books that I keep little notes in, both verbal and visual. Sometimes I think my titles are so corny, but sometimes I can't suck it out of my thumb any better. Oftentimes the titles are documentary, as in *Bowl with Bent Knee*.

**Do you have one title that stands out, like one of your favorites?**

One of them is *He Went and Died*. Another one is *Zakopane*. Zakopane, it's a town in Poland. Another one is *Ene Due Rabe*. It's the name of a Polish child's game.

**Did you ever work for another artist?**

No. It's in part because I graduated when I was thirty-five years old, with my master's degree. I had a child, so my time was really precious. I was tremendously disciplined, as I am now, so to think of working for an artist just was not possible. I don't bemoan that.

I bemoan more things, like I wish I had taken more courses in literature because I love it so much. I wish that I had taken more courses in textiles from Chile. I wish I took a trip to India. I've never been to Africa. I always feel like you have to have yearnings in your life. [*laughs*] I think you're a dead fish if you have everything you've ever wanted.

The less time I have, the more I need to unearth things. This is especially true in my sculpture. The effort does not lessen the older you get. If anything, I coax and squeeze the effort even harder to try to evolve.

**What advice would you give to a young artist that is just starting out?**

Don't work big. [*laughs*] That's all. There are many, many punitive things that come with working big, but for me, it's so worth it.

# About the Artists

and International Center of Photography, New York—and hundreds of group exhibitions at museums, alternative spaces, galleries, and nonprofit organizations. She lives and works in Hartford.

### Petah Coyne

b. 1953, Oklahoma City, Oklahoma / Petah Coyne, referred to as "the queen of mixed media" by *Artforum* magazine, is a contemporary sculptor and photographer working in innovative ways with disparate materials. Ranging from the organic to the ephemeral, her works incorporate such items as dead fish, mud, sticks, hay, black sand, specially formulated and patented wax, satin ribbons, velvet, silk flowers, and, more recently, taxidermy and cast-wax statues. Her work is held in numerous museum collections, including the Museum of Modern Art, New York; the Metropolitan Museum of Art, New York; the Solomon R. Guggenheim Museum, New York; Whitney Museum of American Art, New York; Brooklyn Museum; Philadelphia Museum of Art; San Francisco Museum of Modern Art; Hirshhorn Museum and Sculpture Garden, Smithsonian Institution, Washington, DC; and Kemper Museum of Contemporary Art, Kansas City, Missouri, among others. Coyne lives in New York City and works in West New York, New Jersey. She is represented by Galerie Lelong, New York.

### Ellen Altfest

b. 1970, New York City / Ellen Altfest received a BFA and a BA from Cornell University and an MFA from Yale University School of Art, and attended Skowhegan School of Painting and Sculpture. Altfest has had solo exhibitions at the New Museum of Contemporary Art, New York; the Chinati Foundation, Marfa, Texas; and MK Gallery, Milton Keynes, England. Her work has been included in many national and international group exhibitions, including at the 55th Venice Biennale, the Encyclopedic Palace; Royal Academy of Arts, London; and Plateau, Samsung Museum of Art, Seoul. Altfest is a recipient of a John Simon Guggenheim Memorial Foundation Fellowship; a Richard and Hinda Rosenthal Foundation Award, American Academy of Arts and Letters; and an award from the Marie Walsh Sharpe Art Foundation/ The Space Program. Altfest lives and works in New York City and Kent, Connecticut.

### Peter Campus

b. 1937, New York City / Peter Campus studied experimental psychology at Ohio State University and is widely considered to be a seminal figure in the history of video and new media art. Campus works are held in the collections of numerous public institutions, including the Museum of Modern Art, New York; the Solomon R. Guggenheim Museum, New York; Philadelphia Museum of Art; Walker Art Center, Minneapolis; San Francisco Museum of Modern Art; El Centro Cultural Arte Contemporáneo, Mexico City; Museo Reina Sofía, Madrid; Centre Pompidou, Paris; Fondation Cartier pour l'Art Contemporain, Paris; Kunstmuseum Bern, Switzerland; and Kunsthalle Bremen, Germany. He is a John Simon Guggenheim Memorial Foundation Fellow. Campus lives and works in East Patchogue, New York, and is represented by the Cristin Tierney Gallery in New York.

### Adam Cvijanovic

b. 1960, Newton, Massachusetts / Adam Cvijanovic is best known for his large-scale landscapes on Tyvek adhered directly to the walls where they are shown. The work calls into question the relation between the space of the room and the illusionistic space in the painting. He draws on diverse influences, from Italian Renaissance fresco painting to nineteenth-century panoramas to cinematic iconography and site-specific installation work of the 1970s. His work has been exhibited in museums and galleries throughout the United States and internationally, including Hammer Museum, Los Angeles; Pennsylvania Academy of the Fine Arts, Philadelphia; Royal Academy of Arts, London; Tate Liverpool, England; and Palazzo Strozzi in Florence, Italy, and has been included in the international surveys Prospect.1 New Orleans; Biennale of Sidney, Australia; and Moscow Biennale of Contemporary Art.

### Ellen Carey

b. 1952, New York City / Ellen Carey is a lens-based artist, photographer, educator, and author. Her experimental and breakthrough minimalist/abstract *Pulls* and site-specific installations are created with the large-format Polaroid 20 x 24 camera. Equally original is her darkroom practice, in which she creates cameraless photograms for her continuing *Dings and Shadows* series. Her work has been the subject of fifty solo exhibitions—at institutions including Wadsworth Atheneum Museum of Art, Hartford; Real Art Ways, Hartford; Saint Joseph College Art Gallery, West Hartford; Lyman Allyn Art Museum, New London, Connecticut;

### Tara Donovan

b. 1969, New York City / Tara Donovan is acclaimed for her large-scale installations and sculptures made from everyday objects, as well as for her commitment to process and ability to discover the inherent physical characteristics of an object and transform it into art. She has explored the multiplication of these interactions, at times utilizing hundreds of thousands—even millions—of units to generate powerful perceptual phenomena and subtle atmospheric effects. She is the recipient of a MacArthur Fellowship; a Calder Prize;

a Willard L. Metcalf Award in Art, American Academy of Arts and Letters; a Helen Foster Barnett Prize, National Academy Museum; and a Women's Caucus for Art Presidential Award, among other awards and honors. Her work is held in numerous public and private collections, including Dallas Museum of Art; Indianapolis Museum of Art; the Institute of Contemporary Art, Boston; Museum of Fine Arts, Boston; the Metropolitan Museum of Art, New York; the Museum of Contemporary Art, Los Angeles; Museum of Fine Arts, Boston; Wadsworth Atheneum Museum of Art, Hartford; and Whitney Museum of American Art, New York, among others. She attended the School of Visual Arts and received a BFA from Corcoran College of Art + Design, Washington, DC, and an MFA from Virginia Commonwealth University, Richmond. She lives in Brooklyn, works in Long Island City, and is represented by Pace Gallery, New York.

### Leonardo Drew

b. 1964, Tallahassee, Florida / Leonardo Drew first exhibited his work at the age of thirteen. He attended Parsons School of Design and received his BFA from the Cooper Union for the Advancement of Science and Art in 1985. Drew is known for reflective abstract sculptural artworks, most often based on the psychological and cosmological exploration of a grid or framework. He has collaborated with the Merce Cunningham Dance Company and has participated in artist residencies at Artpace, San Antonio; and the Studio Museum in Harlem, New York, among others. He was awarded the 2011 Joyce Alexander Wein Artist Prize and is featured in the PBS documentary series ART21: Art in the Twenty-First Century, season 7. He lives and works in Brooklyn, New York.

### Carroll Dunham

b. 1949, New Haven, Connecticut / Working since the late 1970s in painting, drawing, and printmaking, Carroll Dunham is known for a conceptual approach, which has included aspects of abstraction and representation. His work has been the subject of numerous solo exhibitions, including a midcareer retrospective at New Museum of Contemporary Art, New York, and has been included in group exhibitions at institutions in the United States and abroad. His work is held in a number of public collections. He lives and works in New York City and Connecticut.

### Tom Friedman

b. 1965, St. Louis, Missouri / Tom Friedman is celebrated for his unique and meticulous approach to art making. Painstakingly created, his works often appear prefabricated, before closer inspection reveals remarkable attention to detail and handicraft. The artist celebrates the acts of construction and destruction through an alchemical transformation of unexpected materials, including Styrofoam and flock. In his artworks, materials and concepts explode and implode both literally and metaphorically. He lives and works in Massachusetts.

### Kate Gilmore

b. 1975, Washington, DC / Kate Gilmore received her BA from Bates College and her MFA from the School of Visual Arts. Her work has been shown nationally and internationally at such institutions as Museum of Contemporary Art Cleveland; Whitney Museum of American Art, New York (2010 biennial); Brooklyn Museum; MOMA PS1, Long Island City, New York; Indianapolis Museum of Art; Istanbul Museum of Modern Art; Haifa Museum of Art, Israel; and Museum of Contemporary Art, Chicago, among others, and in Bryant Park, New York, in a performance installation presented by Public Art Fund. She is the recipient of the Rome Prize, the Louis Comfort Tiffany Foundation Biennial Award, Lower Manhattan Cultural Council Award for Artistic Excellence, New York Foundation for the Arts Performance/Multidisciplinary Fellowship, the Robert Rauschenberg Foundation's Rauschenberg Residency award, and the Marie Walsh Sharpe Foundation/The Space Program award, among other honors. Her work is in the collections of the Museum of Modern Art, New York; Whitney Museum of American Art, New York; Brooklyn Museum; Museum of Fine Arts, Boston; Indianapolis Museum of Art; and Museum of Contemporary Art, Chicago, among other museums.

### Red Grooms

b. 1937, Nashville, Tennessee / Red Grooms's work has been exhibited nationally and internationally for over fifty years and has been included in two Venice Biennales. He has had over one hundred solo exhibitions and been included in countless group exhibitions. His many awards include a National Academy of Design Lifetime Achievement Award; a Governor's Award in the Arts, Tennessee; and the Pennsylvania Academy of Fine Arts Founders' Medal, among others. He is a member of the American Academy of Arts and Letters. His work is in the collections of over forty-five major institutions worldwide. He is represented by Marlborough Gallery and lives and works in New York City.

### Hilary Harkness

b. 1971, Detroit, Michigan / Best known for her detailed paintings of worlds inhabited only by women, Hilary Harkness explores abuses of power, which she presents on an intimate, yet grand, scale. Sex, war, reproduction, free markets, and scientific experimentation play out on an uncensored stage—tethered to historical moments and real-world settings. Her work has been exhibited worldwide and is in the collection of the Whitney Museum of American Art. She has taught and lectured widely at institutions such as Columbia University, Yale University, and the Baltimore Museum of Art. She holds a BA from University of California, Berkeley, and an MFA from Yale University School of Art. She is represented by Mary Boone Gallery, New York.

## Byron Kim

b. 1961, La Jolla, California / Byron Kim is perhaps best known for his painting *Synecdoche*, which was included in the 1993 Whitney Biennial. Composed of a grid of hundreds of panels depicting different skin tones, the work is both an abstract monochrome and a group portrait. His ongoing series of *Sunday* paintings, in which he records the appearance of the sky every week, combines the cosmological and the quotidian. Kim received a BA in English at Yale University and attended the Skowhegan School of Painting and Sculpture. Among his numerous awards are a National Endowment for the Arts Award, a Joan Mitchell Foundation Grant, and the Herb Alpert Award in the Arts. His work is included in the collections of the Art Institute of Chicago; Brooklyn Museum; Hirshhorn Museum and Sculpture Garden, Smithsonian Institution, Washington, DC; National Gallery of Art, Washington, DC; Wadsworth Atheneum Museum of Art, Hartford; and Whitney Museum of American Art, New York, among others.

## Alois Kronschlaeger

b. 1966, Grieskirchen, Austria / Alois Kronschlaeger received his MFA from the School of Visual Arts. He is best known for his site-specific installations and geometric sculptures, which demonstrate a preoccupation with environment and light. Kronschlaeger's work has been shown internationally—solo exhibitions in the Czech Republic, Austria, and Tokyo, and group exhibitions in Beijing, London, Austria, and Mexico City. He had his first major institutional solo exhibition at the Museum of Contemporary Art Tucson, in Arizona, in 2013. Kronschlaeger is the recipient of a New York Foundation for the Arts Architecture, Environmental Structures, and Design Fellowship and a New York City Department of Cultural Affairs Gregory Millard Fellowship. Kronschlaeger lives and works in Brooklyn and is represented by the Cristin Tierney Gallery, New York.

## Tom Otterness

b. 1952, Wichita, Kansas / Tom Otterness moved to New York City in 1970. He began taking classes at the Art Students League, and in 1973 he entered Whitney Museum of American Art's Independent Study Program. In 1978 he began working with Collaborative Projects (aka Colab), a socially active artists' collective. Otterness has been commissioned by a variety of public entities in the United States and abroad, including the General Services Administration; New York City Metropolitan Transit Authority; Battery Park City Authority, New York; Cleveland Public Library; and the City of Münster, Germany, among many others. He is included in numerous museum collections, including the Solomon R. Guggenheim Museum, New York; the Museum of Modern Art, New York; Whitney Museum of American Art, New York; Carnegie Museum of Art, Pittsburgh; and the Miyagi Museum of Art, Sendai, Japan. He is represented by Marlborough Gallery, New York.

## Tony Oursler

b. 1957, New York City / Tony Oursler received a BA in fine arts at California Institute of the Arts in 1979. His art covers a range of mediums: he works in video, sculpture, installation, performance, and painting. Oursler's work has been exhibited in the international surveys Documenta (VIII and IX), in Kassel, Germany; and Skulptur Projekte Münster, Germany; and at the Museum of Modern Art, New York; Whitney Museum of American Art, New York; Hirshhorn Museum and Sculpture Garden, Smithsonian Institution, Washington, DC; Walker Art Center, Minneapolis; Carnegie Museum of Art, Pittsburgh; Tate Liverpool, England; Centre Pompidou, Paris; and Museum Ludwig, Cologne. He lives and works in New York City.

## Roxy Paine

b. 1966, New York City / Roxy Paine's works are discourses in the episteme, which is the concept defining any given era's total body of knowledge. This determines what questions can and, more importantly, cannot be asked within the collective knowledge field. With his first solo show in New York City in 1991, Paine established an early interest in the collision of conflicting impulses of information such as industry and nature, control and chaos, and form and theory. He describes his sculptures as a translation between disparate realms of data and knowledge, testing principles of potential, rigor, and chance, and identifies his work as a trajectory of several overlapping wavelengths: *Art Making Machines, Fungal Fields, Replicants, Specimen Cases, Dendroids,* and *Dioramas.* The idiosyncrasy of his work lies in his sculpture-making process, in which the physical object and conceptual idea are equivalent forces of meditation. Paine is the recipient of a John Simon Guggenheim Memorial Foundation Fellowship. His works can be found in numerous collections, including the Museum of Contemporary Art, Los Angeles; National Gallery of Art, Washington, DC; Hirshhorn Museum and Sculpture Garden, Smithsonian Institution, Washington, DC; the Museum of Modern Art, New York; Whitney Museum of American Art, New York; National Gallery of Canada, Ottawa; the Israel Museum, Jerusalem; and Wanås, Östra Göinge, Sweden.

## Judy Pfaff

b. 1946, London, England / Judy Pfaff received an MFA from Yale University, where she studied under Al Held. A pioneer of installation art in the 1970s, Pfaff synthesizes sculpture, painting, and architecture into dynamic environments in which space seems to expand and collapse, fluctuating between the two- and three-dimensional realms. Her work has been included in the Whitney Biennial and the São Paulo Biennial, and is in the permanent collections of the Museum of Modern Art, New York; Whitney Museum of American Art, New York; Brooklyn Museum; Detroit Institute of Arts; Tate Gallery, London; and others. She is the recipient of

many awards, including the International Sculpture Center Lifetime Achievement Award and the MacArthur Fellowship. Pfaff lives and works in Kingston and Tivoli, New York.

### Will Ryman

b. 1969, New York City / Using found objects and consumer products to make sculptural installations, Will Ryman refers to both psychological problems and political issues in his work. A site-specific installation, *The Roses* (2011), was installed on the Park Avenue malls between Fifty-Seventh and Sixty-Seventh Streets in New York City. In 2013 Ryman created *America*, which was acquired by and is on permanent view at New Orleans Museum of Art. Ryman's work has been exhibited widely, in shows at 7 World Trade Center, New York; Flatiron Plaza, New York; MOMA PS1, Long Island City, New York; the Phillips Collection, Washington, DC; Herbert F. Johnson Museum of Art, Cornell University, Ithaca, New York; Prospect.3: Notes for Now, New Orleans; and Saatchi Gallery, London, among others. He lives and works in New York City.

### Laurie Simmons

b. 1949, Long Island, New York / Since the mid-1970s, photographer and filmmaker Laurie Simmons has staged scenes for her camera with dolls, ventriloquist dummies, objects on legs, and people to create photographs that reference domestic scenes. She has been the recipient of numerous honors, including a National Endowment for the Arts Grant, the John Simon Guggenheim Memorial Foundation Fellowship, the Distinguished Alumni Award at Temple University, and the Roy Lichtenstein Residency in Visual Arts at the American Academy in Rome, among others. She lives and works in New York City and northwestern Connecticut.

### Eve Sussman

b. 1961, London, England / Eve Sussman is known for her films, videos, and installations. Her work is in the collections of the Museum of Modern Art, New York; Whitney Museum of American Art, New York; Smithsonian American Art Museum, Washington, DC; Fundación "la Caixa," Barcelona; and Leeum, Samsung Museum, Seoul. Together with Simon Lee she cofounded Wallabout Oyster Theatre, a microtheater space run out of their studios in Brooklyn. As collaborators, recent projects include *No Food, No Money, No Jewels* and the *Jack + Leigh Ruby* series.

### Philip Taaffe

b. 1955, Elizabeth, New Jersey / Philip Taaffe studied at the Cooper Union for the Advancement of Science and Art. His first solo exhibition was in New York City in 1982. He has traveled widely in the Middle East, India, South America, and Morocco. His work has been included in numerous museum exhibitions and international surveys, including the Carnegie International, Biennale of Sydney (twice), and Whitney

Biennial (three times). His work is held in many public collections, including the Museum of Modern Art, New York; Whitney Museum of American Art, New York; Philadelphia Museum of Art; and Museo Reina Sofía, Madrid. He has had retrospective surveys of his work at Institut Valencià d'Art Modern, Spain; Fondazione Galleria Civica, Trento, Italy; Galleria d'Arte Moderna et Contemporenea, San Marino, Italy; and Kunstmuseum Wolfsburg, Germany. He lives and works in New York City and West Cornwall, Connecticut.

### Janaina Tschäpe

b. 1979, Munich, Germany / Taking the female body for her muse, Janaina Tschäpe explores themes of the body and landscape, sex, death, renewal, and transformation in paintings, drawings, photographs, and video installations. Her use of organic lines and ethereal forms in her paintings creates a network of relationships, linking the process of artistic practice to life cycles found in nature. Tschäpe was born in Munich and raised there and in São Paolo, Brazil. She received her BFA from University of Fine Arts of Hamburg and her MFA from School of Visual Arts. Tschäpe's work has been shown in numerous exhibitions in locations throughout the world, including New York, Tokyo, São Paolo, London, Madrid, Paris, Switzerland, and Berlin.

### Ursula von Rydingsvard

b. 1942, Deensen, Germany / Ursula von Rydingsvard is a sculptor best known for creating large-scale, often monumental sculpture from cedar beams, which she painstakingly cuts, assembles, and laminates, finally rubbing powdered graphite into the work's textured, faceted surfaces. Recently she has cast sculptures in bronze from full-scale cedar models. Her work is represented in the permanent collections of over thirty museums, including the Metropolitan Museum of Art, New York; the Museum of Modern Art, New York; Whitney Museum of American Art, New York; Walker Art Center, Minneapolis; the Nelson-Atkins Museum of Art, Kansas City, Missouri; Storm King Art Center, Mountainville, New York; Detroit Institute of Arts; and National Gallery of Art, Washington, DC. Her sculptures are installed at Microsoft Corporation, Bloomberg, and Barclays Center, and are in many other corporate collections. She has received two grants from the National Endowment for the Arts, a John Simon Guggenheim Memorial Foundation Fellowship, the Skowhegan Medal for Sculpture, and the International Sculpture Center Lifetime Achievement Award. Von Rydingsvard is also a member of the American Academy of Arts and Letters. She works in Brooklyn.

Joe Fig's studio, April 1, 2014, with the sculptures *Tara Donovan: November 21, 2013*
and *Petah Coyne: May 9, 2013* in progress